SIMONE LEIGH

SIMONE LEIGH

Edited by Eva Respini

Institute of Contemporary Art/Boston
in association with
DelMonico Books · D.A.P. New York

CONTENTS

The Institute of Contemporary Art/Boston is proud to present the first survey exhibition of Simone Leigh and to share her powerful, insistent, and indelible art with audiences nationwide. This far-reaching exhibition is the culmination of our long-term engagement with Leigh's art. Notably, in 2020 the museum was awarded the commission of an exhibition of the art of Simone Leigh for the United States Pavilion at the 59th International Art Exhibition of La Biennale di Venezia, which it presented in partnership with the Bureau of Educational and Cultural Affairs of the U.S. Department of State. Leigh was selected as the first Black woman artist to represent the country. For this groundbreaking presentation, titled *Sovereignty*, Leigh created a series of new works addressing absences in the historical archive, giving visibility to knowledge long held and too long unseen. With its monumental presence, *Sovereignty* expanded Leigh's ongoing investigation into ideas of self-determination and agency. This exhibition now brings these explorations to audiences in the United States, joining them with works spanning nearly twenty years of production. *Simone Leigh* features key artworks in bronze, ceramic, video, and raffia, crossing geography, time, and cultures, with specific references to vernacular architecture and handmade processes from across the African diaspora. For the first time, audiences will experience the breadth and depth of Leigh's expansive vision.

This exhibition, long overdue, also occasioned the artist's first monograph, for which the ICA commissioned leading scholars, artists, and writers to explore the ideas and questions that undergird Leigh's practice across various media. The result is a comprehensive volume of critical, poetic, and meditative studies that celebrate the rich intellectual and creative reach of Leigh's vision.

Eva Respini, deputy director for curatorial affairs and Barbara Lee Chief Curator, and co-commissioner of *Sovereignty*, led and shaped this survey and publication. I am grateful for her partnership, thoughtfulness, and curatorial leadership. Following its debut at the ICA, the exhibition will travel to the Hirshhorn Museum and Sculpture Garden in Washington, DC, and to a joint presentation at the California African American Museum and the Los Angeles County Museum of Art in Los Angeles. I am very appreciative of our partners at these institutions for their support and collaboration.

My profound thanks go to the many generous and enthusiastic supporters of this presentation and its numerous components in Venice, at the ICA, and across the country: Ford Foundation, Mellon Foundation, eu2be, Bloomberg Philanthropies, Paul and Catherine Buttenwieser, Girlfriend Fund, Wagner Foundation, Amy and David Abrams, Stephanie Formica Connaughton and John Connaughton, Bridgitt and Bruce Evans, James and Audrey Foster, Agnes Gund, Jodi and Hal Hess, Hostetler/Wrigley Foundation, Barbara and Amos Hostetter, Brigette Lau Collection, Henry Luce Foundation, Kristen and Kent Lucken, Tristin and Martin Mannion, Ted Pappendick and Erica Gervais Pappendick, Gina and Stuart Peterson, Helen and Charles Schwab, Terra Foundation for American Art, VIA Art Fund, Suzanne Deal Booth, Kate and Chuck Brizius, Richard Chang, Karen and Brian Conway, Steven Corkin and Dan Maddalena, Federico Martin Castro Debernardi,

Jennifer Epstein and Bill Keravuori, Esta Gordon Epstein and Robert Epstein, Negin and Oliver Ewald, Alison and John Ferring, Helen Frankenthaler Foundation, Glenn and Amanda Fuhrman, Vivien and Alan Hassenfeld and the Hassenfeld Family Foundation, Peggy J. Koenig and Family, The Holly Peterson Foundation, David and Leslie Puth, Cindy and Howard Rachofsky, Leslie Riedel and Scott Friend, Mark and Marie Schwartz, Kim Sinatra, Tobias and Kristin Welo, Lise and Jeffrey Wilks, Kelly Williams and Andrew Forsyth, Jill and Nick Woodman, Nicole Zatlyn and Jason Weiner, Marilyn Lyng and Dan O'Connell, Komal Shah and Gaurav Garg Foundation, Kate and Ajay Agarwal, Eunhak Bae and Robert Kwak, Jeremiah Schneider Joseph, Barbara H. Lloyd, Cynthia and John Reed, the Fotene Demoulas Fund for Curatorial Research and Publications, and anonymous donors. Additional support for *Loophole of Retreat: Venice* was provided by Goldman Sachs *One Million Black Women* and Lambent Foundation.

The members of the ICA's extraordinary Board of Trustees (listed on page 358) exemplify the joys of commitment and community, and I appreciate their fierce dedication to this exhibition, championing it from the onset. We are also grateful to the generous lenders (listed on page 357) for graciously sharing works from their collections for the enjoyment of thousands of people.

Simone Leigh's art makes space for the experiences, histories, authorship, labor, and subjectivity of Black women, insisting on their visibility and bringing weight and solidity to their figures. Thank you, Simone, for your unparalleled artistic vision.

Jill Medvedow
Ellen Matilda Poss Director

Simone Leigh sculpting *Sentinel* (2022), 2021

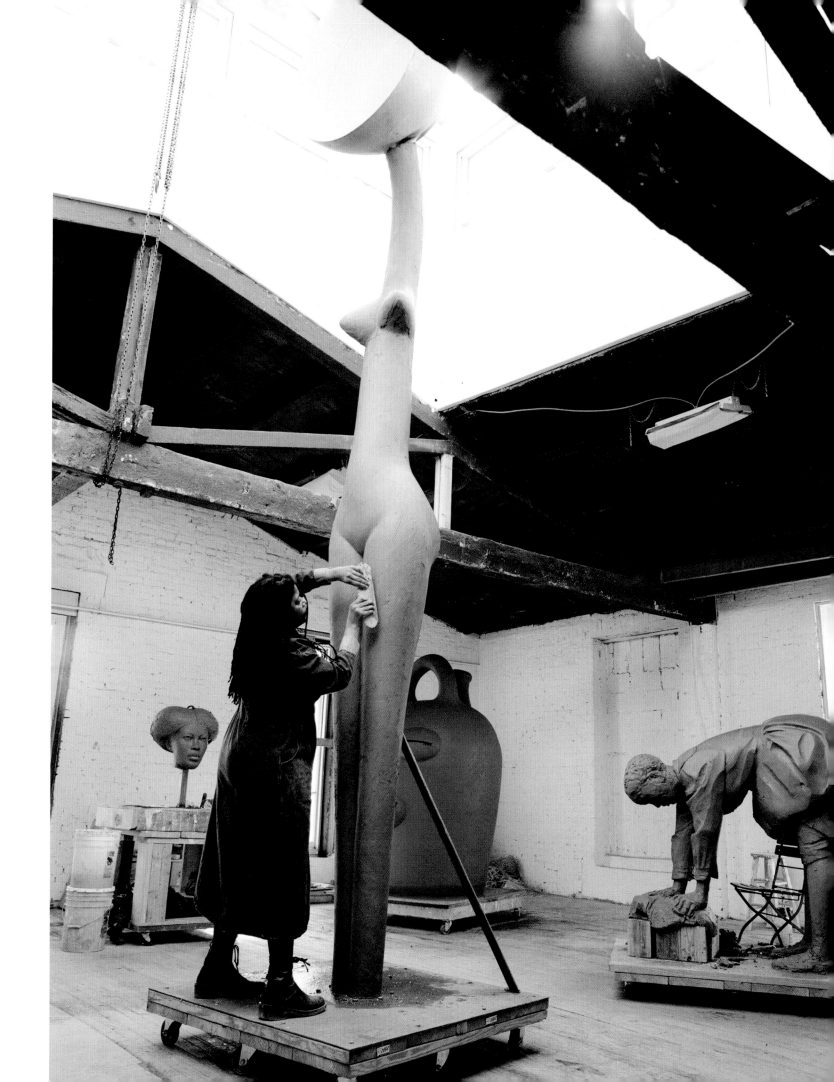

Sentinel, 2022
Bronze
194 × 39 × 23 1/4 inches (492.8 × 99.1 × 59.1 cm)

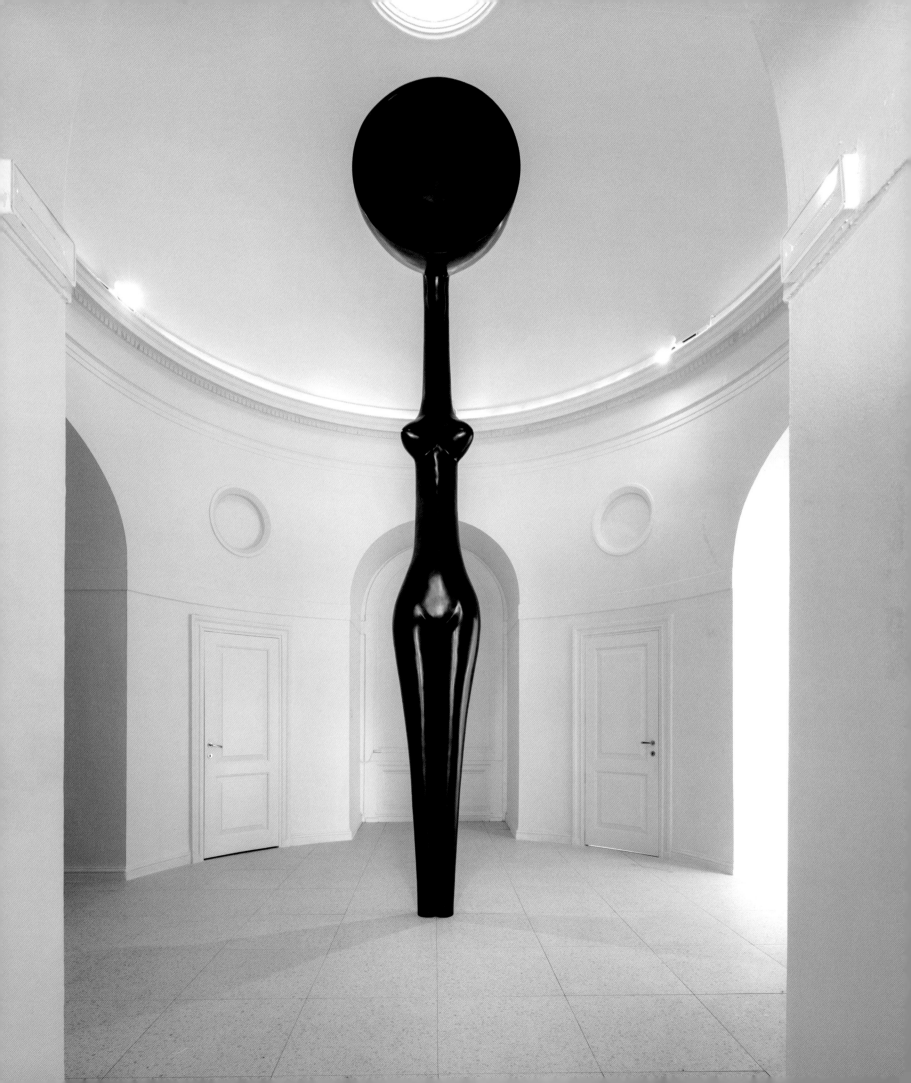

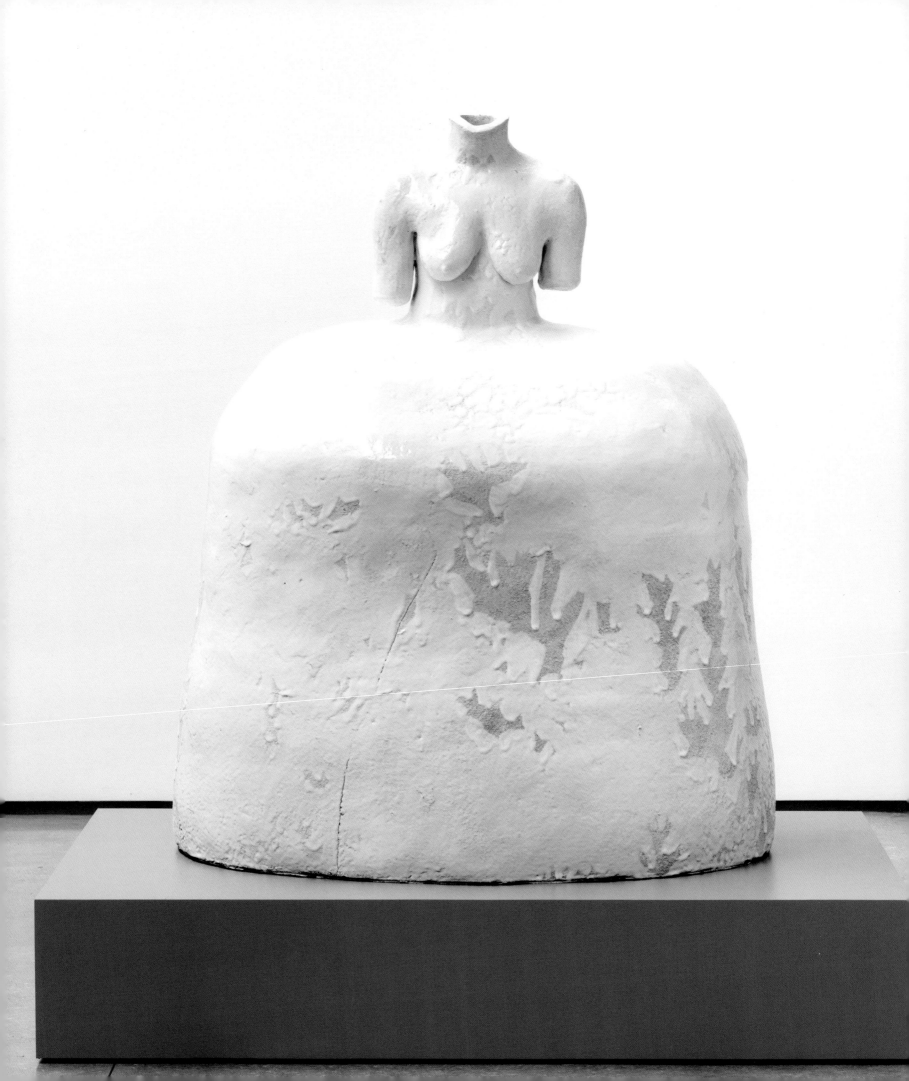

Martinique, 2020
Stoneware
59 1/2 × 50 1/4 × 41 1/2 inches (151.1 × 127.6 × 105.4 cm)

Eva Respini

Introduction:
Simone Leigh, Sculpting Time

In order to tell the truth you need to invent what might be missing from the archive, to collapse time, to concern yourself with issues of scale, to formally move things around in a way that reveals something more true than fact.[1]

Simone Leigh

This is Simone Leigh's first monograph and, along with the exhibition it accompanies, the first sustained project to trace the trajectory of her work in ceramic, bronze, raffia, video, and social sculpture. Since the beginning of her career, Leigh has embraced a polyphonic vocabulary that elaborates on Black feminist thought and collectivity, with artworks that draw on vernacular architecture and the femme form, rendering them via materials and processes associated with the artistic traditions of Africa and the African diaspora. As is the case with any retrospective of a living artist, this is an incomplete story. So far, the media narrative around Leigh's career has often been linked to *belatedness*—the notion that this moment is *overdue*.[2] But perhaps it is the institutions, press, and collectors who are belated. The work has always been there, and its impact and power can no longer be denied. Her art teaches us that time cannot be forced. The work operates on its own terms, and she has created her own systems that are populated with collaborators, writers, and artists of her choosing, continually making room for others. This publication is a testament to the complex responses her work inspires: twenty-one contributors from various fields, areas of expertise, and generations are gathered here, each illuminating Leigh's practice through their respective prisms. Together, these transverse readings map the still-flourishing career of one of the most remarkable artists of our time.

This project is the result of several intersecting endeavors unfolding concurrently over a few years. I invited Leigh to do a survey exhibition and monograph in 2019, before the series of ever-escalating cataclysmic world events that have come to define our moment. At that time, Leigh was celebrating a trifecta of projects in New York: her 2018 Hugo Boss Prize at the Solomon R. Guggenheim Museum (pages 224–25); *Brick House* (2019; pages 214–15), the premier plinth commission on the High Line; and her participation in the 2019 Whitney Biennial. Although it seemed to some that Leigh had just burst onto the scene, what was actually happening was that she was receiving more high-profile press for her increasingly ambitious exhibitions.[3] The curator Rashida Bumbray contextualized the flurry of attention with a blunt assessment: "It feels like a moment, but it is really just that the wool has been lifted from everyone's eyes."[4] Leigh has long participated in a network that builds on Black feminist traditions of communality and exchange, which includes the curators Bumbray and the late Bisi Silva; the writers and academics Sharifa Rhodes-Pitts, Aimee Meredith Cox, and Vanessa Agard-Jones; and the interlocutors Saidiya Hartman, Tina M. Campt, and Lorraine O'Grady.[5] It is their foundational, and ongoing, work that has allowed the field to know Leigh's impact on art history and culture, and to better grasp her unwavering vision about whom she makes her art for, and why.

Leigh's vision has been consistent since she began exhibiting in the early 2000s. As we began work on her retrospective, I felt that something Leigh had been doing powerfully all along needed to be presented on an ambitious, global scale. And so, in early 2020, the ICA submitted an application to the U.S. Department of State for Leigh to represent the United States at the 59th International Art Exhibition of La Biennale di Venezia.[6] One of the most important and visible platforms in contemporary art, this commission is fraught with complexity, given its mantle of national "representation" of a country

1 Leigh quoted in *Simone Leigh: Sovereignty* (Boston: Institute of Contemporary Art, 2022), 2.

2 See, for example, Gregory Volk, "The Overdue Skyrocketing of Simone Leigh," *Hyperallergic*, October 6, 2018, https://hyperallergic.com/463403/simone-lee-luhring-augustine/; Robin Pogrebin and Hilarie M. Sheets, "An Artist Ascendant: Simone Leigh Moves into the Mainstream," *New York Times*, August 29, 2018, https://www.nytimes.com/2018/08/29/arts/design/simone-leigh-sculpture-high-line.html; and "Artist Simone Leigh, Finally in the Spotlight, Reflects on Her Naysayers," CBS News, April 27, 2019, https://www.cbsnews.com/video/artist-simone-leigh-finally-in-the-spotlight-reflects-on-her-naysayers/.

3 Exhibitions of note include Momenta Art in 2004; a 2010–11 Studio Museum in Harlem residency; a 2012 solo exhibition at The Kitchen, where I first saw and comprehended the scope of her work; participation in the 2014 Dak'Art Biennale; an ambitious social practice project with Creative Time, *Free People's Medical Clinic*, in 2014; and solo projects at the New Museum, New York, and Hammer Museum, Los Angeles, in 2016.

4 Bumbray quoted in Pogrebin and Sheets, "An Artist Ascendant."

5 Leigh remarked: "I feel like I'm a part of a larger group of artists and thinkers who have reached critical mass. . . . And despite the really horrific climate that we've reached, it still doesn't distract me from the fact of how amazing it is to be a Black artist right now." Quoted in Hilarie M. Sheets, "Simone Leigh Is First Black Woman to Represent U.S. at the Venice Biennale," *New York Times*, October 14, 2020, https://www.nytimes.com/2020/10/14/arts/design/simone-leigh-venice-biennale.html.

6 The U.S. Pavilion is owned by the Solomon R. Guggenheim Foundation, New York, and the program is administrated by the Peggy Guggenheim Collection with the Bureau for Education and Cultural Affairs of the U.S. Department of State. Every two years, American nonprofit arts organizations are invited to apply to commission an artist or artists for the pavilion. The winning project is selected by a panel assembled by the National Endowment for the Arts. Jill Medvedow and I served as co-commissioners for the 2022 U.S. Pavilion; I was curator of the pavilion.

that has not been inclusive of many perspectives, especially those of Black women.[7] After months of waiting (during which COVID-19 spread across the globe and political instability and racially motivated violence in the United States propagated), we learned that Leigh had won this prestigious commission, and we found ourselves working on two projects simultaneously. The ICA exhibition, we decided, would open after Venice, so Leigh could focus on making new work. Because of the pandemic, the Biennale was postponed by one year. Time slowed down, sped up, and got lost in the Zoom vortex. Pandemic-related restrictions on travel kept us from visiting Venice, so we time traveled through our memories and research.

Physical adjacency was replaced with adjacent histories, which is endemic to how Leigh works—collapsing time and geographies to create new hybrids joined by their colonial histories, all while mining historical gaps, inaccuracies, and fallacies. Even early on, while in a college internship at the Smithsonian Institution's National Museum of African Art in Washington, DC, she investigated the problems associated with the categorization, display, and historicization of objects of the African diaspora, and in many ways she addresses these absences in her art. Hartman's conception of "critical fabulation"[8]—a strategy that invites historians, artists, and critics to creatively fill in the gaps of history—provides a resonant framework for approaching Leigh's work.

Leigh has used this methodology throughout her career: "Many times I am thinking about disparate histories when working on a single sculpture," the artist explained in 2019.[9] This approach is informed as much by the cultural critic Édouard Glissant's writings on creolization and hybridity as by her own lived experience as the daughter of Jamaican immigrants.[10] The artist Malik Gaines describes Leigh's process as "making historical loops."[11] In Venice, her method of addressing missing or overlooked histories was broadcast to viewers at first sight of the U.S. Pavilion through two works outside the building, both monumental in scale and scope: *Façade* and *Satellite*.

With *Façade* (2022; pages 24–25), Leigh transformed the pavilion into sculpture by erecting a raffia facade on the building's exterior. This groundbreaking gesture traced back a historical event that had long fascinated her—the 1931 Paris International Colonial Exposition.[12] Effectively reenacting the colonialist project while it was still ongoing, France mounted the exhibit to display the cultures and peoples of the lands then under colonial control.[13] The Expo included a re-creation of the Khmer temple Angkor Wat as well as hybridized national pavilions designed by French architects and those from colonized nations (figs. 1, 2). Venice's Giardini is reminiscent of aaworld's fair in that it houses dozens of national pavilions, each symbolizing a given country's national ideals. The U.S. Pavilion (fig. 3), a Neoclassical building having affinities with Thomas Jefferson's plantation home Monticello, was designed by William Adams Delano and Chester Holmes Aldrich and opened in 1930, one year before the Paris Expo and during the

7 Responding to a question about what it means to represent the United States, Leigh said, "We need to get rid of the idea of nationalism if we're going to go forward." Quoted in Lauren Williams, "At the Venice Biennale, Artist Simone Leigh Centers Experience of Black Women," WBUR, May 13, 2022, https://www.wbur.org/news/2022/05/13/simone-leigh-venice-biennale.

8 See Saidiya Hartman, "Venus in Two Acts," *Small Axe* 12, no. 2 (June 2008): 1–14.

9 Nancy Kenney, "Simone Leigh, Now in the Spotlight, Contemplates the Theme of Invisibility," *Art Newspaper*, April 24, 2019, https://www.theartnewspaper.com/2019/04/24/simone-leigh-now-in-the-spotlight-contemplates-the-theme-of-invisibility.

10 Glissant's *Poetics of Relation* (Paris: Gallimard, 1990) is perhaps his most cited investigation of these ideas. See also his "Creolization in the Making of the Americas," *Caribbean Quarterly* 54, no. 1/2 (2008): 81–89. On her background, Leigh says: "I think like someone from the Caribbean. I like how complicated it is, seeing beauty in something that was horrifying at the same time." Quoted in Siddhartha Mitter, "Simone Leigh, in the World," *New York Times*, April 14, 2022, https://www.nytimes.com/2022/04/14/arts/design/simone-leigh-venice-biennale-us-pavilion.html.

11 Malik Gaines, "Simone Leigh by Malik Gaines," *BOMB Magazine*, no. 127 (Spring 2014): 124, https://bombmagazine.org/articles/simone-leigh/.

12 In 1992 Leigh encountered a publication on the 1931 International Colonial Exposition, which she describes as both problematic and beautiful: "It has some really well done 'noble-savage' photography. And you really feel the architecture—the camera relates your body to the buildings." Quoted in Mitter, "Simone Leigh, in the World."

13 Artists, writers, and activists of the time offered scathing critiques of the Exposition; in collaboration with the surrealists, the French Communist Party organized a counterexhibition, *The Truth about the Colonies (La Verité sur les Colonies)*. Informed by the philosophies of the Martinican sisters Paulette and Jeanne Nardal and founded by the poets Aimé Césaire and Léopold Sédar Senghor, the burgeoning Négritude movement challenged the principles of racialized difference trumpeted by the Paris Colonial Exposition. See Patricia A. Morton, *Hybrid Modernities: Architecture and Representation in the 1931 Colonial Exposition, Paris* (Cambridge, MA: MIT Press, 2003).

16

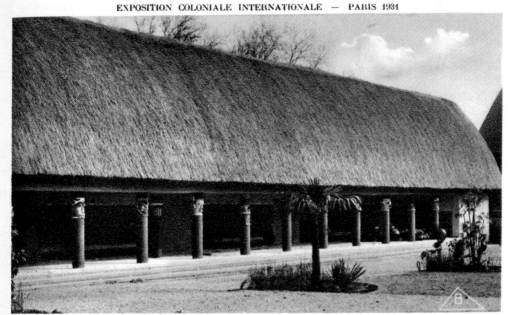

EXPOSITION COLONIALE INTERNATIONALE — PARIS 1931

H. Lacoste, Arch. S. A. D. G.

152 LE JARDIN DU CONGO BELGE — PAVILLON DES TRANSPORTS

Fig. 1 "Exposition Coloniale Internationale – Paris 1931. 152.
Le Jardin du Congo Belge – Pavillon des Transports," 1931. Imp. Braun
& Cie, Editeurs Concessionaires (Paris). Leiden University Libraries,
KITLV Collection 1404343

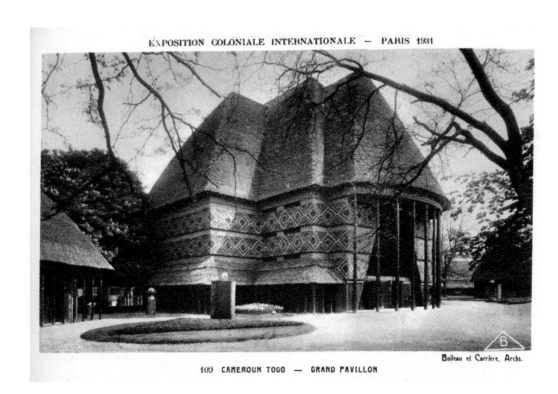

EXPOSITION COLONIALE INTERNATIONALE — PARIS 1931

Boileau et Carrière, Archs.

109 CAMEROUN TOGO — GRAND PAVILLON

Fig. 2 "Exposition Coloniale Internationale – Paris 1931. 109.
Carrefour Togo – Grand Pavillon," 1931. Imp. Braun & Cie, Editeurs
Concessionaires (Paris). Leiden University Libraries, KITLV Collection
1404344

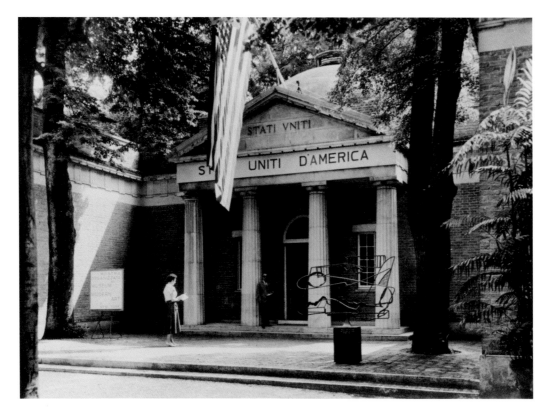

Fig. 3 U.S. Pavilion at the Venice Biennale, 1954.
International Council/International Program. Exhibition Records.
ICE-F-23-54: box 20.5. The Museum of Modern Art Archives,
New York

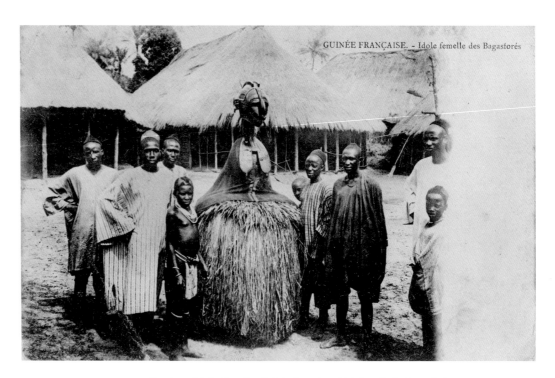

Fig. 4 M. E. Chevrier, *Guinée française – Idole femelle des Bagasforés,* ca. 1901.
National Museum of African Art, Smithsonian Institution. African Postcard
Collection, EEPA 1985-014, Eliot Elisofon Photographic Archives

height both of Jim Crow in the United States and of rising anti-Semitism and fascism in Europe. Leigh's combination of these two proximate events and architectures explores the intertwining legacies of imperialism and colonialism that have long undergirded her work.

Other adjacencies surfaced. When we were finally able to visit Venice in December 2021, Leigh was about to complete her monumental sculpture *Satellite* (2022; pages 250–51), inspired by the traditional D'mba headdress of the Baga peoples of the Guinea coast. *Satellite* draws on the D'mba's multiple historical potencies: the headdresses were used as a conduit to communicate with ancestors during rituals (fig. 4) and, alongside other African sculpture and masks, were a source of fascination for European modernists, who valued such objects for their aesthetic qualities rather than for their original functions.[14] During our late 2021 visit, the exhibition *Migrating Objects* at the nearby Peggy Guggenheim Collection in Venice featured a D'mba collected by Guggenheim (page 36, fig. 1) and reproduced archival images of the colonial appropriation of African artifacts (fig. 5), resonating deeply with Leigh's project. In their imposing, assured scale, their hybrid content and form, and their reach through various time registers, *Façade* and *Satellite* set the tone for Leigh's Venice exhibition, titled *Sovereignty*.

Leigh had participated in previous Venice Biennale events. In 2015 she spoke at the Venice Creative Time Summit,[15] using the highly visible stage to articulate that Black women are her primary inspiration and audience. O'Grady remarked of Leigh's stated focus: "We're talking about something very deep, which is the audience with whom you have interior conversations as you work, in order to shed light on issues that have received no light for centuries."[16] The attention to lineage and history—to her foremothers, as Leigh says[17]—is a pillar of her art. One of Leigh's earliest inspirations is Nigerian pottery (specifically water pots made by Ladi Kwali [page 106, fig. 1]), which sparked her to think about means of production, the

anonymous labor of Black women (the primary makers of water pots), and how African objects and material culture are classified.[18] Her work within ceramic traditions challenges conventional, hierarchical fine arts histories, which still attach to ceramics pejorative associations around decoration, craft, the domestic, and utility. Leigh has found such categories generative, using her art to dismantle and destabilize classifications, histories, and notions of modernity, as fixed by those who are outside of her primary references.

To make an exhibition, work is done in the present to anticipate a future that is yet to unfold. Different time registers come into effect on the timelines of Leigh's own production. Bronzes take about a year to make, ceramics a month. Production is collaborative. Bronze production requires a skilled team working in synch to execute the many required steps. For the Venice exhibition, Leigh worked with Stratton Sculpture Studios in Philadelphia, which had produced her first monumental bronze, *Brick House*. During my visits to the foundry, I observed the kind of seamless choreography that develops only with time, integrity, respect, and care. Unlike many artists who work with large scale, Leigh models each sculpture in clay at full size. The virtuosity in her modeling is achieved through clay's exceptional pliability. The particularly fine texture of modeling clay (unlike other types) allows it to be molded quickly. The presence of Leigh's hand—the finger-pulled clay, the pressure of a forearm—is crucial to the potency and aliveness of her final bronze works. In this publication, Christina Sharpe describes this remarkable quality as "both singular and collective, intimate and monumental."[19] The artist's labor and touch remain in the cast, welded, and patinated bronzes, as can be seen in the slight asymmetry of the monumental *Satellite* or in the hand-formed rosettes that adorn *Last Garment* (pages 28–29). Bronzes, of course, weather history and are virtually indestructible; Leigh has chosen an *eternal* material to render and memorialize Black women.

14 See Ellen McBreen, "Migrating Objects: From Maker to Museum," in *Migrating Objects: Arts of Africa, Oceania, and the Americas in the Peggy Guggenheim Collection*, ed. Vivien Greene (Venice: Solomon R. Guggenheim Foundation with Marsilio Editori, 2021).

15 The summit was part of the activities for the 56th Venice Biennale exhibition *All the World's Futures*, curated by Okwui Enwezor.

16 O'Grady quoted in Mitter, "Simone Leigh, in the World."

17 Kenney, "Simone Leigh, Now in the Spotlight."

18 Leigh stated: "My work in art began with discovering a really beautiful Nigerian water pot, that was made by Ladi Kwali. Then, because I had just a philosophy and cultural studies background, I started to think about the means of production, the knowledge, everything that happens around that object. Typically with water pots, the labor is done by anonymous, mostly black women in Africa. It set me on this journey of thinking about how much labor has been accomplished, how many countries, cities, hospitals are fueled by the labor of black women, and at the same time, they're denigrated. I feel very lucky to be in a position to represent the strength and beauty of women." Leigh in Thelma Golden, "Zendaya and Simone Leigh Are Going Beyond Beauty," *Garage Magazine*, no. 17 (September 7, 2019), https://garage.vice.com/en_us/article/9kebk3/zendaya-garage-simone-leigh-style. For more on Ladi Kwali, see Sequoia Miller's essay in this volume, page 106.

Clay, an elemental material used by cultures across the globe since the dawn of time, forms the basis of most of Leigh's artworks. She pushes the medium's possibilities through scale and method, using techniques such as atmospheric salt firing. The artist thwarts the tendency to see ceramics as fragile, domestic, or utilitarian through her powerfully imposing, solid stoneware pieces (some weighing up to eight hundred pounds). Each piece is built over days and weeks, then dried before several firings in the kiln, where fluctuations in the atmosphere might produce a variety of outcomes. Each firing carries the potential for failure—a work could crack or explode—and the time for remaking needs to be taken into consideration. Agard-Jones has written that ceramics have a memory—they, too, hold on to time and need to be coaxed into new forms.[20] In this publication, she evokes geological time and refers to deep time in assessing the artist's work.[21]

There are other time indices evoked in Leigh's art. Her durational social practice works, comprising workshops, live events, and convenings unfolding over several days or weeks, relate to a kind of lived time that is shaped by history and power. *The Waiting Room*, a series of healing and wellness programs offered as part of Leigh's 2016 New Museum residency, referenced the twenty-four hours during which Esmin Elizabeth Green waited in the emergency room of Kings County Hospital in Brooklyn, without being treated, before she died in 2008. The artist's conferences *Loophole of Retreat*, held over one day in 2019 in New York and three days in 2022 in Venice, takes its title from a chapter in Harriet Jacobs's 1861 memoir referring to the tiny crawl space in which she hid for seven years while avoiding her enslaver and planning for her freedom.[22] Within these various time registers, be it the literal time for clay to dry or the evocation of endured trauma, Leigh finds creative and contemplative possibilities: "I see the waiting room as a space of impossible memorialization in a way," she said, "and a space where aesthetic ideas can get worked out."[23] These social and discursive practices open up

time for Leigh and her co-collaborators to find and make new meanings.

Leigh works in a fundamentally collaborative manner, rooted in Black feminist thought. "A black sense of place is not individualized knowledge; it is collaborative praxis," Katherine McKittrick writes in this volume. "It assumes that our selfhood is always in tandem with other ways of being."[24] The notion of tandem selfhood is most evident in Leigh's social practice works, which she considers crucial to understanding her art as a whole, and which are elaborated in this volume with newly commissioned scholarship and the first chronology devoted to this aspect of her work.[25] Making art drawn from gathering community takes time, care, and labor, as evidenced in *Loophole of Retreat: Venice*, the culmination of Leigh's U.S. Pavilion presentation. The fall 2022 convening in Italy featured performances, films, readings, and talks that were the result of numerous relationships cultivated over years.[26]

The spirit of collaboration also threads through Leigh's video and film works, many of which are made with other filmmakers, artists, and performers. These time-based works include a libretto tracking female hysteria featured in popular television and movies as performed by the mezzo-soprano Alicia Hall Moran in *Breakdown*, made with Liz Magic Laser (2011; pages 88–89); a reimagination of the reclining female nude (a common subject in European painting and sculpture) from the perspective of women of color in *my dreams, my works, must wait till after hell . . .* , made with Chitra Ganesh (2011; pages 92–93); and a visualization of the creative labor in Leigh's studio in *Conspiracy*, made with Madeleine Hunt-Ehrlich (2022; pages 270–71).

The multifaceted aspects of Leigh's art unfold in this exhibition and monograph in a primarily chronological order, which allows the viewer to trace the consistency of the artist's materials and forms, and recurring refrains, including the dome or bell shape (referencing both Mousgoum architecture[27] and the vernacular form of the restaurant Mammy's Cupboard, fig. 6), cowrie shells, braiding, rosettes, face vessels, and eyeless

19 See Sharpe's essay in this volume, page 230.

20 Vanessa Agard-Jones, "What the Sands Remember," *GLQ: A Journal of Lesbian and Gay Studies* 18, no. 2–3 (2012): 325–46.

21 See Agard-Jones's essay in this volume, page 104.

22 Harriet Jacobs, *Incidents in the Life of a Slave Girl* (Boston: Published for the author, 1861).

23 Leigh quoted in Rizvana Bradley, "Going Underground: An Interview with Simone Leigh," *Art in America*, August 20, 2015, https://www.artnews.com /art-in-america/interviews/going-underground-an-interview-with-simone-leigh -56438/.

24 See McKittrick's essay in this volume, page 136.

25 See essays by Tavia Nyong'o and Uri McMillan in this volume, pages 306 and 314, and the "Chronology of Social Sculpture Works" by Anni A. Pullagura, page 296.

26 Rashida Bumbray, who served as curator of the Venice gathering, also organized Leigh's 2012 exhibition at The Kitchen and her 2016 *Free People's Medical Clinic*.

Fig. 5 Parisian art dealer Hélène Kamer (now Leloup) in Guinea in 1957

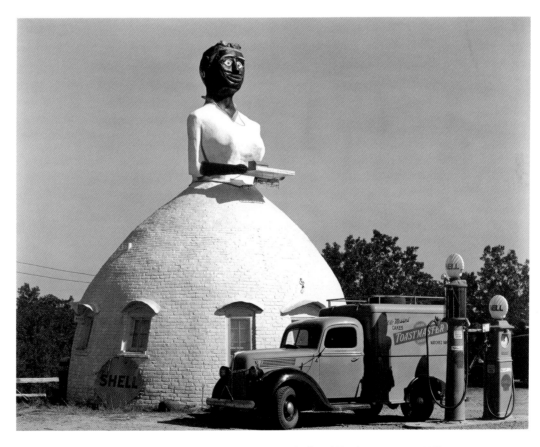

Fig. 6 Edward Weston, *Mammy's Cupboard, Natchez, Mississippi,* 1941.
Gelatin silver print. 7 9/16 × 9 9/16 inches (19.2 × 24.3 cm). Museum of Fine Arts,
Boston, The Lane Collection, 2017.3532

faces. Through Leigh's re-performing of forms in varying materials and scales, new structures of thought and meanings emerge. Individuals, too, recur across her career.[28] The ethos of citation, collaboration, and co-conspiracy is essential to other facets of Leigh's art. Sharifa Rhodes-Pitts is the model for the 2022 bronze sculptures *Sharifa* and *Last Garment* (her live modeling for both is captured in *Conspiracy*) and an astute scholar on Leigh's art.[29] Many of this book's contributors are Leigh's longtime interlocutors and participated in *Loophole of Retreat* in New York and Venice, and this volume's designer, Nontsikelelo Mutiti, has produced a number of other pieces on the artist's work.[30]

In closing, I invite you, dear reader, to spend time with the words and images in this book. As both the exhibition and this publication elucidate, Leigh's singular vision is enriched by considering the remarkable span of her practice, and, crucially, by reading her work alongside that of those whose writings and ideas are inextricably entwined with her art. Through the texts published here, readers can trace how Leigh has contested historical narratives and hierarchies, and, through her artwork, has proposed countertrajectories to the notion of modernity itself. This publication is more than a document of an exhibition; rather, it is essential reading that provides a series of pathways to consider Leigh's groundbreaking, expansive art. In 2013 Leigh penned a manifesto, positing an art world in which her work might circulate: "I imagine a future where auto-ethnographic initiatives documenting 'local forms' of craft and vernacular knowledge would exist across the world. . . . I foresee a time when black artists will be encouraged to dive deep into their work . . . without this strange, accompanying commentary and gatekeeping."[31] All along, Leigh has been sculpting her own time, looping her own histories, with a clear vision of what the future will bring.

27 Steven Nelson expands on this theme in his essay in this volume, page 196. See also Steven Nelson, *From Cameroon to Paris: Mousgoum Architecture in and Out of Africa* (Chicago: University of Chicago Press, 2007).

28 Lorraine O'Grady, for example, participated in one of Leigh's *Be Black Baby: A House Party* events in 2010; performed in connection with *The Waiting Room, Psychic Friends Network,* and *Black Women Artists for Black Lives Matter* (all 2016); participated in both *Loophole of Retreat* convenings; and stars in the film *Conspiracy* (2022).

29 See Sharifa Rhodes-Pitts, "Simone Leigh: For Her Own Pleasure and Edification," in *The Hugo Boss Prize 2018: Simone Leigh, Loophole of Retreat* (New York: Solomon R. Guggenheim Museum, 2019), n.p.

30 Mutiti also designed the magazine for Leigh's *The Waiting Room* project at the New Museum (2016), a free broadsheet for Leigh's Hugo Boss Prize exhibition at the Guggenheim (2019), and the logo for *Loophole of Retreat: Venice* (2022).

31 Simone Leigh, "Everyone Wants to Be Subaltern," *Brooklyn Rail*, February 2013, https://brooklynrail.org/2013/02/artseen/everyone-wants-to-be-subaltern.

pages 24–25
Installation view, *Simone Leigh: Sovereignty*, U.S. Pavilion,
59th International Art Exhibition of La Biennale di Venezia,
Italy, 2022

pages 26–29
Last Garment (details), 2022
Bronze, steel, metal, filtration pump, and water
54 × 58 × 27 inches (137.2 × 147.3 × 68.6 cm) (sculpture);
dimensions variable (pool)

23

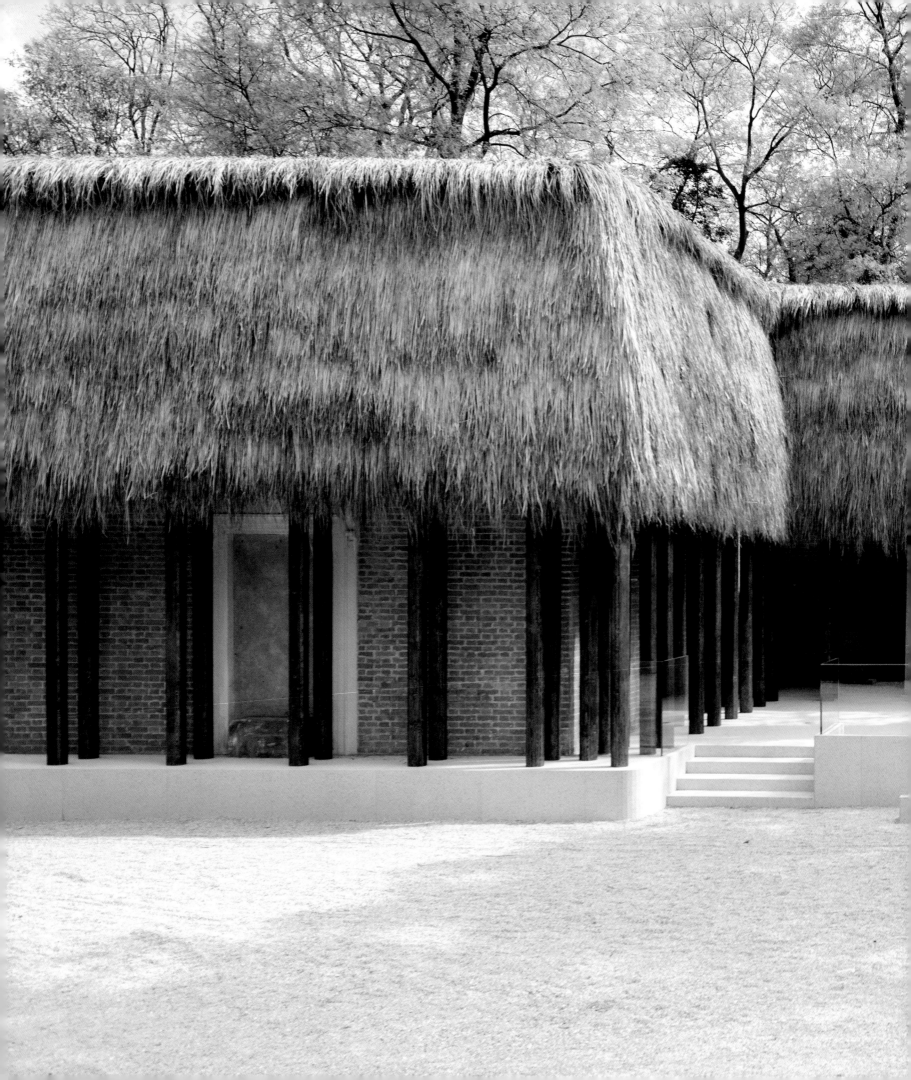

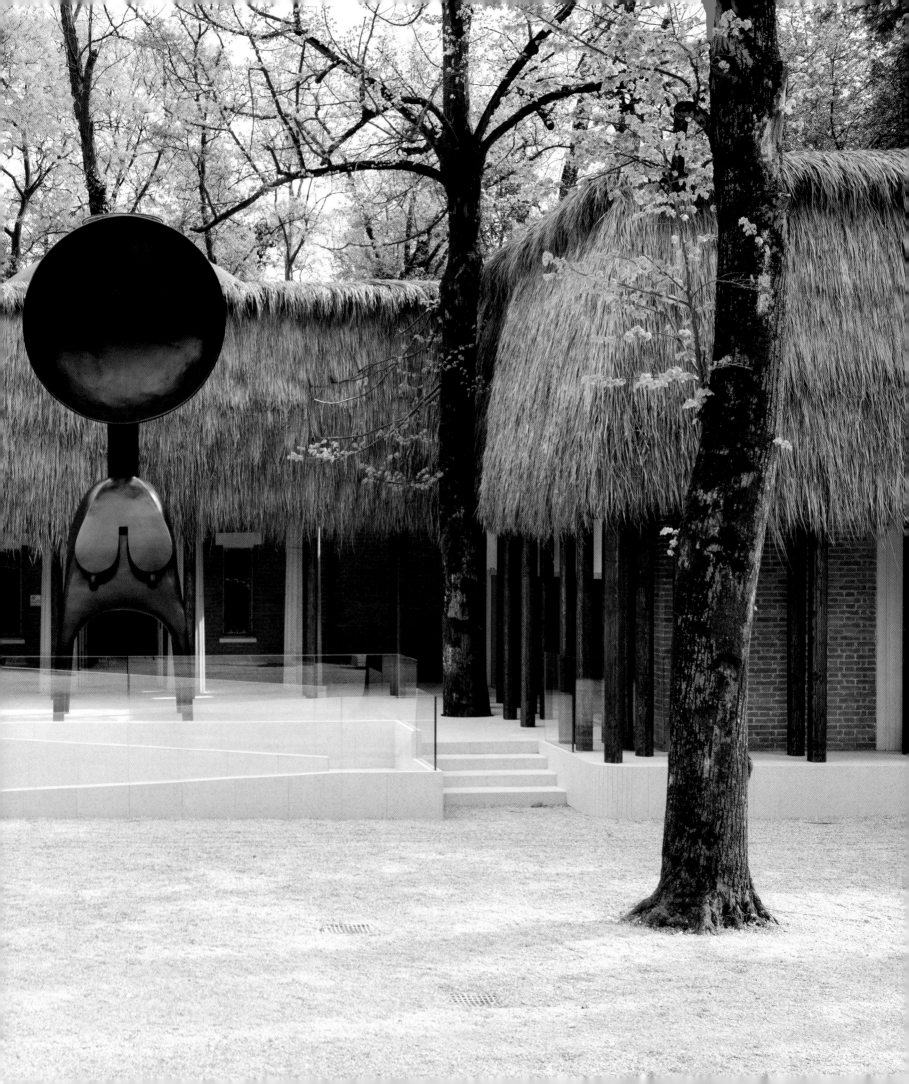

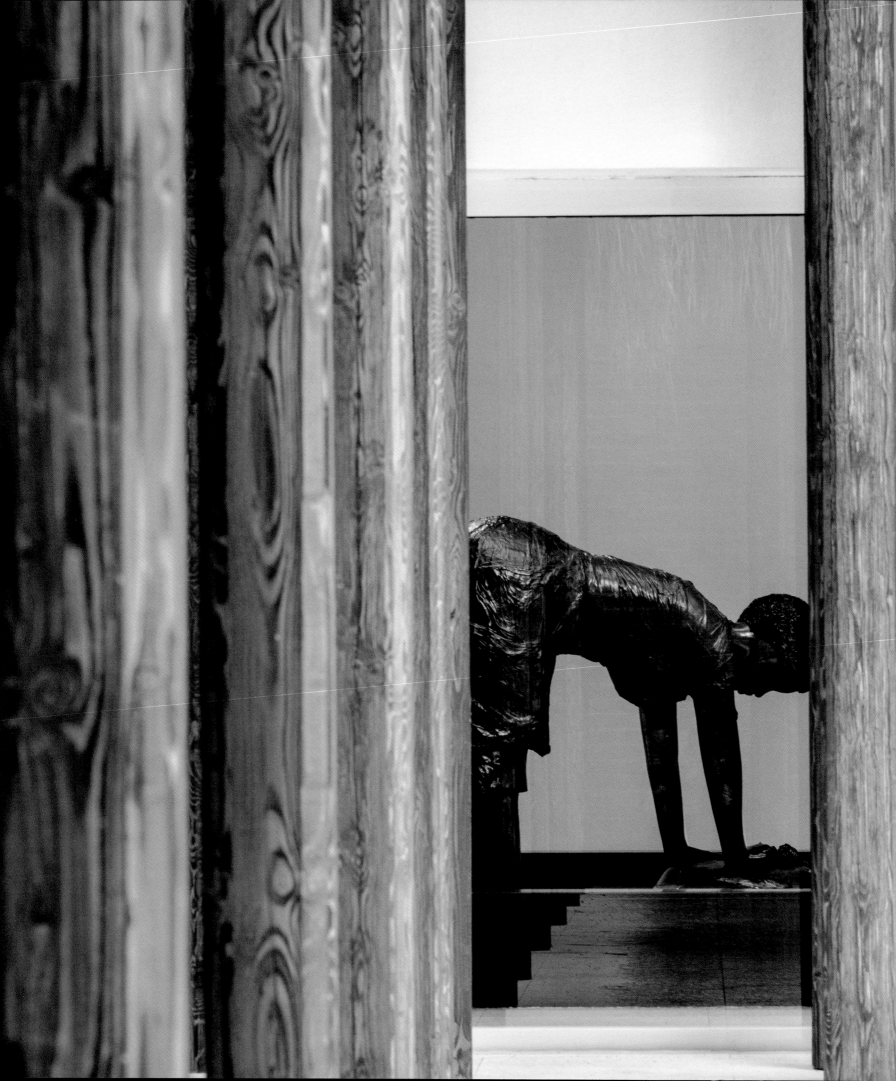

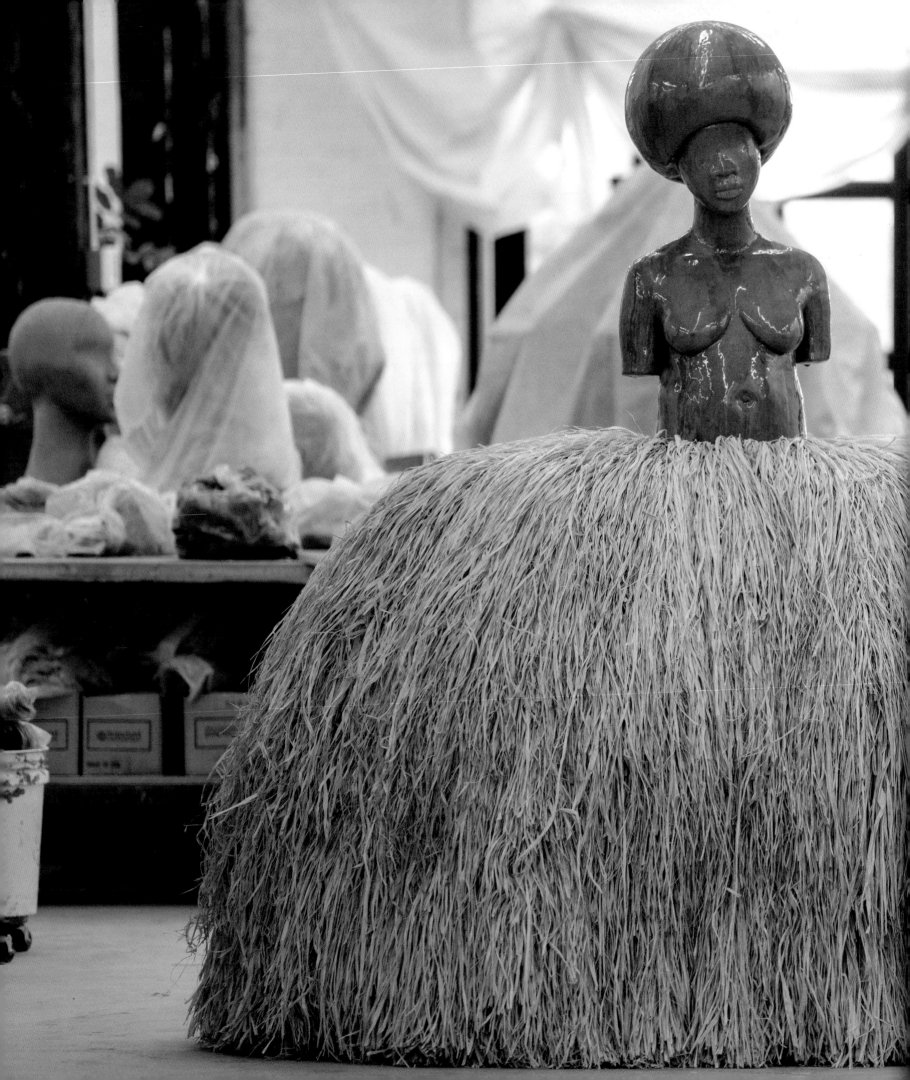

Saidiya Hartman

Extended Notes on the Riot

Simone Leigh is a friend, a collaborator, a co-conspirator, and a sister. A shared set of concerns animates our respective practices, which can be described as an effort to articulate the conceptual rigors of black women's everyday life and ordinary use. A being made into a tool for others, equipment for living, an incubator of possibility, a refuge, a clearing, a dwelling, a loophole of retreat—these are some of the ways that Leigh has articulated the black female condition, the tension between the facts of blackness and the lived experience. Her work, like my own, is preoccupied with the question of scale: how to undo assumptions about the provincialism and narrowness of black women's life and work, so that the dimensions of their existence in the world, their contribution, their way of making and doing might be recalibrated. In Leigh's attention to the black feminine, not simply its myriad duties and functions or the long durée of abuse, violation, exploitation, precarity, and fungibility, but the black feminine as an architecture of possibility, as a grammar of (not) being in the world, I have found a critical language able to convey the epic reach of the black ordinary and the monumentality of the everyday. The solidity and mass of the work illuminate the paradox, express the antagonism: her capacity is yoked in service of others, exploited and devalued. She is load-bearing and breakable. The stark outline of the predicament is that the one who makes a home for others in the world finds herself outside the parameters of the human, not seen and never regarded, excluded and negated.

I have tried to describe something similar in my work on existence in a minor key, on what the chorus has made possible, on the radical thought that fuels the lives of ordinary black women, on the anarchy and beauty of colored girls: *Now it is impossible to turn your back, to carry on like the world is the same. Don't waste a breath asking why she has to hold everything the rest can't bear, like you don't know, like you supposed things were some other way, like there was some gift other than what she offered in her outstretched hands, or shelter outside her embrace.*

How does one convey the beauty of the gathering and how she brings us together? How she does what she does and what unfolds inside the circle? What has she been called to bear for all of us? Refuge is to be found in a skirt of raffia, in a rampart of clay. Simone Leigh's hands have created a world, have disrupted and evaded the dominant economy of the gaze, not by opposition or protest, not by explaining anything, but by looking otherwise, by retreating within, by a radical withholding that makes visible and palpable all that is held in reserve—all that power, love, brilliance, labor, and care. All that beauty. The "Loophole of Retreat" exhibition articulates this world, this dwelling, this possibility. *It is impossible to turn your back, to carry on like the world is the same.*

The ultimate *nègre*, the exemplary slave, is the black female; she is the *everything* and the *nothing* that constitutes our modernity. She is the belly of the world, the factory, the crop, the implement of future increase, and the captive maternal that nurtures the world. Unacknowledged, disavowed, unloved, unseen—yes, but her existence is more than this inventory of violence. There is care and beauty too. Leigh's body of work transforms how we look and instructs us to listen at a lower frequency, to inhabit this architecture of possibility.

This text was originally published in *e-flux Journal,* no. 105 (December 2019).

33

Denise Ferreira da Silva

"If you never . . . you don't . . . ": The Aesthetic (*Forms*) of Refusal

I've seen some preliminary thoughts on the Biennial and concerns about radicality. I need to say that if you haven't read, not a single thing written by Saidiya Hartman or Hortense Spillers. And if you have no knowledge, never heard of Negritude or how it's related to surrealism. If you don't know who Senghor is or why he would have anything to do with art. If you never spent anytime figuring out who was and wasn't at FESTAC '77. If you have no idea what critical fabulation is. If you didn't know what I meant when I said In The Wake. If you never studied Independence architecture. If you don't know why Pauline Lumumba walked through the streets of Kinshasha [sic] bare breasted. If you have no idea who Katherine Dunham is or her scholarship, but yet you consider yourself well versed in the work and contributions of the woman she hired as a secretary, Maya Deren. If the words Black Feminist Thought bring absolutely zero concepts to mind. If the words "Dave the Potter" mean nothing to you. If you didn't ponder the significance of Sharifa's unruly kitchen when she embodied Uhura in my video and you don't even know what a kitchen is. If the words "Dogon statuary" conjurs [sic] nothing. If the only thing you know about Benin bronzes is that Europe stole them. If you casually use words like ethnic, exotic and tribal and you still think those are useful words. If you don't know what story I'm referring to when I talk about A Question of Power. If you thought I was being weird when I told you I was too busy sharpening my oyster knife. If you've never heard of the Herero Genocide. Then you lack the knowledge to recognize the radical gestures in my work. And that is why, instead of mentioning these things, I have politely said black women are my primary audience.[1]

Simone Leigh

34

Reading Simone Leigh's artwork against her critical statement on the contemporary art appreciator reproduced above, I find a formal rendering of refusal both in the artist's statement (that critics of her art lack the critical-intellectual tool for understanding her work) and in that which (black feminist critical tools) she brings into the contemporary art scene. Far from proposing that Leigh's artworks are formal in the sense of being conceptual tools, I find—and I will say in the unreconstructed Kantian language this essay hopes to trouble—that her aesthetical forms do in the "sensible" (in that corner shared by the senses and the imagination) what the theoretical tools deployed by black feminist thinkers inspiring her—Hortense Spillers, Saidiya Hartman, and Christina Sharpe—perform in the "intelligible" (the corner shared by the imagination and the understanding). That much was already evident to me the first time I considered Leigh's work; the first time I stopped to think about what to say about her exquisite forms, the only word that seemed an appropriate guide was *how*.[2] *How* not, however, as a question, but as the beginning of a description for something that seemed to refuse,[3] that aptly sidestepped and undermined anything that would suggest an answer for a question of what or why, any questions that would render the work datum, that is, an unmediated, *natural* expression of black women's experience, histories, or identity.

What follows is a reflection on the significance of the form of Leigh's artistic intervention—her expressed intention that her artwork contributes to the creation of an audience for black feminist thought. In considering the artist's intention, however, I am interested in how Leigh's work unsettles the presumed position of the appreciator. This radical artistic gesture, which is also represented in the text that serves as frontispiece to this essay, is a request—even if for a moment—that the appreciator (public, critic, curator, and other artist) reflect on what is a basic tenet in the field of aesthetics. What Leigh's imperative interpellation ("if you never . . . you don't . . . "), which is a refusal of a refusal to engage with black forms (theoretic, aesthetic, historic), recalls is how the presumed transparent position of the appreciator,[4] that of the subject of disinterested (aesthetical) judgment,[5] the subject without properties[6]—the one that is available to the critic, the artist, the viewer, the curator, or the gallery or museum director—is thoroughly mediated by distorted "meanings" of blackness and Africanness found in the anthropological, historical, and aesthetical archives.

Most comments on Leigh's sculptures published in mainstream media describe a collection of objects that are expressive of black women's subjectivity. Many times, however, these texts also include, but ignore, Leigh's comments on (a) how her work deploys and explores the complexity of black feminist thought; (b) how the available (scientific and aesthetic and historic) archive is composed of pieces that distort or erase black women and their labor; and (c) how her sculptures are critical treatments of the available archival items and black feminist forms.[7] Taking another route, and considering all three simultaneously, I find that Leigh's statements on her work delineate another position in the aesthetic field. For the artist herself owes her performance as such (as artist) to the mediation (through personal memory and academic training) of both the problematic archives and the black feminist tools she mobilizes. When the exhibition (such as her pavilion at the Venice Biennale) turns into a site of presentation and operation of theoretical tools, the sculptures are added to the formal black feminist toolbox. In sum, Leigh's creative gesture is both an example of and informed by the critical tools of black feminist thought. When confronting the appreciator, demanding that

1 Simone Leigh (@simoneyvetteleigh), Instagram, May 16, 2019, https://www.instagram.com/p/BxiJl58gl4t/?hl=en.

2 Denise Ferreira da Silva, "How," *e-flux Journal*, no. 105 (December 2019), https://www.e-flux.com/journal/105/305515/how/.

3 Here I read this statement in light of Tina M. Campt's comment on Leigh's work's "capacity to actively create our own gaze—a Black gaze that demands active forms of engagement, rather than passive acts of watching or consumption—that requires the work of witnessing from its viewer. It is the work of enduring discomfort and facing it head on." Campt, *A Black Gaze: Artists Changing How We See* (Cambridge, MA: MIT Press, 2021), 153–54.

4 For the presentation of the argument regarding the assembling of the subjects as transparent in post-Enlightenment philosophy, see Denise Ferreira da Silva, *Toward a Global Idea of Race* (Minneapolis: University of Minnesota Press, 2007).

5 "Everyone must admit," Kant says, "that a judgement about beauty in which there is mixed the least interest is very partial and not a pure judgement of taste. One must not be the least biased in favor of the existence of the thing, but must be entirely indifferent in this respect in order to play judge in matters of taste." Immanuel Kant, *Critique of the Power of Judgement*, ed. Paul Guyer, trans. Paul Guyer and Eric Matthews (Cambridge, UK: Cambridge University Press, 2000), 91.

6 See David Lloyd, *Under Representation: The Racial Regime of Aesthetics* (New York: Fordham University Press, 2019), in particular chapter 3, for the argument about how the subject without properties, the major figure produced in the Kantian and later renderings of the aesthetic, became the form—the model as the conditions of possibility—for the post-Enlightenment figuring of the proper (white European) political subject.

7 For an enacting of this key black feminist critical gesture, see Tina M. Campt, *Listening to Images* (Durham, NC: Duke University Press, 2017).

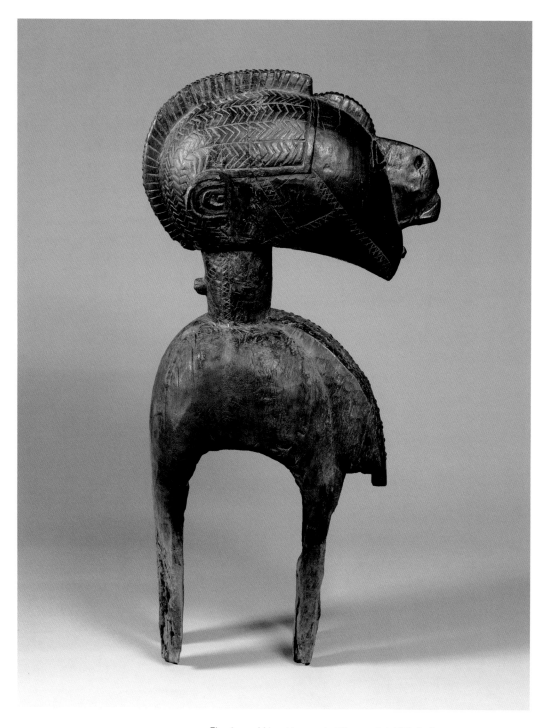

Fig. 1 Africa, Unrecorded Baga artist, "D'mba" headdress. Guinea, ca. early 20th century. Wood and brass tacks. 55 7/8 × 15 3/4 × 29 1/2 inches (142 × 40 × 75 cm). Peggy Guggenheim Collection, Venice (Solomon R. Guggenheim Foundation, New York), 76.2553 PG 243

its position be located (as that of one who does not engage black feminist thought), she intervenes, by refusing the claimed transparency, in that which the field of aesthetics shares with other areas of post-Enlightenment thinking, namely, subjectivity, the figuring of the modern subject, which presumes that it is both separated from and reflected (actualized or expressed) in what lies out there, as nature or world.[8]

I

For the past one hundred years or so, artists have been quite vocal in terms of how conceptual and theoretical trends have influenced their work. Psychoanalysis's influence on the surrealists is a case in point,[9] but the naturalists who preceded them were also in tandem with the scientific (determinative) orientation of the previous century. When reading Leigh's comments on her work with regard to black feminist thought, I see something else, in addition to the conceptual borrowings or the influences she names in the frontispiece. Her making visible of black women's history and labor (including intellectual) is no small part of Leigh's formal intervention in contemporary aesthetics.[10]

How she does so can be grasped from her own comments on her work. For instance, in "Super Nature," published in 2008, Leigh provides us a key for reading her intervention in contemporary art. Describing her installations, she says that "materials are collected, decorated, scarred to amplify or designify the ethnographic object of its Orientalist markings."[11] Key here is obviously the act of designifying the object, of stripping it of the scientific ("ethnographic") signature. How this happens is something the viewer is compelled to attend to precisely because of how the works gather and recompose *materials* (clay, cowrie shells, and raffia) and *forms* (architectural [African] and physical [black]), which is something most

critical and mainstream media commentators miss consistently. "Leigh's 7m-tall bronze sculpture, based on D'mba headdresses in the shape of a female bust" (fig. 1), says a critic about *Satellite* (2022), "towers over visitors as they arrive"; the writer goes on to say that "Leigh's work explores the Black female body and imagery from the African diaspora—how it has been portrayed and used by other people. But while here the objects take on that *familiar imagery*, Leigh gives it her own spin, blowing them up in scale."[12] Nothing in the remainder of the text returns to Leigh's description of the task, which is to designify these images. All the reader can conclude is that Leigh's "own spin" is given in making the "familiar" object (like the black female bust) bigger!

What accounts for this gap between the artist's account of what the elements included in the work do and what most mainstream commentators see the work doing? It can be presented in different ways. Here I do so through a distinction between a representational and a documentational rendering of records. As already noted, Leigh's expressed intention is to designify that which is known about, the *familiar* "meanings" attributed to Africanness and blackness. We know why she moves to do this. In a statement at the opening of her Venice exhibition, *Sovereignty*, Leigh explained, "One thing that's difficult for black women . . . is that what has been written about us is often wrong or skewed or distorted."[13] However, many, if not most, commentators classify Leigh's work as figural and representational, and some treat these as synonyms. Directly or indirectly and implicitly or explicitly, comments on and descriptions of her works (the objects she creates and exhibits) present them as expressions of black femme subjectivity, of black women's experiences, identities, and histories. But, as Leigh's statement suggests, the different interpretations of how the work is about black femme subjectivity distort.[14]

8 I develop an argument regarding how blackness troubles this figuring of the subject as subjectivity throughout but especially in chapter 2 of Denise Ferreira da Silva, *Unpayable Debt* (Berlin: Sternberg, 2022). While the specifics of the argument are relevant to my comments on Leigh's work, they are not directly related to my argument here. I mention the book in case there is an interest in the place of subjectivity in the trajectory of modern thought and in how it thrives in the context mapped by the analytics of raciality.

9 Among the many texts that cover this relationship, see Aaron H. Esman, "Psychoanalysis and Surrealism: André Breton and Sigmund Freud," *Journal of the American Psychoanalytic Association* 59, no. 1 (2011): 173–81.

10 Her profile in Black Art Story states: "Leigh has described her work as auto-ethnographic, and her interests include African art and vernacular objects, performance, and feminism. Her work is concerned with the marginalization

of women of color and reframes their experience as central to society." "Profile: Simone Leigh (1967–)," Black Art Story, accessed July 10, 2022, https://blackartstory.org/2020/05/19/profile-simone-leigh-1967.

11 Simone Leigh, "Super Nature," *Small Axe* 12, no. 1 (February 2008): 121.

12 "Venice Biennale 2022: The Must-See Pavilions in the Giardini," *Art Newspaper*, April 19, 2022, https://www.theartnewspaper.com/2022/04/19/venice-biennale-2022-the-must-see-pavilions-in-the-giardini. My emphasis.

13 Leigh quoted in "In Venice, Simone Leigh Reimagines Colonial Narratives," *The Economist*, May 3, 2022.

14 The relevant interpretations are included in the Annex at the end of this essay.

37

According to the artist, her work (the actual work of creating and the creations) is not only the undoing but also a re-doing of "meanings" that are in fact determinative (anthropological) products. It is an intervention in the archives of art (African art), of knowledge (anthropological knowledge), and of history (colonial and postcolonial references): as she said at the Venice opening, "In order to tell the truth, you need to invent what might be missing from the archive, to collapse time . . . to formally move things around in a way that reveals something more true than fact."[15] As Tina M. Campt nicely describes, "by enacting furtive forms of freedom from within the confines of enclosure, Leigh revalues forms of Black women's labor too often rendered invisible."[16] That is precisely what the works in *Sovereignty* perform over and over again, which is a critical and creative gesture. Leigh's intervention does not even require that viewers ask wherefrom this familiarity. The works show them that it is due to how anthropological (here I'm thinking of both nineteenth-century racial anthropology and twentieth-century cultural anthropology) tropes have come to compose the glossary of stereotypes of Africanness (primitive, archaic, etc.) and blackness (watermelons, round forms, etc.) that became part of the twentieth-century common sense. For precisely these familiar "meanings" constitute the materials onto which Leigh applies a designifying technique,[17] that is, these anthropological (the cultural ones) and sociohistorical (the stereotypes) meanings are altered in the creative work, which, Leigh tells us, is inspired by Saidiya Hartman's notion of critical fabulation.[18]

Targeting both the historical archive and the critical arsenal, and working at their limits, Hartman's fabulation moves to restore precisely what has been flattened out, erased, and relies on the imagination to consider, write about, and speculate on dimensions of experience that are expunged by determinative renderings of black existence. To Leigh, Hartman's methodological proposal has been crucial: "I started to feel really supported by some of these ideas, like Saidiya Hartman's idea of 'critical fabulation,'" she said in a 2019 interview. "It's something that really is helpful for me every day that I'm making artwork."[19] In Leigh's version of critical fabulation, her work on the archives of knowledge and of history combines material and mental forms in a gesture that also requires that the viewer do some (critical, reflective) work on her own sensibility when confronted with the stereotypical representations of blackness and Africanness, with *familiar* "meanings" that lie deep in her imagination.

II

When Leigh dresses the U.S. Pavilion at the Giardini with a colonial (1931 Paris International Colonial Exposition) representation of West African architectural elements and places *Satellite* at the entrance to greet the visitors (pages 250–51), the double gesture dares and invites them to consider, *to reflect*, even if for the duration of the visit, on their own familiarity with the (anthropological, historical, and aesthetical) archives to which that monument to the colonial, racial, cisheteropatriarchal matrix belongs.[20] She does this by staging an occupation, as she seizes Thomas Jefferson's home, with *objects* that gather "distorted meanings," black feminist concepts, African aesthetic forms, and stereotypical images (the washing woman) and forms (watermelon). That is, in this exhibition *Sovereignty*, the first act in Leigh's intervention is a formal occupation (by African and U.S. black architectural forms) of a replica of Monticello, which cannot but belie the colonial (historical) archform of the U.S. political subject par excellence and of the colonial (aesthetic) legacy of the Venice Biennale. It is as if, responding to Audre Lorde's famous

15 Leigh quoted in "In Venice, Simone Leigh Reimagines Colonial Narratives."

16 Campt, *A Black Gaze*, 146.

17 A technique in which I cannot but find an exemplar of the "resistance of the object"; that is, as an instance of the performative political gesture of refusal of the very (ontological) grounds of engagement. See generally Fred Moten, *In the Break: The Aesthetics of the Black Radical Tradition* (Minneapolis: University of Minnesota Press, 2003).

18 For a description of what it entails, see Alexis Okeowo, "How Saidiya Hartman Retells the History of Black Life," *New Yorker*, October 19, 2020, https://www.newyorker.com/magazine/2020/10/26/how-saidiya-hartman-retells-the-history-of-black-life.

19 Leigh in "Zendaya and Simone Leigh Are Going Beyond Beauty," interview by Thelma Golden, *Garage Magazine*, no. 17 (September 7, 2019), https://garage.vice.com/en_us/article/9kebk3/zendaya-garage-simone-leigh-style.

20 As described by Sebastian Smee: Leigh "has covered the pavilion itself with grass thatching—reviving (with scalding irony) the 1931 Paris Colonial Exposition. That show presented the cultures of colonized peoples in Africa and Asia for the delectation of bourgeois Westerners, spurring a profound counter-reaction among Asian and African intellectuals. The effect of the thatching—a discrete work in itself, called 'Facade'—is startling and has drawn enormous online attention." Sebastian Smee, "A Great Venice Biennale Unfolds, Against All the Odds," *Washington Post*, April 22, 2022, https://www.washingtonpost.com/arts-entertainment/2022/04/22/venice-biennale-2022/.

statement that the master's tools will never dismantle the master's house, by accepting the implicit challenge (to create new tools), Leigh's formal treatment of materials and forms, which have been anthropologically and aesthetically presented as originally African or black American, unsettles the comfortable familiarity of their meanings, by recalling—both augmenting and deforming—their problematic significations.

How is it that the work unsettles this familiarity? For it to make sense, it is important to recall how raciality plays in the field of the aesthetic. From the initial reformulation by the nineteenth-century version of anthropology, in the analytics of raciality, it has played in the ethic moment of the liberal political architecture when it delimits the region of operation of humanity and its principles, when it names both the minds that can (white Europeans/nonracist persons) and those that cannot ("others of Europe"/racist persons) entertain such principles. What is distinctive about racial subjugation—when compared with the operations of gender and sexuality and colonial expropriation and capital exploitation—is how it does not play in the ethic and economic moments of the liberal polity as a mechanism of exclusion, as a negative tool. Instead, it has a positive, productive effect, which is the production of a particular kind of social subjects—types of collective minds (moral + intellectual attributes)—that do not conceive of and, for this reason, are naturally not contemplated by these principles of humanity, which are constitutive of all the versions of the modern subject, including the subject of the aesthetic. In this context, blackness and Africanness, as categories of racial and cultural difference, name subjects and objects that do not find a proper place in the aesthetic field. This is a demotion that occurs when black or African forms are treated as datum,[21] that is, as unmediated or "natural" (biological and cultural) expressions of the particular mental contents of the persons or populations to which it is said to belong. In the case of artworks, it manifests in commentary that, for instance, takes the materials as the artistic object and, as Leigh notes in the frontispiece, fails to *appreciate how* it is in-*form*ed by the theoretical and aesthetical forms the artist also mobilizes when working, creating, that is.

What I find in Leigh's designifying gesture is precisely a deployment of *racial forms* that demand a readjustment of the position of the appreciator, whose first movement is (as many of the commentators quoted in the Annex [page 43] have done) to take her objects, and the black and African forms she uses in creating them, as datum, that is, as immediate expressions of blackness and Africanness. For it is not enough for the viewer to be knowledgeable of critical statements informed by the social categories, and to be able to understand the significance of intersectionality. Leigh's is an artistic intervention, not a paper or a pamphlet. Her presentation of the critique targets that which is distinctive of the aesthetic field, namely, the presumption of disinterest in the object, which renders (aesthetic) appreciation distinct from (theoretical) reflection—in other words, the artistic object is transparent before the proper subject of taste.

Against the grain, Leigh's work forces the viewer—white or not, woman or not, feminist or not—to reflect on her own familiarity with the stereotypical and anthropological representations of blackness (black women and African art), on her own positionality. While the viewer is busy wondering about how Leigh is trying to recast these images, the materials she uses, and the meanings she mobilizes and *de-forms*, the objects stand there, in their sheer size, solidity, and opacity. It is as if the works tell the viewer that she cannot simply grasp to capture in the work what she already knows about black women (whom the work comments on). The viewer has to stay with the tall bronze sculptures without eyes or other facial features and reflect on their formal (textures, solidity, height) and material attributes and on how she *knows* what she knows about and how she *understands* them. At the center of this reflection, however, is not the artist and her work, but the viewer and what she already knows, her mental contents, including the representations of (the "meanings" given to) black women and African forms and materials with which she is already familiar.

My point is: Leigh's sculptures may appear representational to the viewer who is knowledgeable about art, history, and anthropology, but this is not how they figure black femme subjectivity. Her materials and forms are not *data* that express black women's histories, experiences, and identities. These are *records*, reconstructed archival items that document juridic and symbolic violence. They say more about those who benefit from and maintain the political conditions these documents

21 Here I use the term to refer to at least two of the meanings identified in the *Oxford English Dictionary*:

1.a. Chiefly in *plural*. An item of (chiefly numerical) information, esp. one obtained by scientific work, a number of which are typically collected together for reference, analysis, or calculation.

2.a. Something given or granted; something known or assumed as fact, and made the basis of reasoning; an assumption or premise from which inferences are drawn.

indicate, be they anthropologists, artists, or even archivists. For in Leigh's work the concepts of black feminism are also raw materials; what her objects make available to the appreciator—the opportunity to appreciate her own position—is mediated by thought. Everything in these works is of a formal nature, including that which is already interpreted and determined—the products of thought that Leigh literally turns inside out when she uses the discredited (because constructed as symbols of physical or mental inferiority) African and black forms to comment on the very *familiar imagery* that has been selected to justify those forms' symbolic construction as foreign to the proper aesthetic field.

III

Leigh told Thelma Golden in 2019:

> I realized at a certain point, as I was trying to make better work and push the work further, that I was relying more and more on the scholarship of black women intellectuals, and also noticing that they, as well, were laboring anonymously. People in the academy may not feel that way, but in general I was noticing, especially in art, a complete absence of knowledge of these large bodies of work that are now into their third or fourth generation. If you think about the Nardal sisters, who did a lot of the work to create Negritude in the '30s in Paris, it's really been years and years of work.[22]

Trust in this statement appears in Eva Respini's description of Leigh's works for the Venice exhibition, in which she says that

the artist "will address an 'incomplete archive' of black feminist thought."[23] However, what appears in mainstream commentary on the exhibition suggests that the statement has been taken literally, that is, that *Sovereignty* assembled elements—Dogon statuary, the Herero genocide, raffia, black female breasts, and the like—that immediately ("naturally") express black female subjectivity.

For most commentators and critics classify Leigh's sculptures as representational, evident in the statement, for example, that "African somatic" characteristics in the work express Leigh's "origins" and in the lack of consideration of her other formal (intellectual) references beyond repeating the phrase "black feminist thought."[24] That is, the expected next step does not ensue, the commentary on how Leigh does what she says she does, on how, as many have said, it "centers the black female experience." Such comments ignore what the artist says regarding her intention and her influences and inspirations.[25] Read, for instance, this description of the Venice exhibition: "The highly specific groundedness of Leigh's project, titled *Sovereignty*, contains a diversity of ceramic and bronze sculptures, both abstract and naturalistic female forms, others featuring jugs, raffia, and cowrie shells. . . . *Sovereignty* connects the dots between the artist's stated devotion to Black femme subjectivity and self-determination in a statement that is as clear as it is self-sufficient. The roots of these works feel as though they penetrate the very ground of the Giardini, tunneling through the island towards the interior of the Earth."[26] What I see in such descriptions are examples of what Leigh responds to as well as refuses in the frontispiece: an incomplete knowledge of the available critical arsenal,

22 And she continues to say: "It started with wanting to cultivate an audience for people who could understand the symbols and signs in my work more. . . . I really feel like the most important thing I've done in my career was the *Loophole of Retreat* conference [Leigh's 2018 Hugo Boss Prize show at the Guggenheim], where those women were gathered, and also where Annette Richter, the great-great- granddaughter of the founder of the United Order of Tents, was able to come and tell her story. I've been really happy about creating an audience and being a part of making this history more visible." Leigh in "Zendaya and Simone Leigh Are Going Beyond Beauty."

23 Respini quoted in Erica Gonzales, "Sculptor Simone Leigh Makes History as the Frist Black Woman to Represent U.S. at the Venice Biennale," *Harper's Bazaar*, October 15, 2020, https://www.harpersbazaar.com/culture/art-books -music/a34383553/simone-leigh-venice-biennale/.

24 A popular description of her work: "Her work is concerned with the marginalization of women of color and reframes their experience as central to society. Leigh has often said that her work is focused on 'Black female subjectivity,' with an interest in complex interplays between various strands of history." Wikipedia,

s.v. "Simone Leigh," last modified August 17, 2022, https://en.wikipedia.org/wiki /Simone_Leigh.

25 See Leigh's comments quoted in Victoria L. Valentine, "Simone Leigh Is at the Guggenheim, the Whitney, and Even on CBS Where She Said: 'It's So Shocking What Is Happening to Me," Culture Type, May 4, 2019, https://www .culturetype.com/2019/05/04/simone-leigh-is-at-the-guggenheim-the-whitney-and -even-on-cbs-where-she-said-its-so-shocking-what-is-happening-to-me/.

26 Laura Raicovich, "Captivating Highlights from the 2022 Venice Biennale," *Hyperallergic*, April 26, 2022, https://hyperallergic.com/727730/captivating -highlights-from-the-2022-venice-biennale/. A few more similar comments: "'Last Garment' . . . , a bronze sculpture depicting a laundress at work. It connects Ms Leigh to her Caribbean roots: the piece is based on a 19th-century photograph shot in Jamaica by C.H. Graves, entitled 'Mammy's Last Garment.' Such stereotypical images were widely used at the time by the British government to market Jamaica as a tropical paradise." "In Venice, Simone Leigh Reimagines Colonial Narratives."

which exposes the arrogance that is supported precisely by the anthropological, historical, and aesthetical records Leigh's sculptures designify. An effect of this arrogance is that the significance of Leigh's intervention does not become available to the field of aesthetics because those for whom her forms are familiar do not find it necessary to ask what she means by designification and how it impacts our understanding of art and aesthetics.

Toward doing some work in this direction, I will close this section with some comments on Leigh's move, which I think will also help us to exorcise the phantom of representation as it haunts other artists whose works confront the colonial, racial, cisheteropatriarchal matrix. What I find is that the move, which happens in the work, is a transformation that occurs not through discourse, not through recasting (changing form), but by changing the raw material. For instance, it happens in *Façade* (2022; pages 24–25), which is rematerialized with wood, raffia, etc., and *Last Garment* (2022; page 255), which rematerializes a racist image of Jamaica that was used in postcards (page 145, fig. 2)—the washing woman—as a bronze sculpture. The other sculptures, as they perform further rematerializations that occur inside the rematerialized U.S. Pavilion, acquire the meanings conveyed by the title *Sovereignty*, which in this context is about control at the level of meaning creation, or signification. Take the watermelon, for instance, which is part of the repertoire of symbolic violence (stereotypes) against black people; in Leigh's sculpture, it is transformed into a mold for oversize cowrie shells, which are part of the repertoires of economic violence (slavery) against black people.[27]

To be sure, in the case of the inside sculptures, the formal gesture is the similar obverse of *Façade*—the first necessary transformation of the master's house into the sovereign domain of black feminist thought, which enables the others. It is as if the casting in bronze of the figure of the woman washing clothes is an expression of *Sovereignty*, which is exercised as a critical (formal intellectual) treatment of the historical or personal archive in which that postcard is or could be found: "I think there's a line going through this show," Leigh said, "that's about the souvenir—the idea that we like to bring other worlds

into our world. The souvenir is a seemingly harmless object that has actually proven to be quite devastating. This one is a very racist image."[28] Furthermore, Leigh's sculptures comment on the limits of that very context's (the Venice Biennale) definition of what belongs in contemporary art (sculpture in bronze) and what does not, that is, Leigh's materials: ceramic, raffia, cowrie shells, clay, and the forms of black feminism and the black femme. As she put it in a 2019 interview, "I would describe the cowrie shell as a stand-in for the female body, or a body in general, or a representation of an absence as well as a presence."[29] This, this absence, I find, is not so much one of content; this is not about exclusion of African and black forms from the art scene. For, as Leigh comments, Western (mostly white, European, cis male) artists have drawn inspiration (as well as content and forms) from African art for over a century now. Hence, the *absence* here is not really material (content) but formal, both conceptual (lack of ac*knowledge*ment of black feminist critical tools) and aesthetical (the African forms and materials are not considered properly artistic). As the commentary reviewed above shows, when confronted with "familiar" black or African forms, today's "politically educated" appreciators (whether critic, artist, gallery/museum director, or member of the public)—that is, the ones who have a sense of the interventions that confront the colonial, racial, cisheteropatriarchal matrix—are still not yet ready to see the forms as something other than *datum* (anthropological or historical specimen), the inclusion (or repatriation) of which would attend to and correct a colonial or racial wrong, whether theft or misrepresentation.

IV

Among all the troubling statements about Simone Leigh's work, I highlight the following not so much for what it says but for what it cannot articulate: "Her sculptures can be representative of an idea or, in many cases, representative of Black women across the diaspora and what they have done, not what was done to them." How does it follow from the statement by Leigh that immediately precedes it: "What has been written about us is very complicated and often wrong, skewed, or distorted. So, when we are trying to gather information it's often from

27 As Nicole J. Caruth says, "In sculpting and building up the shapes, instilling in each her own views and aesthetics, they are totally transformed and offer up new frames of reference." Quoted in Alex Greenberger, "How Simone Leigh's Sculptures Centering Black Women Brought Her to the Venice Biennale," *Artnews*, October 19, 2020, https://www.artnews.com/feature/simone-leigh-who-is-she-why-is-she-famous-1234574361/.

28 Leigh quoted in Calvin Tomkins, "The Monumental Success of Simone Leigh," *New Yorker*, March 28, 2022, https://www.newyorker.com/magazine/2022/03/28/the-monumental-success-of-simone-leigh.

29 Leigh quoted in Nancy Kenney, "Simone Leigh, Now in the Spotlight, Contemplates the Theme of Invisibility," *Art Newspaper*, April 24, 2019, https://www.theartnewspaper.com/2019/04/24/simone-leigh-now-in-the-spotlight-contemplates-the-theme-of-invisibility.

someone who had a different intention than what we have."[30] How is it that a statement on how the work is about dealing with the fact that the available information is already treated by a certain intention can be followed by the conclusion that Leigh's work is representative of black women across the diaspora and, even worse, of an "idea"? Reading this piece, I could not but wonder if the same would be said about Magritte's or Dalí's or other surrealists' works. For instance, is Dalí's *The Metamorphosis of Narcissus* representative of the idea of the Ego? Is Dalí's work representative of the experience of white European men? Is Magritte trying to represent the workings of the unconscious?

When asking these questions, I am not trying to dismiss or qualify representational artworks as less than. What interests me is how commentators cannot read the forms in Leigh's work as other than datum—natural (black female bodily forms) or cultural (African referents, including materials). Why, when looking at such objects, as they become the "raw materials" of Leigh's (art)work, that to which she applies the forms that result from her and others' intellectual labor, critics and commentators do not take into account what the artist herself highlights in this connection. As when she told Thelma Golden, "Because I had just a philosophy and cultural studies background, I started to think about the means of production, the knowledge, everything that happens around that object. Typically with water pots, the labor is done by anonymous, mostly black women in Africa. It set me on this journey of thinking about how much labor has been accomplished, how many countries, cities, hospitals are fueled by the labor of black women, and at the same time, they're denigrated."[31]

Leigh articulates an artistic intention with a double charge, which focuses on the political (economic, racial, and cisheteropatriarchal) dimension and the aesthetical (the refusal to consider it art) dimension that is reflected by anonymity, in that which is usually associated with craft and the making of useful objects (of objects with use value and as such are not artistic). This is the context in which the following statement by Leigh epitomizes what most critics seem to understand: "I feel very lucky to be in a position to represent the strength and beauty of women."[32] When read against Leigh's statement that opens this essay, and other of her comments on her practice, this last sentence gives a meaning to the verb "to represent" that is distinct from the ones articulated by the critics occupying the position hailed by her imperative negation ("if you never

. . . you don't . . . "). For when black female physical forms combined with African art forms are gathered in Leigh's reclaimed history of the United States, the one that recalls the slave quarters, what is conveyed is not an unmediated black femme subjectivity, as something given by the black femme artist who expresses it, because the artist is, well, a black cis woman.

What these forms refer to is an archive in which they receive and convey meanings that, as Leigh says, are distorted and problematic. Nevertheless, these are what is available to the artist, for whom these forms are raw materials that carry the meanings already circulating in the anthropological, historical, and aesthetical archive, which will also become the artist's raw materials. The forms—the watermelon and the plantain as well as the jug and the hut—are anatomic (organic) and historic, but also cosmic and quantic. Looking at her work, it is not difficult then to see the pieces as representational (in the sense of being datum that can immediately grasp black women and their histories and experiences) due to the forms' anatomical and historical references. I do not think such a reading is intrinsically or fully incorrect. The forms do, indeed, do this work. However, this work is precisely the subject matter of Leigh's art. The representational work done by these forms and by those who interpret them as datum of black women's experience and history and identity is what Leigh works through and designifies, because they are archival (historical, anthropological, and aesthetical) items of misogynoir.

In Leigh's *Sovereignty*, inside a building formally (intellectually, analytically, aesthetically) seized by black feminist tools, these forms acquire a documentational role. They are the documents of black women's subjugation in all moments of the post-Enlightenment political architecture, the symbolic (the appropriated forms by Picasso and others), the ethic, the juridic (slavery and the Herero massacre), and the economic (slavery and the washing woman). What does not become available as either datum or document is precisely black femme subjectivity itself; it is there in its critical manifestation, in its intellectual deployment as a thinking existent who reflects on her own political trajectory, but not as a collectivity to be observed, studied, and interpreted. The only black femme subjectivity present in the work, the only subjectivity at all, is that of the artist, whose intention (political and aesthetical) the pieces manifest.

30 Lauren Williams, "Artist Simone Leigh's Work Transforms the US Pavilion at the Venice Biennale," WBUR, April 22, 2022, https://www.wbur.org/news/2022/04/22/simone-leigh-venice-biennale-ica.

31 Leigh in "Zendaya and Simone Leigh Are Going Beyond Beauty."

32 Leigh in "Zendaya and Simone Leigh Are Going Beyond Beauty."

* * * * *

My claim here is that Leigh's work unsettles the position of the appreciator, as it is composed within the contemporary art scene. Something her sculptures do, for instance, instead of offering an object relief (from colonial or racial violence) or confirmation (of one's critical and progressive credentials), is to demand that the viewer check her own immediate response; but they do so without offering a resolution, by raising a question (about whether or not one has naturalized the racist meanings Leigh uses as raw material) without any promise of settling it, that is, of giving something that answers the question. To be sure, because Leigh does not even frame it as a question, what the person standing before her work has to reflect upon is the very familiarity of the (theoretical and aesthetical) forms and raw materials without being given the context for it. Though it is to be assumed that the appreciators (critics, audience, curators, museum directors) know that, like the work of other contemporary artists, Leigh's is mediated. That it also conveys the artist's formal (conceptual and material) references, most commentators on the work exhibited at the Venice Biennale seem to have forgotten.

Thinking with Simone Leigh's charge that the majority of those occupying the position of the appreciator in the contemporary scene lack the conceptual tools for grasping her work has inspired questions about the aesthetic that I hope help to outline, without apprehending or in any other way limiting or confining, what lies beyond the challenge brought by these artworks that confront the colonial, racial, cisheteropatriarchal matrix. Though it seems unavoidable that one approaches these artistic interventions assuming that they express or actualize particular histories, experiences, and subjectivities, these artistic statements do not seem to seek the inclusion of formerly absent perspectives so much as threaten, in their very existence, a shift at the core the field of aesthetics.

Annex

"Brick House is a bronze bust of a Black woman with a torso standing at 16 feet tall and looks out over the raised outdoor park in New York. The sculpture's torso combines the forms of a skirt and a clay house. The sculpture's head is crowned with an afro framed by cornrow braids. This is the first piece in Leigh's Anatomy of Architecture collection, an ongoing body of work in where [*sic*] the artist combines architectural forms from regions as varied as West Africa and the Southern United States with the human body. Brick House combines a number of different architectural styles: 'Batammaliba architecture from Benin and Togo, the teleuk dwellings of the Mousgoum people of Cameroon and Chad, and the restaurant Mammy's Cupboard in Natchez, Mississippi.' The content of Leigh's sculpture contrasts the location it is in directly, as it is surrounded by 'glass-and-steel towers [that] shoot up from among older industrial-era brick buildings, and where architectural and human scales are in constant negotiation.'"[33]

Celebrity Height Wiki

"America also chooses to favor an important female presence, the American Simone Leigh, the first black woman to represent the United States at the Venice Biennale. . . . [S]he favors ceramics as a medium, using it in the creation of mammoth female bodies often with African somatic characteristics, accentuating themes dear to her origins."[34]

Maria Chiara Valacchi, *Elle Decor*

"In the spring of 2019, a sixteen-foot bronze bust of a Black woman appeared on the High Line in New York. Mounted on a plinth, it was clearly visible to pedestrians and people in cars and taxis on Tenth Avenue, and its power caught and held their attention. Her hair was done in long braids, and her torso had an architectural dimension, which echoed the traditional building styles of the Mousgoum people of Cameroon. (Two years earlier, Leigh had been similarly inspired by dome-shaped, mud-and-raffia kitchen houses, called *imbas*, from Zimbabwe; she had built three of these structures for a show at Marcus Garvey Park, in Harlem.) Her monumental High Line sculpture was figurative and abstract, a mysterious and majestic goddess of Black womanhood."[35]

Calvin Tomkins, *New Yorker*

"We proceed toward the heart of the Giardini, where—large, compared to others—the USA Pavilion stands out: from the outside, in the partial straw roof and in the female 'totem' towering in front, the signature of the great Simone Leigh, sculptor and performer from Chicago who brings all black women power to the Lagoon. Her creations are huge, matriarchal, grandiose: 'Sovereignty' is the title of the project. Need we ay more?"[36]

Francesca Amé, *Vogue Italia*

33 Simone Leigh: Timeline (2019), CelebHeightWiki, accessed July 22, 2022, https://www.celebheightwiki.com/simone-leigh-height.

34 Maria Chiara Valacchi, "Alla Biennale di Venezia 2022 questi sono i padiglioni nazionali di cui parlano tutti," *Elle Decor*, April 20, 2022, accessed June 5, 2022, https://www.elledecor.com/it/arte/a39768686/biennale-arte-venezia-2022-padiglioni-da-vedere/ (my translation).

35 Tomkins, "The Monumental Success of Simone Leigh."

36 Francesca Amé, "Biennale Arte: Un itinerario di tre ore ai Giardini per vedere il meglio dei padiglioni," *Vogue Italia*, April 22, 2022 (my translation).

trophallaxis, 2008/2017
Terracotta, porcelain, epoxy, graphite, gold and platinum glazes,
and antennas
Approximately 12–15 × 15–20 feet (3.7–4.6 × 4.6–6.1 m) (height × diameter)

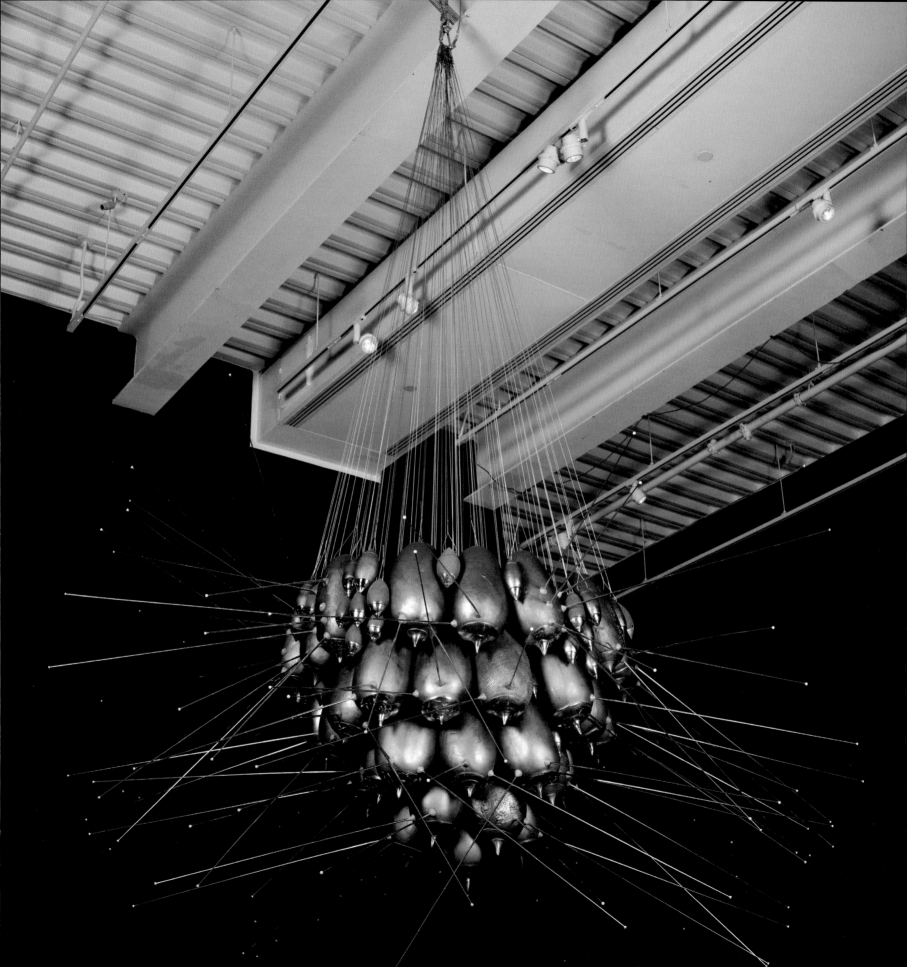

pages 48–49 and facing
Installation views, *You Don't Know Where Her Mouth Has Been*,
The Kitchen, New York, 2012

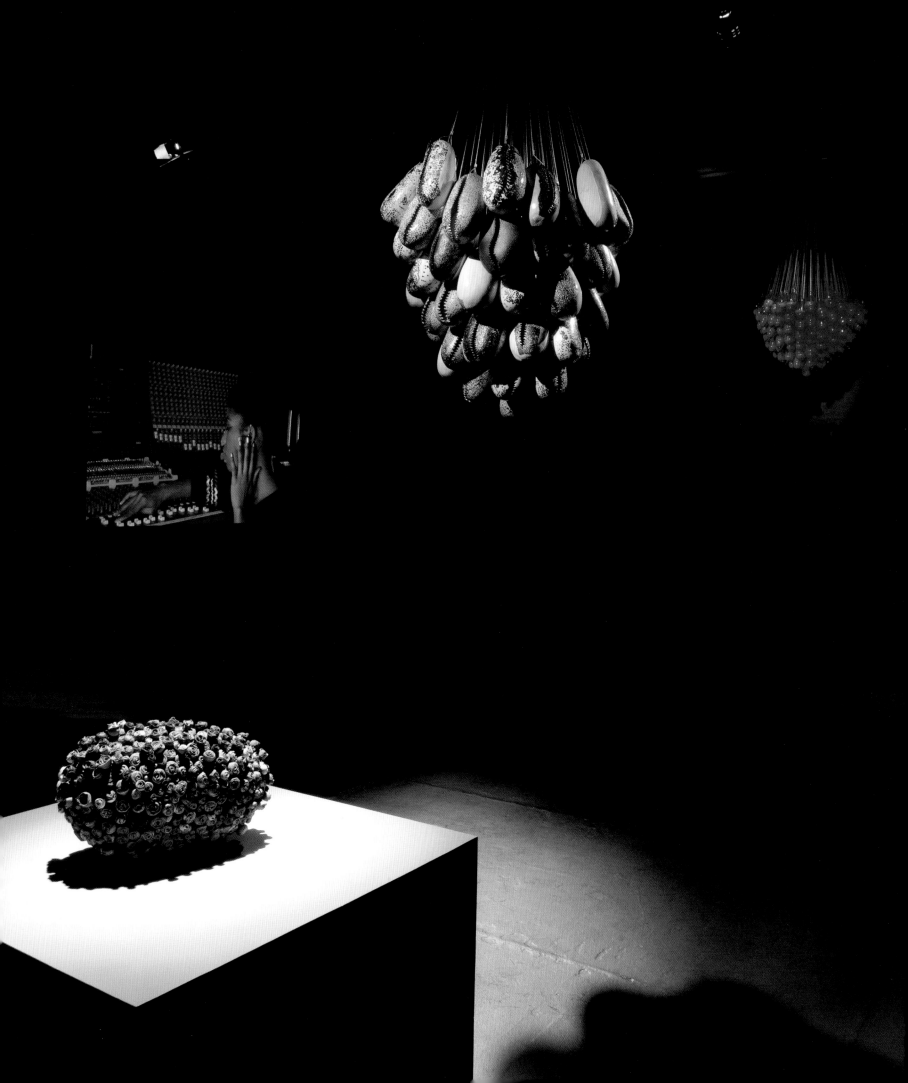

You Don't Know Where Her Mouth Has Been (detail), 2012
Porcelain and wire
Dimensions variable

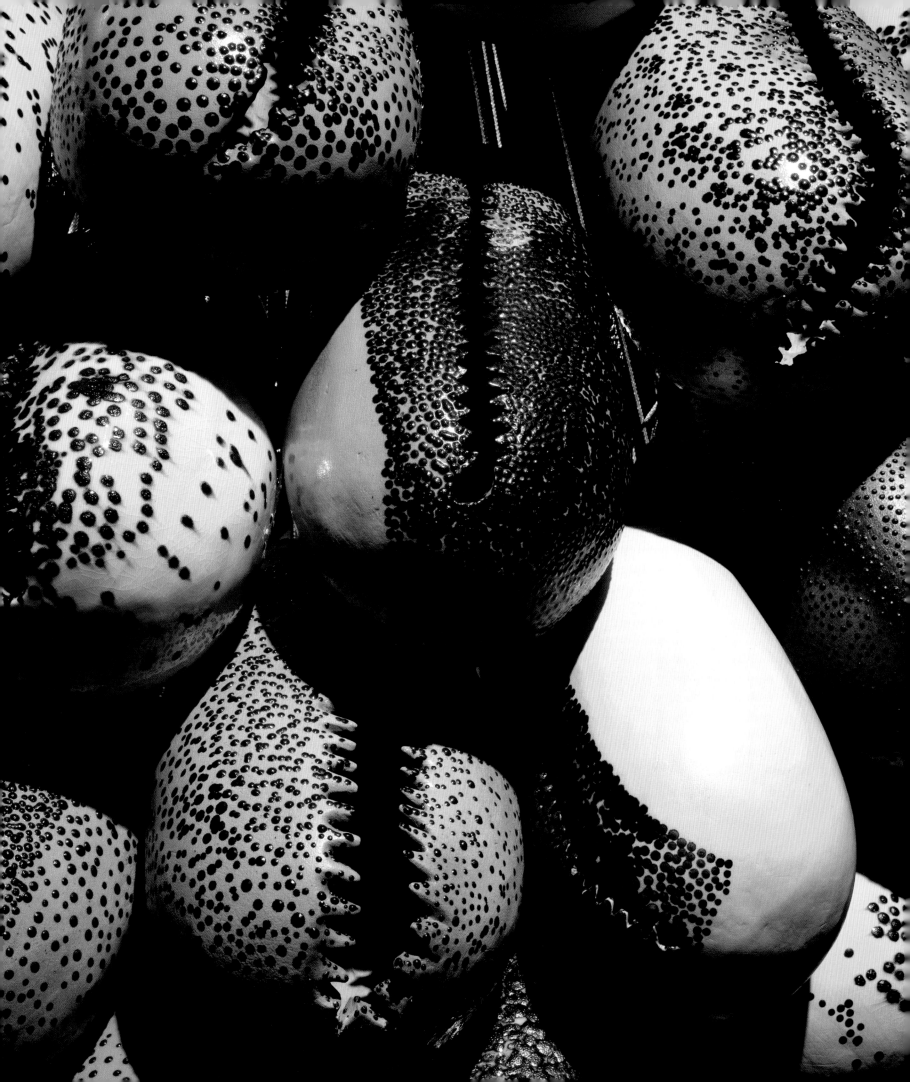

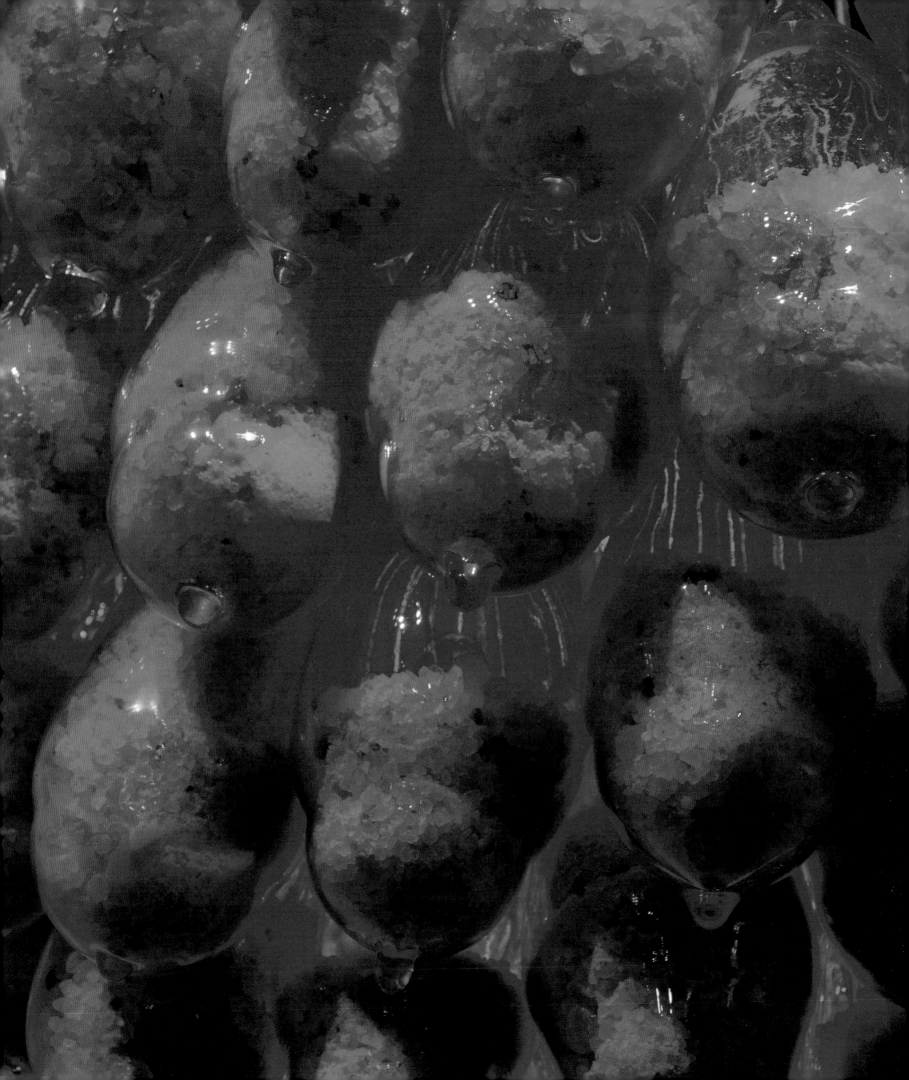

Kool-Aid (detail), 2011
Glass, salt, wire, light, and color gels
Dimensions variable

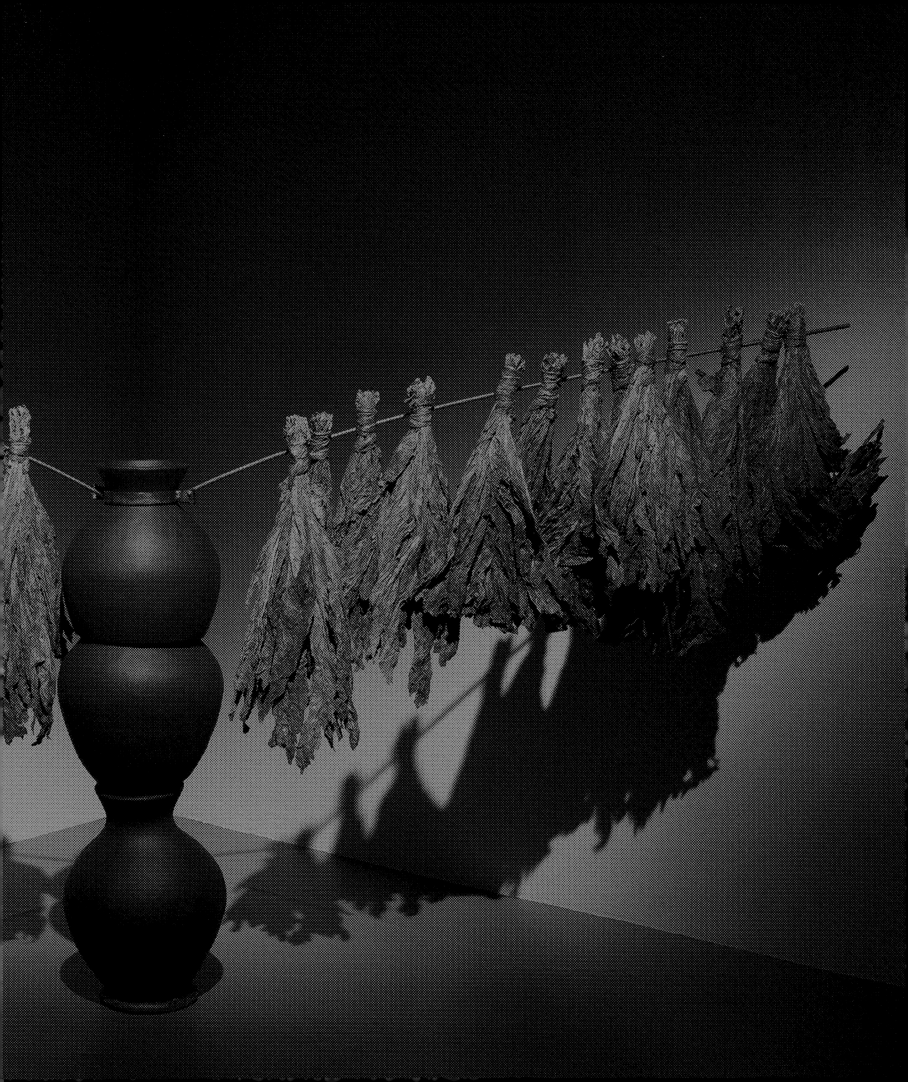

pages 56–57
Crop Rotation, 2012
Terracotta, paint, steel, and tobacco
Approximately 67 1/2 × 131 × 15 inches (171.5 × 332.7 × 38.1 cm)

facing
Brooch #1, 2004
Porcelain, terracotta, lab apparatus, steel, and platinum luster
36 × 38 × 12 inches (91.4 × 96.5 × 30.5 cm)

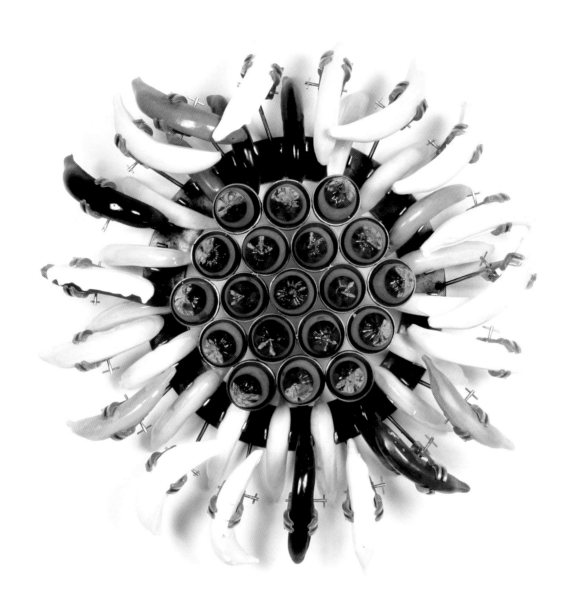

Installation view, *Lisa DiLillo & Simone Leigh*, Momenta Art,
Brooklyn, New York, 2004

facing
White Teeth (For Ota Benga) (detail), 2001–4
Porcelain, steel, glass, and wire
Approximately 84 × 120 × 12 inches (213.4 × 304.8 × 30.5 cm)

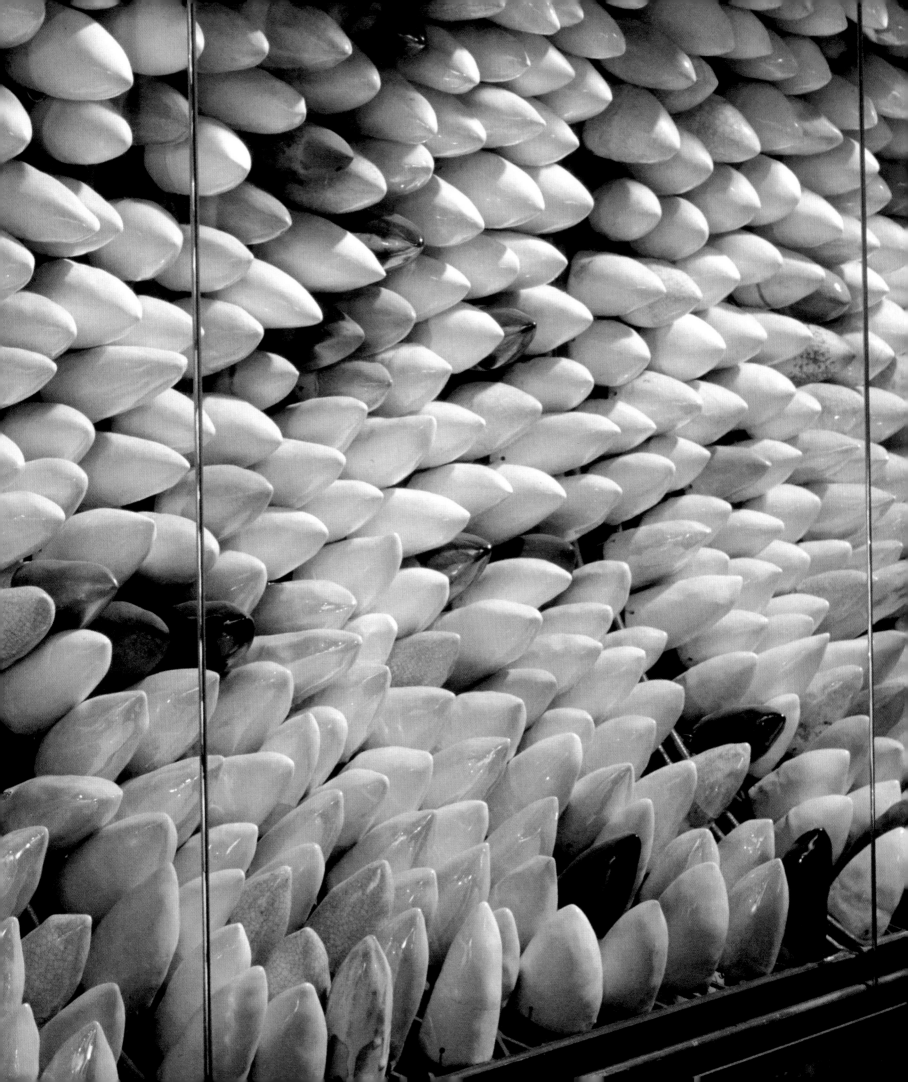

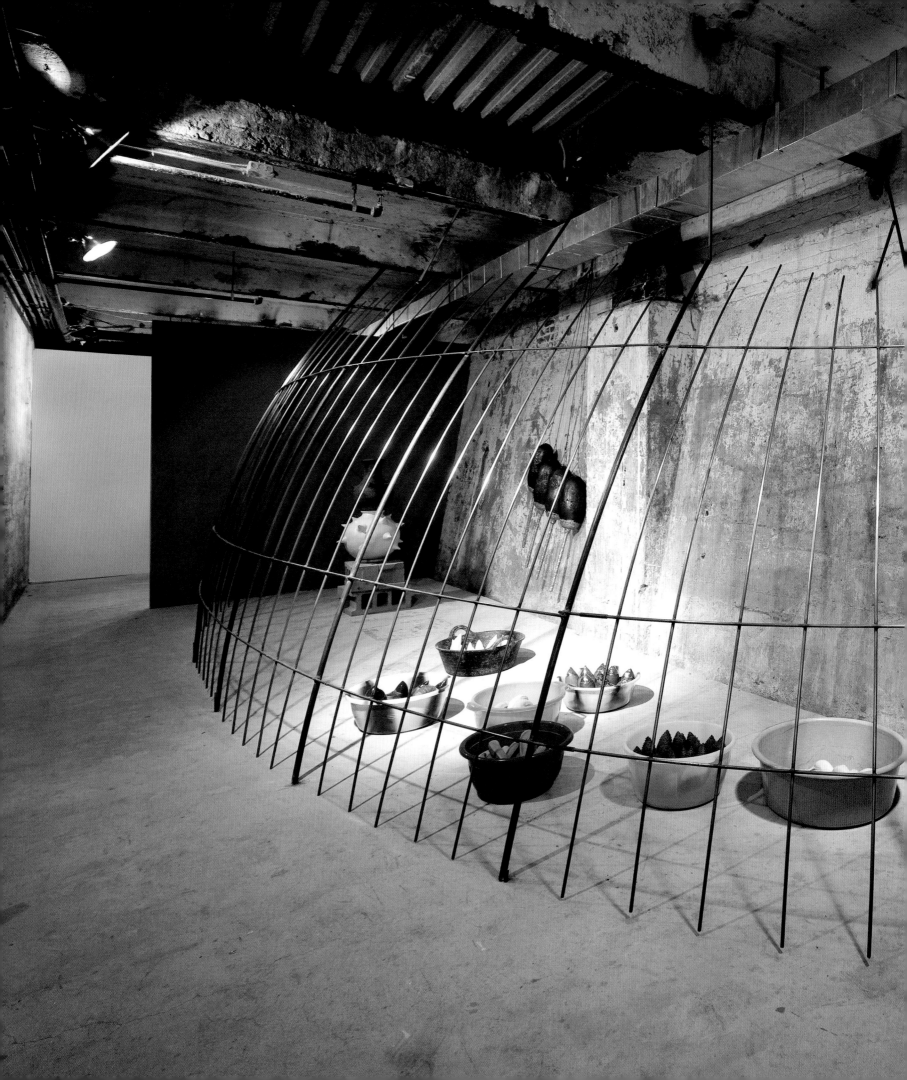

pages 64–65
Cage, 2009
Steel
6 × 27 × 7 feet (1.8 × 8.2 × 2.1 m)

facing
wedgewood bucket, 2009
Porcelain and plastic
10 × 14 × 14 inches (25.4 × 35.6 × 35.6 cm)

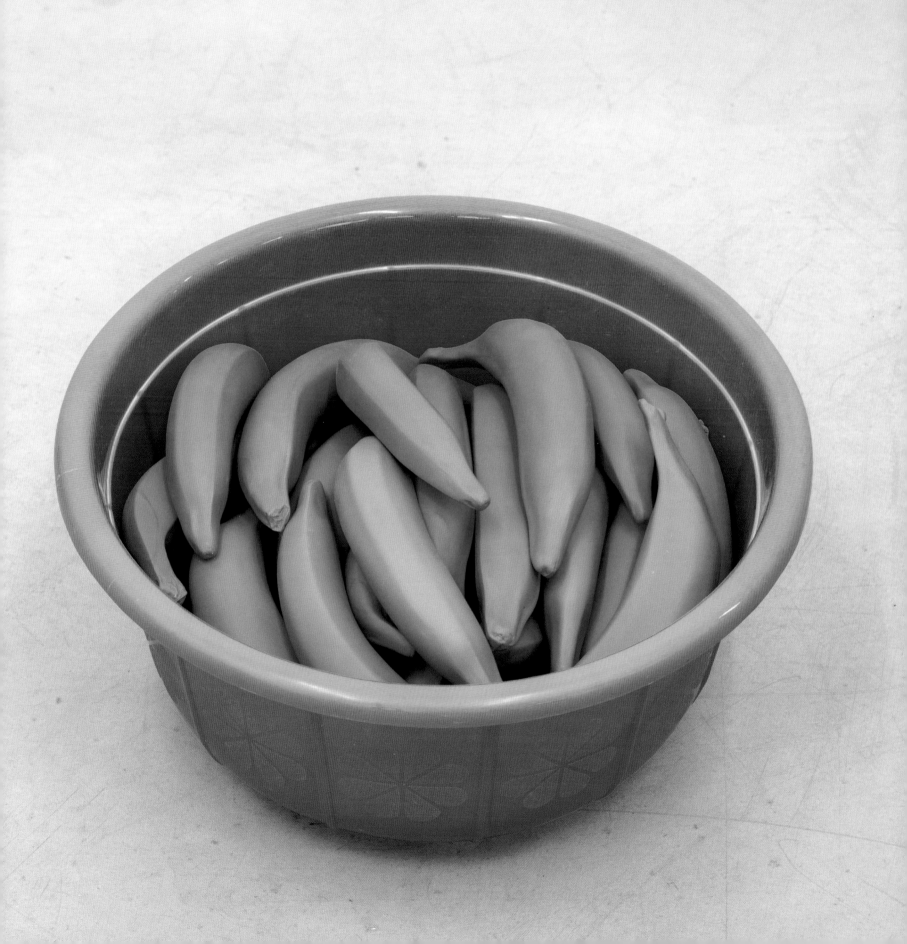

Slipcover, 2008
Porcelain, steel, and plastic slipcover
32 × 32 × 6 inches (81.3 × 81.3 × 15.2 cm)

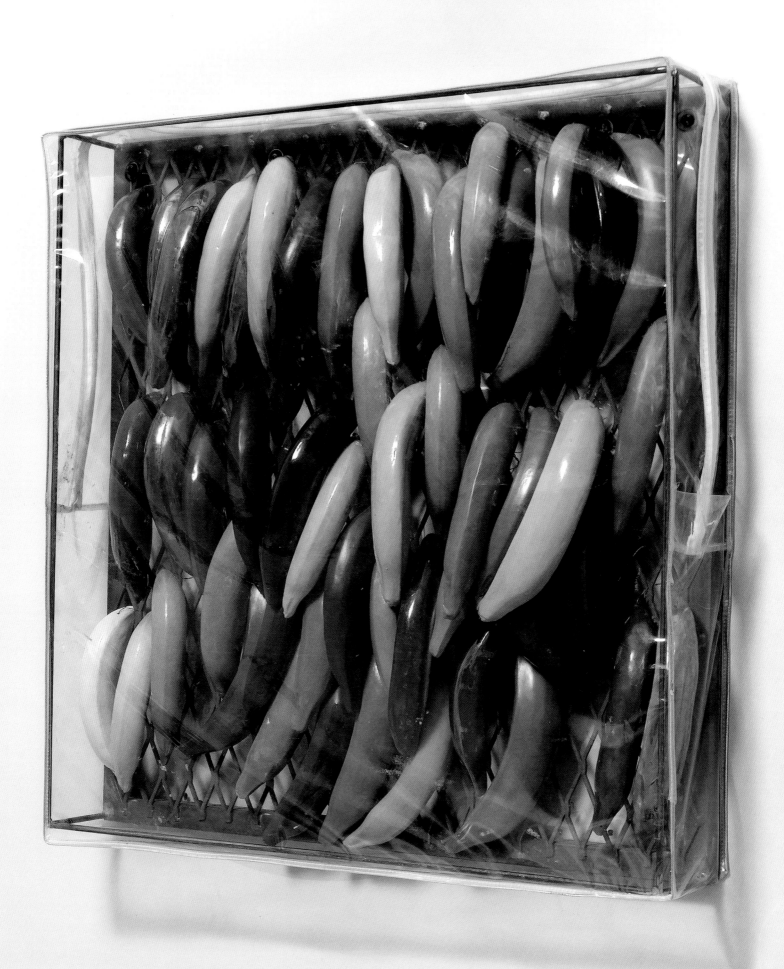

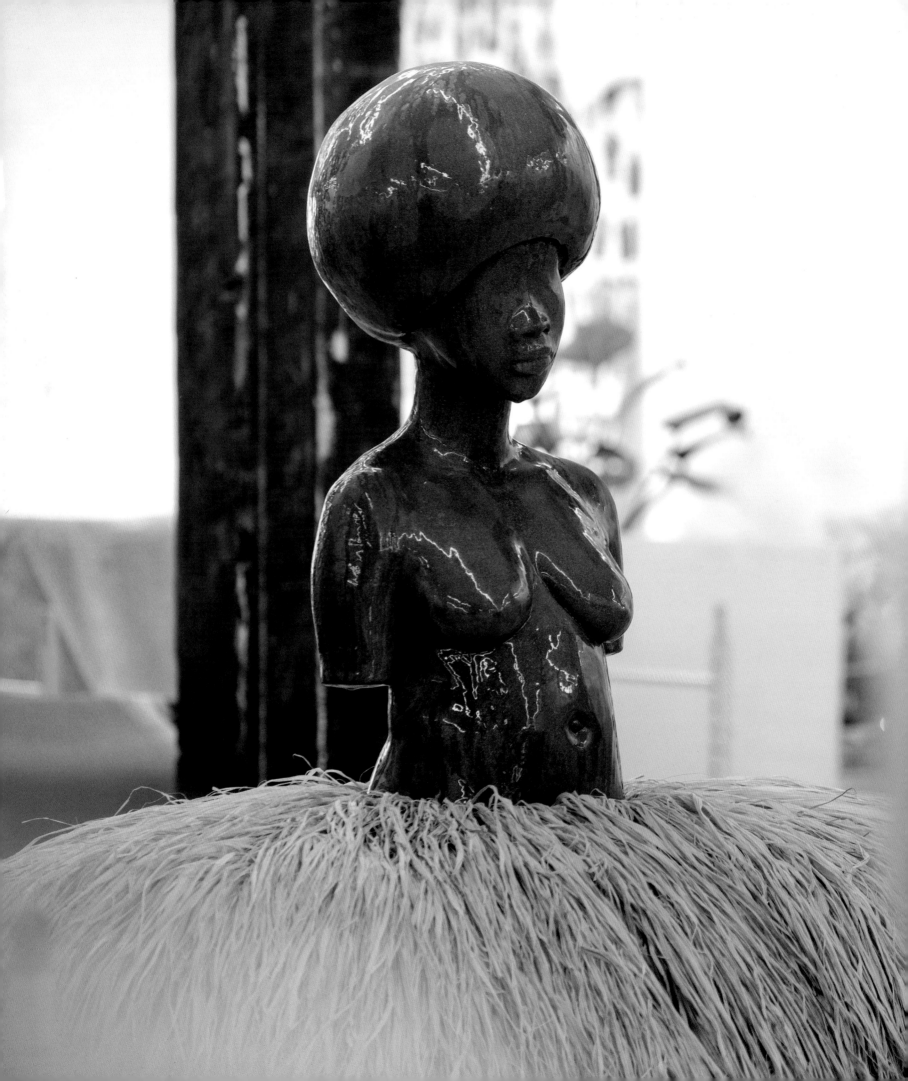

Rizvana Bradley

Awaiting Her Verb

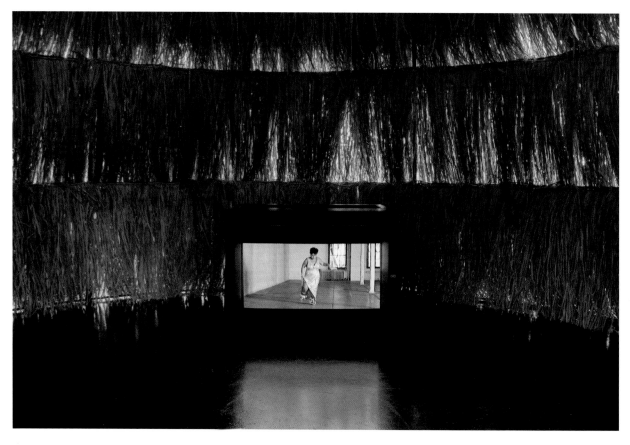

Fig. 1 *Aluminum*, 2016. Installation view, *Hammer Projects: Simone Leigh*, Hammer Museum, Los Angeles, 2016

A body horizontal, recumbent but not prone. A body laid low, passive but not submissive. The partial view of this body, half buried by a pile of stones, recedes; and yet this apparently compliant, tractable, unprotesting body is not entirely abject. Simone Leigh's *my dreams, my works, must wait till after hell . . .* (2011; pages 92–93), the single-channel video artwork made with her friend and collaborator the artist Chitra Ganesh, including a score by Kaoru Watanabe, traces with virtuosic subtlety the legacy of the *serpentine line*—the intangible allure of the turned back made so famous in art history by William Hogarth's eighteenth-century theory of the body's sensuous contours, a figural motif that solidified the indelible iconicity of the (white) female body's "line of beauty."[1] This now infamous line, exemplified by the nudes of artists such as Jean-Auguste-Dominique Ingres, became essential to the representation of the modern body and variously extended through nineteenth- and twentieth-century vocabularies of abstraction in work by a range of artists of different aesthetic persuasions, including Paul Cézanne, Josef Albers, John Cage, Cindy Sherman, and Kiki Smith. But where twentieth-century artists subjected the serpentine line to a series of strategically improvisational abstractions, and contemporary feminist artists critically subverted the integrity of its representational motifs, Leigh's retracing of this line expresses a crucial difference: undercutting the putative autonomy of the work of art, Leigh's retracing follows from a prior inscription that is also an exscription,[2] from the unfolding of a vernacular tradition by which black radical praxis is marked and upon which it remarks, a tradition that belies the conceit that the work of art is the product of the isolated genius or the mastery of an individuated creator. Attending to this irreducible difference, inherent to Leigh's repertoire, requires attuning to the political and aesthetic divergences and deviations that are this tradition's inheritance and bequeathment, its gift and burden.

For Leigh, such aesthetic propositions seem less directed by conceptual deliberations over the politics of gender and racial representation than bound up with the imperatives of an enduring history of black insurgency and dissent *as praxis*, which the work of art demands to sustain. Leigh's artistic repertoire has remained of long-standing interest precisely because her work conveys not the transparency of the (black female) body, but rather the politico-philosophical problematic or dilemma expelled by and from the cipher of this singular, racially gendered figure: the sense of *being made a body that must bear* the (im)possibility of a world that both requires the reproduction/reproductive labor of that body and forecloses upon that body's existence.[3] If the viewer is troubled by the obscurity of this body's origin, it is because Leigh's body has lost its head, and with it, perhaps, its raison d'être. What would be the radiating center of subjectivity for the resting model has been effaced. If this figure is one who, in Frantz Fanon's idiom, is predestined to *wait*, if this figure could be said to be *waiting*, it is not for the conferral of external recognition, not for the imminent canonization of black form.[4] This is not a *body* that awaits being written into Western art history and its lexicon of beauty. Rather, this figure *retreats* even as it repeats; it at once bears and slips from the impositions of form, the imperatives of canonization, and the injunctions of representation. Here is a video portrait that refuses its subject. It is a work that understands that the existential drama of blackness is cleaved to and by the (racial) matter(ings) of gender. In the words of Hortense Spillers, here is a figure "unvoiced, misseen, not doing, awaiting [her] verb."[5] Perhaps Leigh's 2016 exhibition and residency at the New Museum, *The Waiting Room*, with its emphasis on the underground exigencies and extemporaneities of the black (feminine) care that sustains the intramural,[6] could be said to track the gendered declension between Fanon's waiting and Spillers's *awaiting*. (And yet, the shadow of a doubt: *Are* we the ones we've been waiting for?)[7] Paradoxically, perhaps, the contemporaneity of Leigh's work signs through a dispersed history of artful refusals, through black radical traditions animated as much

1 William Hogarth, *The Analysis of Beauty* (1753; Chicago: Reilly & Lee Co., 1908).

2 On exscription, see Jean-Luc Nancy, *The Birth to Presence*, trans. Brian Holmes et al. (Stanford: Stanford University Press, 1993).

3 See Rizvana Bradley, *Anteaesthetics: Black Aesthesis and the Critique of Form* (Stanford: Stanford University Press, 2023).

4 Frantz Fanon, *Black Skin, White Masks*, trans. Charles Lam Markmann (New York: Grove Press, 1967), 120. For further discussion, see Kara Keeling, *The Witch's Flight: The Cinematic, the Black Femme, and the Image of Common Sense* (Durham, NC: Duke University Press, 2007), 27–44; and David Marriott, *Whither Fanon? Studies in the Blackness of Being* (Stanford: Stanford University Press, 2018), passim.

5 Hortense J. Spillers, *Black, White, and in Color: Essays on American Literature and Culture* (Chicago: University of Chicago Press, 2003), 153.

6 See Spillers's chapter "Black, White, and in Color, or Learning How to Paint: Toward an Intramural Protocol of Reading," in *Black, White, and in Color*, 277–318.

7 Cf. June Jordan, "Poem for South African Women," in *Directed by Desire: The Collected Poems of June Jordan*, ed. Jan Heller Levi and Sara Miles (Port Townsend, WA: Copper Canyon Press, 2005), 278–79.

by impossible dreams and wayward longings as by a politics endlessly deferred. The revolution is unfinished, rough around the edges, raw out of the loom with an unruly hem, a decadent garment with no one weaver to blame.

If the novelty of Leigh's practice cuts against the grain of the presumed autonomy of the individual artist, as that figure has been enshrined within the Western aesthetic tradition, then it should be no surprise that Leigh has placed such emphasis on collaborative fabrication. The filmmakers and artists Madeleine Hunt-Ehrlich and Liz Magic Laser; the multidimensional artist and mezzo-soprano Alicia Hall Moran; the curator, choreographer, author, and performing artist Rashida Bumbray; and the writer and scholar Sharifa Rhodes-Pitts, to name but a few of her fellow travelers, have all been brought into the fold of Leigh's vision, which insistently focuses on black feminine/feminist traditions of artistry and intellectuality. Leigh's work evinces, and would seem to extend, an ardent study of and reverence for the improvisational immanence that distinguishes black practices of gathering, congregating, journeying, and wandering as ulterior modalities of making.[8]

This unshakable proclivity for the minor runs palpably, if not transparently, through the constellation of concerns that animate Leigh's repertoire, and not least in video works such as *my dreams, my works, must wait till after hell . . .*, *Uhura #3 (Tanka)* (2012), and *Aluminum* (2016). Indeed, one of the most salient dimensions of Leigh's artistic practice is its oblique disclosure of the racially gendered conditions of possibility for what Fred Moten describes as "that thinking of the whole that is continually interrupted by temporal and ontological differentiation."[9] This trio of works assiduously pursues a black feminist understanding of the *reproductive possibilities and constraints* that have perpetually grounded, delimited, and (sus)stained black life and existence.[10] In *Aluminum*, Rashida Bumbray performs an immersive dance, which was also presented live to close Leigh's 2016 *Psychic Friends Network* exhibition and artist residency at Tate Exchange, London. Bumbray's choreographic and improvisational labors mark the depth of influence of African metaphysical and philosophical traditions upon the "black New World"—specifically, as Robert Farris Thompson's monumental study *Flash of the Spirit: African and Afro-American Art and Philosophy* has illustrated, in the interlocking forms of expression that have come to inform the visual art, dance, and music of the African American world.[11] In the performance, as Helen Molesworth describes, Bumbray dons "a floor-length gown, wearing anklets adorned with the tops of cans—jewelry Leigh purchased at the *muthi* (traditional medicine) market in Durban, South Africa."[12] As celebration, lament, eulogy, and ancestral tribute, *Aluminum* underscores the role of black feminist reproductive labor in the preservation and reinvention of ritual as the respiration of tradition. Here, a series of improvisatory repetitions, later extended through Leigh's use of the performance footage in an installation during her 2016–17 exhibition at the Hammer Museum in Los Angeles (fig. 1), continually accent and contend with the *ground*, establishing what we might call (after Thompson), a *cosmogrammatical* communing with the *earth*—a ritual enactment of marking the ground "for [the] purposes of initiation and [the] mediation of spiritual power *between* worlds."[13] By emphasizing the centrality of ritual to the transfer of nonsecular knowledge, *Aluminum* alludes to the importance of ancestral connectivity. Even as Bumbray's encircling movements serve, in the vein of Leigh's work, as a clarion call to "defend the dead," as M. NourbeSe Philip might say,[14] the performance also ultimately insists upon the opacity of ancestral life. And yet one cannot help but sense *Aluminum*'s yearning for a spiritual return that could be other than, as Saidiya Hartman puts it, "the last resort of the defeated."[15] Nevertheless, black ritualistic practice, in the context of this tradition, must be understood as that which aspires to "ritual contact with divinity," as Thompson wrote, where "to become possessed by the spirit . . . is to . . . capture numinous flowing force within

8 See Sarah Jane Cervenak, *Black Gathering: Art, Ecology, Ungiven Life* (Durham, NC: Duke University Press, 2021), and *Wandering: Philosophical Performances of Racial and Sexual Freedom* (Durham, NC: Duke University Press, 2014).

9 Fred Moten, *In the Break: The Aesthetics of the Black Radical Tradition* (Minneapolis: University of Minnesota Press, 2003), 98.

10 Rizvana Bradley, "Living in the Absence of a Body: The (Sus)Stain of Black Female (W)holeness," *Rhizomes: Cultural Studies in Emerging Knowledge*, no. 29 (2016), https://doi.org/10.20415/rhiz/029.e13.

11 Robert Farris Thompson, *Flash of the Spirit: African and Afro-American Art and Philosophy* (New York: Random House, 1983).

12 Helen Molesworth, "Art Is Medicine: Helen Molesworth on the Work of Simone Leigh," *Artforum* 56, no. 7 (March 2018), https://www.artforum.com/print/201803/helen-molesworth-on-the-work-of-simone-leigh-74304.

13 Thompson, *Flash of the Spirit*, 108 (emphasis added).

14 M. NourbeSe Philip, *Zong!* (Middletown, CT: Wesleyan University Press, 2008), passim.

15 Saidiya Hartman, *Lose Your Mother: A Journey Along the Atlantic Slave Route* (New York: Farrar, Straus, and Giroux, 2008), 99.

16 Thompson, *Flash of the Spirit*, 9.

one's body."[16] Such performances, opaque though they may be, announce not so much an *absence* as a *surfeit* of meaning, an exorbitance whose haptic transmission proceeds in and from the *suspension* of movement, in dereliction of the worldly economy of spatiotemporal coordination.[17] Bumbray's performance registers the contrapuntal fashion in which blackness surfaces a singularly irregular movement—a *riotous countermomentum* that blurs the distinctions between floating, flying, and falling—within and despite its violent positioning "in the *stillness* of time and space."[18] The biopolitical order of the world rightly fears that this black kinaesthesis might be contagious.[19]

As the historically broken arc of such performances conveys, blackness could perhaps have always been said to signal the unraveling or f(l)ailing of the project of enclosure that authorizes itself under the banner of *sovereignty*. Blackness could itself be taken as an ongoing irruption of the immanently unsovereign, which the state and its analogues work obsessively to repress, even at their own expense. Indeed, as Hartman provocatively suggests, it could very well be that extinction is the only thing that could "[bridge] the gulf between the sovereign and the fungible."[20] The limits to and spuriousness of sovereignty's pretensions—whether figured in the nation-state, the empire, the settler colony, or the individuated subject—are disclosed everywhere and all the time by black traditions whose variegated practices of gathering, of attention, care, and mutual aid,[21] however circumscribed, tend toward the impossible artistry of shared preservation: our beleaguered breath, or "radical pneumaticism," which is ceaselessly made to come before the asphyxiations of the world, but which we nevertheless hold and are held by in this riven togetherness.[22]

Conversely, if, as David Marriott unflinchingly instructs us, sovereignty depends on the perpetual restaging of "the perfect beauty of black death," then we would be remiss not to observe, after Biggie, that "life ain't sweet."[23] Blackness is not vitality, but rather that which (un)makes every vital category.

Returning once again to *my dreams, my works, must wait till after hell . . .*: Here, the almost imperceptible movement of the torso, the figure's evanescent heaving, signals a respiration that strains against *time*, specifically the time of the frame. The physical inversion of the body troubles the temporality of the filmed encounter with the spectator as watchful other. For such a posture solicits an entirely different kind of gaze, "like the one we make to a quiescent body lying on the ground," as Darby English would have it.[24] Yet the nature of the slumber is left unqualified. Could it be characterized as repose? Or does it express a singular depletion that compels a thought about a body whose energy is held in reserve for the experimental form it might advance? Leigh draws us further into an impossible conjunction, the unbearable simultaneity that can be said to pervade black life and embodiment—the simultaneity of a *weighted existence* and a *lightness of being* that was never meant to *be*. The video's extreme durational effect draws out a representational conundrum: its essential breathwork exposes an onto-epistemological entanglement and rupture, which presents itself as conceptual impasse, between what Fanon famously avowed as the black's relentless and irredeemable fall into "an utterly naked *declivity*" and the "black countergravity" Tina M. Campt has theorized as that which "defies the physics of anti-blackness that has historically exerted a negating force aimed at expunging Black life."[25] We encounter an aporia that holds us in *suspense*.

17 Rizvana Bradley, "Black Cinematic Gesture and the Aesthetics of Contagion," *TDR: The Drama Review* 62, no. 1 (Spring 2018): 14–30. On spatiotemporal coordination and its disruption, see also, respectively, Frank B. Wilderson III, *Red, White, and Black: Cinema and the Structure of U.S. Antagonisms* (Durham, NC: Duke University Press, 2010); and Fred Moten, "Blackness and Nothingness (Mysticism in the Flesh)," *South Atlantic Quarterly* 112, no. 4 (2013): 737–80.

18 Bradley, "Black Cinematic Gesture," 23; Spillers, *Black, White, and in Color*, 302.

19 Bradley, "Black Cinematic Gesture," passim.

20 Saidiya Hartman, "The End of White Supremacy, An American Romance," *BOMB Magazine*, no. 152 (Summer 2020), https://bombmagazine.org /articles/the-end-of-white-supremacy-an-american-romance/.

21 "[Black women's] mutual aid did not traffic in the belief that the self existed distinct and apart from others or revere the ideas of individuality and sovereignty, as much as it did singularity and freedom." Saidiya Hartman, "The Anarchy of Colored Girls Assembled in a Riotous Manner," *South Atlantic Quarterly* 117, no. 3 (July 2018): 471.

22 On the "radical pneumaticism" of black music, in particular, see Nathaniel Mackey, *Breath and Precarity* (Durham, NC: Three Count Pour, 2021). On being made to come before the world, see Bradley, *Anteaesthetics*.

23 David Marriott, "The Perfect Beauty of Black Death," *The Philosophical Salon*, June 2017, https://thephilosophicalsalon.com/the-perfect-beauty-of-black -death/; The Notorious B.I.G., "Last Day," *Life After Death*, Bad Boy Records and Arista Records, 1997.

24 Darby English, *How to See a Work of Art in Total Darkness* (Cambridge, MA: MIT Press, 2010), 242.

25 Fanon, *Black Skin, White Masks*, 10 (emphasis added); Tina M. Campt, *A Black Gaze: Artists Changing How We See* (Cambridge, MA: MIT Press, 2021), 47.

Leigh's suite of video works calls for a reconsideration of the irreducible expressions of black sensuosity and sensoriality that are perhaps too readily circumscribed by the vocabularies afforded by more intelligible registers of subversion, whether the latter takes the form of *fugitivity*, *resistance*, or *counterperformance*. Granted, there may be no handy devices for deconstructing the (anti)black "prison-house of language."[26] Calvin L. Warren approaches the problem of "grammatical paucity and the lack of intelligible language to describe the indescribable" by endeavoring to undermine the very terms he is forced to make use of, writing "the term being under erasure to indicate the double bind of communicability and to expose the death of blackness that constitutes the center of ~~being~~."[27] *My dreams, my works, must wait till after hell . . .* affects not so much a mode of destruction as a radical *retreat* from the prison-house of the film frame, a technology of enclosure that would seem to annul the figural inhabitation that, in this instance, bears the racially gendered conditions of possibility for black experimentation. Yet, at every turn, Leigh poses the blackness of the body as a question. In the hands of the artist and her collaborators, the medium of video is everywhere made to bear the trace of this question. Video becomes a vehicle for the act of "critical fabulation"[28] (to invoke Hartman's idiom), of documenting the practices of those relegated to marginalia, who surface (from) the depths of the abyss merely as footnotes to modernity's aesthetic project.[29]

Leigh's work touches upon a final philosophical problem. The intractability of that problem unfolds in and through the confrontation between, on the one hand, those whose existence is tethered, if not reducible, to the impossibility of being, and the history of technological modernity, on the other. What happens when those who paradoxically inhabit the conundrum of nonbeing brush up against a history of embodied technesis?[30] How does a technological medium register the ineffable (non)presence of those who cannot refuse the markings of an incalculable breach of time and space, or what Frank B. Wilderson III refers to as "the 'terminal.'"[31] How do we qualify the visual appearance of those who materialize within technical modernity as if "infused with too much *anima*"?[32]

Let us close, or rather alight on an interval, by way of Leigh's 2012 wall-size single-channel video installation *Uhura #3 (Tanka)* (fig. 2). Unfolding with a soundscape composed of Kaoru Watanabe's taiko drums and flute playing, *Uhura #3 (Tanka)* features a performance by Sharifa Rhodes-Pitts that speculatively reprises the character of Lieutenant Nyota Uhura (played by Nichelle Nichols, who passed away as this essay was being written) from the original *Star Trek* television series, the USS *Enterprise*'s communications officer from the United States of Africa.[33] Nichols is, tellingly, generally noted in film history only for performing U.S. television's first scripted interracial kiss, with her costar William Shatner during the episode "Plato's Stepchildren," which aired on November 22, 1968. As I have observed elsewhere, the interracial kiss is a broken sign, overdetermined and insufficient, the site of a performance that (dis)orders the racial economy of love and desire, freighted with libidinal exchange even as it bears a hapticity that is irreducible to and exceeds its symbolic transits.[34] Be that as it may, Leigh's piece dissents from film history's habitual emphasis and directs our attention elsewhere. Recalling her time watching Uhura on *Star Trek* as a child, Leigh notes, "I had to deal with the conundrum that she mostly repeated one line."[35] Indeed, as Nichols herself exasperatedly put it in a candid

26 Friedrich Nietzsche, *Writings from the Late Notebooks,* ed. Rüdiger Bittner, trans. Kate Sturge (Cambridge, UK: Cambridge University Press, 2003), 110. See also Fredric Jameson, *The Prison-House of Language: A Critical Account of Structuralism and Russian Formalism* (Princeton, NJ: Princeton University Press, 1972).

27 Calvin L. Warren, *Ontological Terror: Blackness, Nihilism, and Emancipation* (Durham, NC: Duke University Press, 2018), 179n1.

28 See Saidiya Hartman, "Venus in Two Acts," *Small Axe* 12, no. 2 (June 2008): 1–14.

29 For an earlier reading of Édouard Glissant's conception of the abyss, see Rizvana Bradley and Damien-Adia Marassa, "Awakening to the World: Relation, Totality, and Writing from Below," *Discourse: Journal for Theoretical Studies in Media and Culture* 36, no. 1 (Winter 2014): 112–31.

30 Mark Hansen, *Embodying Technesis: Technology Beyond Writing* (Ann Arbor: University of Michigan Press, 2000).

31 Wilderson, *Red, White, and Black,* 195.

32 Moten, *In the Break,* 161 (emphasis in original).

33 Nyota Uhura is something of an amalgamation of Bantu and Swahili: "Uhura's last name is a corruption of the Bantu word *uhuru,* meaning 'freedom,' 'independence,' or 'liberation,' and her apocryphal first name, Nyota, is a Swahili word for 'star,' but her first name is never used on-screen in the original *Star Trek.*" andré m. carrington, *Speculative Blackness: The Future of Race in Science Fiction* (Minneapolis: University of Minnesota Press, 2016), 76. In both the original series and the 2009 film (dir. J. J. Abrams), Uhura's name provided one of many objects of pornotropic fixation and humor.

34 Rizvana Bradley, "Certainly No Clamor for a Kiss," Haptic Bodies conference, Barnard Center for Research on Women, New York, March 4, 2017.

35 "Art Practical on Simone Leigh," Ballroom Marfa, April, 29, 2013, https://www.ballroommarfa.org/archive/art-practical-on-simone-leigh/.

Fig. 2 *Uhura #3 (Tanka)* (still), 2012. Digital video (color, sound; 5:04 minutes)

interview: "I mean I just decided that I don't even need to read the FUCKING SCRIPT! I mean I know how to say, 'hailing frequencies open.'"[36]

In Leigh's video installation, Uhura remains nominally silent, looped in a series of syncopated repetitions: her torso rotating between her control panel and the imaginary space of the starship's bridge behind her, her right hand adjusting the knobs and faders of the interface in step with Watanabe's taiko drums, her left dancing upon the earpiece where the sonic abstraction of frequency might be imagined to meet the flesh, her smiling face and erratic gaze occasionally meeting that of the onlooking spectator. The filmmaker and theorist Daniel Barnett observes that repetition is in fact the quiet ground of cinema, the "mediation zone" from which temporality and meaning flow, the movement that emerges only through "the frame line that lies between the pictures . . . the invisible vector, the anteroom of meaning."[37] And yet here we find a figure whose reproductive labors, though serially framed, have more in common with the interval of the frame line than with anything that acquires the force of meaning *within* the frame. Meanwhile, *Tanka* (meaning "short poem" or "short song") refers to a form of Japanese poetry, preeminent from the ninth to nineteenth centuries, that is traditionally thirty-one syllables, unrhymed, and printed in a single unbroken line. Perennially forced to embody technesis, made the vestibule for the transmission of languages in which she can claim no name and no regard,[38] Uhura is suspended in the silence of communicability—and yet her poetry, her lyrical surplus,[39] breaks (in upon) speech as the cacophony of quietude, the music of the unspeakable. In the waiting room, she anticipates the echo: *Let's take it again from the top.*

36 William Shatner and Chris Kreski, eds., *Star Trek Memories* (New York: Harper Collins, 1993), 212; quoted in Carrington, *Speculative Blackness*, 81.

37 Daniel Barnett, *Movement as Meaning in Experimental Film* (Amsterdam: Editions Rodopi, 2008), 71.

38 On the relation between black femininity and the violence of nomination, see Spillers, *Black, White, and in Color*, passim.

39 The phrase "lyrical surplus" comes from Moten, *In the Break*, 38. For an inquiry into the relationship between black femininity and lyrical surplus, see Rizvana Bradley, "Reinventing Capacity: Black Femininity's Lyrical Surplus, and the Cinematic Limits of *12 Years a Slave*," *Black Camera* 7, no. 1 (Fall 2015): 162–78.

Yasmina Price

Passing the Torch:
Black Women, Intimacy, and Arson in *Conspiracy*

Fig. 1 Simone Leigh and Madeleine Hunt-Ehrlich, *Conspiracy* (still),
2022. 16mm and 8mm film (black-and-white, sound; 24:00 minutes)

Two pairs of hands dance across two films. Sculpting hands, they move by touch, feeling their way around the amorphous clay to give way to the smooth sides of a vase; a sensitively shaped forehead; the ridges of thickly braided ropes. These hands belong to Simone Leigh and Inge Hardison, two Black women artists separated by several generations but brought together by a latticework of expressive force, Black sociality, and nurtured continuation. Their bond is animated by the mesmerizing attentiveness to the sculptural haptics in *Hands of Inge* (1962) and *Conspiracy* (2022). The first is a 16mm black-and-white documentary directed by John W. Fletcher, narrated by Ossie Davis, and scored by jazz musicians, which was made as an overview of Hardison's practice. The second is a collaborative piece Leigh made with her friend the filmmaker Madeleine Hunt-Ehrlich, known for a method of surrealist documentaries whose historical attunements accompany her attention to the interiorities of Black women. *Conspiracy* invites *Hands of Inge* into a choreography of inspiration, (re)citation, and inheritance.

An incantation of multiple architectures of the self for Black women, *Conspiracy* is a tribute to the manual labors of creation. The wandering hypnosis of Hunt-Ehrlich's gorgeous monochromatic cinematography ritualizes the assertive elegance of Leigh's clay and stone artisanry. The performative gestures of the film are a reinscription of *Hands of Inge*, whose subject was not only a sculptor but also an actor, a photographer, and someone who played with form throughout her artistic life. Hardison's most recognizable work was a series of busts depicting "Negro Giants in History." Produced in the 1960s, this collection included such figures as W. E. B. Du Bois, George Washington Carver, Paul Robeson, Sojourner Truth, and Harriet Tubman. Her pieces carried historical weight with a light touch, a delicate balance that is also enacted in *Conspiracy*. Hardison later made a series called Our Folks (1983), which portrayed ordinary people and illuminated a sculptural praise poetry that was not only about monumentalizing historical figures but also celebrated the everyday.

Conspiracy is a choral response that mirrors images inherited from *Hands of Inge*. It begins with a citation (fig. 1) of the earlier documentary's opening image, which shows Hardison's hands in a closeup, fingers extended upward and pressed together as if to cover her eyes. Leigh and Hunt-Ehrlich's film most directly references the stylized choreography of a sequence in which Hardison's hands are shown carefully demonstrating a series of tools against a black backdrop. Here, it is Leigh's hands displaying the tools that frame her as an artist, a craftsperson, and a worker: they bend and unbend a thick piece of wire; they playfully oscillate from side to side with a wire clay cutter; one hand holds the perforated rectangle of a clay shredder and brushes it lightly against the other arm; one hand holds up a hammer. Rather than glossing over completed pieces, the film inhabits and documents the studio as a place of ongoing making, just as *Hands of Inge* aestheticized even the mundane aspects of Hardison's sculptural labor.

Conspiracy's orientation toward process and gathering is an invitation into the intimate and historical terms that nurtured the film into being. Leigh and Hunt-Ehrlich have had a decade-long creative friendship, and this piece extends a conversation they also share with a larger constellation of Black women cultural workers. There is a layered significance to the sourcing from *Hands of Inge*, which is itself a visual assemblage in which Black women hold each other's appearances. The film was edited by Hortense "Tee" Beveridge, who was the first Black woman to be a member of the Local 771 union for motion picture film editors. *Hands of Inge* was placed in the collection of Pearl Bowser, a veritable doyenne of Black cinema, who later donated her collection of motion pictures to the Center for African American Media Arts at the Smithsonian's National Museum of African American History and Culture.

In a singular artwork, *Conspiracy* draws together a long history of Black women's polymorphic practices. The nested references to cultural caretaking and artistic ingenuity are heightened by Lorraine O'Grady's presence in the film. An extraordinary conceptual and performance artist whose hybrid practices ultimately defy any form of containment, she has also been a mentor to Leigh, embodying a thread of continuity among these artists. O'Grady, with her majestically two-toned hair and impeccable earrings, is first shown flipping through a catalogue in front of a shelf of plastic-wrapped objects and then appears again as a witness to the film's closing event of Black feminist arson.

A telling divergence between *Hands of Inge* and *Conspiracy* concerns the terms of their production. Whereas the former was made *about* Hardison, the latter was coauthored by Leigh herself. This signals the divergent levers of autonomy available to these two artists. *Conspiracy* was made as part of the ensemble of pieces in Leigh's U.S. Pavilion—titled *Sovereignty*—at the Venice Biennale. A play with power and possibility, Leigh and Hunt-Ehrlich's film makes itself a container for gestures of autonomous expressivity for Black women. Citations from Zora Neale Hurston in the narrative voice-over are crucial in this capacity. The film draws specifically from *Tell My Horse* (1938), in which the anthropologist, and once peerlessly prolific chronicler of African American culture, documented her participatory experiences of voodoo in Haiti and Jamaica.

Leigh's experimentations in *Sovereignty* compare with how Hurston worked, sui generis, to craft an ethnographic

method that attempted to shift normative hierarchies and procedures. Within her larger oeuvre of attending to and cataloguing Black folklore, Hurston's *Tell My Horse* is a reflective travelogue that addresses the legacies of colonialism in the Caribbean islands, the imbrications of class antagonisms and antiblackness, popular memory, and spiritual practices. While Hurston remained undeterred, this formal bricolage of vivid descriptions was initially dismissed as lacking the rigor of "real" anthropology. Black women's creative practices have systematically been delegitimized in dominant institutional and organizational contexts—as have their intellectual production and their militant activities, in a litany of omissions without end. The cinematic occasion of *Conspiracy* is not a counter-image to these absences. Rather, it is the documentation of relationalities that always showed up as presence. The film is not orientated toward proving anything to a hostile, condescending gaze: these Black women look at each other and see each other, with a conspiratorial wink that can be felt even if it is not seen.

Leigh and Hunt-Ehrlich's shared aesthetic project, in a manner that enmeshes with Hurston, is an honoring of Black kinship and regeneration. The specific excerpts drawn from *Tell My Horse* address the intergenerational process of preparing a bride for a wedding. The narration describes a sequence of bathing and massaging, using an oil prepared from khuskhus, a Jamaican grass. This context magnifies the procreative capacities of ritual, tied to women's collective labors in childbearing. The montage that accompanies these narrative fragments—showing Leigh vigorously scrubbing her hands with a brush and washcloth in a bowl of murky water—extends this sense of generative potential beyond the biological. There is an erotics to the privileging of touch in *Conspiracy*, in the ways that Audre Lorde used the term to encapsulate creative vitality and tactile pleasure.[1] The visual grammar inherited from *Hands of Inge* is also one that foregrounds embodied knowledge. Sensory tactility is activated in a particular way with sculpture and the proximity between the artist's hands and the material. Touch is method. The art-making and sense-making functions of this practice also manifest a haptic memory that coincides with the film's geographic mobility.

A sense of diasporic Blackness is tracked across Leigh's and Hunt-Ehrlich's respective practices. In *Conspiracy*, Jamaica is evoked with particular importance for the sculptor, as her family's place of origin. Leigh's sculpture *Last Garment* (2022; page 255), which is rendered in living form by the writer and

historian Sharifa Rhodes-Pitts in the film, was based on a stereographic postcard titled *Mammy's Last Garment, Jamaica* (page 145, fig. 2). Captured by the photographer C. H. Graves, this 1879 image shows a Black figure dressed in white knee-deep in a stream of water, bent over a barely visible piece of white fabric being washed. In Leigh's Venice pavilion, the sculptural afterlife of this index of colonial representational violence was placed in a dark reflecting pool, severely bordered in black. Doubled in the reflection, the figure is multiplied in the film when Rhodes-Pitts is shown posing to mimic the figure in the postcard as a basis for the sculpture.

Leigh shaped a material tribute to her friend and collaborator called *Sharifa* (2022; page 272) as her first foray into portraiture. In an echo of one of the most charming sequences in *Hands of Inge*—a series of parallel cuts between Hardison's daughter Yolande and her mother's sculpture of her—two close-ups of *Sharifa*'s face, first in profile and then head-on, are mirrored in *Conspiracy*. This visual repetition is also accompanied by an affective dimension. In *Hands of Inge*, the voice-over notes that no work had given Hardison more "joy and pleasure" than the bust of her daughter. In turn, Yolande Hardison has been caretaking her mother's legacy. A quality shared between Hardison and Leigh is a practice of loose, subversive canonizing—molding clay as an act of witnessing devoted to the intimacies of family and friendship. This speaks to a connection to Camille Billops, another multidisciplinary artist who worked across mediums, including film, sculpture, and archiving. In dialogue with bell hooks in 1996, Billops spoke of writing a book in a way that resonates with Hardison's and Leigh's artistic practices: "Put all your friends in it, everybody you loved, and do a lot of them so one day they will find you and know that you were all here together."[2]

Conspiracy creates a place of gathering. Through its sonic composition, the film assembles a musical and intertextual collage. The first sounds are "Angel Chile," from Jeanne Lee's *Conspiracy* (1975) album, which inspired the film's title. In the song, Lee's avant-garde jazz is expressed through a phonic mosaic of spellbinding vocalizing, staccato breathing, a facsimile of stifled laughter, crescendos of hypnotic wailing, and precisely softened screeching. Lee's intonations are by turns and all at once captivating, agonizing, and lilting, accenting the film's sense of ceremony. The space outside Leigh's studio in Red Hook, Brooklyn, is the site of the cathartic conflagration that closes *Conspiracy*, accompanied by a few last strains of Lee's voice. A statue with a voluminous raffia skirt, which was

1 Audre Lorde, *Uses of the Erotic: The Erotic As Power* (New York: Out & Out Books, 1978).

2 bell hooks, *Reel to Real: Race, Sex, and Class at the Movies* (New York: Routledge, 1996), 147.

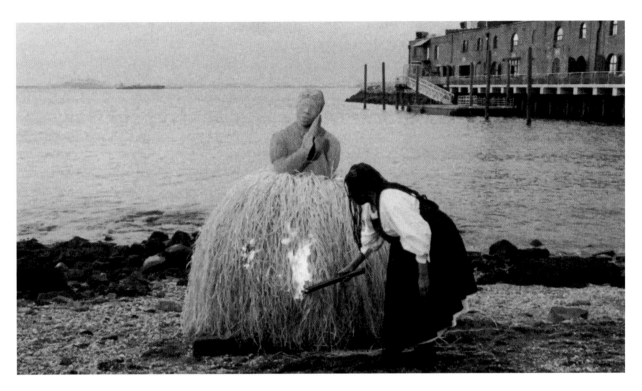

Fig. 2 Simone Leigh and Madeleine Hunt-Ehrlich, *Conspiracy* (still), 2022. 16mm and 8mm film (black-and-white, sound; 24:00 minutes)

shown being assembled earlier in the film, is pushed to the water's edge and set on fire by Leigh (fig. 2). The inspiration behind this symbolic blaze was Vaval, the straw mannequin King of Carnival in Martinique, French Guiana, and Guadeloupe, who is ceremonially set on fire as a catalyst for religious, social, and political regeneration.

Conspiracy is powerfully elemental—carried by earth, threaded with water and air, and ending with fire. Opacity, concealment, and disguise are all dynamic traits of the visual language across Hunt-Ehrlich's filmography, and here they are paired beautifully with insights into Leigh's sculptural practice as part of an ecosystem of collective cultural labor, which precedes the final figures and is never only limited to them. The theatricality of the film's burning finale resists the museum logics of forced, sanitized durability and the relegation of objects to carceral vitrines. Hunt-Ehrlich and Leigh's coauthored enchantment weds its historically layered tribute to Black women's cultural production to an allowance for ephemeral impermanence. There is much to hold on to and preserve, but lighting a fire and letting things burn is not always a loss. The film ends with a clearing for those forms of endurance that are honored by the two artists: intimate socialities across creative expressions and between generations. *Conspiracy* is a linking of Black women through inspiration, mentorship, and friendship. Intermingling artistic labors and collective histories, Leigh and Hunt-Ehrlich's shared composition is a tribute to the vitality of regenerative arson as a torch passed between Black women.

An earlier version of this text appeared in "Fire Blossoms: A Dossier by Yasmina Price," *Three Fold*, no. 7 (Summer 2022).

pages 88–89
Liz Magic Laser and Simone Leigh, in collaboration with Alicia Hall Moran
Breakdown (still), 2011
Single-channel video (color, sound; 9:00 minutes)

pages 90–91
Installation view, *In-Between Days: Video from the Guggenheim Collection*,
as part of the exhibition program *Re/Projections: Video, Film, and
Performance for the Rotunda,* Solomon R. Guggenheim Museum, New York,
March 2021

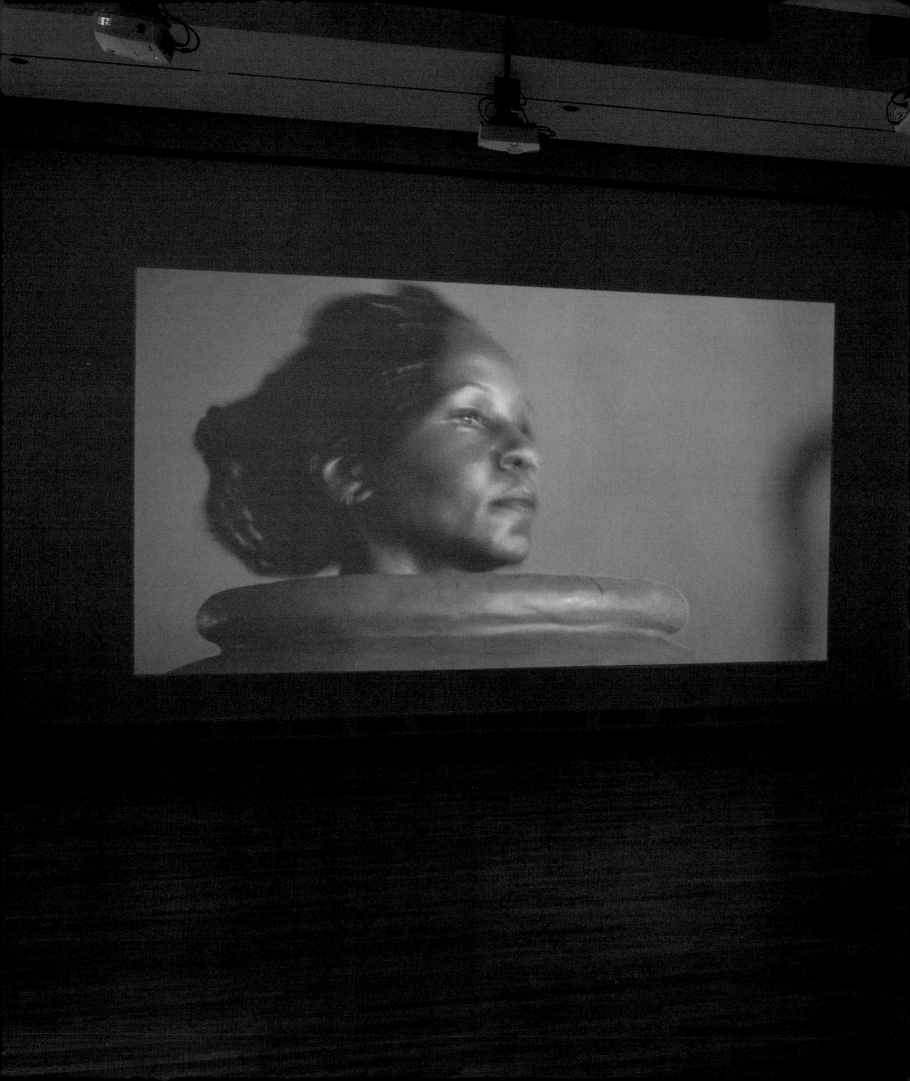

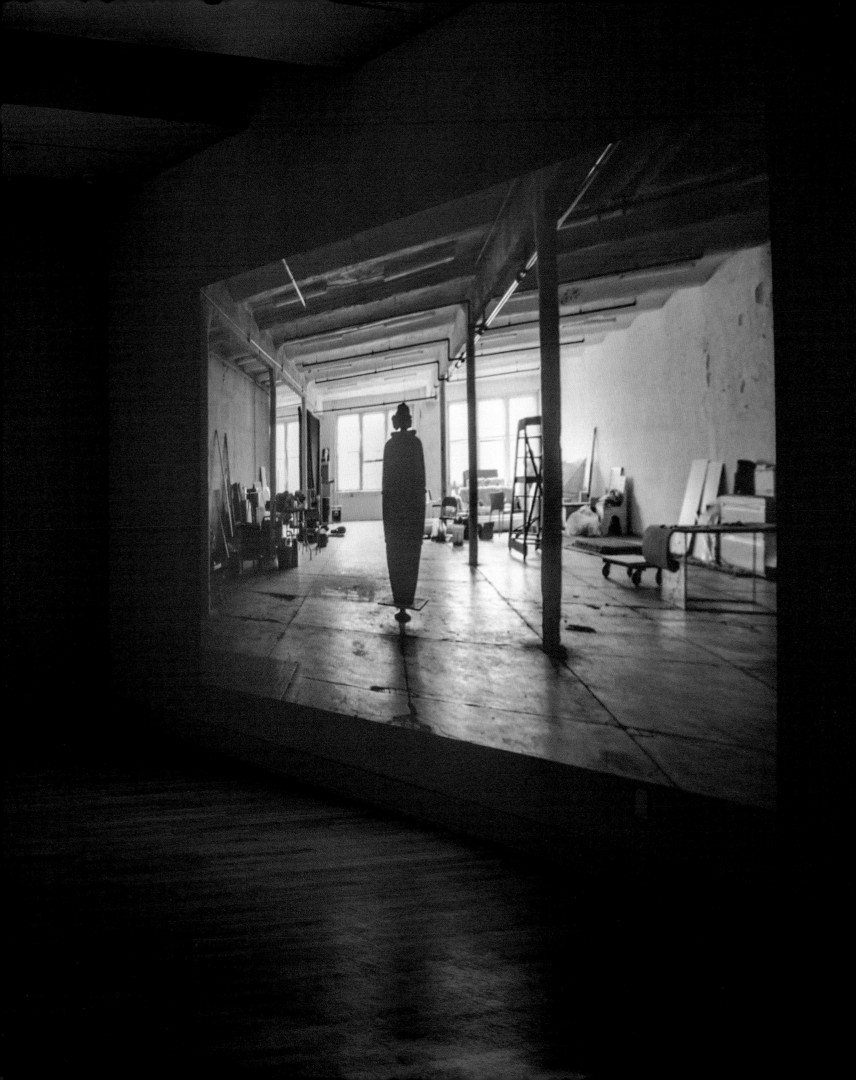

pages 92–93
Girl (Chitra Ganesh + Simone Leigh)
my dreams, my works, must wait 'til after hell . . . (still), 2011
Single-channel video (color, sound; 7:14 minutes)

pages 94–95
Installation view, *Gone South*,
Atlanta Contemporary Art Center, 2014

pages 96–97
Waiting, 2016
Three-channel video installation with objects
(color, sound; 3:08 minutes)

pages 98–99
*Untitled (M*A*S*H)* (still), 2018–19
16mm film (color, sound; 11:03 minutes)

101

Vanessa Agard-Jones

Clay's Memory

Fig. 1 Simone Leigh Studio, 2021

In the face of disastrous, world-reorienting flooding—of climates changing, waters rising, and worlds unmade—Toni Morrison offered us one reframe, observing that "all water has a perfect memory and is forever trying to get back to where it was." Rather than wrapping water's return in eternal lament or indulging in apocalyptic critique, she instead drew a parallel linking flooding's catastrophic presence to writers and artists, who, in her words, "[remember] where we were, that valley we ran through, what the banks were like, the light that was there and the route back to our original place."[1]

Simone Leigh remembers where we were. And clay has memory too.

Unfurling that memory through her own embodied, emplaced praxis, Leigh, to be clear, is not preoccupied with memory's perfection, nor with a narrow conception of origin—far from it. Instead she plumbs diasporic pasts (imperfectly recalled, imperfectly rendered) to both diagnose and project us beyond our present, to a time we are only scarcely able to apprehend. Her work transports us to a time of postcolonial and postplantation possibility—not the foreclosed futures that occupy so much of our contemporary politics, but the ones once and remaining on our horizons. There's a lot of talk about geological time these days—about how our apparatuses for thinking about the past, for imagining our futures, are irremediably shaped by the tectonic shifts of the planet that we inhabit. By what many call the Anthropocene. Leigh too is in this world of deep time, invoking and evoking both the earthly and the political histories of our world.

Clay is the substrate, the central material of Leigh's art-making. It is the elemental medium that makes her transcendent art not only possible but thinkable. Clay is her tool for returning us to the valleys and riverbanks that are themselves the sites of this material's making—to its glistening in late afternoon light, illuminating the routes and roots of its instantiation.[2] Walking into her studio to see her works in process at day's end, with the golden rays reflected off Brooklyn's East River, I am knocked off-kilter—dizzied by their presence, the sheer volume of clay in the room, the inscription of Leigh's labor, the heat of the kiln, the reams upon reams of research pinned to the walls, the transformation of Leigh's mind-work to form (fig. 1). Raffia, bronze, celluloid, and ash abound in her studio's material constellation, each one imbued with its own history of appearance, use, texture, and relation in Black diasporic worlds—but clay remains at the heart of things. Leigh calls upon us to reflect not only on its pliability but also on its ability to mold us in turn.

Clay—differentiated by its unique mix of minerals, including illite, kaolinite, chlorite, sepiolite, smectite, and bentonite—offers a map of its own making. Each amalgam bears the inscriptions of the land from which it came, of the collisions that made it manifest, and of the social worlds that made it a commodity. Clay remembers from whence it came. It is from whence it came. Like sand, clay is an earthly expression of emplacement.[3] For these reasons, clay too has a kind of perfect memory.

Born of the elemental alchemy of rock touching water and that rock touching air, clay embodies Leigh's insistence upon remembrance, an evocative parallel to her primary work methodology: citation. Pause with each of her works; look for the lineage. Leigh's citations here are at once intimate and expansive, but always simultaneously at the macroscale of African diasporic cultural forms and at the microscale of Leigh's own life's milieu. She cites both "her people" writ large and *her people*—those who are proximate, dearly held. Hers is a habit of mind, an analytical practice, derived from Black feminist ways of looking, making, reading, relating, and being—a critical demeanor that takes the substrates of the world alongside the substrates of our lives as the grounds from which we apprehend what is and dream of what might be.[4] Leigh has consistently upended colonial traditions of knowledge production in Africa and its diasporas, plumbing instead the trajectories made possible by autoethnographic dwellings.[5] And that she has done so through ceramics, often devalued as a mere domestic or decorative art, is one crucial dimension of the memory-work on display in Leigh's forms.

Clay has memory too.

1 Toni Morrison, "The Site of Memory," in *Inventing the Truth: The Art and Craft of Memoir*, ed. William Zinsser (Boston: Houghton Mifflin, 1995), 99.

2 On roots/routes, see particularly Paul Gilroy's analysis of Martin Delany's novel *Blake; Or, The Huts of America* (1859), in *The Black Atlantic: Modernity and Double Consciousness* (Cambridge, MA: Harvard University Press, 1995), chap. 1.

3 On sand's memory, see Vanessa Agard-Jones, "What the Sands Remember," *GLQ: A Journal of Lesbian and Gay Studies* 18, no. 2–3 (2012): 325–46.

4 On "critical demeanor," see Ann duCille, "The Occult of True Black Womanhood: Critical Demeanor and Black Feminist Studies," *Signs: Journal of Women in Culture and Society* 19, no. 3 (Spring 1994): 591–629.

5 One articulation of Leigh's autoethnographic vision can be found in Simone Leigh, "Everyone Wants to Be Subaltern," *Brooklyn Rail*, February 2013, https://brooklynrail.org/2013/02/artseen/everyone-wants-to-be-subaltern.

Sequoia Miller

The Ceramics of Simone Leigh

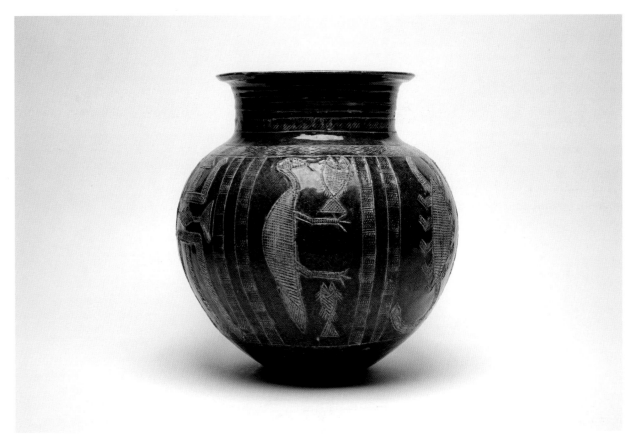

Fig. 1 Ladi Kwali, *Untitled*, 1963. Stoneware. 14 1/8 × 14 inches
(35.9 × 35.5 cm) (height × diameter). George R. Gardiner Museum of
Ceramic Art, Toronto, Gift of Michael and Mary Mason

Conspiracy (2022), a film by Simone Leigh and Madeleine Hunt-Ehrlich, shows the artist and her assistants at work in her ceramic studio—building a vessel, lighting a kiln, hoisting one of the artist's monumental sculptures. Even as *Conspiracy* makes clear that ceramics and labor are at the center of Leigh's practice, the film ends with the burning in effigy of a paper and raffia figure, which was also rendered in ceramic in the sculpture *Anonymous* (2022; page 259). The implication is that ceramics is not the end in itself for Leigh, but rather a means to an end. Leigh's work, I propose, engages the symbolic register of ceramics as both a material and a formal language through its specific histories. Clay's embedded meanings become instruments for Leigh to resist Western structures of fine art while applying pressure to broader questions related to race, power, and the limits of Enlightenment humanism.

Ceramics has had an unstable status as an artistic medium since fine art became a category of European cultural production during the Italian Renaissance. Associated with utility, the manual arts, and brute matter, the medium had long been relegated to the margins of art history as an applied or decorative art form. Although ceramics has had a "secret history" as sculpture, it gained a degree of currency only in the post–World War II period when Peter Voulkos, Toshiko Takaezu, and others began making large, abstract works in clay.[1] Yet audiences, institutions, and discourse around this work grew alongside contemporary art rather than within it, emerging under the rubric of studio craft or studio ceramics.[2] In recent years, however, ceramics has transformed into a vital medium for contemporary art as its deep cultural resonances have become sources of power and meaning rather than hindrances. For Leigh, the clay itself materializes labor and place, while the forms of ceramic vessels evoke both the female body and the traditions out of which pots emerge. We see this most clearly in Leigh's work related to West African water jars and to ceramic face jugs made by enslaved and freed Black potters in the American South.

Water Jars

The water jar form has recurred in Leigh's work as an emblem of women's bodies, labor, and cultural knowledge. Water jars vary over geography and time but are typically round, generous forms with a narrow neck and not too large to be carried when full. They are often made by women in a given family or village, using common, locally dug clay fired in open-air pits and designed for local use. The jars emerge out of quotidian materials and woman-centered knowledge and kinship systems, while also evoking the body as a fertile, life-sustaining vessel. Leigh says, "For ten years, I was obsessed with these water pots. It was a kind of perfect form, and it was something women had been making all over the world for centuries, this anonymous labor of women."[3] The form emerges in Leigh's early works such as *Untitled* (2006), from the Hottentot Venus series, with its rounded base, swelling belly, and narrow neck. Leigh exaggerates and literalizes the connection to fertility and the female body by covering it in breast-like forms and referencing, in the series title, Sarah Baartman, a Khoikhoi woman brought from present-day South Africa to Europe as a sexualized curiosity in the early nineteenth century. Leigh thus brings the water jar into conversation with colonialism, racism, and the distortions they engender, particularly with regard to Black women, while also emphasizing it as a carrier of embodied, female knowledge.

The water jar was also central to the practice of Ladi Kwali, an internationally celebrated Nigerian potter of the mid-twentieth century who, like Leigh, explored subjectivity through materials, form, and tradition. Kwali was from the Gwari (Gbagyi) region of central Nigeria and had learned pottery-making within her matrilineal line. In 1954 she joined Abuja Pottery, a colonial British project led by the Oxford-educated potter Michael Cardew, soon becoming a star potter and traveling with Cardew to Europe and North America to exhibit and lead workshops. Kwali is perhaps best known for her water jars combining traditional Gwari construction, form, and surface ornament with European-style materials and firing (fig. 1).[4]

1 For more on ceramics within mainstream Western sculpture, see Simon Groom and Edmund De Waal, *A Secret History of Clay: From Gauguin to Gormley* (Liverpool: Tate, 2004); for more on post–World War II ceramics, see Jeannine J. Falino, ed., *Crafting Modernism: Midcentury American Art and Design* (New York: Abrams, in association with MAD/Museum of Arts and Design, 2011).

2 For more on studio ceramics, see Martha Drexler Lynn, *American Studio Ceramics: Innovation and Identity, 1940 to 1979* (New Haven, CT: Yale University Press, 2015); for more on studio craft, see Janet Koplos and Bruce Metcalf, *Makers: A History of American Studio Craft* (Chapel Hill: University of North Carolina Press, 2010); for more on intersections of studio ceramics and contemporary art, see Sequoia Miller, *The Ceramic Presence in Modern Art: Selections from the Linda Leonard Schlenger Collection and the Yale University Art Gallery* (New Haven, CT: Yale University Art Gallery, 2015).

3 Leigh quoted in Calvin Tomkins, "The Monumental Success of Simone Leigh," *New Yorker*, March 28, 2022, https://www.newyorker.com/magazine /2022/03/28/the-monumental-success-of-simone-leigh.

4 For more on Kwali, Cardew, and the Abuja Pottery Training Centre, see Tanya Harrod, *The Last Sane Man: Michael Cardew—Modern Pots, Colonialism and the Counterculture* (New Haven, CT: Yale University Press, 2012); for more on Kwali's influence, see Jareh Das, *Body, Vessel, Clay: Black Women, Ceramics & Contemporary Art* (London: Two Temple Place, 2022).

Kwali's use of glazed stoneware, a technology introduced to the area by Cardew, reframed her practice within a colonial context, while leveraging her access to much broader, and largely white, audiences. Made in stoneware, Kwali's water pots became impractical for use and were therefore able to circulate as sculpture rather than pottery. Her incised surfaces were in the Gwari style yet sometimes incorporated unusual imagery such as airplanes, increasing the sense of individual authorship and artistry over traditional practice, which becomes designated "anonymous" in the colonial context. Performing her ceramics through demonstrations and workshop tours only enhanced her visibility, allowing her to claim space, express her artistry, and adapt her matrilineal training to the diaspora.

While Leigh's early exposure to water jars stoked an obsession with the form, Kwali's work serves as a model of a different order. Leigh was inspired by Kwali early on, and the two share a lineage, having both learned from apprentices of Bernard Leach, the leading advocate for Asian-influenced studio pottery in the early and mid-twentieth-century Anglophone world.[5] Kwali participated in colonial and institutional structures, particularly as a public figure, yet her work can also be seen as a loophole—a space of self-examination and care on her own terms. She realigned the meanings of her material, formal language, and historical tradition, while building on the language of the ceramic vessel. The jar form in Leigh's work, from the Hottentot Venus series to *Crop Rotation* (2012; pages 56–57) and *Cupboard IX* (2019; page 158), similarly reshapes tradition to a set of meanings that rely on the symbolic resonance of the ceramic water jar while expanding upon them.

Face Jugs

If Leigh's water jars suggest reparation of Black matrilineal lineage and the flexibility of tradition, a second historical jar form illuminates the artist's use of the deep symbolic register of ceramics that is specifically resonant with her exploration of Black female subjectivity. Two large-scale ceramic works of 2022, *Anonymous* and *Jug* (pages 260–61), along with the film *Conspiracy*, reference both a particular historical photograph (page 327, fig. 5) and the ceramic tradition embedded within it.

The photograph is a racist satirical image showing a young Black woman sitting at a desk admiring a sunflower in a ceramic jar of an unusual type called a face jug (fig. 2). Found in the Edgefield district of South Carolina in the mid- to late nineteenth century, these jugs were made by enslaved and later freed African American potters for use within the Black community.[6] Face jugs are distinguished by applied clay features on the outside of a modest stoneware jar. The faces are typically asymmetrical and exaggerated, with unglazed white clay teeth and eyes that contrast with the darker, glossy vessel. Scholars attribute authorship of the jugs to Black potters in the area, linking them stylistically to power figures created in central Africa, the origin of many of the Black inhabitants of the region, and suggesting a spiritual or religious purpose.[7] The jugs, then, are the material representation of an African tradition transplanted directly to the American South, embodying continuity, adaptation, ingenuity, and survival.

Leigh reimagines elements of the racist historical image within the language of her monumental ceramics. In *Anonymous*, the figure reappears at more than life size, with a vessel or cupboard-like skirt glazed in a mournful white. The upper torso is rendered naturalistically, approaching the status of portraiture. In *Jug*, also white and nearly as large, the face has been reorganized into an array of cowrie shells. Becoming less literal, the jug embodies a kind of figuration in its overall shape and in the cowrie forms that together evoke the human at a more elemental register. *Jug* becomes a "no face," a recurring theme in Leigh's art, and a representation of African diasporic traditions, imagery, and identity, while remaining not fully accessible. *Anonymous* and *Jug* have opposing trajectories of visibility: one edging toward portraiture and the other toward abstraction.

5 Kwali worked with Cardew, Leach's first and most famous apprentice. Leigh learned ceramics from Michael Theideman, also a Leach apprentice, at Earlham College in the early 1990s; see Anderson Ranch Arts Center, "Summer Series Conversation: Simone Leigh," July 15, 2021, https://youtu.be/k3e9-SKH2Co). For Kwali's influence on Leigh, email to author, September 2017. On Leach, see Emmanuel Cooper, *Bernard Leach: Life and Work* (New Haven, CT: Yale University Press, 2003); for a critical view on Leach as an orientalist, see Edmund De Waal, *Bernard Leach* (London: Tate Gallery, 1998).

6 See Adrienne Spinozzi, ed., *Hear Me Now: The Black Potters of Old Edgefield, South Carolina* (New York: Metropolitan Museum of Art, 2022); and Claudia Arzeno Mooney, April L. Hynes, and Mark M. Newell, "African-American Face Vessels:

History and Ritual in 19th-Century Edgefield," *Ceramics in America* (2013), https://chipstone.org/article.php/537/Ceramics-in-America-2013/African-American-Face-Vessels:-History-and-Ritual-in-19th-Century-Edgefield.

7 Unlike most communities in the United States, many African Americans in the area could trace their lineage to the *Wanderer*, one of the last documented vessels to bring enslaved people illegally from Africa to the United States. See Erik Calonius, *The Wanderer: The Last American Slave Ship and the Conspiracy That Set Its Sails* (New York: St. Martin's Press, 2006).

Fig. 2 Unrecorded Edgefield District potter, *Face Vessel*, 1850–80.
Alkaline-glazed stoneware with kaolin. 10 1/4 inches (26 cm) (height).
Metropolitan Museum of Art, New York, Purchase, Nancy Dunn
Revocable Trust Gift, 2017

These works are rife with symbolic meanings deeply held within clay. It is the very stuff out of which life emerges, the primordial preconscious earth; the vessel symbolizes the human body with neck, shoulders, lips, and feet; ceramic containers serve as a metonym for sustenance and survival; the endurance of the ceramic shard speaks to how we humans have long walked on the earth. These and other persistent, almost sticky associations have hindered clay's exploration as a medium for sculpture in the Western tradition. Rather than enabling an autonomous aesthetic experience, as idealized by the Enlightenment philosopher Immanuel Kant as the basis for art, clay retains a conspicuously earthbound presence.[8] Similarly, where modernism emphasizes how form reads in space, clay is insistently present as a material, intervening in that encounter. *Anonymous* and *Jug* exploit this persistence of ceramics, relying and expanding on the deep register of meaning to become more layered works of art.

In Leigh's hands, this at once symbolic and material register of ceramics becomes a way to apply pressure to how we understand being human. The system of racial capitalism that first developed during the European Enlightenment denied full humanity to people of African descent, not just pragmatically and legally but also conceptually. More recently, writers within the framework of Afropessimism have asserted that the "social death" experienced by people enslaved in the past continues into the present; other writers allow for greater latitude while exploring the how constructions of Blackness work against according full, complex personhood to people of African descent.[9] In relation to Leigh's work, ceramics is useful because its symbolic register predates Western structures and codes of fine art, whose hierarchies developed in tandem with colonialism and definitions of race.

While Leigh's ceramic work operates clearly as sculpture, at the same time it resists the ways that sculpture has functioned in that history. It does this by attending to the materiality of ceramics through its sheer physical presence at monumental scale; the repeated iteration of vessels-as-bodies; and the specific invocation of traditions, histories, and idioms from Africa and the African diaspora like Gwari water jars and Edgefield face jugs. Leigh's ceramic practice invokes a symbolic order that predates the circumscription of Blackness by Western political and aesthetic philosophy. Her materials, sources, and references address conceptions of humanity and subjectivity that are far more holistic and inclusive, proposing an understanding of ourselves outside of the legacies of colonialism and racism.

Leigh's language of ceramics extends well beyond the examples cited here. Yet each work, regardless of scale, technique, material, or allusion, resists inherited ideas about sculpture and the scope of human experience. A recent work from 2022, titled *Sphinx*, points toward an expanding formal vocabulary that pushes further toward the limits of the human (page 279). As a mythical beast with a person's head and a lion's body, the sphinx can represent blurred boundaries between human and animal worlds. Its notorious silence, rendered in this work through the absence of eyes and mouth, as in many of Leigh's figures, also evokes the strength born of restraint and a refusal to divulge. As earth, vessel, and ancient tradition, ceramics continues to inspire us in Simone Leigh's hands.

8 Immanuel Kant's *Critique of Judgement*, first published in 1790, laid the theoretical foundation for visual art in the West as an aesthetic experience of an assumed neutral disinterestedness, outside of the parameters of daily life and materiality. For recent commentary, see Michel Chaouli, *Thinking with Kant's "Critique of Judgment"* (Cambridge, MA: Harvard University Press, 2017).

9 On the concept of social death, see Orlando Patterson, *Slavery and Social Death: A Comparative Study* (Cambridge, MA: Harvard University Press, 1982). On Afropessimism, see Frank B. Wilderson III, *Afropessimism* (New York: Liveright Publishing Corporation, 2020). For more on the exclusion of Black women and, in particular, mothers, see Hortense J. Spillers, "Mama's Baby, Papa's Maybe: An American Grammar Book," *Diacritics* 17, no. 2 (Summer 1987): 64–81. For more on the status of Blackness within Western structures of humanism, see Fred Moten, *Black and Blur* (Durham, NC: Duke University Press, 2017); and Calvin L. Warren, *Ontological Terror: Blackness, Nihilism, and Emancipation* (Durham, NC: Duke University Press, 2018).

Rianna Jade Parker

Women in the Yard:
The Legacy of Afro-Jamaican Ceramics

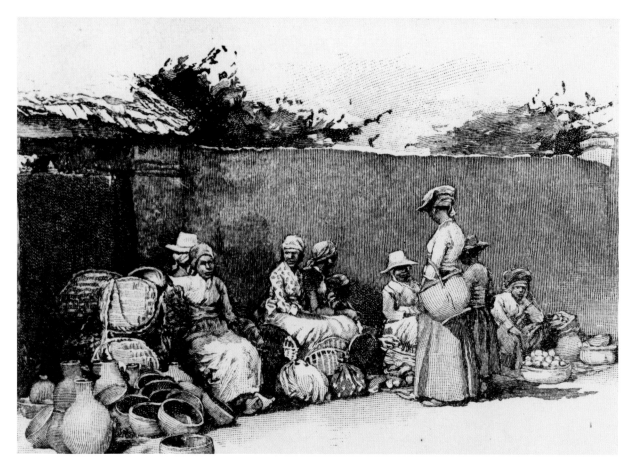

Fig. 1 "Women with pots, bowls, and jars on display," date
unknown. National Library of Jamaica Digital Collections

The expansive practice of Simone Leigh, born in Chicago to two middle-class Jamaican immigrants, connects to cultural and historical contexts of ceramic production across the Caribbean, where earthenware is a clear manifestation of syncretic adaptations, habitual repetition, and practical and oral testimony.

Traditional pottery communities in the Caribbean (both before and after permissible emancipation) are uniquely successful examples of locally made craft entrepreneurship that contributed substantially to the formal economic and informal social viability of the region through the manufacture of an essential commodity. By the eighteenth century, the Caribbean colonies relied on overlapping economic networks to feed themselves, furnish their households, and accumulate material possessions. During "free time," Afro-Jamaicans cultivated small plots on plantations to grow root crops and produced crafts for consumption by townspeople, planters, and overseers. A legal trade system was established through Sunday markets that permitted enslaved laborers to facilitate internal and external economic networks. Skilled, adept, and resourceful, Black women by the mid-nineteenth century were the chief pottery makers and sellers in these markets (fig. 1). These ceramics were used by Afro-Jamaicans, made by Afro-Jamaicans, and most notably sold in the internal markets of Jamaica, adding a new structure and dignity to their lives under enslavement and in the early emancipation era.

Inaccurate appraisals of Afro-Jamaican womanhood assume that their predominance in the household made the Black woman a matriarch and therefore the Black Caribbean family "matrifocal"; disproportionate responsibility is misread as authority. With *Last Garment* (2022; page 255), Leigh has reconstructed the Black Caribbean woman's likeness and subjectivity, in part as a counteraction to a photograph produced in 1879 Jamaica by the American photographer C. H. Graves, which he disparagingly titled *Mammy's Last Garment, Jamaica* (page 145, fig. 2). Graves's depiction of the feminized domestic worker circulated widely as postcards, delineating the British West Indies' new native populations as religiously clean and disciplined and therefore unthreatening, making Jamaica a worthy tropical destination for colonial expeditions. Leigh's room-consuming and larger-than-life-size bronze laundress is bent over at the hip and her feet and ankles are submerged in a black reflecting pool in which she watches you watching her.

The Antiguan writer Jamaica Kincaid commemorated some version of this life in her short prose piece "Girl," first published in 1978:

Wash the white clothes on Monday and put them on the stone heap; wash the color clothes on Tuesday and put them on the clothesline to dry; don't walk barehead in the hot sun; cook pumpkin fritters in very hot sweet oil; soak your little cloths right after you take them off; when buying cotton to make yourself a nice blouse, be sure that it doesn't have gum in it, because that way it won't hold up well after a wash; soak salt fish overnight before you cook it.

Kincaid, in the voice of the archetypal Caribbean mother, continues:

This is how you iron your father's khaki pants so that they don't have a crease; this is how you grow okra—far from the house, because okra tree harbors red ants; when you are growing dasheen, make sure it gets plenty of water or else it makes your throat itch when you are eating it; this is how you sweep a corner; this is how you sweep a whole house; this is how you sweep a yard; this is how you smile to someone you don't like too much; this is how you smile to someone you don't like at all.[1]

I imagine that Louisa "Ma Lou" Jones, born in 1913 in Jamaica as a twin and into a family of twenty, started her day like most women of her generation, moving in tandem with the rising Caribbean sun and in service to others, mostly with pleasure and pride. Forcibly domesticated in early childhood, she too bore the generational responsibility of keeping given and found families co-operative, all while transferring cultural beliefs and practices as a defense against apathy and despair. Encumbered by the facts of underdevelopment and deep poverty in the legacy of British slavery and colonialism, Ma Lou received little formal education. But under the tutelage of her grandmother, mother, and aunts, by the age of thirteen she had full-time employment as a potter.

Later married, Ma Lou had several children of her own, three of whom became her studio assistants. But only one daughter, Marlene "Munchie" Roden, took up the art form professionally, continuing the family enterprise. The system and processes used to pass down this technical knowledge are inherently complex and social. The cultural knowledge is synchronically explicit and implicit, gained through a learning style based on observation and absorption, where the routine of

1 Jamaica Kincaid, "Girl," *New Yorker*, June 26, 1978, https://www.newyorker.com/magazine/1978/06/26/girl.

craft production is punctuated by filial reverence and fondness between the women in the yard. "The less 'important' objects in African art are ones that enter the domestic sphere and are changed by daily or ritual use, by care and love," Leigh has said. "They bring me back into the realm of women's labor."[2]

Ma Lou's pottery was of the low-fired variety (fig. 2)—fired at less than 900 degrees Fahrenheit and using a large amount of sand that opens up the clay structure and allows moisture to escape, making the pots ideal for cooking. She produced mostly yabbas, a type of coarse, low-fired earthenware with a large orifice and direct rim that is representative of the independent production of the enslaved Caribbean women.[3] After obtaining and processing the clay, creating the forms, and drying them, Ma Lou fired them, following a technique practiced among the Akan peoples of West Africa, in an open fire made with palm fronds stacked on top of dry cow manure and lit with hot coals. She would then eventually cart the wares to Kingston, stacking them for sale at a place called Mullings Grass Yard on the Spanish Town Road alongside those of her contemporaries. She made cooking pots, coal stoves, cooling jars, and yabbas at 5 Job Lane until her passing in 1992.[4] Her signature coiled pots were smoothed with a piece of wood and evened with a scraper (similar pots were recovered from seventeenth-century contexts in the sunken pirate city of Port Royal in the southeast coast of Jamaica). And as her maker's mark, Ma Lou impressed four shallow and circular shapes in a horizontal line on the pot shoulder, two inches below the rim. Her daughter Munchie imprinted five dimples.

The closing years of the 1940s brought an influx of imported aluminum kitchenware to Jamaica, notably a type known colloquially as the "dutchie" pot, which quickly replaced the yabba and almost amputated the local pottery scene. During a three-year hiatus between 1954 and 1957, Ma Lou committed to a more reliable source of employment for a Black woman in colonial Jamaica, as an auxiliary worker. After experiencing a mystical vision, she returned to ceramics, and further supplemented her income with sales through small-scale agriculture. Eventually becoming a celebrated embodiment of Jamaica's art and heritage, Ma Lou remains the only other artist of her time mentioned in the same breath as Cecil Baugh, Jamaica's most praised potter and founder of the ceramics department at the former Jamaica School of Art (now Edna Manley College of the Visual and Performing Arts).

But even as her ceramics became more popular as fine art to be displayed as decorative dressing in homes and offices, Ma Lou still stressed that the yabbas had multiple functions and were essentially made to be used, including to cook stews, rice, and fried foods. At the Miami Ceramics League in the 1960s, she led a demonstration that culminated in her showing the students how to prepare traditional Jamaican dishes—ackee and salt fish, plantains and boiled yams—in the same objects they made, using no modern tools such as thermometers and measuring cups.[5]

The rooted Caribbean potter has mostly been rendered invisible to the eyes of cultural historians. But in *Jamaican Ceramics: A Historical and Contemporary Survey*, the Jamaican ceramist and historian Norma Rodney Harrack sweetly memorializes her experiences with Ma Lou: "I had the opportunity to make her acquaintance whilst I was a student at art school. . . . I would engage her in conversation while at the same time observe her making yabba pots using perhaps the most direct, sensitive and intuitive approach."[6]

In one fabricated scenario, Simone Leigh too would have sat in ancestral company in Ma Lou's yard talking with other Afro-Jamaican women about function, aesthetics, and history. Leigh, like other Black women ceramists, cannot help but be aware of the dichotomies within her own narratives and style in order to achieve an artistic equilibrium between the economy and personal expression. She combines the practical with the emotional, discovery with actualization, all essential to spiritual significance and her integrity. Leigh's artistic practice is in part a testimonial triumph of transcultural memory and adaptivity. This diasporic cultural conservation is a framework for the spirit and practice of resistance, which favors the core purpose of the ceramic venture: to mediate the health and sustenance of human society.

2 Leigh in Siddhartha Mitter, "Simone Leigh, in the World," *New York Times*, April 14, 2022, https://www.nytimes.com/2022/04/14/arts/design/simone-leigh-venice-biennale-us-pavilion.html.

3 "Yabba" is believed to be derived from either the Twi word *ayawa*, meaning "earthenware dish," or a local Arawak word for "big mouth," referencing the form rather than the function or decoration of the object.

4 Roderick Ebanks, "Ma Lou and the Afro-Jamaican Pottery Tradition," *Jamaica Journal* 17, no. 3 (August–October 1984): 31–37.

5 Paul Heidelberg, "Father of Pottery in Jamaica Brings His Style to Broward," *South Florida Sun-Sentinel*, March 19, 1988.

6 Norma Rodney Harrack, *Jamaican Ceramics: A Historical and Contemporary Survey* (Kingston, JM: University of the West Indies Press, 2022), 70.

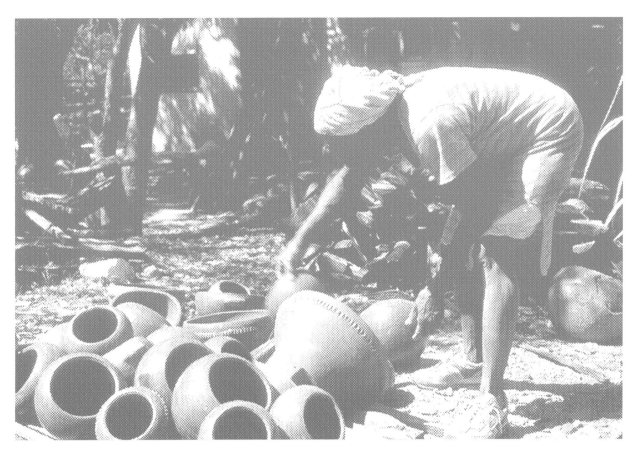

Fig. 2 Jamaican potter Ma Lou, ca. 1980s

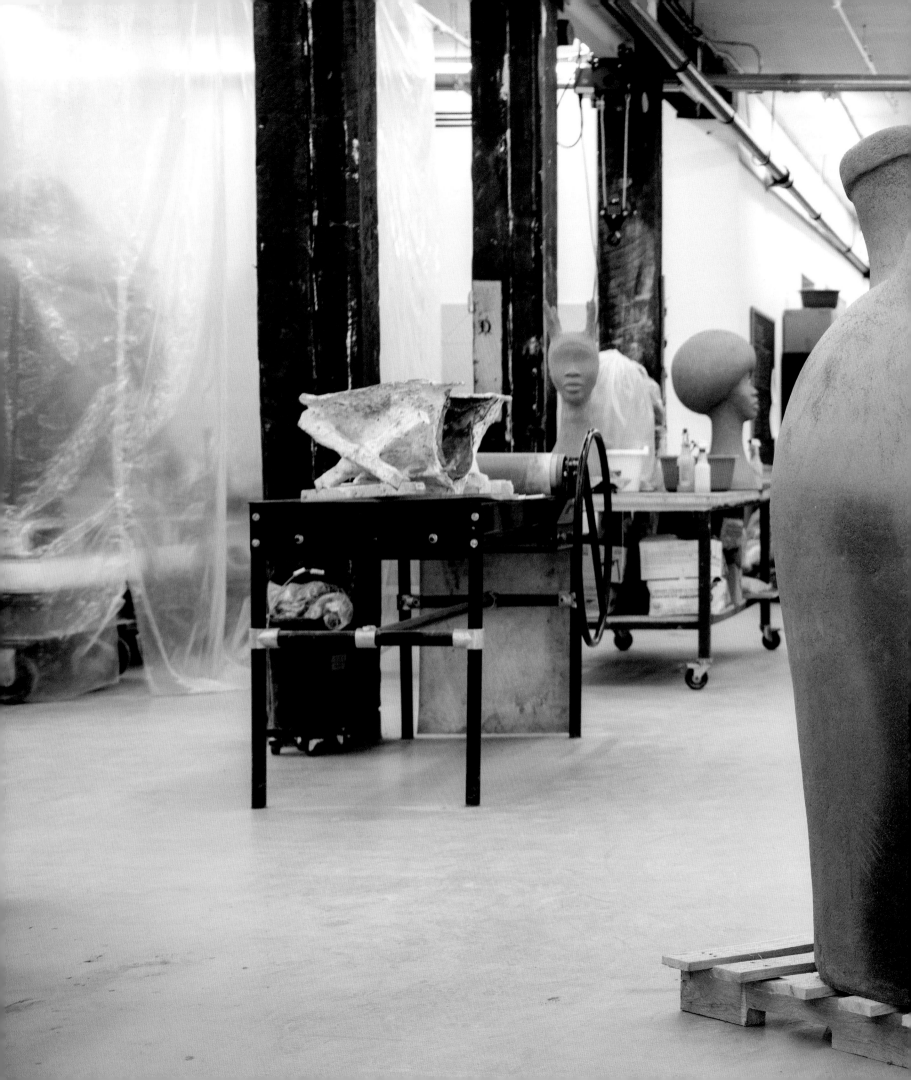

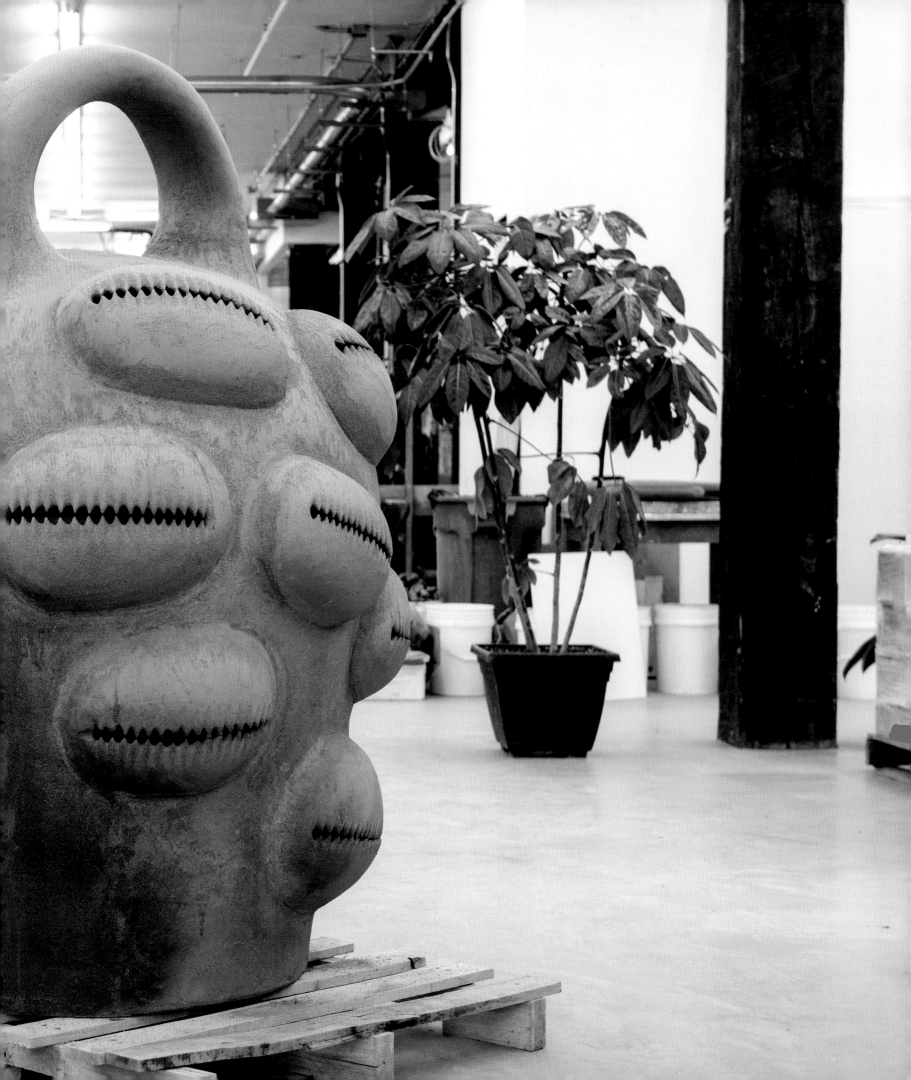

pages 120 and 121 (detail)
Overburdened with Significance, 2011
Porcelain, terracotta, and graphite
22 × 8 × 14 inches (55.9 × 20.3 × 25.6 cm)

facing
Jug, 2014
Unfired Lizella clay
24 × 18 × 18 inches (61 × 45.7 × 45.7 cm)

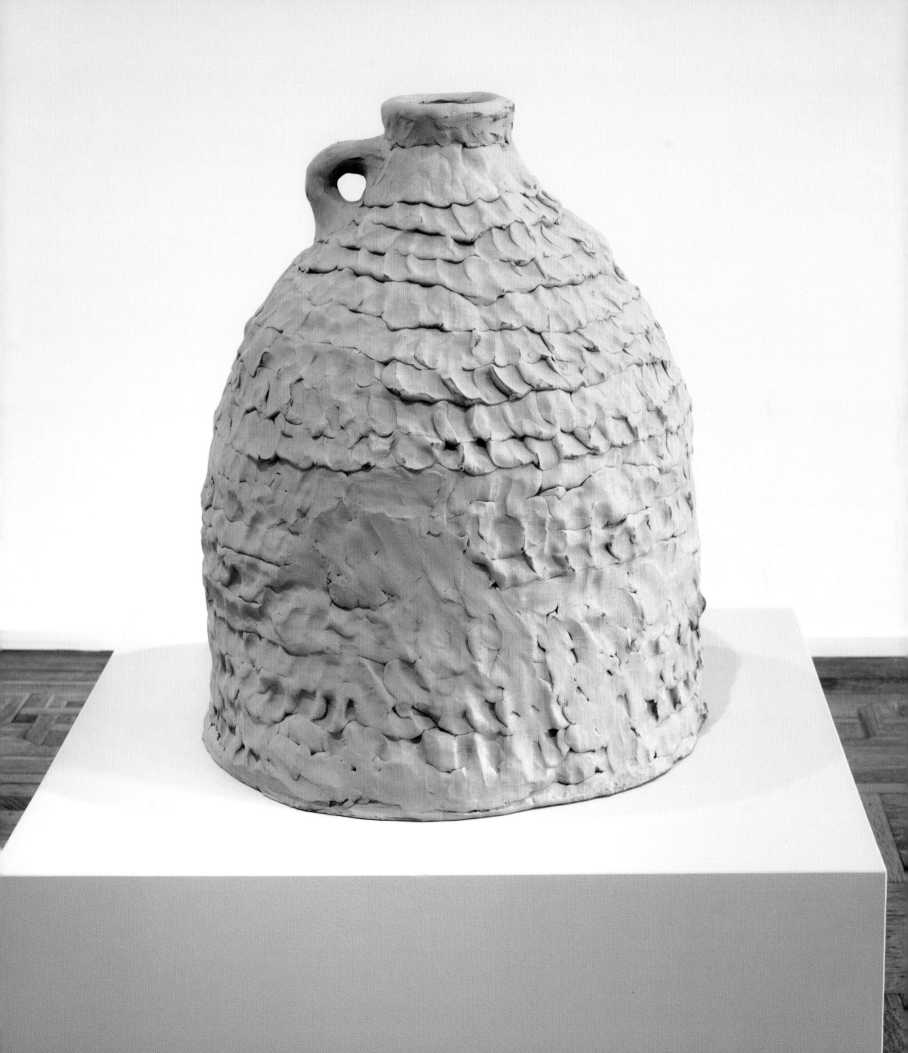

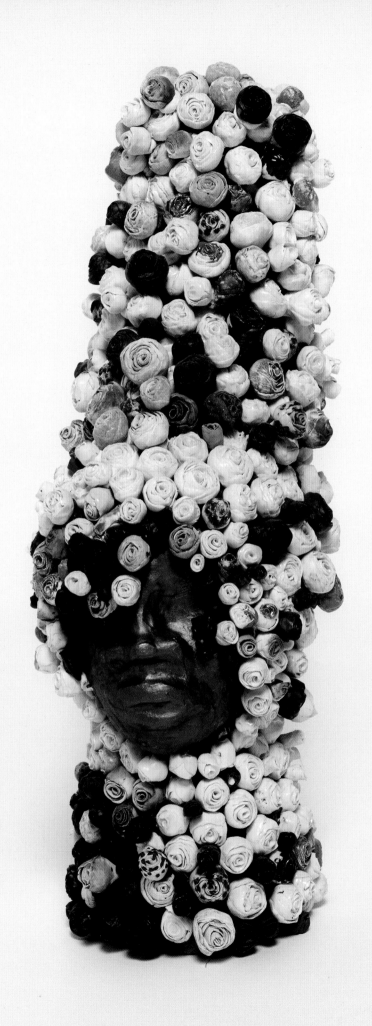

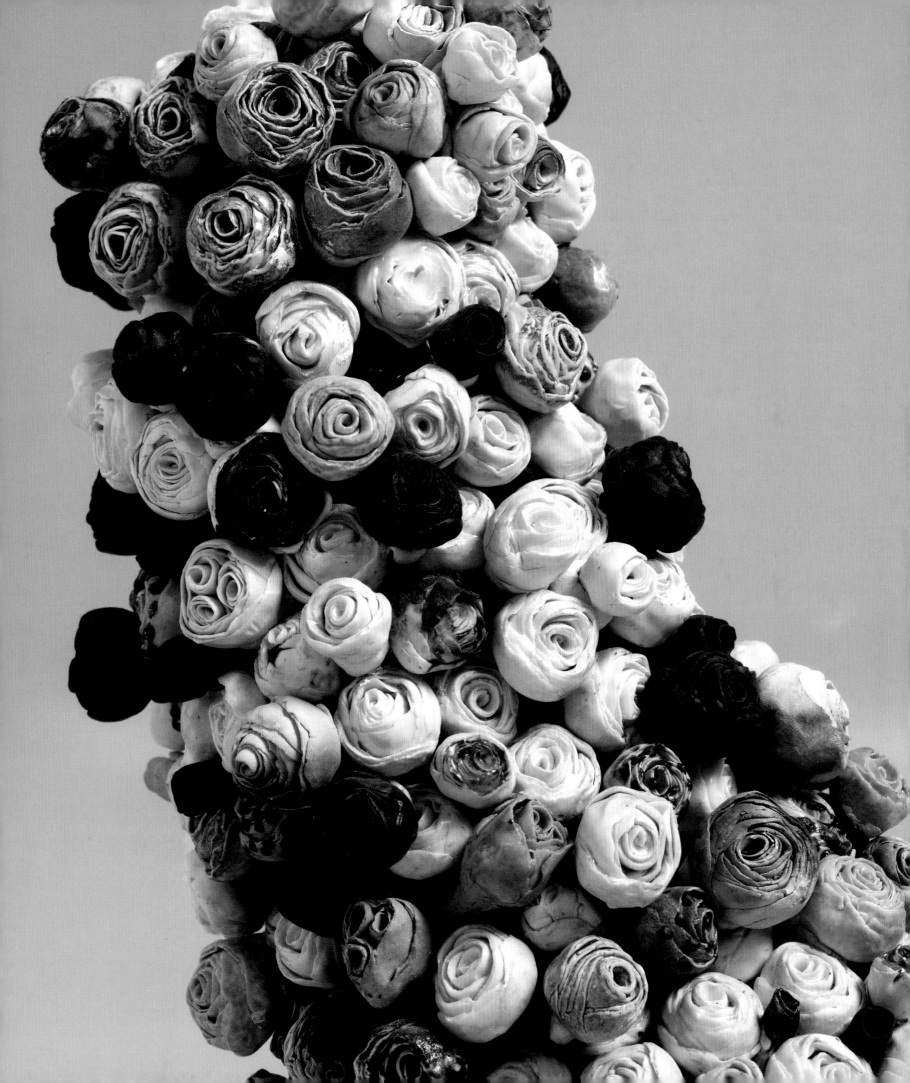

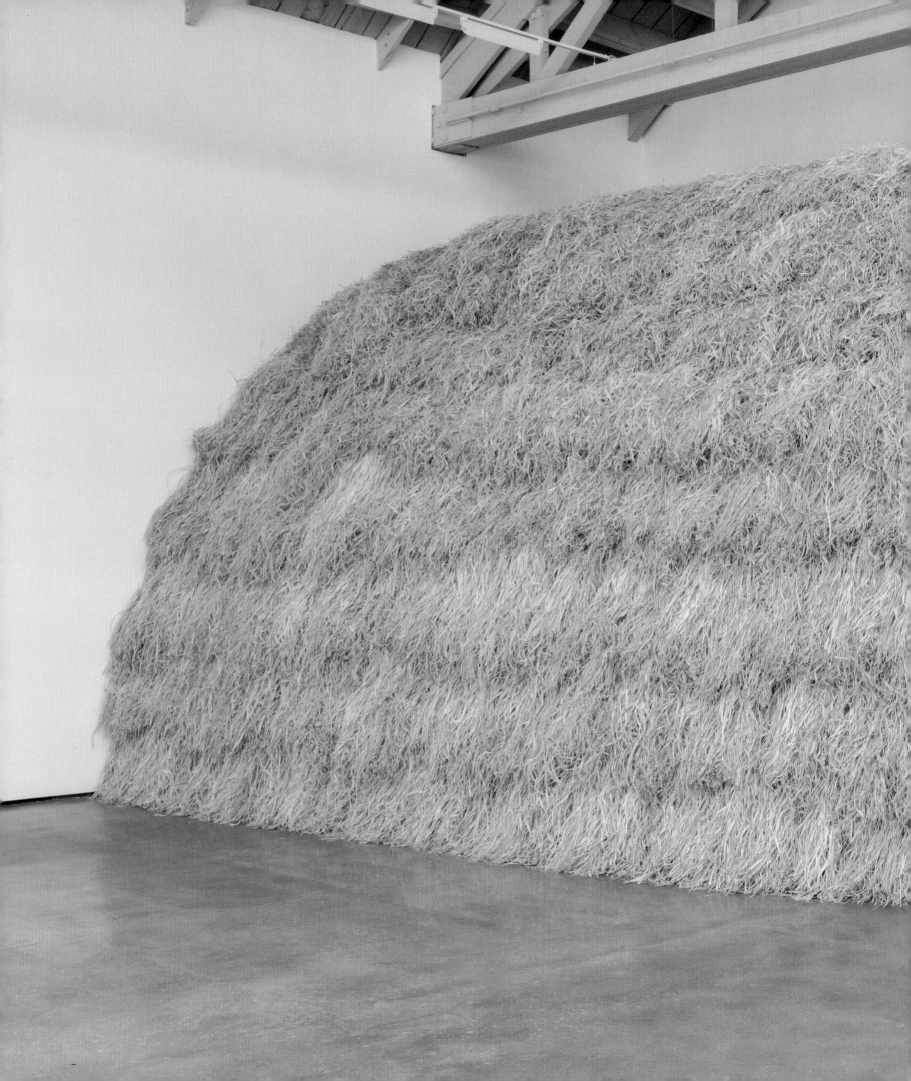

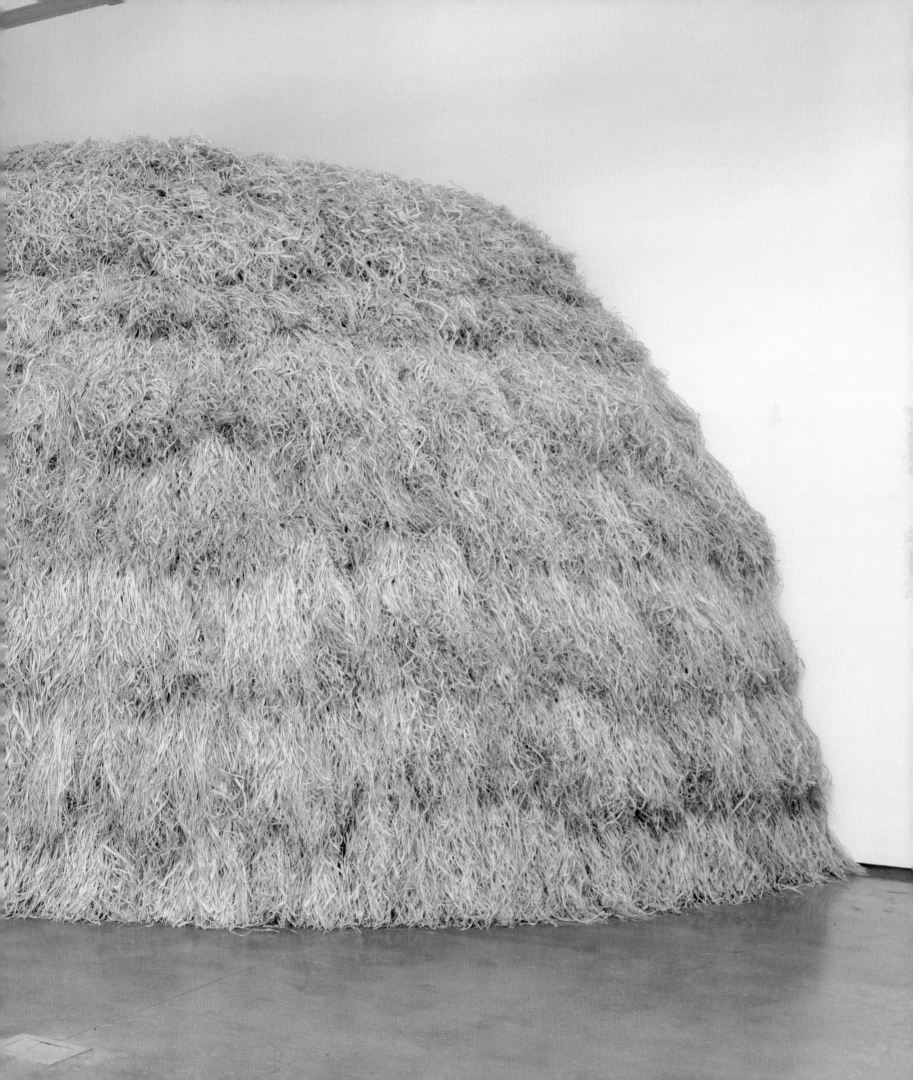

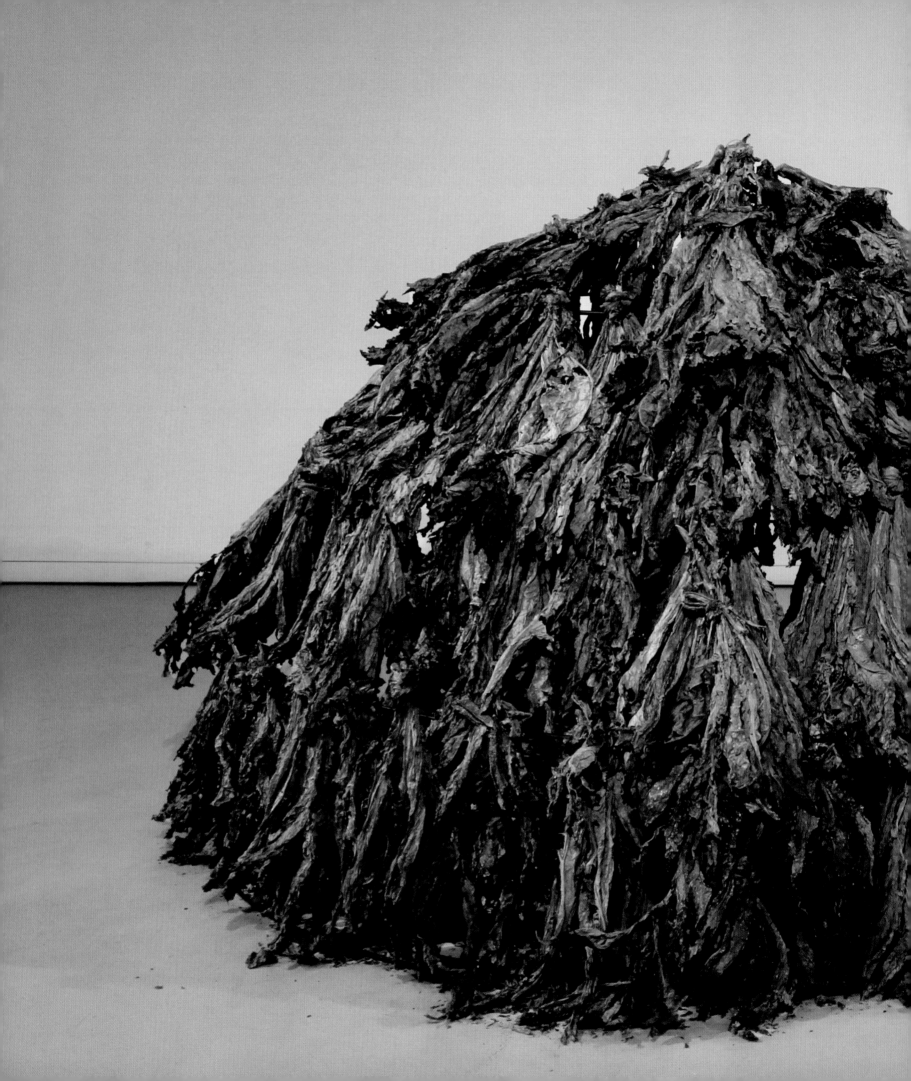

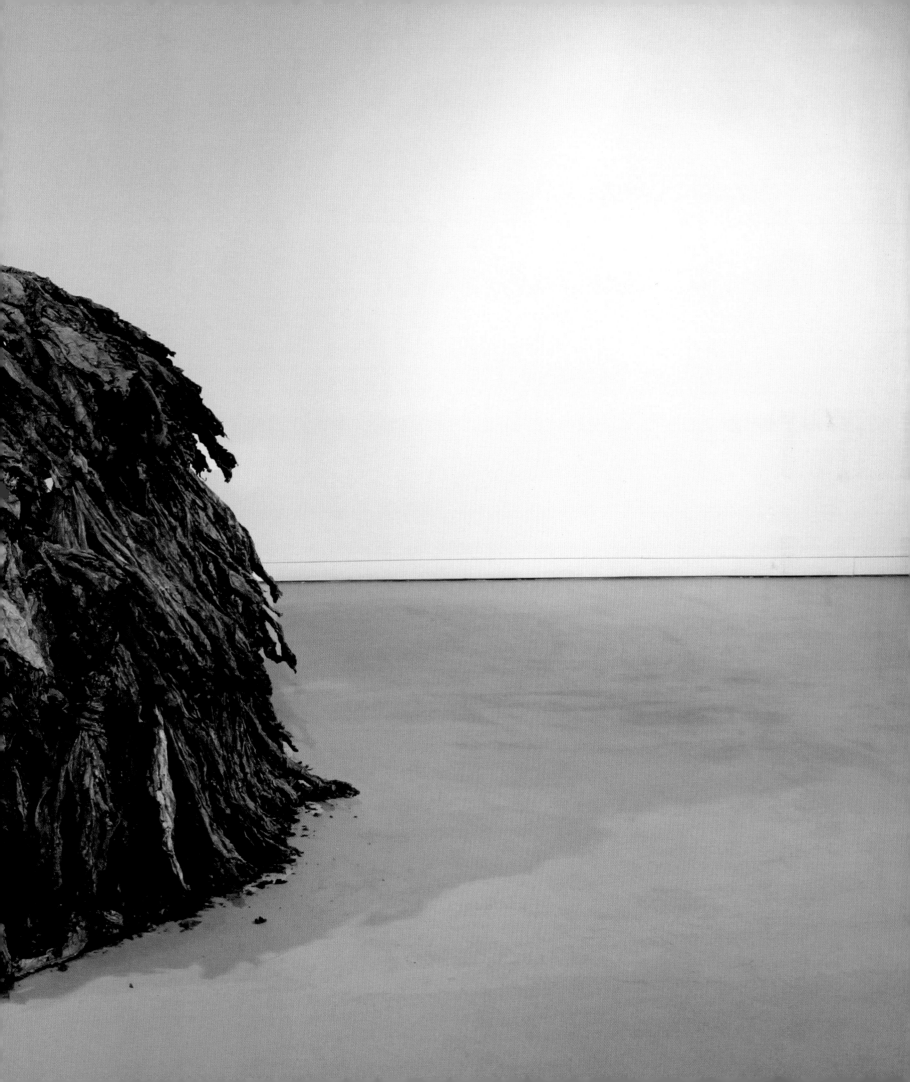

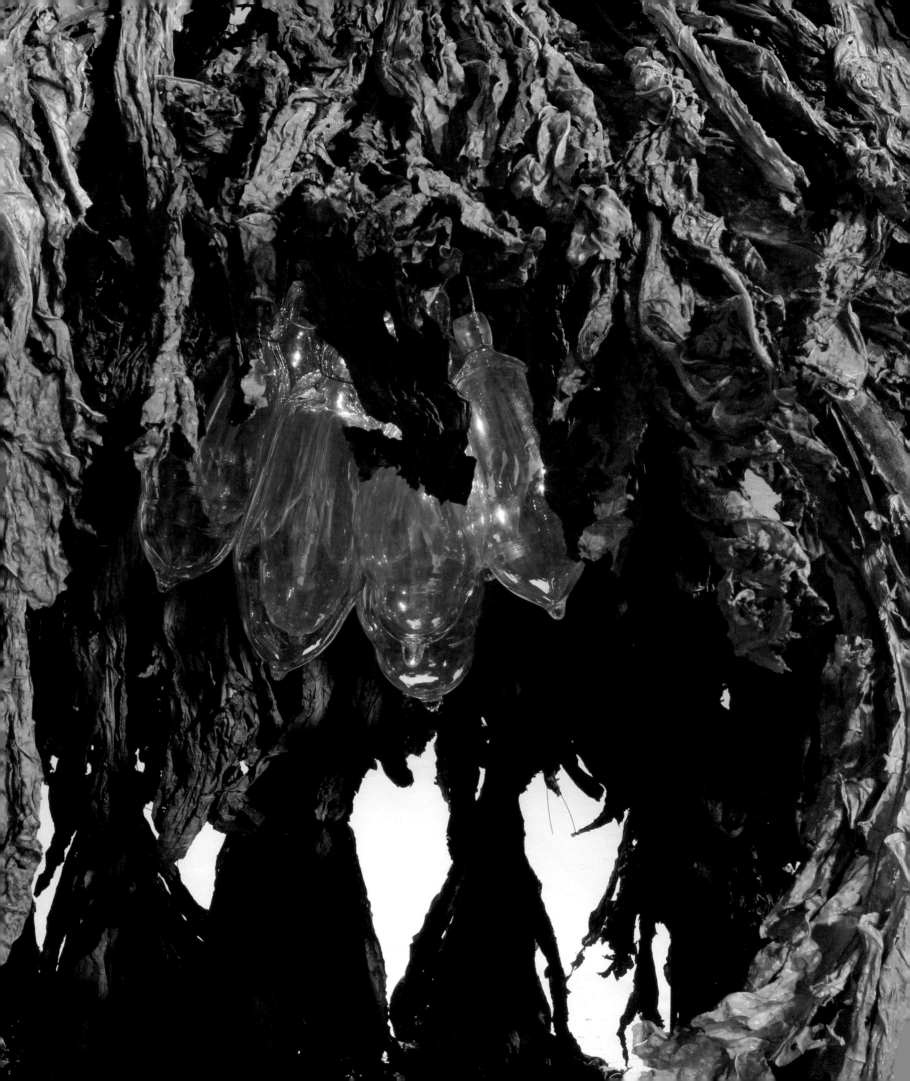

facing
Cupboard II (detail), 2015
Glass, tobacco, and steel armature
60 × 96 inches (175.3 × 243.8 cm)

pages 122–23
Cupboard X, 2020
Steel and raffia
Dimensions variable

pages 124–25
Installation view, *Crop Rotation*, Kentucky Museum of Art and Craft,
Louisville, 2015

Cowrie (Pannier), 2015
Terracotta, porcelain, and steel
58 × 54 × 32 inches (147.3 × 137.1 × 81.3 cm)

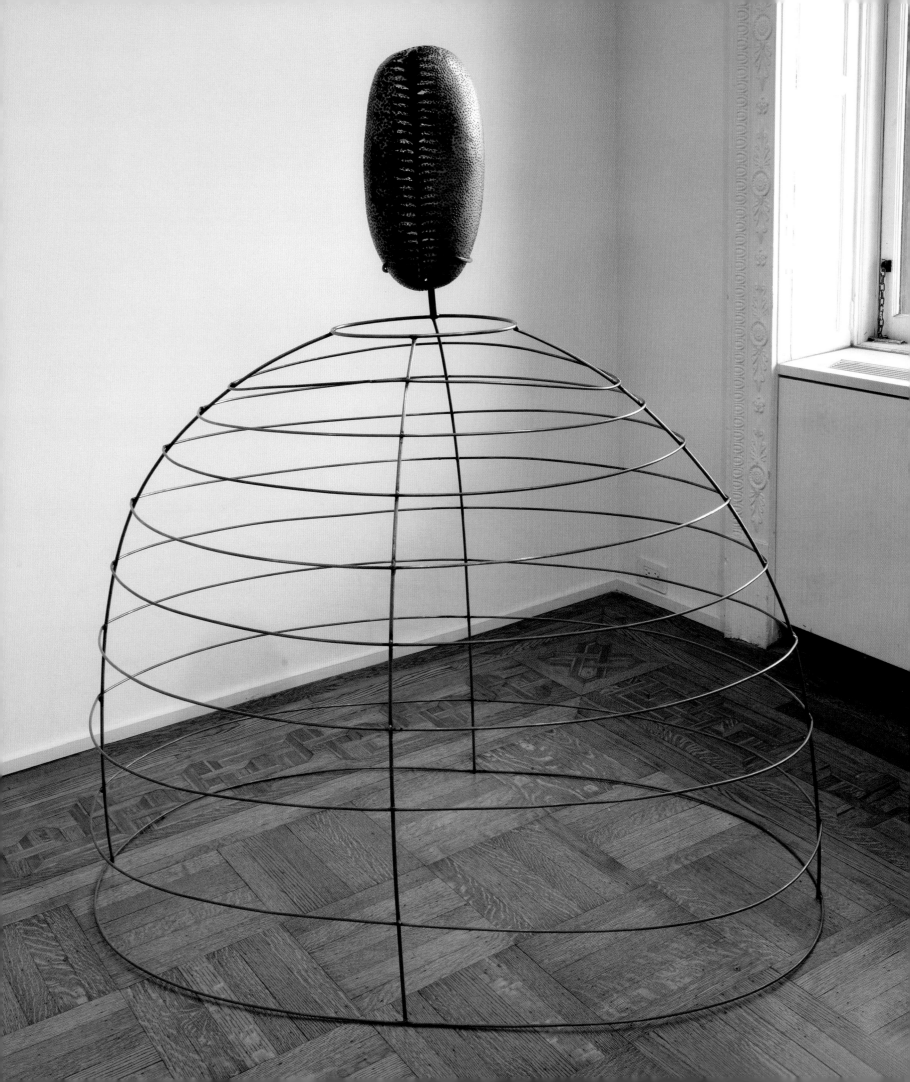

Cowrie (Sage), 2015
Terracotta, porcelain, sage, string, wire, and steel
36 × 28 × 28 inches (91.4 × 71.1 × 71.1 cm)

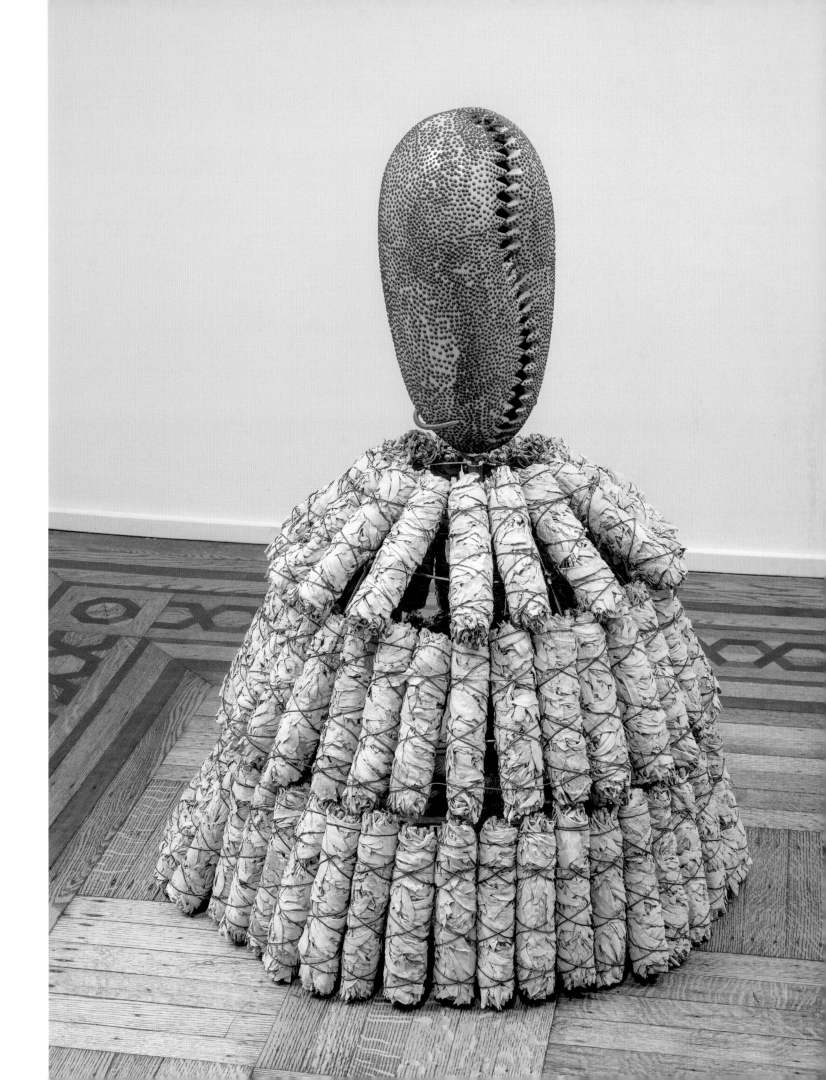

Cowrie (Blue), 2012
Terracotta, porcelain, cobalt, and epoxy
11 × 19 1/2 × 11 inches (27.9 × 49.5 × 27.9 cm)

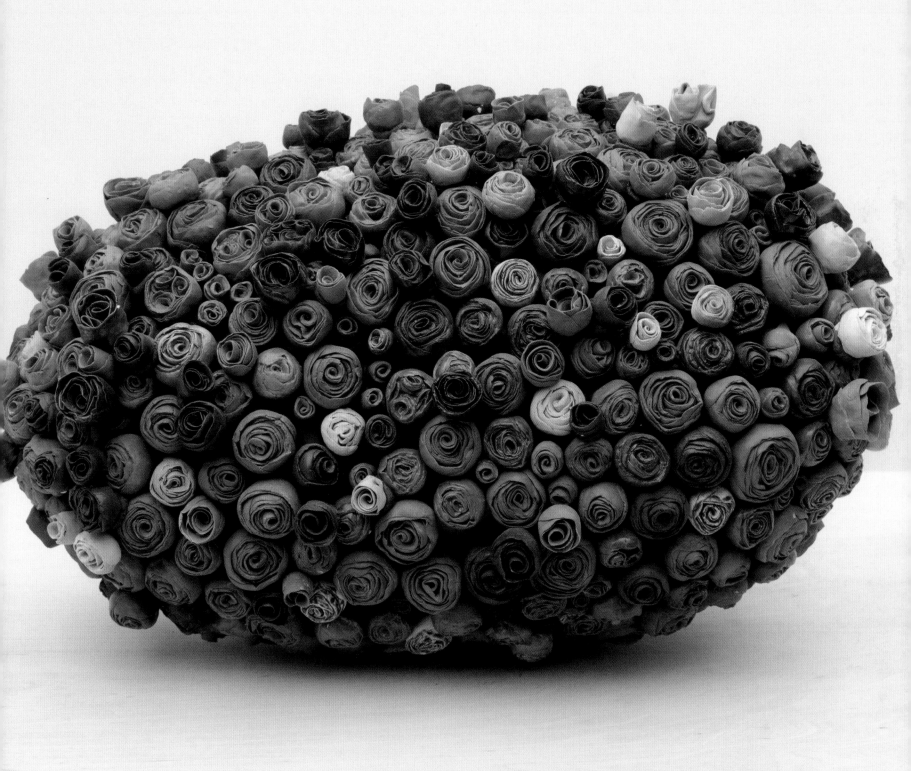

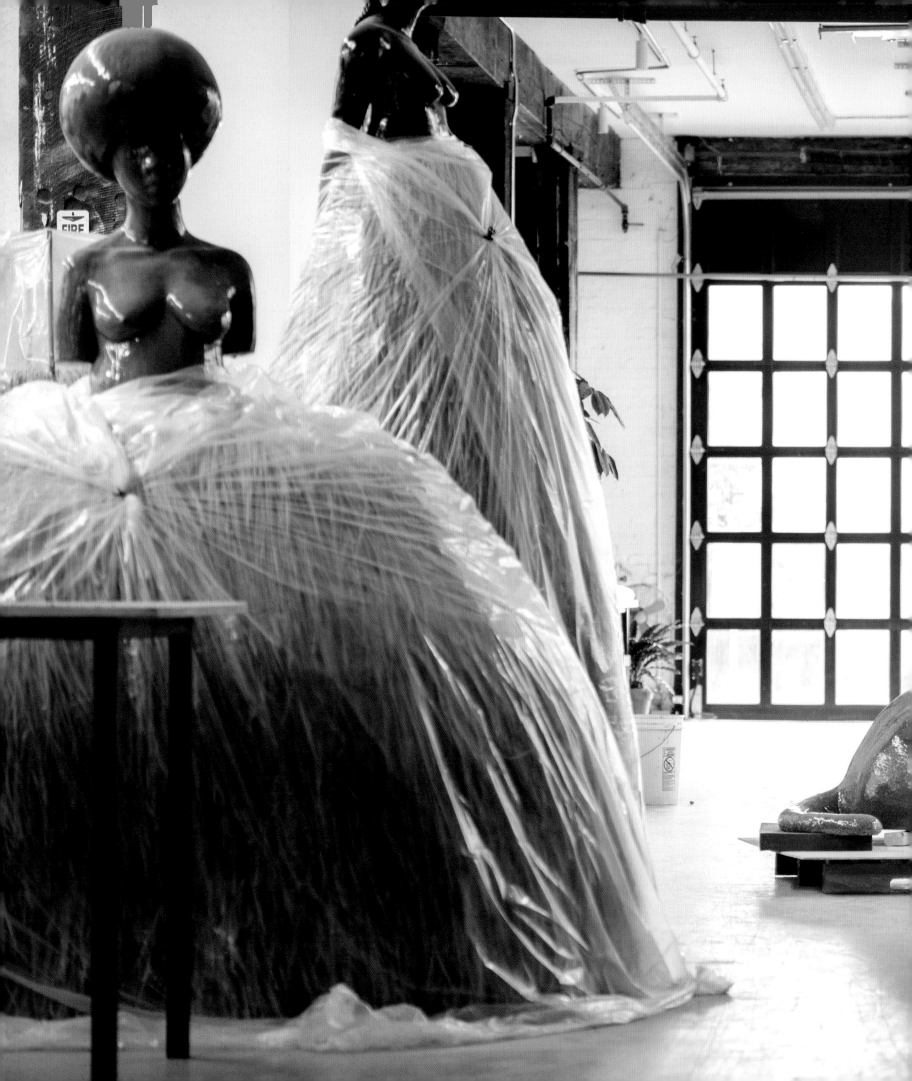

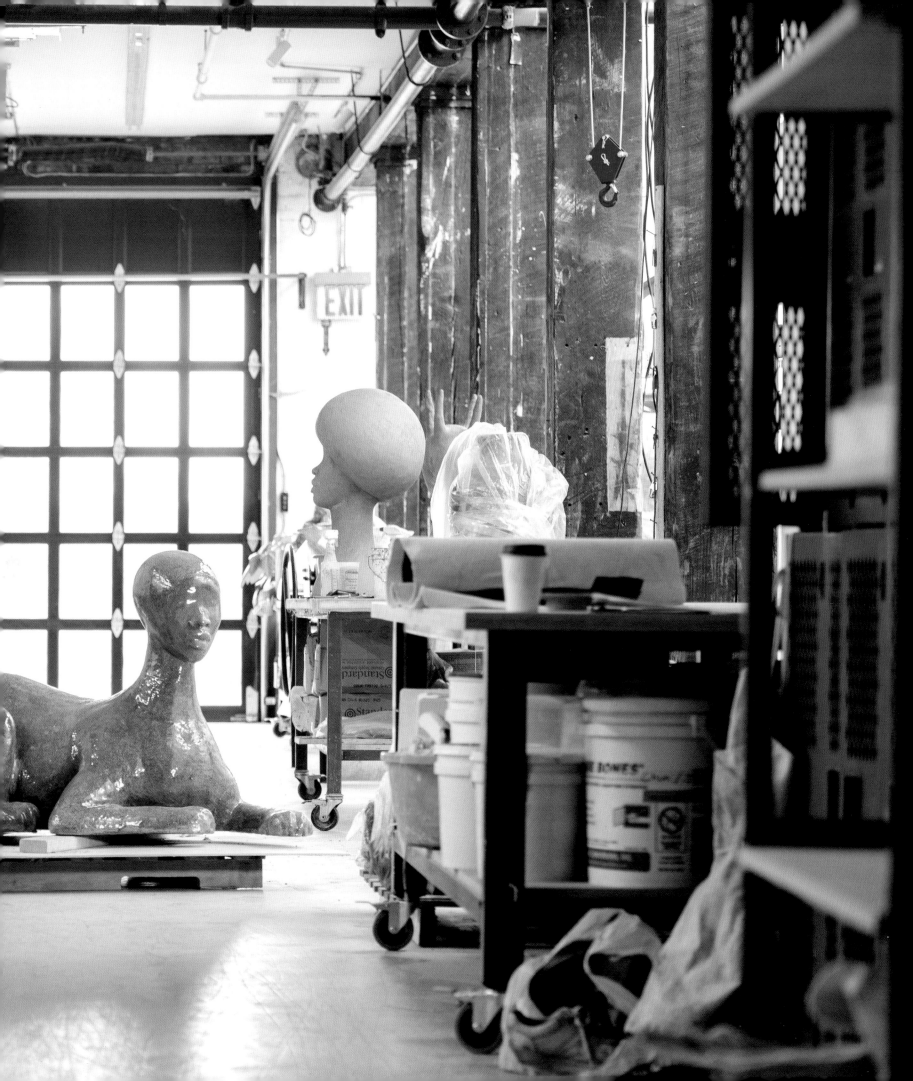

Katherine McKittrick

A Glossary of the Tangible and Unfettered

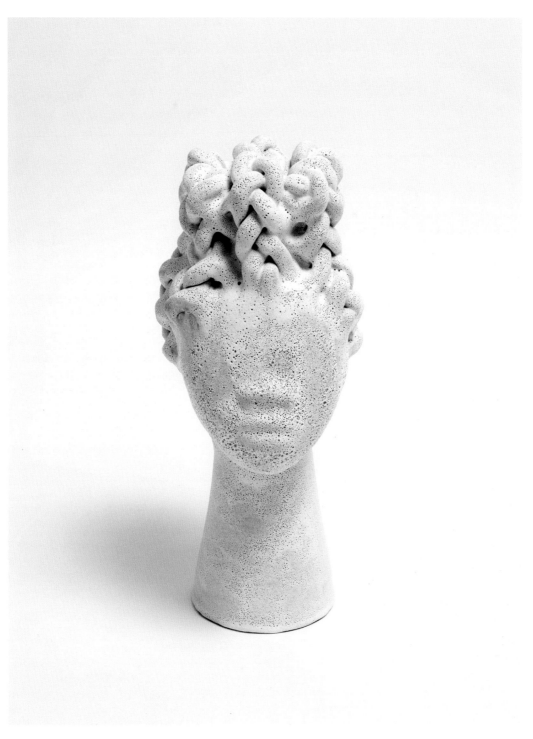

Fig. 1 *The Village Series #4*, 2018. Stoneware. 17 3/4 × 8 1/4 × 10 inches (45.1 × 21 × 25.4 cm)

CAPTURE

The history of geography—the practice and study of exploring, mapping, representing, and coming to know the world and its interspecies inhabitants—is unwieldy and immense. The history unveils many geographers, settlers, anthropologists, scientists, and more, capturing and cataloguing and studying flowers and streets and scarcity and dispossession and pathways and accumulation and populations (societies, citizens, inhabitants, people). Capture is, for me, the metanarrative. Capture underlies and gives texture to catalogue and study. In conjunction with race and racism, expressed through the powerful gendered ideologies of colonialism-imperialism and estranged from black histories and ideas and place-making practices, black geographic life is articulated through effacement-objectification.

TRACES

It is painful writing about black geographies. The plantation, the slave ship, the Middle Passage, the willful terror (seeming histories, forever pasts) continue to animate place, space, time, and location. I know (we know) that past and present geographies are both divergent and overlapping rather than twinned. We know linear temporalities are fictive and punishing; we know geography is unstable, alterable. Even so, the traces of the plantation, the slave ship, the Middle Passage, the terror hold steady.

ABSENTIA

The plantation, the slave ship, the Middle Passage, the terror, the effacement-objectification unravel into a terrible sense of place: an always emergent-actualized violence that is obscured from view and moves unevenly across time and space and is perfected through different iterations of geographic capture that are rolled into a normalized production of space that is fueled by the unseeable and laborious world-making (place-making) activities of black diasporic communities. Or, according to this grim lens, black diasporic life implicitly makes geography what it is, in absentia. Prevailing geographic knowledges thus cue a special kind of brutality, one that pairs multiscalar colonial-plantocratic practices (race thinking, racial violence) with the precise science of the survey (the description and mathematization of land and property holdings), thus establishing an eerie yet seemingly natural connection between blackness, objectification, place, displacement, and imperial expansionism.

AGONY

There are days, weeks, when I cannot bear this. Normative time-space is so dense and heavy and forever. The colonial evidence, the survey, is dizzying. It stretches.

FINDINGS

The grim spatial lens is a replication of how things already are. The methodology constrains the outcome so that black geographies are concealed and/or degraded. The lens asks, for example: How does colonialism capture the figure of the black? How does the plantation harm? How is spatial progress achieved over time? Show me how things have improved, give me the specifics, the numbers, please. Describe your findings, describe the harm, avoid stories that are in excess of the perimeters of anticipated research outcomes. In this, black geographies and black feminist geographies—the spatial insights, observations, and inventions of Sandra Brewster or M. NourbeSe Philip or Nella Larsen or Sadie Barnette or Ingrid Pollard—are impossibilities. *A South Bronx Story*. Jackie Kay. Cecily Nicholson.

BREACH

I think a lot about the production of space and how the discipline of geography and its practitioners, in concert with race thinking, fictively obliterate a black sense of place. The traces, harms, and methods pave over different kinds of activities—acts of black livingness, the creative-intellectual labor of rebellion—that persistently unsettle prevailing geographic systems. Black geographies offer alternative methodologies that move through, breach, and unsettle the metanarrative. What if we recode and reimagine blackness as emerging from a black sense of place? A black sense of place illuminates the geographic processes that emerged from plantation slavery and its attendant racial violences yet cannot be contained by the logics of white supremacy. A black sense of place is a location of difficult encounter and relationality; it uncovers and sustains entangled (black and non-black) geographies. A black sense of place is not individualized knowledge; it is collaborative praxis. It assumes that our selfhood is always in tandem with other ways of being—including those ways of being we cannot bear. A black sense of place always calls into question, struggles against, critiques, undoes normalized racist scripts. A black sense of place is a diasporic-plantocratic-black geography that reframes what we know by reorienting and emphasizing *where* we know from.

LEAP

What a feat, to undo and unsettle mathematized displacement, violent expansionism, forever objectifications. How exhaustingly brilliant, within the context of white supremacy and emergent-actualized violence and obliteration, to demand and write and invent and create multifarious black epistemologies of *where* and concretize-imagine rebellious geographic stories.

STARBURSTS

The creative works of Simone Leigh concretize and imagine black feminist geographies and a black sense of place. Working with and across the temporalities and spaces of multiple colonialities—plantation, postplantation, extraction, racial capitalism, racial violence, migrations, Africa, the African diaspora—Leigh's sculptures and installations include eyeless and faceless head-and-shoulder and neck-and-shoulder porcelain and stoneware statues (fig. 1), walls of porcelain teeth, hand-tied winged tobacco leaves tethered to a terracotta vase, cowrie shell repetitions, glazed stoneware, giant glazed vessels, raffia skirts, and thatched rooftops. A bronze sculpture of a woman washing a garment is nested in sovereignty (page 255). From afar, *Brooch #2* (2008) looks like a star or a flower or a sun or a planet. Closer, *Brooch #2* reveals itself to be thirty-six clasps holding black and brown and white and yellow plantains, all encircling nineteen bullet-shaped steel and platinum cones. The brooch unwinds into a kind of unbearable sunburst, a badge of imperial adventure.

LOVE

Leigh's body of work is layered and multifarious; textures, representations, visual and textual clues, diasporic invocations, and entangled histories collapse to convey the purpose of black art, black feminist art, and art criticism: to interrogate white supremacy, to name terror, to offer and establish and enact and share decolonial creativity, to look back, to talk back, to care for black life, to arrange and assemble, to invite mutuality, to create alternative worlds and possibilities, to share a lesson in subversion, love. Viewed as a collection and a series of overlapping images, the creative pieces offer a geographic story that remaps normative curatorial and architectural sites such as the museum, the gallery, the cityscape, the outdoors. The creative pieces emplace black femininity anew.

DURESS

The emplacement and remapping are expressions of black feminist geography. Leigh's creative works can be threaded together to form a kind of dynamic constellation that continually disrupts colonial time-space because the work is being produced across and through calcified colonial infrastructures. Leigh invents a black sense of place under duress.

WHERE 1

The brooches and sculptures and eyeless-faceless figures, the scaled-up vessels, the stoneware formations, the towering black feminine *Satellite* (2022; pages 250–51), the thick traces of dismal colonial-plantation life—these works take up space and

in this signal that geography (our surroundings, our environments, the surveys and map legends and houses and streets and paths) is alterable. (Once again: within the context of white supremacy and emergent-actualized violence and obliteration, Leigh demands and writes and creates multifarious black epistemologies of *where* and concretizes-imagines rebellious geographic stories.)

WHERE 2

The three-dimensionality of the sculptures is, therefore, especially meaningful. Many of Leigh's sculptures are heavy and dense. Typical geographic systems and processes are both subverted and dethroned as she creates black feminist geographies by centering worlds that are otherwise erased; she reconcretizes the environs by inserting heavy and dense multiscalar black feminist infrastructures into the landscape. Leigh's spatial decisions are remarkable because the art is not simply placed within the building, the outdoors, the gallery, the institution; the art is, instead, *where* itself. Put differently, she disrupts time *and* space and produces three-dimensional black feminist infrastructures and geometries *of time and space*. This is a radical expression of black feminist geography: it boldly insists on presence-through-reconfiguration by building, constructing, and fabricating tangible black worlds *as* physical geographies. Typical pathways are disrupted, walkways are reconfigured. As we move, we make way for the structure, the satellite, the sentinel. We move through geography anew! We are tasked to circumambulate.

ILLUMINATION

Leigh's creative works show how a black sense of place and black feminist geographies are produced with and through uneven social relations and difficult histories. The bold reconcretization of space does not unravel into a seamless celebration of black feminist freedom in place but instead demonstrates that one (not the only) function of black feminist creative labor and its attendant geographies is to simultaneously unveil and unsettle racial violence. Thus, the production of space, the duress, the differential scales of the creative works, the materials, the narratives are all situated precariously on the edge of obliteration and possibility. This is illuminated in Leigh's commitment to centering black women's labor and her observations that this onerous work is secreted and unseeable across time and space; in unmasking and creatively refashioning endless hours of intense labor, something happens to my (our) sense of place: new stories are revealed, the social reproduction of space is writ large. This is illuminated as the art, the artist, the viewers, we (together) live with the living memory

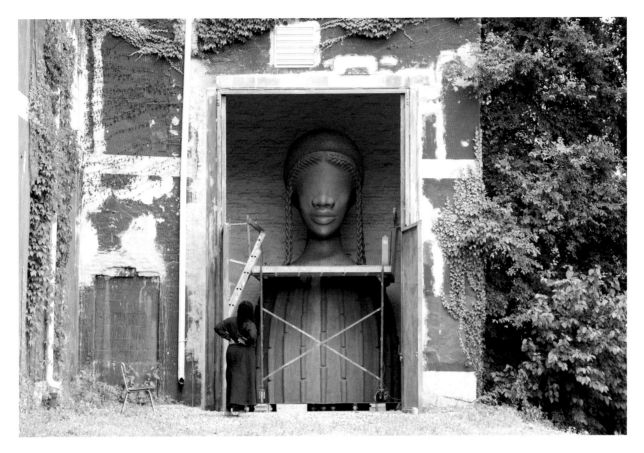

Fig. 2 Simone Leigh and her sculpture *Brick House* while in progress, 2018

of slavery and emergent and actualized violence. This is illuminated in the materials Leigh uses to construct black feminist geographies: stone, bronze, steel, terracotta, gold and platinum glazes, porcelain, graphite, cobalt, epoxy, raffia (minerals, rocks, chemicals, fluids, fibers, resins, mining, theft, experimentation, overseers, slow death). This is illuminated by creative labor, that is, the physical, psychic, physiological, and affective exertion that accompanies building and fabricating tangible black feminist worlds (imagining, constructing, lifting, moving, molding, chipping, pressing, casting, hoisting).

JUMPING

The diasporic underpinnings of Leigh's work animate the beautiful potential of black feminist geographies. The work sways across different geographies, moving between local and transnational imaginaries that are animated by precision and opacity and familiarity (depending on perspective): 30th Street and 10th Avenue, Natchez, Jamaica, USA, Southern Africa, water's edge, Atlantic Ocean, Mississippi, Togo, New York, West Africa, satellite, Highway 61, Cameroon, Namibia, Martinique, Birmingham, the waiting room, the clinic, Benin, Chad. Leigh employs geographic scale, creative up-scaling, and the multiscalar to draw attention to how black life and livingness are both grounded in place and untethered, too. She jumps scale! The heterogeneous and alternative geographies overlap and diverge and are animated by diasporic literacies, deliberate yet unexplained prompts the reader is left to decipher or already knows or briefly recognizes or cannot make sense of: Hortense, Brick House, Crop Rotation, Shower Cap, White Teeth, Daphne, Audre. Swakopmund. Jug, Home, Cupboard, Thelma. Sharifa. These spatial activities, prompts, possibilities, and dynamisms give a glimpse of how alternative geographies are made; we observe a concretized and dense sense of place that is also fleeting.

TEMPERING

Leigh's work perfects the intricate workings of black feminist geographies; she shows that the production of space and a black sense of place are shaped by scientifically imaginative-creative practices. The suturing of science and imagination and creativity (shaping and reshaping and molding clay, bronze, stone, and porcelain; calculating scale; smelting, casting; surveying weight; measuring distance; mathematizing height; sculpting; studying, renarrating; sand blasting, welding; concretizing heartbreak, beauty; revising, tempering) signals that black feminist geographies, the fabrication of place, is studied invention. Or, for example, *Brick House* = weight + height + diameter + time = 5,900 lbs. + 16 ft. + 9 ft. + always (fig. 2).

TANGIBLE-UNFETTERED

Eschewing frames that posit black women's creative-activist-intellectual work is motivated by uncomplicated-resilient care, refusing narratives that read black creative work as innate and instinctive and easy, undoing scripts that situate black femininity as nowhere-everything-object, the brilliance of Leigh's creative vision and practice is how she invokes a precise-patient-diasporic-assiduous-calculable-indeterminable-laborious sense of place: tangible-unfettered black feminist geographies.

REFERENCES

Browne, Simone, and Sadie Barnette. "In Conversation: Simone Browne and Sadie Barnette." In *Black Futures*, edited by Kimberly Drew and Jenna Wortham, 462–69. New York: One World, 2021.

Campt, Tina M. *A Black Gaze: Artists Changing How We See*. Cambridge, MA: MIT Press, 2021.

Carby, Hazel V. *Imperial Intimacies: A Tale of Two Islands*. London: Verso Books, 2019.

Césaire, Aimé. "Poetry and Knowledge." In *Lyric and Dramatic Poetry: 1946–82*, translated by Clayton Eshleman and Annette Smith, xlii–lvi. Charlottesville: University Press of Virginia, 1990.

Clark, VèVè Amasasa. "Developing Diaspora Literacy and Marasa Consciousness." *Theatre Survey* 50, no. 1 (2009): 9–18.

Close, Cynthia. "*Simone Leigh: Sovereignty* at the 59th Venice Biennale." *Art & Object* 43, no. 2 (March–April 2022): 1–14.

ESG. *A South Bronx Story*. Universal Sound US CD10, 2000, compact disc.

Haley, Sarah. *No Mercy Here: Gender, Punishment, and the Making of Jim Crow Modernity*. Chapel Hill: University of North Carolina Press, 2016.

Harris, Cheryl I. "Whiteness as Property." *Harvard Law Review* 106, no. 8 (June 1993): 1707–91.

Katz, Cindi. *Growing Up Global: Economic Restructuring and Children's Everyday Lives*. Minneapolis: University of Minnesota Press, 2004.

Kay, Jackie. *The Adoption Papers*. Highgreen, UK: Bloodaxe Books, 1991.

Larsen, Nella. *Quicksand*. 1928. Reprint, New York: Penguin, 2002.

Lowe, Lisa. *The Intimacies of Four Continents*. Durham, NC: Duke University Press, 2015.

Massey, Doreen B. *Space, Place and Gender*. Oxford: John Wiley & Sons, 2013.

McKittrick, Katherine. *Demonic Grounds: Black Women and the Cartographies of Struggle*. Minneapolis: University of Minnesota Press, 2006.

Mcleod, Laurel. "Simone Leigh Makes History and Brings the Black Female Experience to the Forefront." *Arts Help*, August 16, 2021. Accessed June 9, 2022. https://www.artshelp.net/simone-leigh-makes-history-and -brings-the-black-female-experience-to-the-forefront/.

Nicholson, Cecily. *Wayside Sang: Poems*. Vancouver, BC: Talon Books, 2017.

Philip, M. NourbeSe. *She Tries Her Tongue, Her Silence Softly Breaks*. Charlottetown, PE: Ragweed, 1989.

Rhodes-Pitts, Sharifa. "Artist Unknown, Vessel Possibly for Water." In *Simone Leigh*. New York: Luhring Augustine, 2018.

Smith, Neil. "Contours of a Spatialized Politics: Homeless Vehicles and the Production of Geographical Scale." *Social Text*, no. 33 (1992): 55–81.

Tyhurst, Rosa. "Ingrid Pollard: Carbon Slowly Turning." *Art Monthly* 456 (May 2022): 33.

Whiteford, Meg. "The Making of Simone Leigh's *Brick House*." Hauser & Wirth, June 7, 2020. https://www.hauserwirth.com/ursula/28500-making -simone-leighs-brick-house/.

Wynter, Sylvia. "Rethinking 'Aesthetics': Notes Towards a Deciphering Practice." In *Ex-iles: Essays on Caribbean Cinema*, edited by Mbye Cham, 237–79. Trenton, NJ: Africa World Press, 1992.

Daniella Rose King

Simone Leigh:
Caribbean Diasporas and Cleansing the "Colonial Stain"

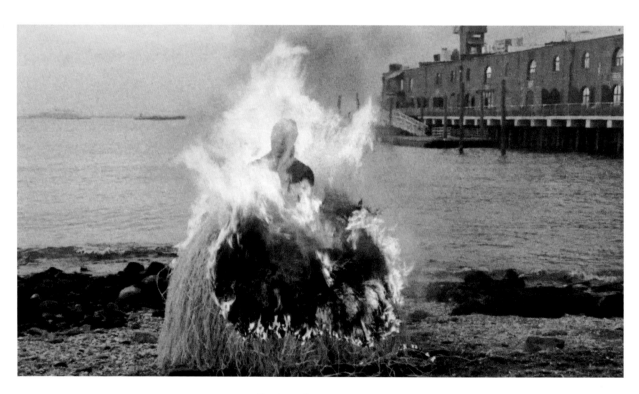

Fig. 1 Simone Leigh and Madeleine Hunt-Ehrlich, *Conspiracy* (still), 2022.
16mm and 8mm film (black-and-white, sound; 24:00 minutes)

Though a longtime New Yorker, Simone Leigh was born to Jamaican émigré parents in Chicago, and her life and work have been shaped by aspects of Caribbean diasporic identity and experience—the "endless ways in which Caribbean people have been destined to 'migrate,'" as Stuart Hall once said.[1] The Caribbean exists for many as both a geographical reality—an archipelago of landscapes—and an imagined place, an immaterial "poetics of relation," as Édouard Glissant would have it.[2] A place that created the fortunes and futures of the Western hemisphere but is made invisible within in. It is a space of all these seemingly dissonant qualities.

As a British Caribbean curator and a recent arrival to New York in 2015, I was welcomed by Leigh into her community and found a loving and supportive home away from home away from home. A sort of global black diasporic family of art (and adjacent) workers was ever-present in her kitchen, around her dining table, in her studio, and at her exhibitions, and her practice contained familiar questions of diaspora, place, belonging, rootedness, and hybridity. I first worked with Leigh as a curatorial researcher on her 2016 exhibition at the New Museum, *The Waiting Room*, which referenced the death of Esmin Elizabeth Green, a forty-nine-year-old Jamaican émigré, in the waiting room of Brooklyn's Kings County Hospital Center in 2008. Green was invisible to the staff and security guards, who allowed her to wait some twenty-four hours, her final one spent collapsed on the floor and writhing in pain. She had been dead for forty minutes before a nurse finally checked on her. Leigh, in her conceptualization of the project, centered the subjectivity of this woman as a way of calling attention to the structural disparities in medical care and racism within the medical-industrial complex and of bringing this discourse into the mainstream of museums and the wider culture.

Conceptions of diaspora, humanism (Sylvia Wynter), and creolization as a constant transformation (Glissant)[3] are encountered in the way Leigh works, her varied sources, discourses, and visual cultures, and how she assembles communities, creating powerful roots and connections to places.

From a visual lexicon that includes cowrie shells, plantains, jugs and pots, raffia, lace, rosettes, Mami Wata, carnival and ceramic traditions, and other diasporic vernacular markers, the Caribbean appears—through form, process, and the intellectual framework that underpins the labor—as praxis.[4] Sharifa Rhodes-Pitts has described how Leigh is "working with traces of the colonial stain—these things that the culture can't look away from even while insisting that they are marginal."[5] Inspired by that phrasing, I look to certain of Leigh's works that conjure the cleansing nature of fire, the domestic labor of the laundress, and the invisible, foundational labor of generations of black women cleaners, caretakers, and fire-starters.

Vaval, the King of Carnival

In February 2020, weeks before COVID-19 changed the world, Leigh traveled to the Caribbean island of Martinique, a former French colony and now an overseas department of France. Visiting with her friend and collaborator Madeleine Hunt-Ehrlich, who was undertaking research on the feminist scholar Suzanne Césaire, Leigh was familiar with the place through the work of another friend, the anthropologist Vanessa Agard-Jones, who had written her dissertation on the chlordecone exposure epidemic in Martinique and how it unsettled sexual politics on the island.[6] A persistent organic pollutant related to DDT, chlordecone is carcinogenic, an endocrine disrupter that affects the reproductive and nervous systems and brain development in children, and is responsible for Martinique's high rate of prostate cancer per capita (a close second to neighboring Guadeloupe). Chlordecone was used chiefly on banana plants, a key part of Martinique's economy, and French authorities directly authorized its use. Notably, the toxicity of chlordecone does not transfer into the banana crops exported to (mainly French) consumers abroad but remains in the soil and waterways for decades or longer. Traces of the pesticide have been found in the bloodstreams of 92 percent of Martinique's population. On the island, the literally toxic legacies of slavery are painfully evident. Many of the big banana producers were descendants

1 Stuart Hall, "Cultural Identity and Diaspora," *Framework: The Journal of Cinema and Media*, no. 36 (1989): 79.

2 Édouard Glissant, *Poetics of Relation*, trans. Betsy Wing (Ann Arbor: University of Michigan Press, 1997).

3 See Katherine McKittrick, ed., *Sylvia Wynter: On Being Human as Praxis* (Durham, NC: Duke University Press, 2015), and Édouard Glissant, *Caribbean Discourse: Selected Essays*, trans. J. Michael Dash (Charlottesville: University Press of Virginia, 1989), 142.

4 See McKittrick, *Sylvia Wynter: On Being Human as Praxis*.

5 Sharifa Rhodes-Pitts quoted in Siddhartha Mitter, "Simone Leigh, in the World," *New York Times*, April 14, 2022, https://www.nytimes.com/2022/04/14/arts /design/simone-leigh-venice-biennale-us-pavilion.html.

6 The pesticide had been banned in the United States in 1975 because of its toxicity to humans but continued to be used in Martinique and Guadeloupe for two more decades.

of the same slave-owning families (known locally as *békés*)[7] who oversaw the sugar plantations that had similarly fed and fattened the French Empire.

Before the start of Lent every year, Fort-de-France, Martinique's capital, hosts a carnival during which various masquerade characters parade and revel in the streets, culminating in the burning of the Vaval, the King of Carnival. The Vaval represents a different satirical, often nefarious public figure, concept, or institution each year, rendered as a huge papier-mâché statue on a float that is paraded through the streets before the effigy is burned as a penance for the wild celebrations, signaling the end of the carnival. In 2020 the Vaval took the form of chlordecone, appearing as a blue-skinned man wearing a pith helmet, with a bunch of bananas slung over his shoulder. This spectacle sought to name, ridicule, and release the public from the toxic afterlives of slavery, if only for a night.

It was this gesture that informed and inspired Leigh in her ceremonious burning of an effigy of James A. Palmer's 1882 photograph *The Wilde Woman of Aiken* (page 327, fig. 5). The photograph belongs to a cache of racist portraits produced to mock Oscar Wilde's U.S. lecture tour in 1882, during which his ideas about the contemporaneous Aesthetic movement, peculiar dress, and Irishness were derided. Cruel images of black people proliferated in nineteenth-century American visual culture, so it follows that this portrayal of Wilde, the consummate outsider, as a black woman was meant as the ultimate ridicule.[8] Leigh's burning of the Vaval took place on the Red Hook shore, mere steps from her Brooklyn studio, and it constitutes the final scene of *Conspiracy* (2022), a twenty-four-minute-long film made in collaboration with Hunt-Ehrlich (fig. 1). The film registers several interconnected moments: Leigh's experience of Martinique's carnival; *Anonymous* (2022; page 259), a glazed stoneware sculpture that isolates the figure of *The Wilde Woman of Aiken*, turning her skirt into a jug; and the iconic 1961 film *Hands of Inge*, which shows the sculptor Inge Hardison working in clay. *Conspiracy* maps the physical labor of Leigh's artwork, the many hands involved in the practice, alongside the intellectual labor and mentorship of others; in the final moments, as

the effigy burns, we see the artist Lorraine O'Grady looking on. The work is indicative of Leigh's process and of the interconnected, sustained concerns and influences. According to the artist, she "spent a year thinking about her [the woman subject of the Palmer photograph]. She weighed on me. How to depict her without reifying all the racism of the image, over, and over again?"[9] It was after experiencing carnival that Leigh found the resolution for re-presenting this unknown woman's image. After shaping her likeness in papier-mâché, she covered the wire frame of the figure's skirt with raffia and set her alight on the beach. For Leigh, the ephemerality and impermanence of the effigy offered one possible answer to the ongoing problem of permanent monuments.[10] The action of burning—the use of fire and the mode of destruction—also offers collective, cleansing release. Further, as the artist remarked in an interview, "It gave me so much relief . . . to destroy my work in that way."[11]

Women's Work

Conspiracy starts with black-and-white footage, filmed from above, showing Leigh's hands as she coils a rope of clay into a circle, repeating this gesture one rope on top of another, a simple and ancient technique for creating a pot or vessel. In other shots we see the artist applying tools to clay, smoothing, cutting, patting. We see the hands and bodies of her team of studio workers, including studio assistant Sarah Wang, laboring on the pieces, some to be glazed and fired, some to be cast in bronze, all to be reunited in Leigh's pavilion at the 59th International Art Exhibition of La Biennale di Venezia.

The human task—the hours, thought, planning, execution, sweat, pain, material and immaterial resources required for this output—cannot be overstated. And here Leigh is letting us in on some of the secrets, some of the behind-the-scenes effort, some of the hands and minds required for a mammoth task of producing a pavilion exhibition, not to mention maintaining a practice or a studio. Women's work, domestic labor, the back-breaking work of black women on which our modern world has been built have been Leigh's concern, as is making this visible and legible to audiences. There are her porcelain

7 Tim Whewell, "The Caribbean Islands Poisoned by a Carcinogenic Pesticide," BBC News, Martinique, November 20, 2020, https://www.bbc.co.uk/news/stories-54992051.

8 For a discussion of the complicated roots of this photograph and background on Wilde's tour and its reception, see Victoria Dailey, "The Wilde Woman and the Sunflower Apostle: Oscar Wilde in the United States," *Los Angeles Review of Books*, February 8, 2020, https://lareviewofbooks.org/article/the-wilde-woman-and-the-sunflower-apostle-oscar-wilde-in-the-united-states/.

9 Leigh, conversation with the author, July 7, 2022.

10 Another relevant work in this context is Leigh's *Martinique* (2022; page 288), a headless sculpture that references a nineteenth-century statue in Martinique of Joséphine Bonaparte (who grew up there), which was beheaded and splattered with red paint in 1991 to protest her connection to slavery on the island; the monument was torn down by activists in 2020.

11 Mitter, "Simone Leigh, in the World."

Fig. 2 C. H. Graves, *Mammy's Last Garment, Jamaica*, 1879. The New York Public Library. Schomburg Center for Research in Black Culture. Photographs and Prints Division

rosettes, pinched and rolled by the artist's hand in the thousands, which adorn the crowns of her busts and speak to the invisible labor and creative expertise of generations of women seamstresses, sewers, and craftspeople, as does her work with lace, another laborious and intricate and highly skilled trade, often attributed to women. The theorist Françoise Vergès posits that the Capitalocene rests on the visible invisibility of black women and women of color, of their labor and exhaustion.[12] Leigh's work conjures the black feminized reproductive and caregiving labor—from artists to cleaners to doctors to mothers to writers—as essential to the functioning of society, to every stage of capitalism from the plantation to today.

Leigh's bronze sculpture *Last Garment* (2022; page 255), placed in a pool of water, shows a woman clad in cotton rags and lace typical of the nineteenth-century Jamaican working class, with rosettes for hair, bent over while washing clothing on a stone. The scene is taken from an 1879 souvenir postcard depicting a black Jamaican woman laundering clothes in a river set against a lush backdrop of foliage (fig. 2). The postcard was in wide circulation in the late nineteenth and early twentieth centuries, after the end of slavery in the Caribbean, as the British Empire sought to transform former sugar colonies into tourism destinations and to continue the extraction and oppression of the black populations by marketing the Caribbean as a tropical paradise, a verdant landscape populated by "noble savages." What could be more unthreatening to a potential visitor than the sight of a black woman dressed in rags washing clothes in the river? The visual codes of the souvenir postcard communicate that the woman is an undesirable, simple, innocent thing who would be corrupted by modernity and education. What the image, along with that of the woman in the Oscar Wilde caricature, offers contemporary viewers is a moment to reckon with these women, to try to see past the racist and misogynist lens of the photographers and customers. These two images made a mere decade apart are of the same project of racial capitalism and white patriarchal hegemony, its roots running deep in the Caribbean and the Americas. Leigh's study of these images, in video, bronze, and ceramic, reframes and recasts the women upon whom these ideals were projected, releasing them from the bondage of their representation.

The figure in *Last Garment*, modeled by the writer Sharifa Rhodes-Pitts, a frequent collaborator and friend of Leigh's, is doubled over and doubled up, mirrored in the water's surface in an intense, everlasting moment of inward reflection,

of introspection. The pose, a complicated vision of fortitude, strength, and discomfort, is similar to that of the woman photographed in 1879 but also resonates with two of Leigh's earlier works, both from 2017: *Dunham II* (page 151) and *Cupboard VII*. For the latter, shown at the New Museum as part of the group exhibition *Trigger: Gender as a Tool and Weapon*, Rhodes-Pitts performed within the bounds of the raffia structure in a similar bent-over pose while her head and shoulders were immersed in the walls of the sculpture. In *Dunham II*, named after the legendary dancer and multihyphenate Katherine Dunham, a bent-over figure made of terracotta and steel[13] hinges at the hips, her shoulders disappearing into the wall. The neck of a vessel emerges out of the side of the figure's hips, transforming them into an anthropomorphic pot, exploring the complexities held within the notion of a laboring body, one made to carry and to bear, as well as an empty vessel, and a capacious conduit.

On Plantain and Porcelain

In *wedgewood bucket* (2009; page 67), several blue porcelain plantains are contained within a red plastic bucket, the ubiquitous kind one might find in a market or homewares store in Brooklyn, London, Lagos, or Bridgetown. Plantain, a cooking banana, part of the *Musa* family, was imported to the Caribbean from Southeast Asia as a cheap provision for the enslaved; it has since become a widely grown staple food, appearing daily on Caribbean plates, as well as on those across the diaspora. The fruit is loaded with historical and cultural connotations. Tied to ongoing questions of trade and labor, Martinique's chlordecone scandal, and slurs hurled at black people in general, the fruit has been used as a signifier of race and place. Leigh's blue plantains take on another signifier with complicated links to the Caribbean: Wedgwood, a fine china and porcelain manufacturer founded in England in the mid-eighteenth century. The luxury brand's trademark blue-and-white jasperware was proudly displayed in china cabinets across the globe (including in Leigh's own mother's). The founder, potter Josiah Wedgwood, was an abolitionist (despite selling many wares to slave owners and thus indirectly profiting from enslaved labor); his medallion with a motif of a kneeling man in chains accompanied by the words "Am I Not a Man and a Brother?" was distributed widely on pottery and in print.

Leigh similarly deployed the plantain in *Slipcover* (2008; page 69) and *Brooch #1* (2004; page 59), creating a series of works that speak to questions of respectability politics, the

12 Françoise Vergès, "Capitalocene, Waste, Race, and Gender," *e-flux Journal*, no. 100 (May 2019), https://www.e-flux.com/journal/100/269165/capitalocene-waste-race-and-gender/.

13 For the current exhibition, Leigh remade this work in bronze as *Dunham* (2023).

home, histories of the Caribbean, and diaspora aesthetics. *Brooch #1* assembles numerous plantains into the shape of a gigantic wall-based breastpin, its demure-sounding title dissonant with its appearance, like an insect, alien, or satellite that projects from the wall. *Slipcover* gathers a number of skin-toned porcelain plantains into a steel grid, the whole construction wrapped in a zipped-up plastic sofa cover. The plantains' intimate skin tones derive from a series of dolls that Leigh found,[14] a recognition of colorism, another afterlife of colonialism.

Women's intellectual, emotional, and physical labor underpinned the organization and (re)production of the Caribbean plantation and what came after, as well as its Capitalocenic futures. Leigh has said, "The tendency when people hear Black women's stories is to focus on what happened *to* them, not the intellectual labor and creativity they brought to the situation. . . . My work is about what they did *from* those compromised positions—the labor, the care, the love, the ideas."[15] As such, Leigh's artistic explorations sit within a broader project of black feminist critique that seeks to highlight not only the ways that our bodies, labor, subjectivities, and souls have been exploited and debased but also the many contributions, innovations, spaces, and futures made possible by black women.

It is the very centering of black women's experiences and ontologies in Leigh's work that constitutes the living legacy of resistance and struggle on the plantation and *in the wake* (Christina Sharpe)[16] of chattel slavery, in the Caribbean and scattered throughout the diaspora. These resistances are felt in the hybridity and creolization of our epistemologies and cultural traditions, our oral traditions, and our communities of care.

14 Leigh, conversation with the author, July 7, 2022.

15 Leigh quoted in Mitter, "Simone Leigh, in the World."

16 Christina Sharpe, *In the Wake: On Blackness and Being* (Durham, NC: Duke University Press, 2016).

pages 152 (detail) and 153
Figure With Skirt, 2018
Terracotta, graphite, porcelain, steel, and raffia
79 1/2 × 70 × 70 inches (201.9 × 177.8 × 177.8 cm)

facing
Dunham II, 2017
Terracotta, graphite, and steel
41 1/2 × 22 × 23 inches (105.4 × 55.9 ×58.4 cm)

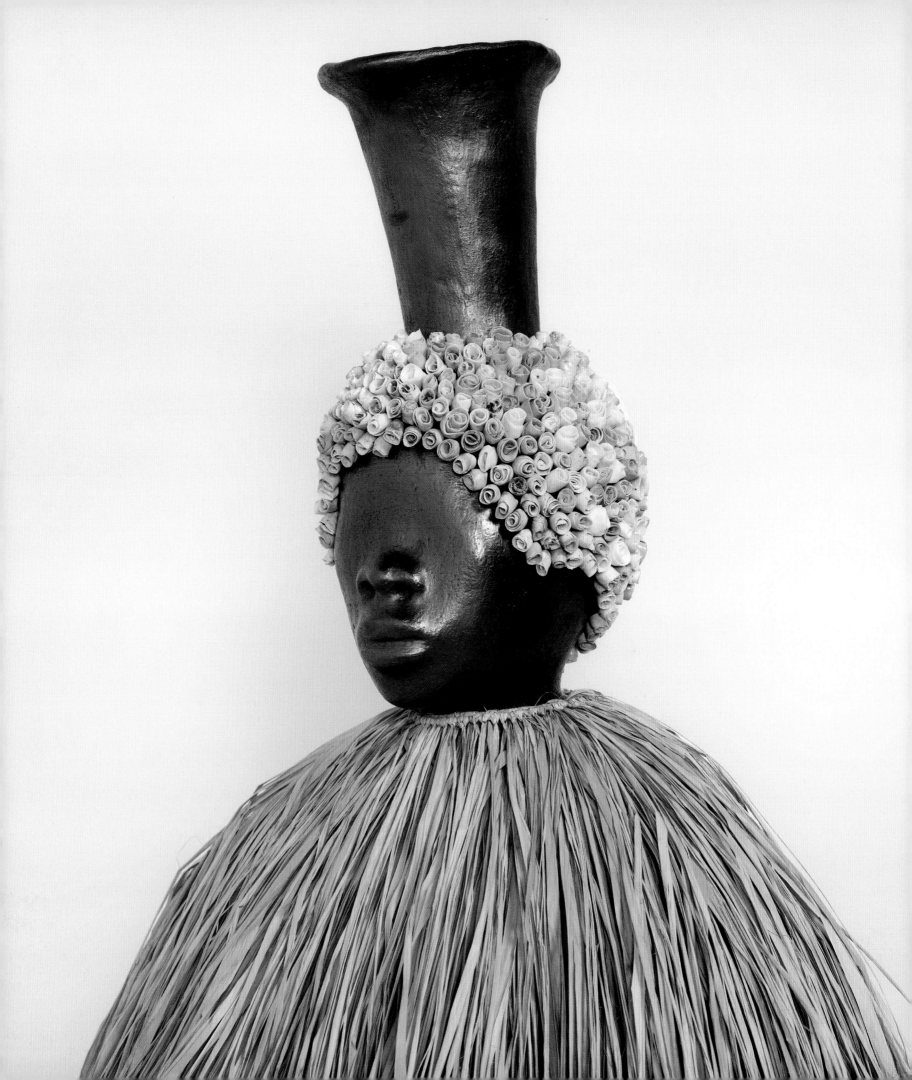

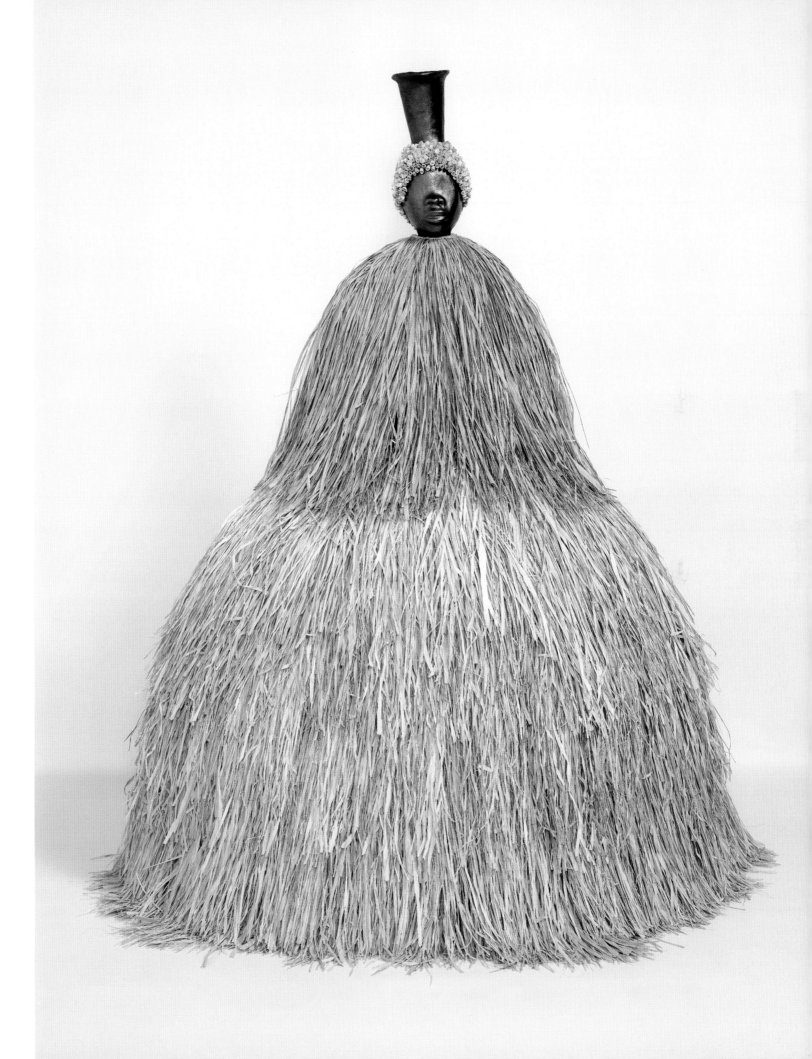

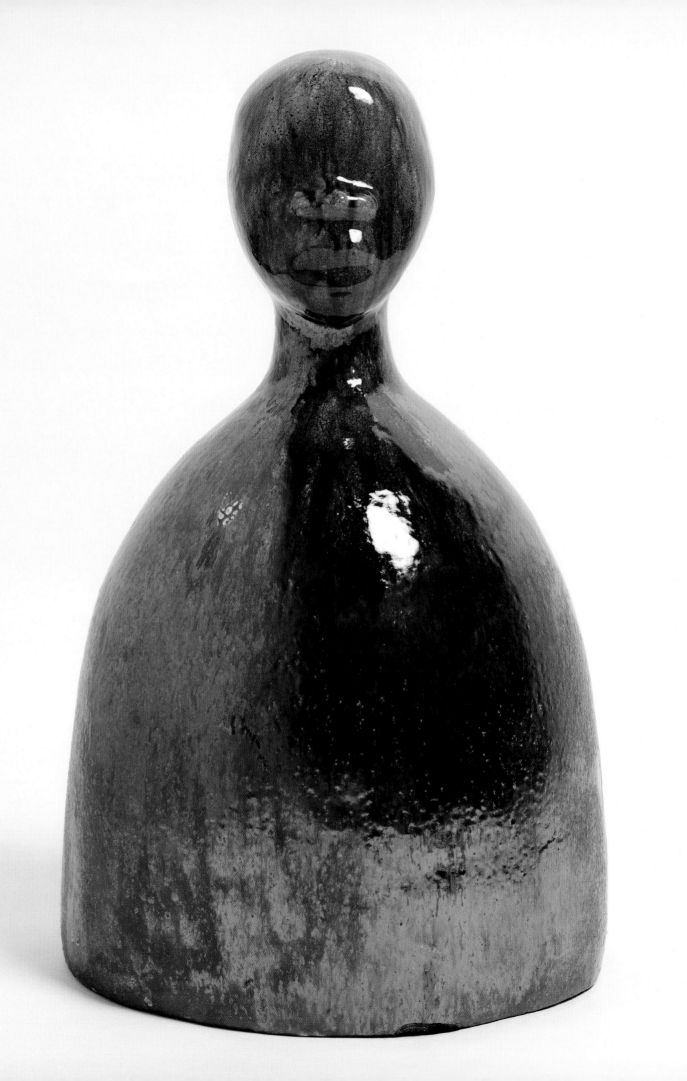

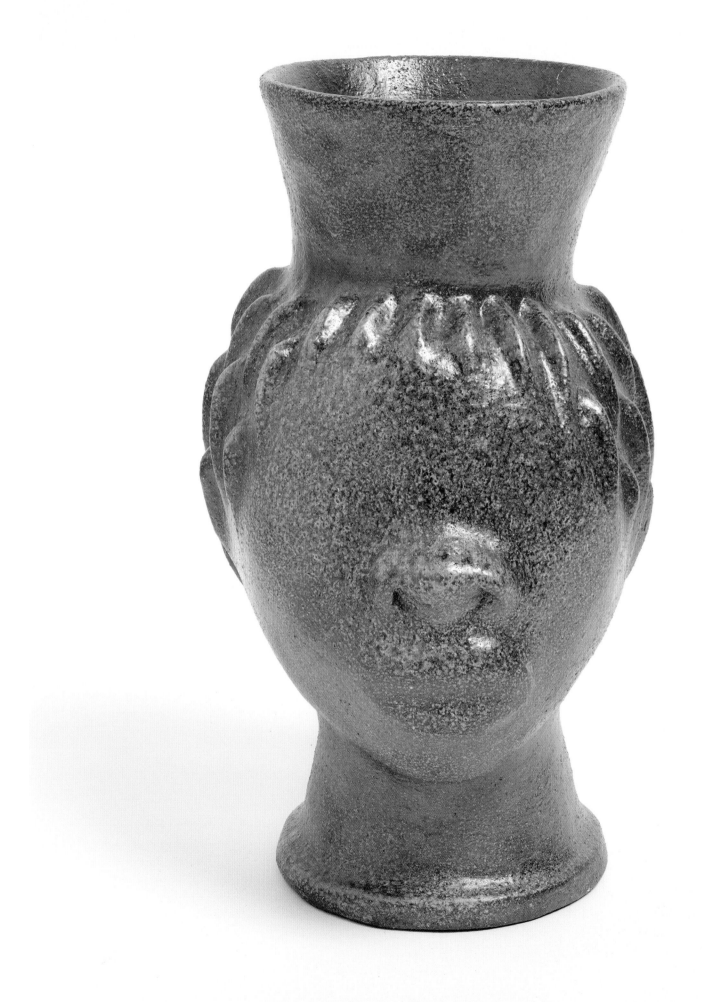

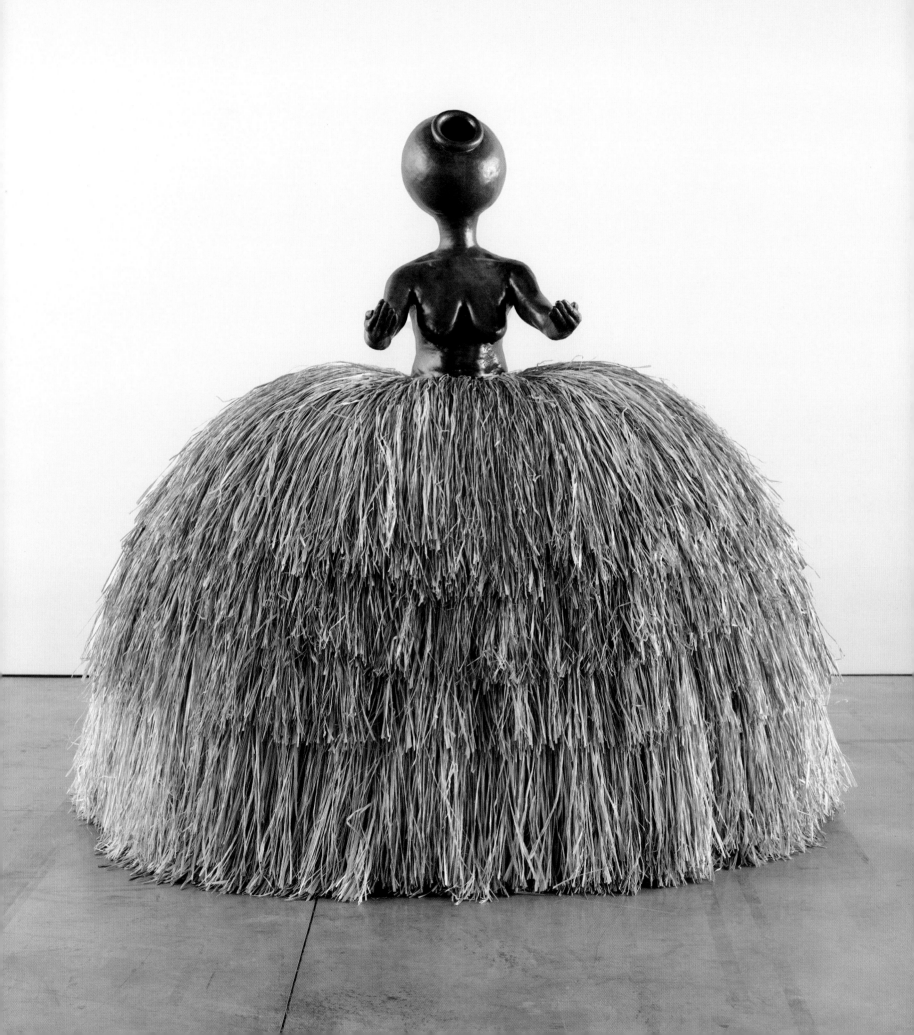

Cupboard IX, 2019
Stoneware, raffia, and steel armature
78 × 60 × 80 inches (198.1 × 152.4 × 203.2 cm)

pages 162–63
Installation view, *Simone Leigh*, Luhring Augustine Chelsea,
New York, 2018

pages 164–65
The Village Series #1, 2018
Stoneware
Two elements, each 16 × 16 × 16 inches (40.6 × 40.6 × 40.6 cm)

facing
No Face (Pannier) (detail), 2018
Terracotta, graphite, porcelain, raffia, epoxy, and steel armature
72 5/8 × 75 × 58 inches (184.5 × 190.5 × 147.3 cm)

160

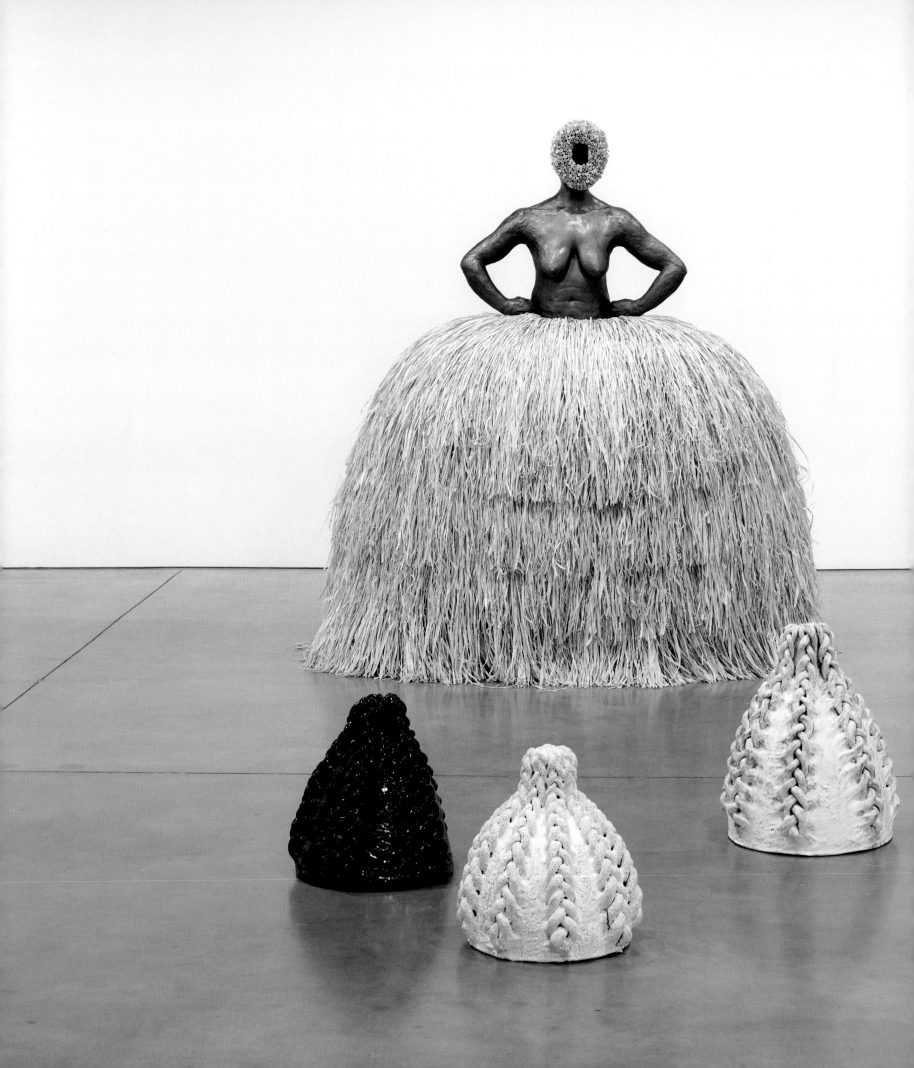

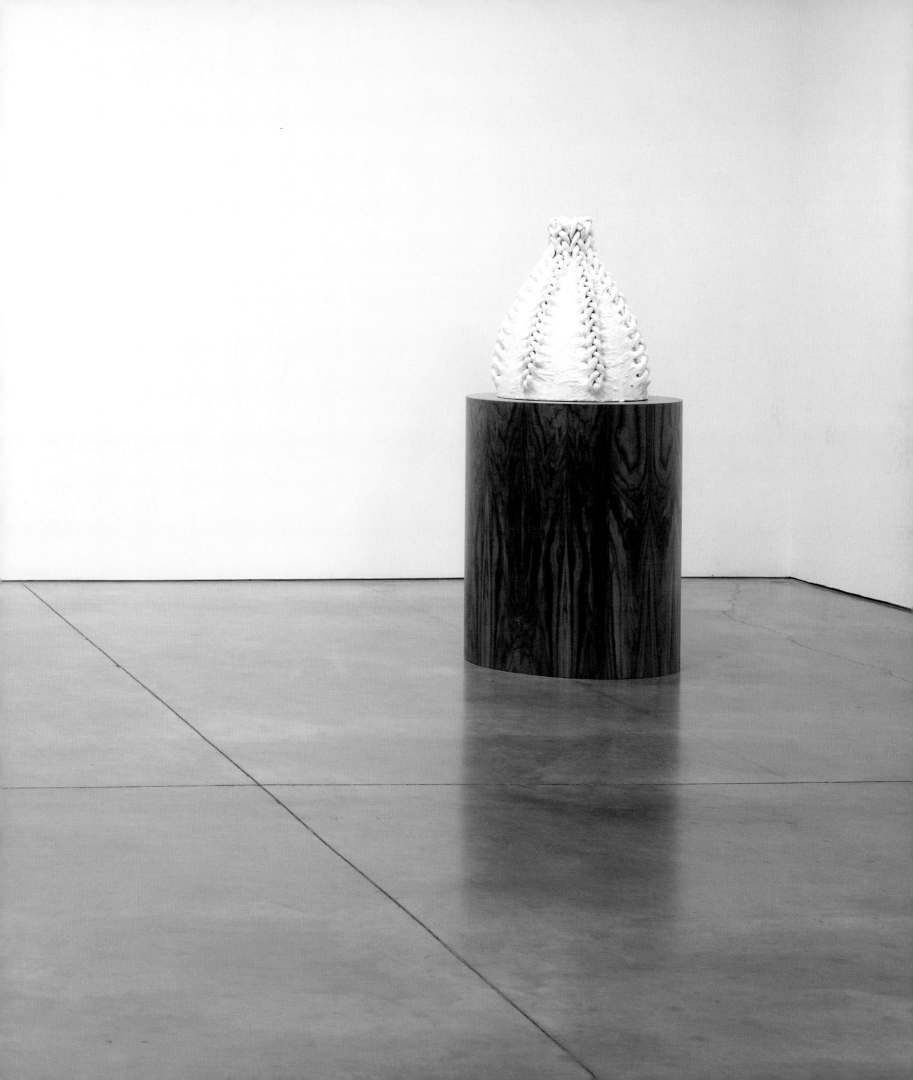

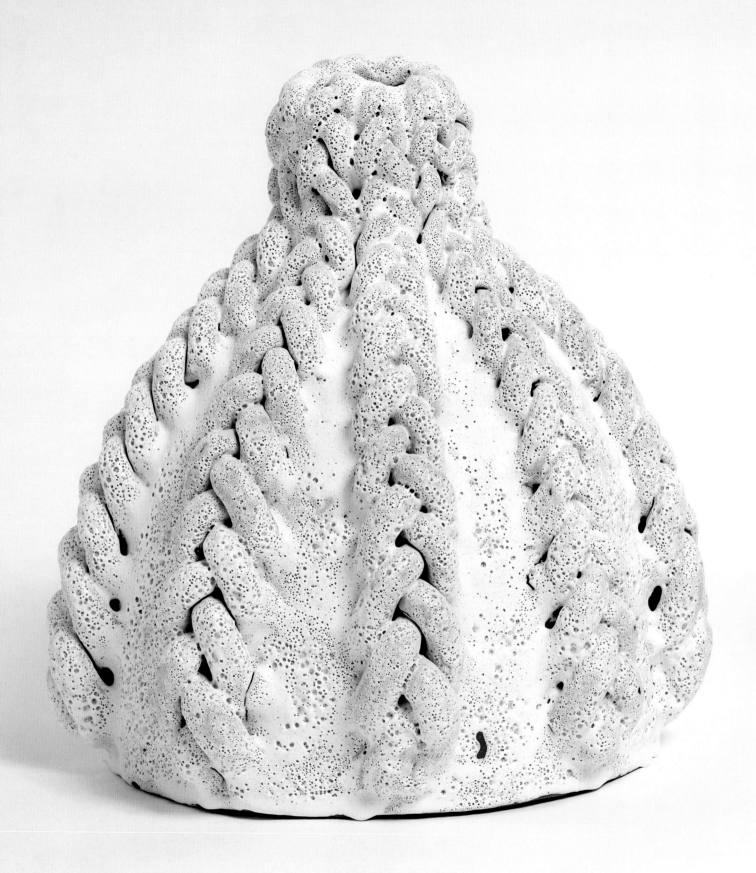

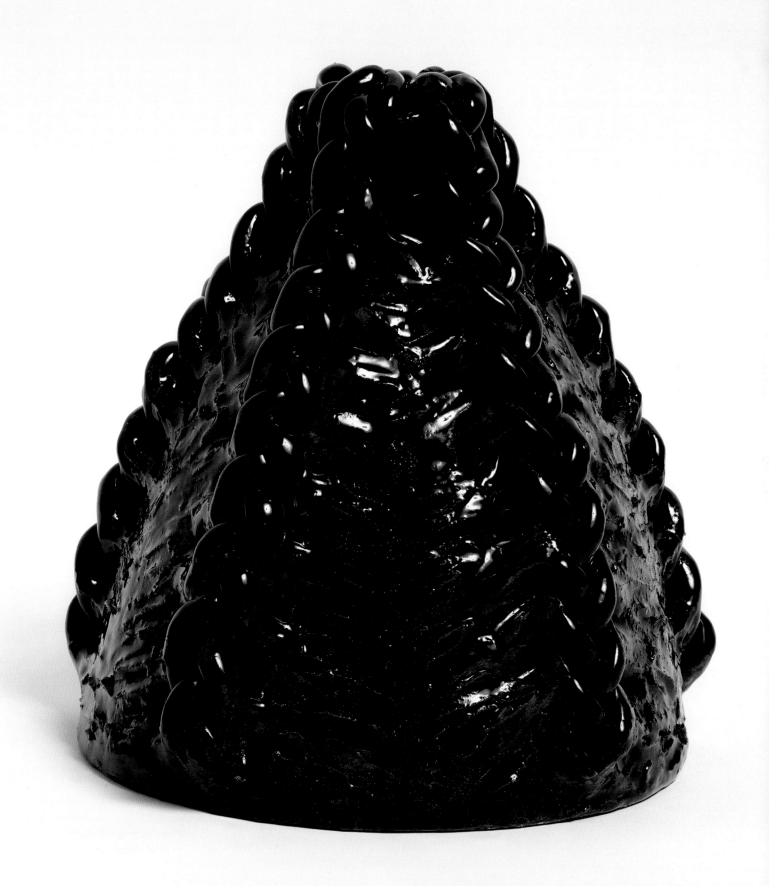

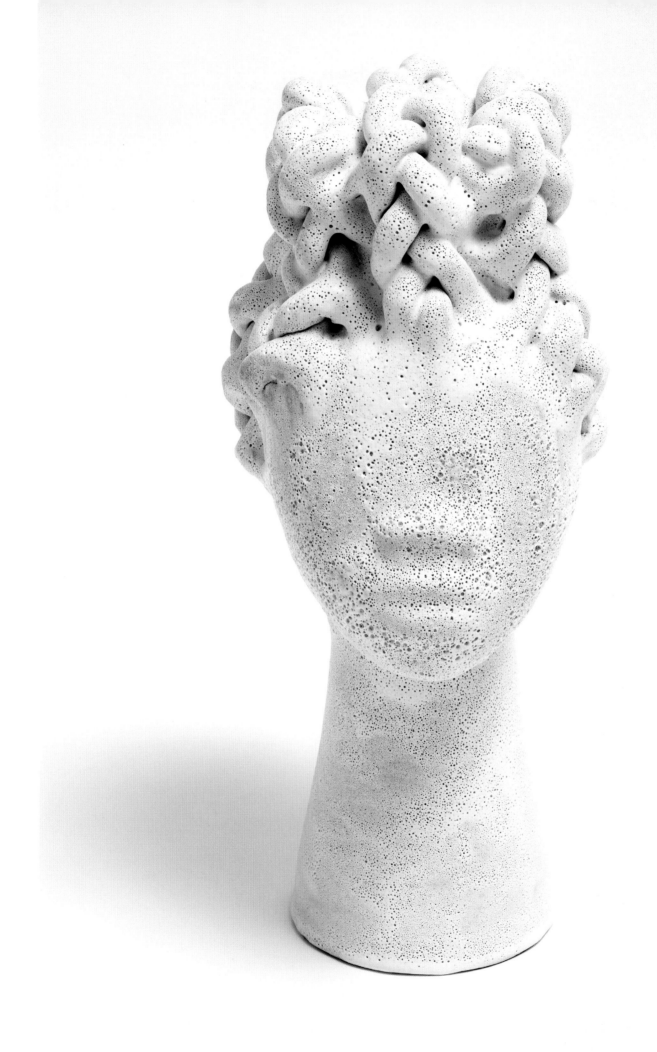

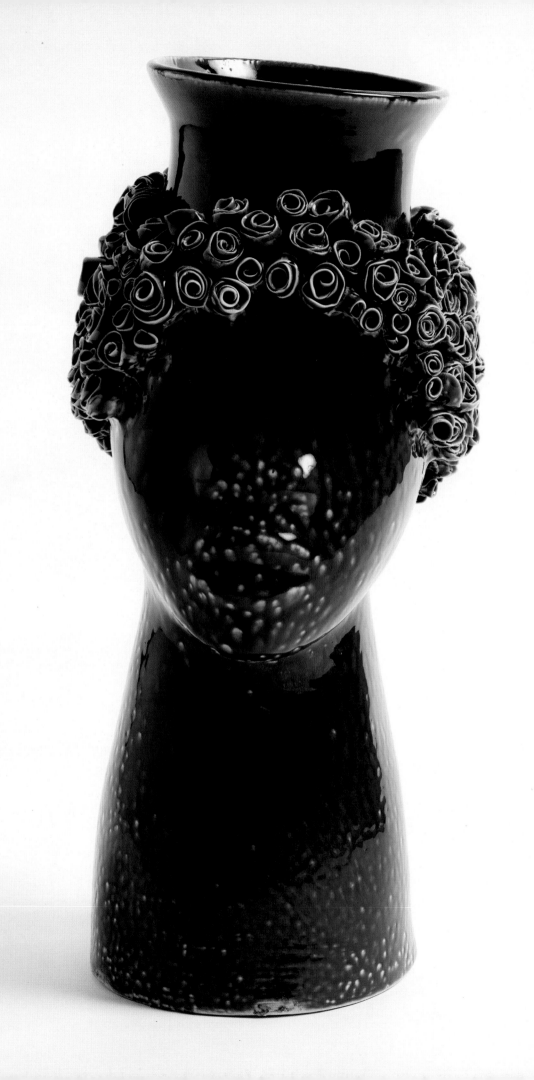

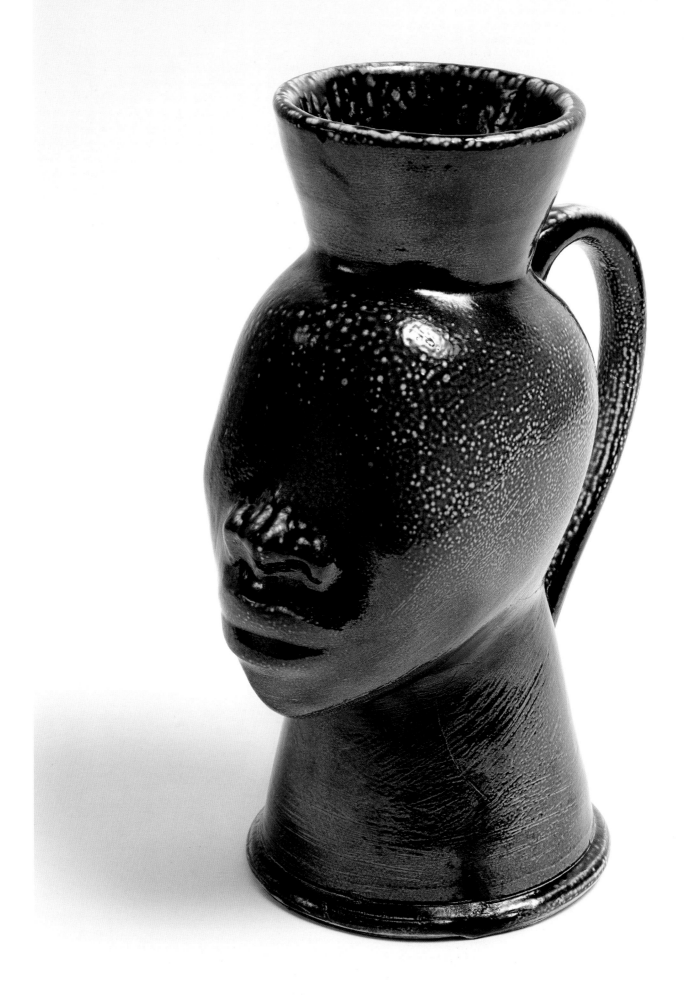

Georgia Mae, 2017
Stoneware, porcelain, and resin
34 1/4 × 14 3/4 × 15 inches (87 × 37.5 × 38.1 cm)

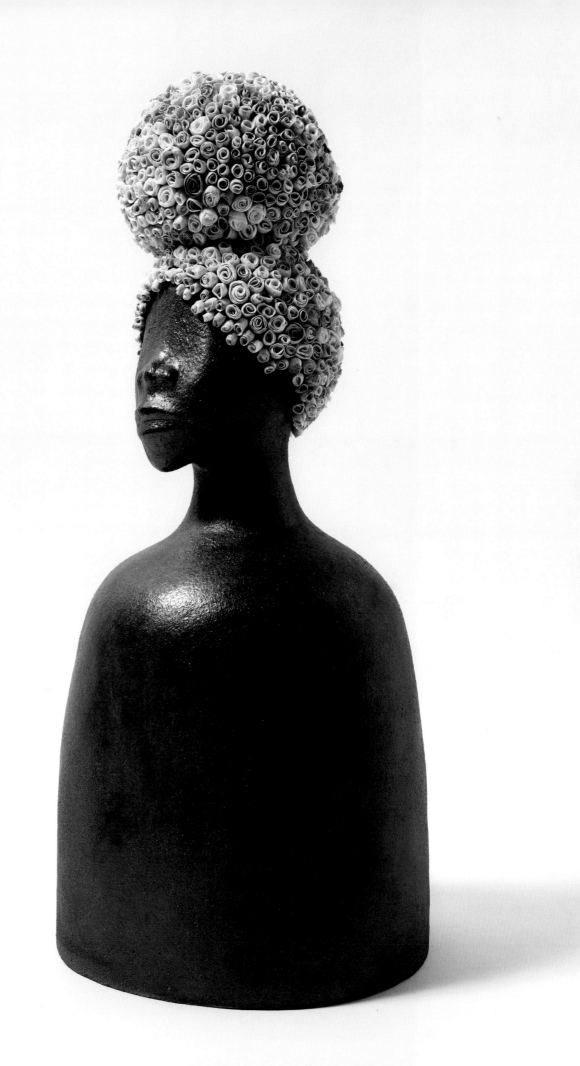

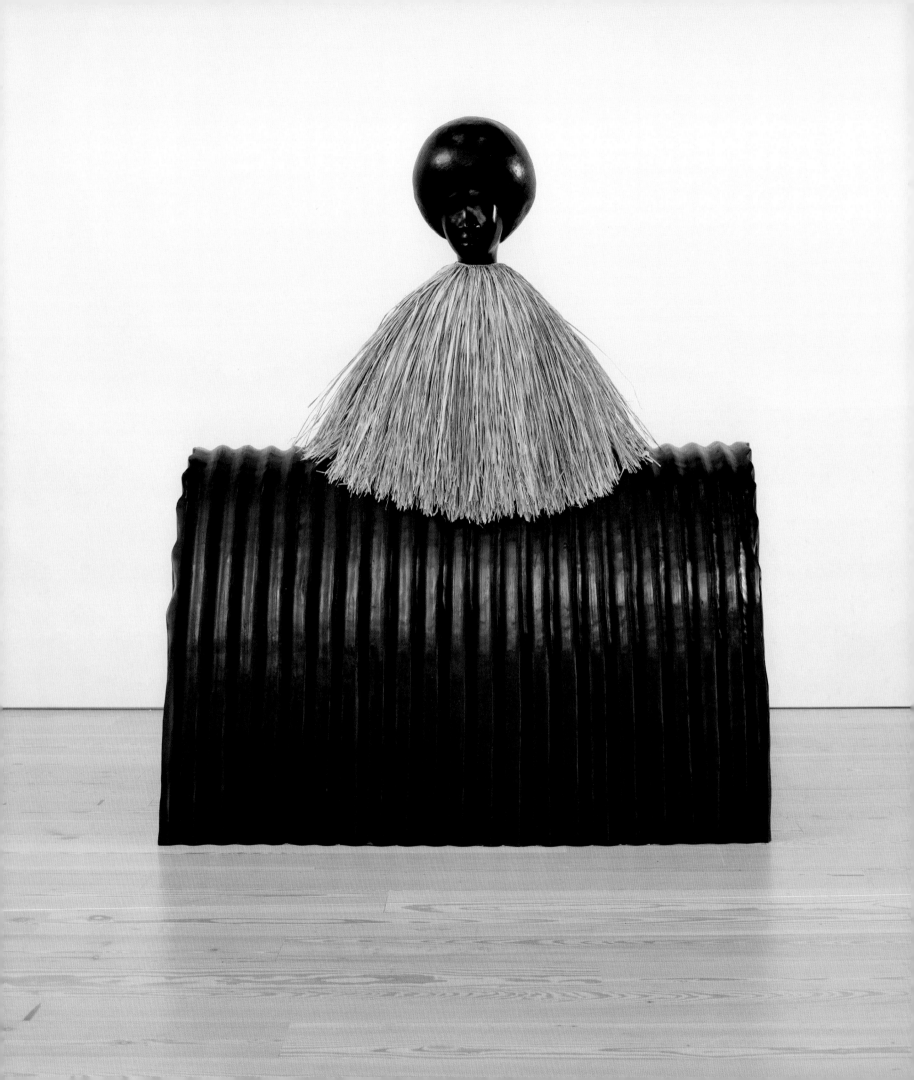

Corrugated, 2019
Bronze and raffia
73 × 81 × 40 1/2 inches (185.4 × 205.7 × 102.9 cm)

173

Stick, 2019
Bronze
85 × 63 × 63 inches (215.9 × 160 × 160 cm)

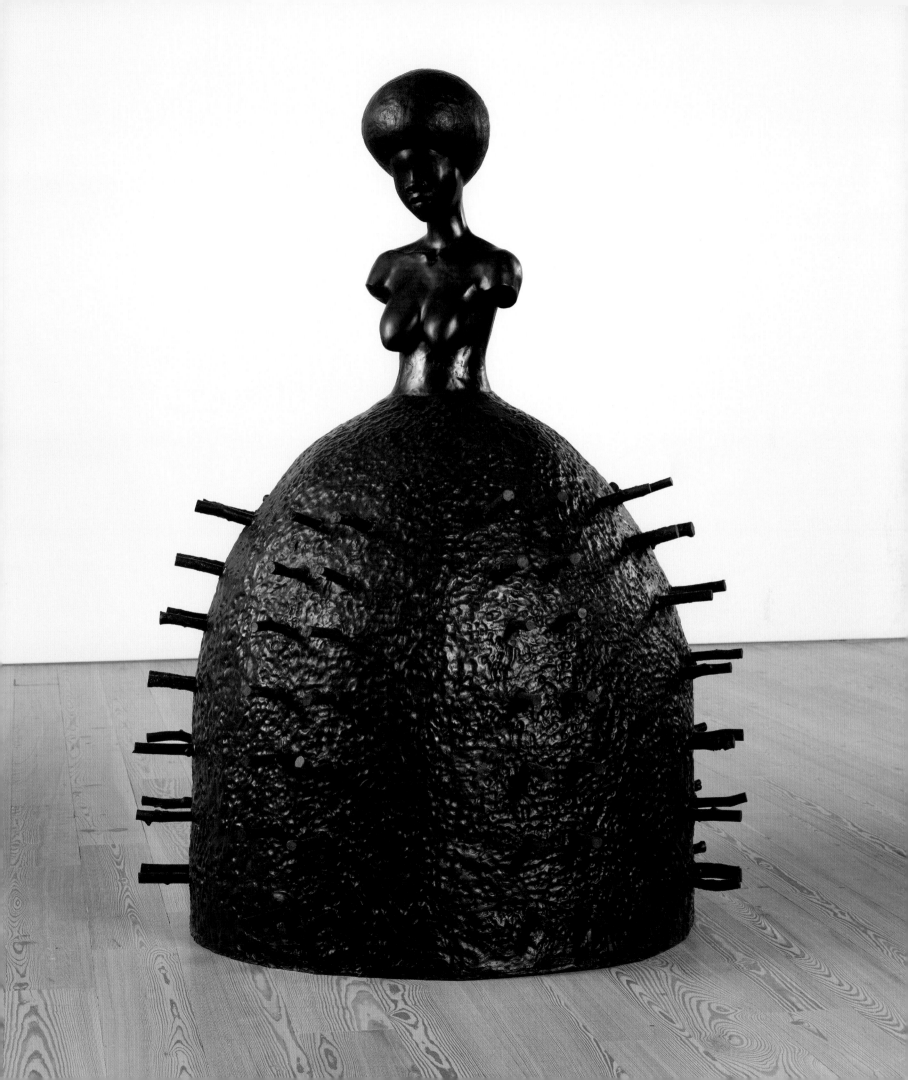

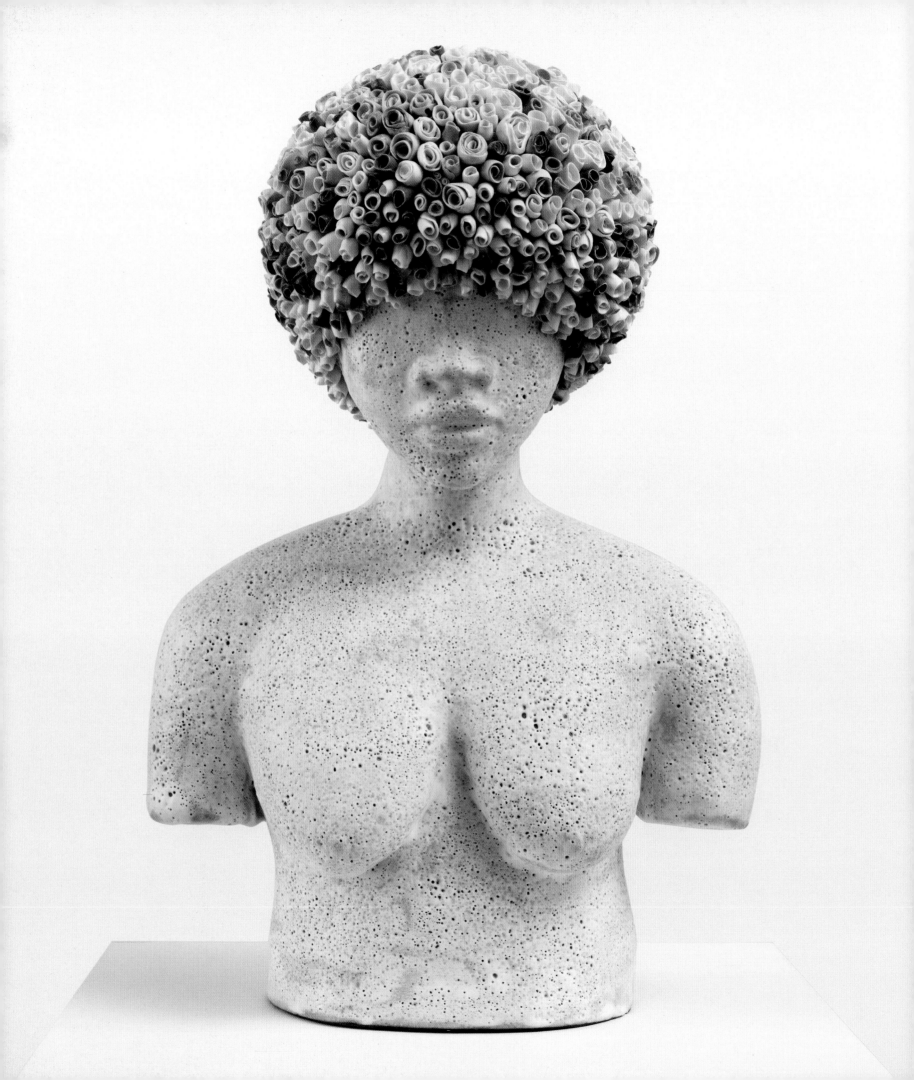

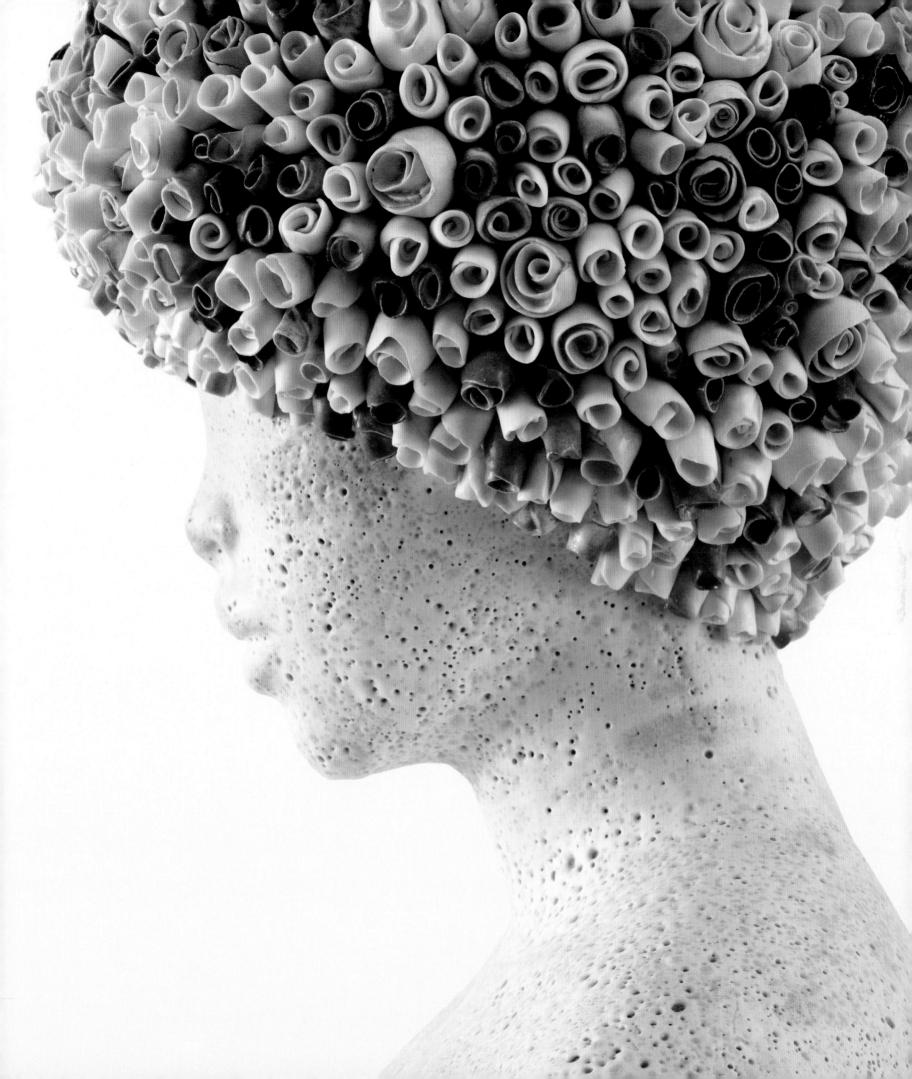

pages 176 and 177 (detail)
Untitled, 2021
Stoneware
26 × 11 3/4 × 9 inches (66 × 30 × 22.9 cm)

facing
Dunham, 2017
Terracotta, porcelain, raffia, steel, glass beads, epoxy, and India ink
35 × 30 × 30 inches (88.9 × 76.2 × 76.2 cm)

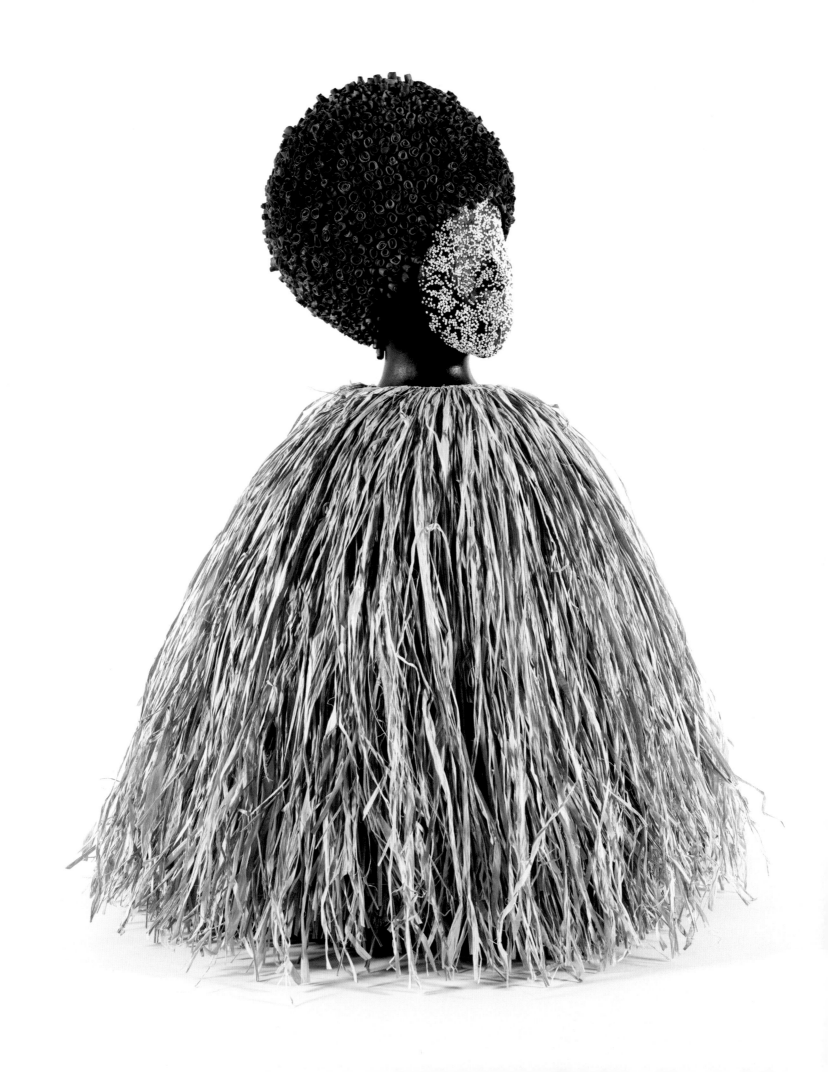

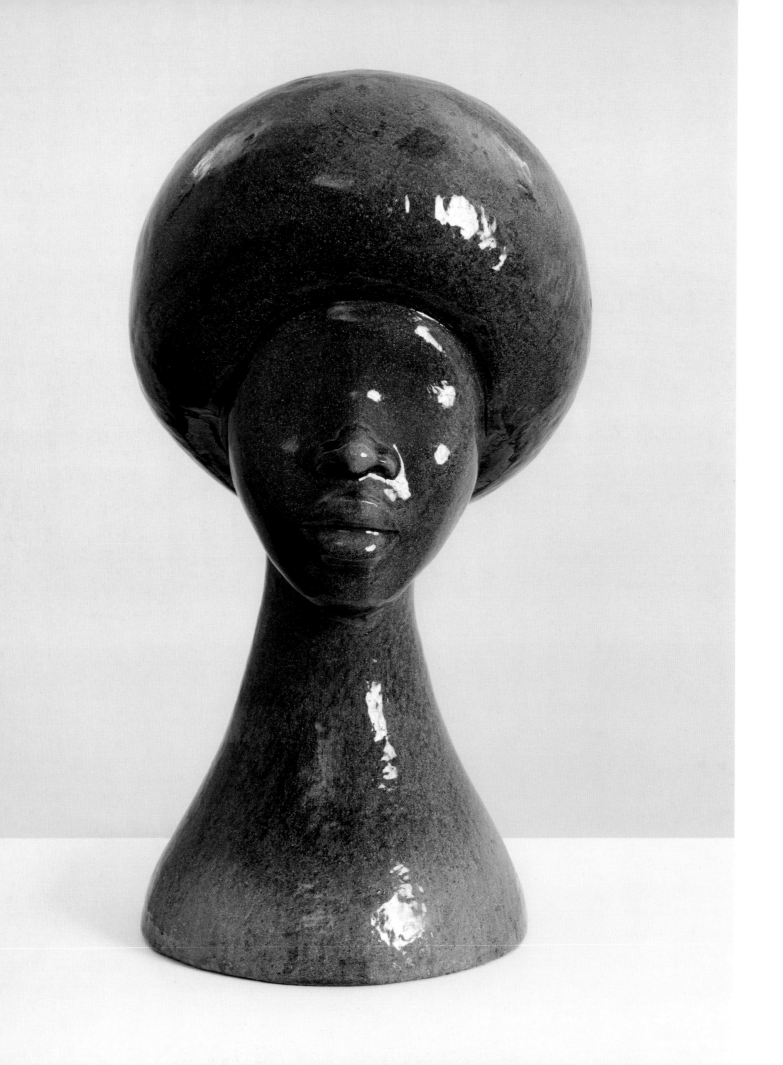

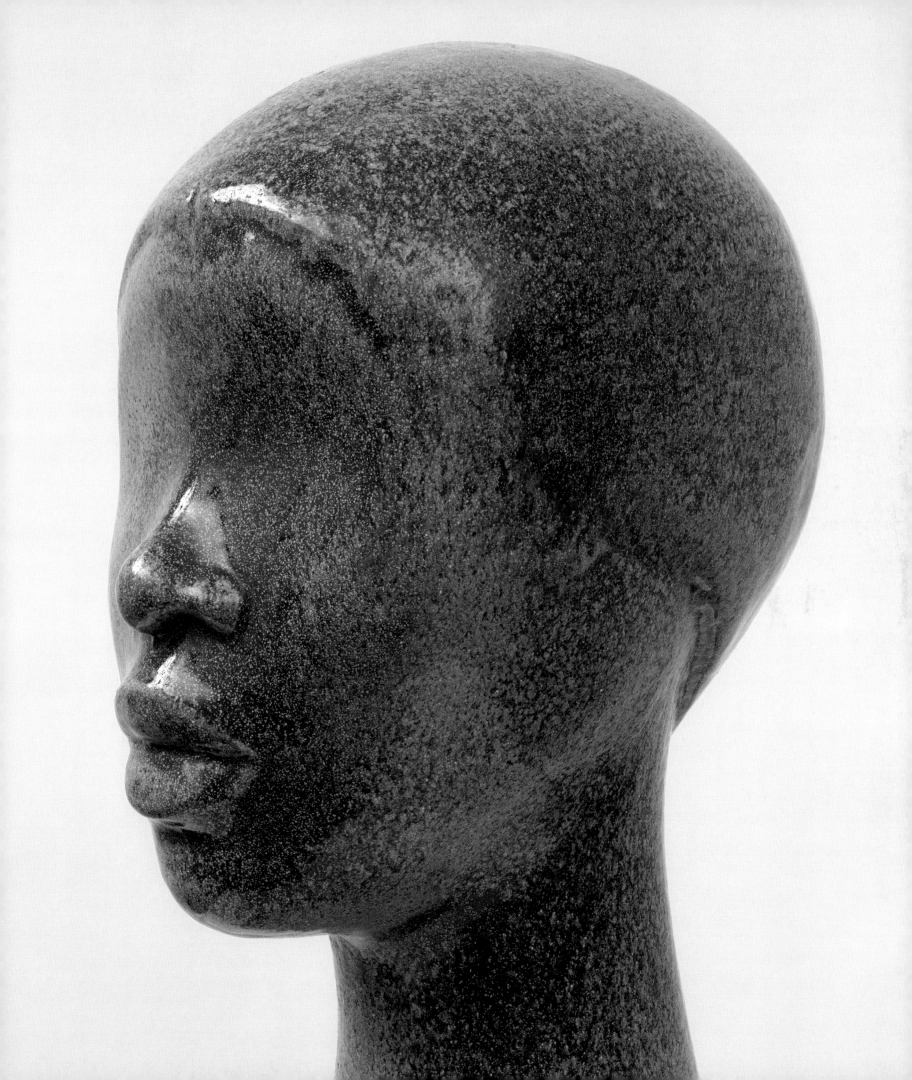

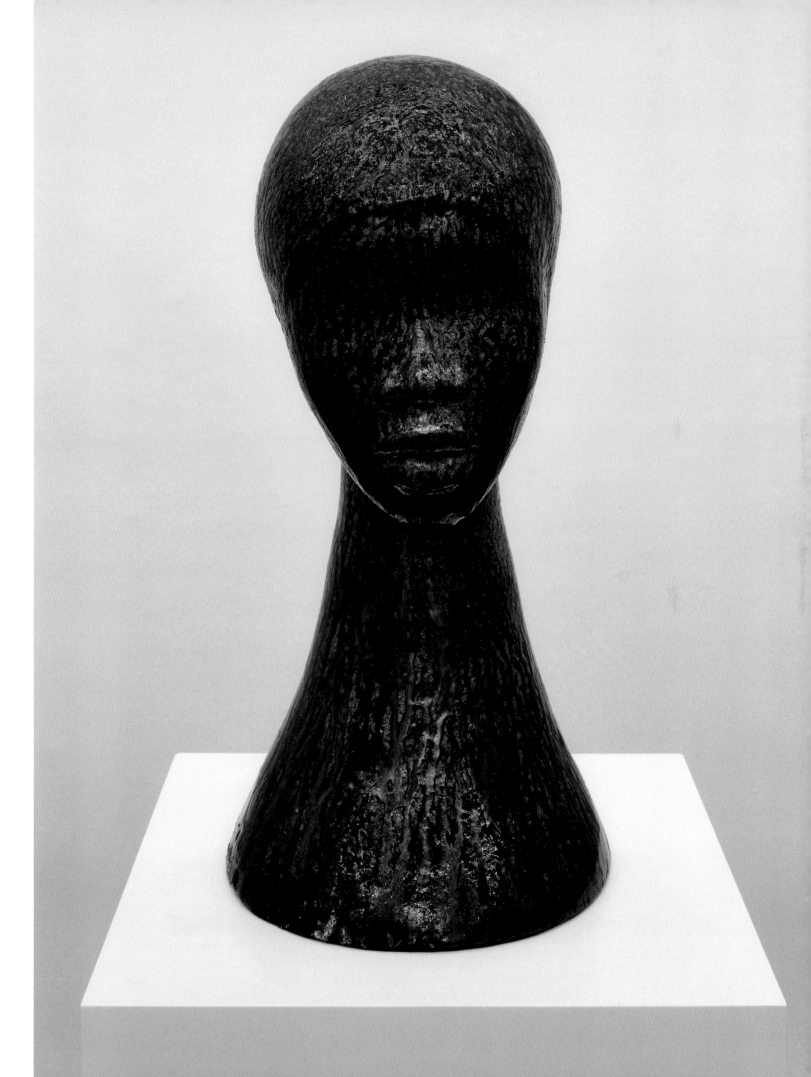

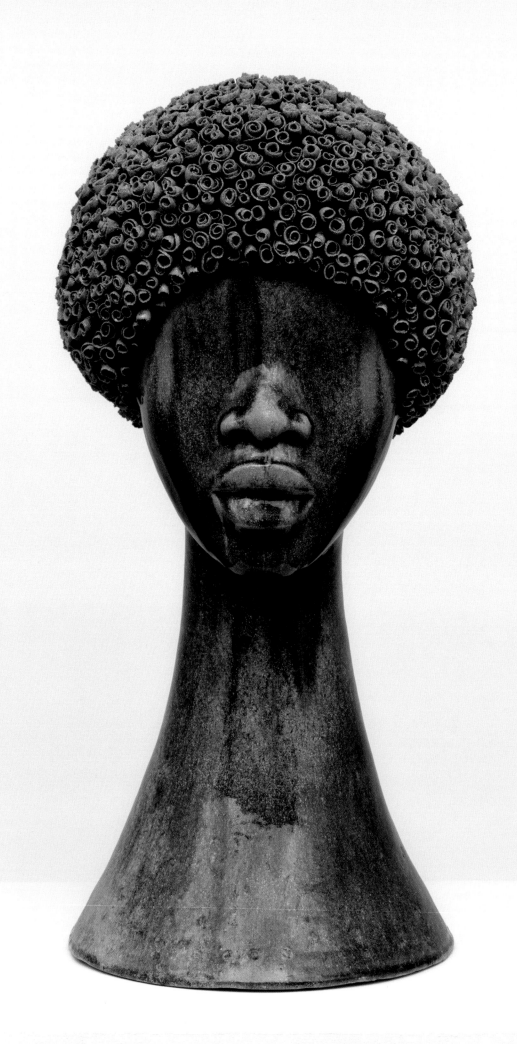

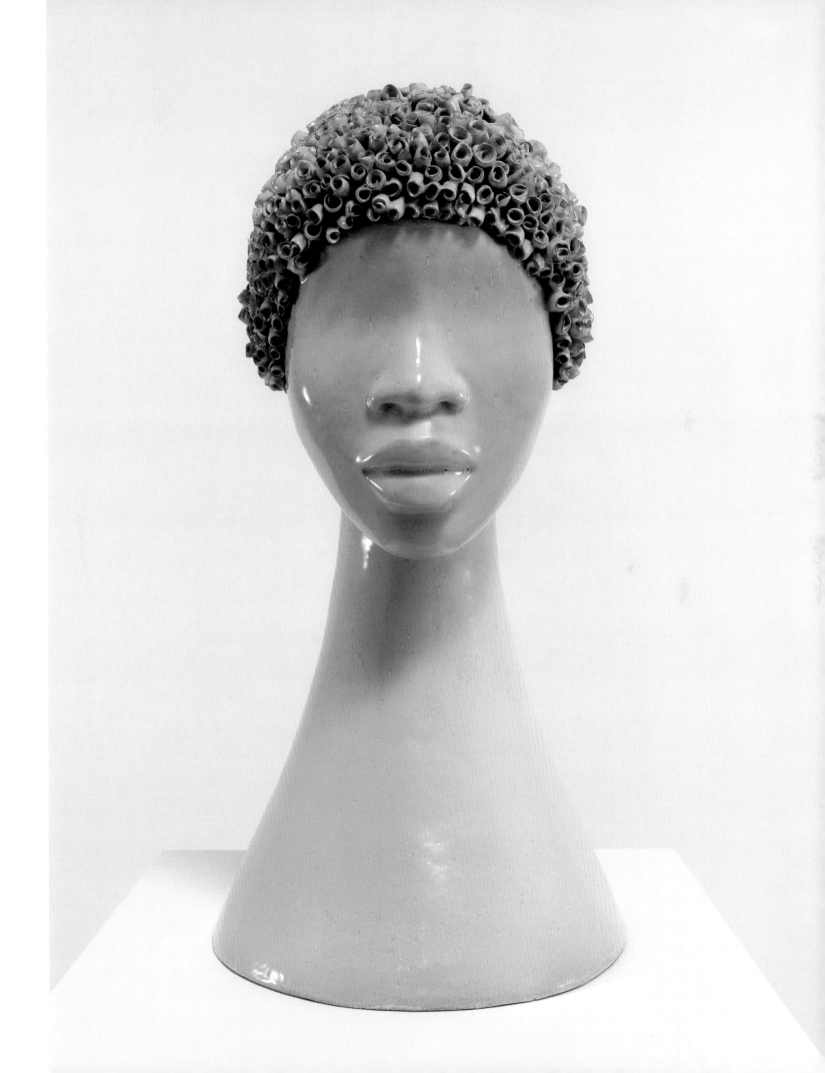

page 184
Titi (Igneous), 2021
Stoneware
26 1/4 × 13 1/4 × 12 inches (66.7 × 33.7 × 30.5 cm)

page 185
Titi (1352-Y), 2021
Stoneware
25 1/2 × 12 1/4 × 14 1/4 inches (64.8 × 31.1 × 36.2 cm)

facing
Sentinel IV (Gold), 2021
Bronze and gold
128 × 25 × 15 inches (325.1 × 63.5 × 38.1 cm)

186

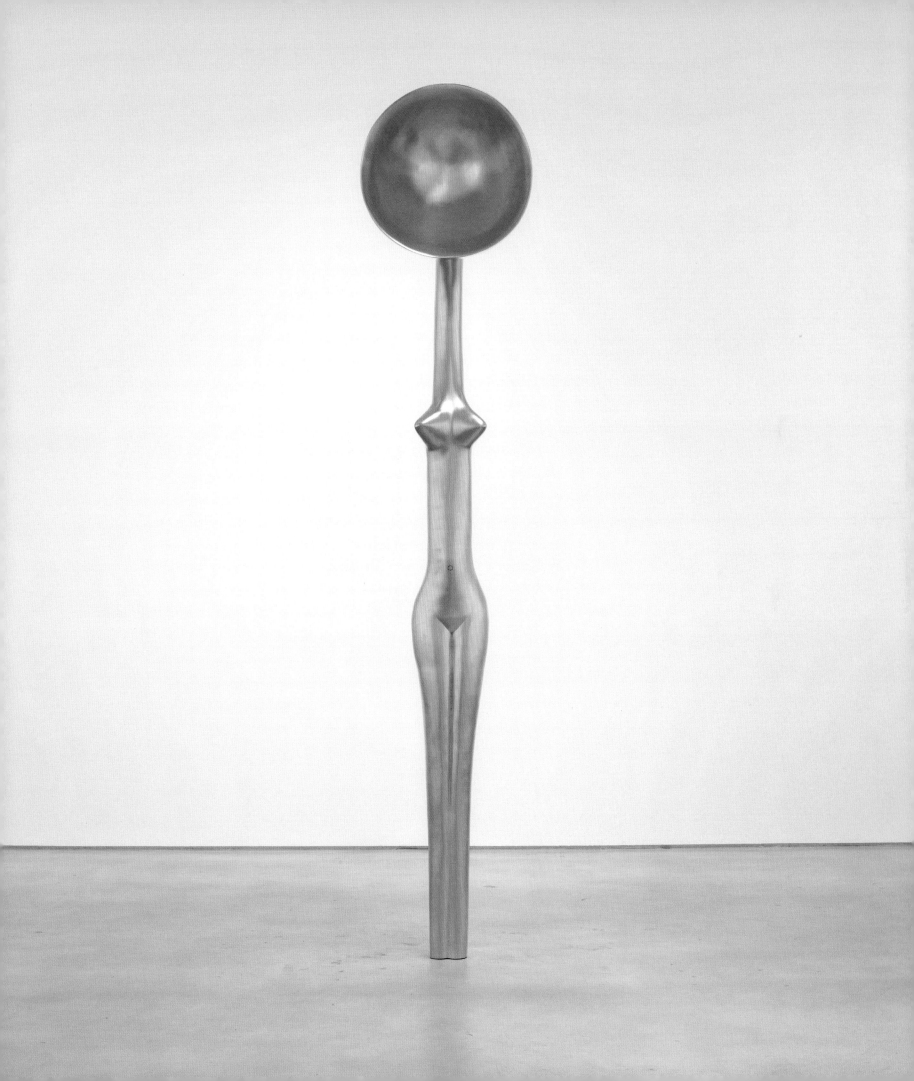

facing and pages 190–91 (details)
Untitled, 2022
Stoneware
28 × 17 1/4 × 11 3/4 inches (71.1 × 43.8 × 29.8 cm)

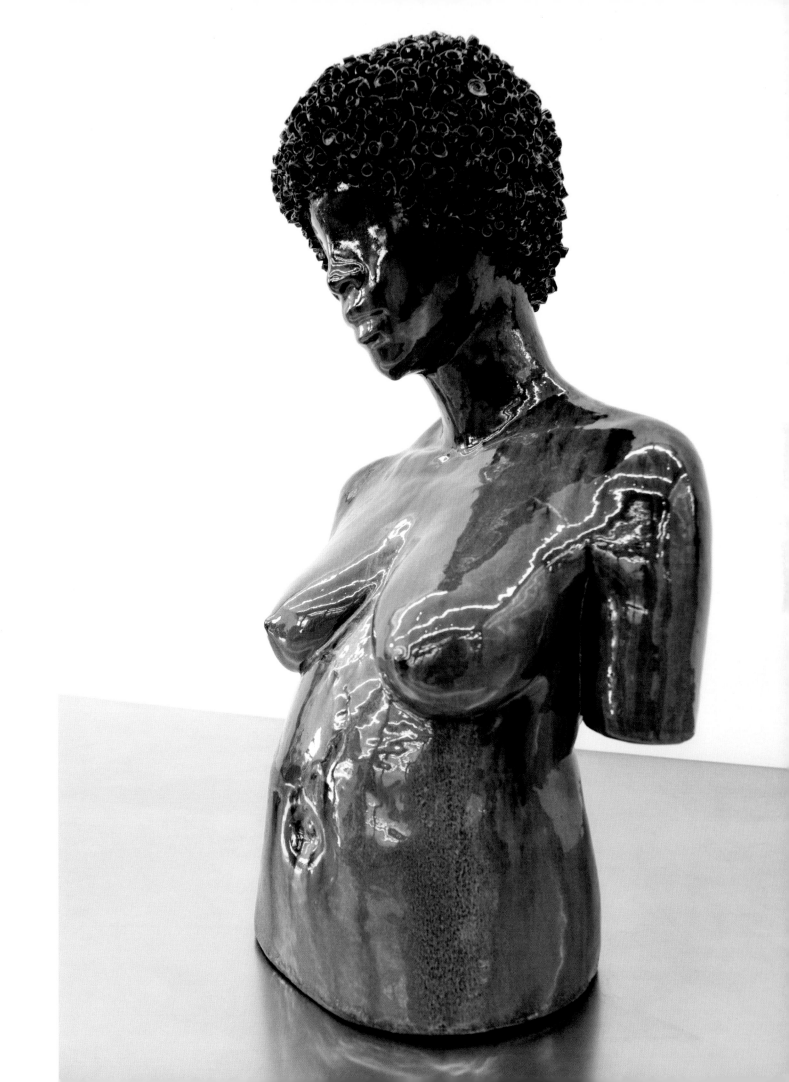

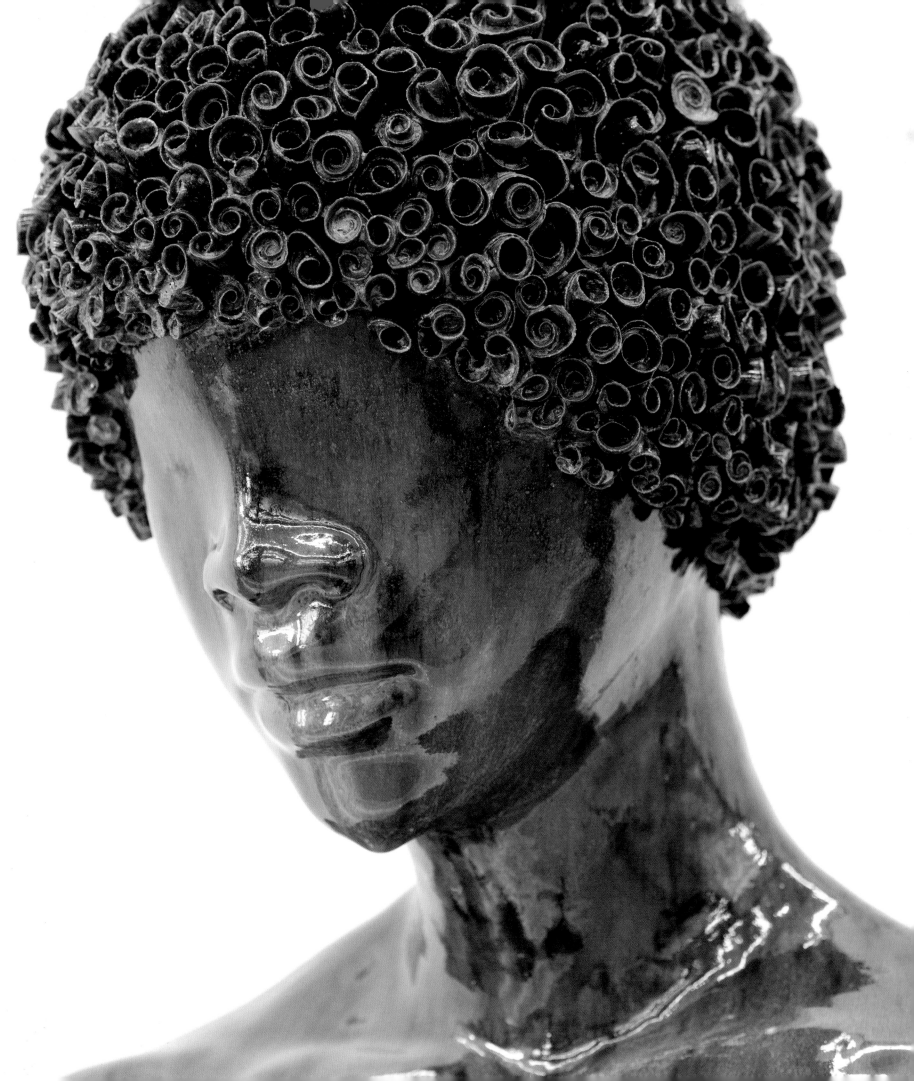

Planet, 2021
Stoneware, raffia, and steel armature
101 1/2 × 44 1/2 × 47 inches (257.8 × 113 × 119.4 cm)

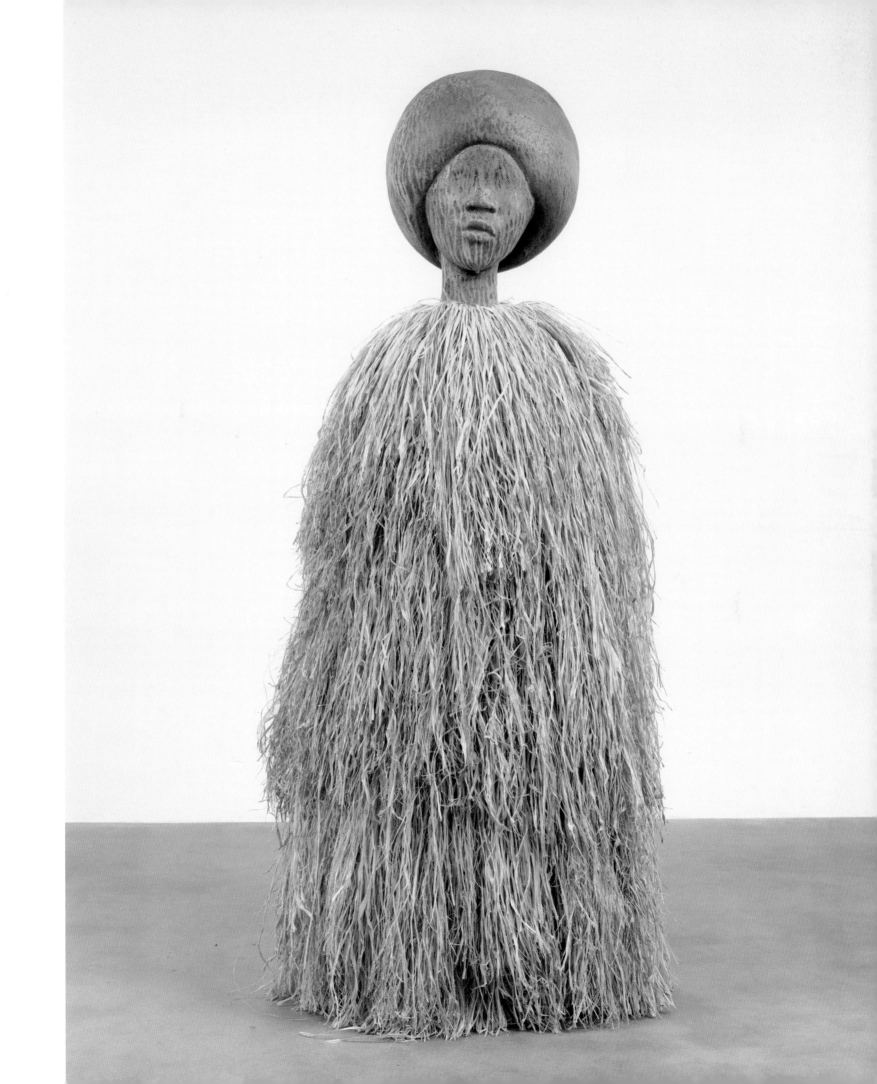

Steven Nelson

Simone Leigh:
The Alchemy of Architecture

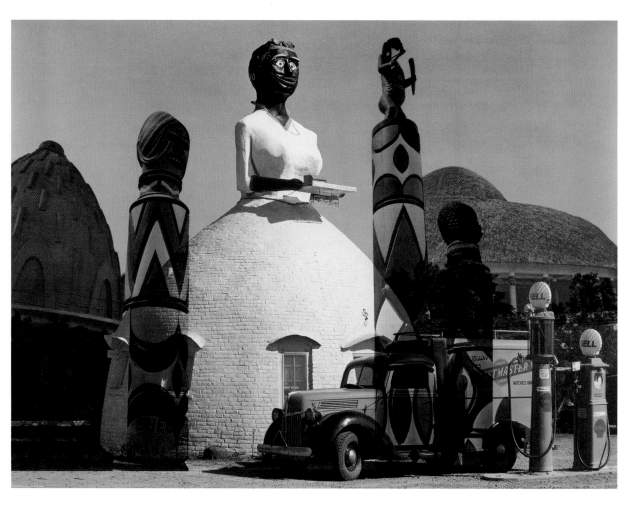

Fig. 1 *Landscape (Anatomy of Architecture Series)*, 2016. Digital collage.
Dimensions variable

In 2009 Simone Leigh created the installation *The Gods Must Be Crazy* at the SculptureCenter in New York (pages 64–65). The installation's terracotta pots and plastic buckets and fruits were placed inside a rebar cage, its form inspired by the 1968 movie *Planet of the Apes*. But, as Leigh noted in an interview, "when I started making drawings, I realized it was more like the structure of a Central African teleuk."[1]

Leigh first encountered the domestic structure through a catalogue on the form she saw in her early twenties.[2] Around the time she was conceiving of the cage, though, the two of us had been in conversation about my 2007 book, *From Cameroon to Paris: Mousgoum Architecture In and Out of Africa*.[3] In that study, I considered the Mousgoum domed house, known as a *teleuk*, in a variety of historical and contemporary contexts that considered the building itself as well as its representation from the mid-nineteenth century to the end of the twentieth. What resonated most for Leigh was how the *teleuk* both reflected and structured the experiences of Mousgoum people as well as its position as an ethnographic object in the 1931 International Colonial Exposition in Paris, one of the artist's great obsessions and an impetus for much of her work.

Since *The Gods Must Be Crazy*, architecture has become increasingly important in Leigh's practices, reaching its crescendo in her 2022 Venice Biennale installation, *Sovereignty*. Whether expressed in the construction of a cage, the fusion of a *teleuk* with a Black woman's body, the collaging of imagery of world's fairs and American vernacular architecture (fig. 1), or the all-out reimagining of a neo-Palladian pavilion, architecture and the built environment provide powerful tools for the artist to highlight Black women's subjectivity, labor, and power. The 1931 International Colonial Exposition was the largest display of French imperialism ever mounted. By this time the French empire was enormous: nearly one-third of the world's population was under French rule. One commentator noted, "As a matter of fact there are but few hours of the day when some part of the French colonial domain is not in the full glare of sunlight."[4] Empire was front-and-center in the French psyche, and information about the colonies appeared in a wide range of French sources. Sub-Saharan Africa made up a large part of France's empire, and French perceptions of and fantasies about this part of the world were often projected onto the body of Josephine Baker. Though born in the United States, Baker was a ubiquitous presence in 1920s and 1930s Paris. Indeed, the association of Baker's body with the colonies was made explicit when she was crowned "Queen of the Colonies" during the run-up to the exposition's opening.

Organizers commissioned pavilions representing the scope of France's far-flung dominion. Each pavilion featured re-created architecture from the area. The West Africa Pavilion, for example, was inspired by the fourteenth-century Great Mosque of Djenné in Mali; the Indochina Pavilion by the twelfth-century temple of Angkor Wat. Leigh was particularly drawn to the French Equatorial Africa Pavilion, which showcased a Mousgoum *teleuk*. By the early twentieth century, the *teleuk* was well known in the French popular imagination through colonial journals and postage stamps, as well as through descriptions and photographs of the domestic sculpture from André Gide and Marc Allégret's 1926 journey through West and Central Africa. In addition to Gide's widely known book *Travels in the Congo*, the two travelers' materials on the *teleuk* appeared in the European popular press and publications on modern art. In addition to a refashioned *teleuk*, the pavilion also included flora and fauna from French Equatorial Africa, which comprised present-day Congo, Gabon, Central African Republic, and Chad, as well as information about the subjugation of the colony, some of its peoples, its raw products, and French improvements to infrastructure. To add authenticity to the setting, thirty-seven people from the colony were imported, living in the pavilion during the exposition's run. Other pavilions were similarly appointed. Indeed, the exposition's millions of visitors were able, as organizers stressed, to take a tour of the world in a day.

In effect, the exposition, with its exotic locales re-created on Parisian soil and its naming of Baker as queen, was not about the colonies, the people who populated them, or the popular African American performer. Though organizers stressed that the exposition was intended to make the colonies feel that they were part of France, these things were brought together to assert French nationalism in ways that affirmed to the French public that the colonies were a necessary component of the state. The primitivist buildings and bodies of the colonized were appropriated as elements of French identity.

1 Kemi Ilesanmi, "An Interview with Simone Leigh," *Art21 Magazine*, May 21, 2009, https://magazine.art21.org/2009/05/21/an-interview-with-simone-leigh /#.YurApuzMKF0.

2 See Jane Ursula Harris, "Moulting," *Believer Logger*, March 31, 2015, https://www.thebeliever.net/logger/2015-03-31-moulting/.

3 Steven Nelson, *From Cameroon to Paris: Mousgoum Architecture In and Out of Africa* (Chicago: University of Chicago Press, 2007).

4 "France's Far-Flung Colonial Domain," *Literary Digest* 72, no. 6 (February 11, 1922): 27.

In short, the exposition was a complex, architectonic French self-portrait.[5] Looking at the conflation of Baker's body with the colonies, studying the spaces the French created for the exposition, and understanding the colonized as staged for the codification of France's imperial project, Leigh noted, "I was struck that [the exhibition] was a reenactment of the colonial project while it was still happening. The effect was profound."[6]

Leigh studied the histories of the fair through images and texts. She paid close attention to the Mousgoum *teleuk*. As Leigh learned more, her obsession with the exposition merged with her background in Black feminism. Though Audre Lorde would tell us that the master's tools will never dismantle the master's house, Leigh remarked in response to the 1931 International Colonial Exposition, "This was the first time I thought to use the master's tools as inspiration and form in my work."[7] She kept examining the exposition, studying the histories and legacies of European and American imperialism, and focusing on the appropriation of African architecture as well as the importation of colonial subjects. She homed in on the transformative effect that French appropriation had on the buildings, including the Mousgoum *teleuk*. In this light, the fair could be seen as a skeuomorph, which for Leigh is "a derivative object that retains metaphors and ornaments of [an] original object."[8] She also began to understand this skeuomorph as a productive site for intervention. Leigh was drawn to the relationship of the body of Josephine Baker to the colonized, understanding both her and the Mousgoum *teleuk* as icons of French imperialism. She also thought about reenactment and how the example before her could be transformed. Leigh started to integrate the exposition—as well as African domestic structures historically made of earth or thatch—into her work.

The iconization of Baker and of the *teleuk* informed the works included in Leigh's 2015 exhibition at the Tilton Gallery in New York, as did Edward Weston's 1941 photograph of Mammy's Cupboard (page 21, fig. 6), an iconic restaurant in Natchez, Mississippi, shaped like a mammy figure who invites would-be diners to enter (the restaurant is still in operation). With all these items at hand, Leigh's Tilton exhibition brought together architecture and pottery, the built environment and notions of containment. "Throughout my career," Leigh noted at the time, "I've considered the black female body as a repository of lived experience."[9] Armed with the exposition and a building-made-human, Leigh created objects, including cages, ceramic domes, bananas, and jugs, that point to Black women's experiences while also upending histories of colonization and American racism. The objects in the Tilton show were metamorphoses of, in Leigh's words, "an architecture that functions as a symbol of your own demise."[10] Such considerations, fundamental to Leigh's work, also guided her study of African architecture.

Bringing together thoughts of both the Black female body and architecture as repositories of lived experience, Leigh looked more closely at African architecture, particularly the *teleuk* and the architecture of the Batammaliba, who live in northern Togo and Benin. In both contexts, architecture is cast as inseparable from human experience, serving as the setting for life's events large and small. Indeed, Batammaliba houses, as the art historian Suzanne Preston Blier has shown in detail, are considered in many ways as human beings. Anthropomorphism is one of the most important concerns in the building, symbolism, and use of the structure. The house's parts accord to human anatomy. It is both male and female. It is elaborately dressed for funerals of Batammaliba elders. At the end of the day, it is considered both a conceptual portrait of its residents and a part of their family.[11] Indeed, Leigh's Anatomy of Architecture series shares its name with Blier's book on Batammaliba architecture.

The series, which began with Leigh's 2016 exhibition of the same name at the Hammer Museum in Los Angeles, took its cues from Batammaliba and Mousgoum examples. Morphing domestic architecture with the bodies of Black women, Leigh's objects—repositories that transform architecture into a protective container of Black female interiority—hold space and keep confidence. Much has been written, with regard to her projects *The Free People's Medical Clinic* (2014) and *The Waiting Room* (2016), about the importance of Leigh's interest in not

5 For more discussion, see Nelson, *From Cameroon to Paris*, 98–146.

6 Leigh, correspondence with the author, January 2, 2020.

7 Leigh, correspondence with the author, January 2, 2020.

8 Ilesanmi, "An Interview with Simone Leigh."

9 Leigh quoted in Harris, "Moulting."

10 William J. Simmons, "Interviews: Simone Leigh Discusses Her Two New Exhibitions in Kentucky and New York," *Artforum*, March 2, 2015, https://www.artforum.com/interviews/simone-leigh-discusses-her-two-new-exhibitions-in-kentucky-and-new-york-50482.

11 See Suzanne Preston Blier, "Houses Are Human: Architectural Self-Images," in *The Anatomy of Architecture: Ontology and Metaphor in Batammaliba Architectural Expression* (Chicago: University of Chicago Press, 1994), 118–56.

making everything visual.[12] Yet the state of the nonvisibility is equally important in Leigh's architectural engagements. With structures that generally have no means of access made into bodies with minimal facial features, Leigh blocks access to the interior worlds suggested by these artworks. These figures turn inward, guarding and protecting their inner selves. While Leigh beautifully shows how we transcribe ourselves onto architecture, while she makes visible the indelible link between home and our dreams and memories, while she takes advantage of architecture's emotional and psychological possibilities, her figures keep their secrets and reserve their right not to speak. They retain their power.

Leigh's transformation of architecture is an enactment of Lorde's call to "define and empower."[13] Leigh creates realities in which Black female bodies exist neither as icons for a colonial world rife with subjugation nor as the art world's mammies. The monumental structure *Brick House* (2019; pages 214–15), installed on New York's High Line, exuded Black women's power, exalting them as heroes in a masculine world of steel and glass. *Sovereignty*, a remarkable skeuomorph of the pavilions of the 1931 International Colonial Exposition, defined the U.S. Pavilion in Venice as a Black womanist, diasporic space oozing with what Leigh describes as "over-the-top Blackness."[14] Whether large or small, Leigh's spaces and architectonic bodies not only signal protection of the self, not only transform alien spaces into centers of Black female agency, not only speak of intimacy and belonging, but they also assert Black female diasporic voice and presence in a too-often hostile world.

12 See, for example, Nancy Kenney, "Simone Leigh, Now in the Spotlight, Contemplates the Theme of Invisibility," *Art Newspaper*, April 24, 2019, https://www.theartnewspaper.com/2019/04/24/simone-leigh-now-in-the-spotlight-contemplates-the-theme-of-invisibility; and Helen Molesworth, "Art Is Medicine: Helen Molesworth on the Work of Simone Leigh," *Artforum* 56, no. 7 (March 2018): 164–73.

13 Audre Lorde, "The Master's Tools Will Never Dismantle the Master's House," in *Sister Outsider: Essays and Speeches* (Freedom, CA: Crossing Press, 1984), 112.

14 Siddhartha Mitter, "Simone Leigh in the World," *New York Times*, April 14, 2022, https://www.nytimes.com/2022/04/14/arts/design/simone-leigh-venice-biennale-us-pavilion.html.

Jessica Lynne

The Vernacular Revered

Fig. 1 *A particularly elaborate imba yokubikira, or kitchen house, stands locked up while its owners live in diaspora*, 2016. Installation view, *inHarlem*, Studio Museum in Harlem at Marcus Garvey Park, New York, 2016

Six summers ago, if you happened to have found yourself walking north on Fifth Avenue in Harlem, along the perimeter of Marcus Garvey Park, you would have noticed a grouping of large black sculptures arranged in the park's center. Perhaps you might even have been intrigued enough to enter the park for a closer look at the three structures, and in doing so, you would have observed their textured clay exteriors, peppered with elongated triangular black mounds. You would have made note of the thatched roofs, and as you circled each sculpture slowly, you would have realized that even though these structures imply the familiarity of habitability, they have, in fact, no windows or doors. Functionality here, you might have thought as you decided to sit for a while in the grass under the afternoon sun, is implied and materiality is a portal through which histories meet, overlap, and reveal themselves.

Such is the very scene that describes my first encounter with Simone Leigh's *A particularly elaborate imba yokubikira, or kitchen house, stands locked up while its owners live in diaspora* (2016; fig. 1), commissioned as part of the Studio Museum in Harlem's *inHarlem* public art series. I lingered for the better part of the day with Leigh's magnanimous *imbas*, contemplating the significance of their temporary physical residence in the Black geography that is Harlem and their perpetual psychic relationship to the Black geography of their origin. Leigh's *imbas* evoke the domiciles of Shona-speaking people in rural areas of present-day Zimbabwe that are imbued with multiple registers of meaning culturally, spiritually, and socially. Moreover, as Leigh noted in an interview at the time, the forms' surfaces reflect elements of Cameroonian design found on the Mousgoum *teleuk*, and the thatched roofs were created via an architectural system employed in Burkina Faso. "So this sculpture is very hybrid," Leigh asserts in that interview.[1]

Indeed, what struck me then about these vernacular architectural forms and what continues to resonate with me is how the vernacular, in Leigh's hands, becomes a prism through which African diasporic epistemologies are reckoned with, articulated, and renegotiated. The hybrid, as named by the artist, via the architectural module of the cone-on-cylinder house, becomes the nexus for a plurality of Black geographic and psychic presences. Leigh's intentional use of materials, aesthetic interventions, and approaches enable her to enunciate new meaning and, importantly, new inquiries into the very

conditions that create, act upon, and inform Black life. The historical presences from which Leigh draws now become, as Robert Farris Thompson remarks, "occasions for creative homage and elaboration."[2]

Writing on what she terms as Leigh's "vessel onto-epistemology," Amber Jamilla Musser calls particular attention to the materials used repeatedly in Leigh's ceramic practice: raffia, terracotta, graphite. Musser reads Leigh's figural sculptures as "onto-epistemological disruptions" that possess their own knowledge codes and systems that are realized through materiality. "Leigh's insistence on thingness and the knowledges embedded in materiality," Musser writes, "alters the dynamics of subject/object. Instead of focusing on the production and regulation of an interiority, the vessels allow us to think about the role of materiality as something that connects to histories beyond the individual, something that exerts its own power, and something that requires an orientation that is not about recognition."[3] In extending this argument to Leigh's *imbas*, we see there as well a history activated via an object rooted in specificity and, to a certain extent, illegibility, depending on the sociopolitical/cultural position of the viewer.

In continuing a reading of such vernacular architecture aligned with Musser's analysis, we might also understand the "hybrid" as a critical epistemological cipher or circuit that, per Musser, "shows us a way to think about racial knowledges as encoded through practices, traditions, and materials, parts of the assemblages of racialization that fall outside the domain of recognition, desire, and bounded subjectivity. Race, here, enters as a different type of category altogether, one that shifts the boundaries of what and how to know."[4]

Still, peering at Leigh's figural sculptures, such as *Daphne* (2016; page 246, fig. 3) or *Hortense* (2016; fig. 2), for example, evidences further the relationship between material, African diasporic knowledge, and memory. Both are black clay busts whose faces have been either completely covered, as in the case of *Hortense*, or depicted without eyes and merely a nose and mouth, as in *Daphne*. The former's bust is studded with the same mounds that define the exterior of Leigh's *imbas*, while the latter wears a headpiece of ceramic flowers that curves into a loop. A raffia skirt covers the bottom half of the bust. Here again, materials converge to result in, as Tina M. Campt so aptly observes, "a Black feminist chorus."[5] These

1 Leigh in Eric Booker, "In Conversation inHarlem," *Studio* (Winter/Spring 2017): 52.

2 Robert Farris Thompson, *Flash of the Spirit: African and Afro-American Art and Philosophy* (New York: Vintage Books, 1984), 206.

3 Amber Jamilla Musser, "Toward Mythic Feminist Theorizing: Simone Leigh and the Power of the Vessel," *Differences: A Journal of Feminist Cultural Studies* 30, no. 3 (December 2019): 84.

4 Musser, "Toward Mythic Feminist Theorizing," 85.

figures are not portraits. They are not didactic renderings of models who have stood before Leigh as inspiration. Yet in their names, I know and see and feel the offerings of a towering Black feminist scholar such as Hortense Spillers, as an example, and know this is but one voice integral to Leigh's circuit of Black knowing.

I think too of *Cowrie (Sage)* (2015; page 131), a nonfigural sculpture that dons a skirt of sage bundles positioned beneath a large, glazed porcelain cowrie with dots that have been painted by hand on the form. Sage has long been used for medicinal and spiritual purposes within Indigenous and Black communities. The cowrie, once a form of currency throughout present-day West Africa, perhaps most importantly signifies blessings of and connection to the water spirit Mami Wata. The tobacco-leaf bunches that hang as part of *Crop Rotation* (2012; pages 56–57) call to mind my own family's history in the Black South as tobacco farmers in rural Virginia. In his novel *A Visitation of Spirits*, the late Randall Kenan calls forth the harvesting process of this crop, which was another staple product of slave labor in the region:

> You've heard how the men come back at the end of the day, when the fields have been attended for the week, and how they stand about the women as they finish tying the last drag-full of tobacco leaves and look at the piles of tobacco on the sticks and dread the day's ultimate task? Surely you have. For they form a chain of men and women from the high long pile that teeters slightly, and they pass the sticks off the pile, one by one, from one person to the next, through the door, inside, up, up into the belly of the barn, where they will hang, waiting for the fire that will cure them and make them valuable.[6]

Leigh implicates a transatlantic loop of remembrance, and it is this circuit of Black knowing that undergirds and defines, for me, the functionality of her work, refusing the utilitarian expectations so frequently imposed on those artists who work in ways typically assigned the moniker of "craft." Her material choices move with and about Africa and its diaspora like a ring shout. In this, we glean an intellectual and aesthetic project that reminds me of Amelia Groom's meditation on the practice of the late artist Beverly Buchanan. "Rather than

striving to claim visibility or representation," Groom writes of Buchanan, "the right to opacity is about claiming spaces of refuge from the fetishistic and disciplinary modes of scrutiny to which marginalised peoples are disproportionally subjected."[7]

Leigh likewise presents a space of refuge—intellectual or otherwise—for those Black folk, particularly Black women, for whom she creates. I knew this clearly that late summer afternoon meandering through Harlem, and I know it even more emphatically now. We are sacred. We are respected. We are revered.

5 Tina M. Campt, "Verse Five: Sounding a Black Feminist Chorus," in *A Black Gaze: Artists Changing How We See* (Cambridge, MA: MIT Press, 2021), 145–65.

6 Randall Kenan, *A Visitation of Spirits* (New York: Vintage Books, 2000), 256.

7 Amelia Groom, *Beverly Buchanan: Marsh Ruins* (London: Afterall, 2020), 77.

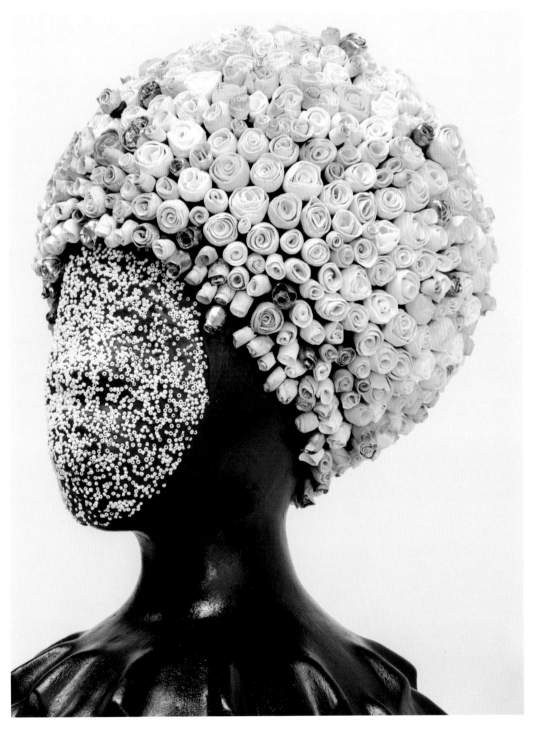

Fig. 2 *Hortense*, 2016. Terracotta, India ink, porcelain, glass beads, 14-karat gold luster, and epoxy. 26 × 16 × 16 inches (66 × 41 × 41 cm)

Sharifa Rhodes-Pitts

Survival Theory, or, the Idea of Africa

Fig. 1 Jan Cobus, *Africa, Image 1*, ca. 1675–1700. Embroidered tapestry.
9 feet 3 inches × 11 feet 5 inches (2.8 × 3.4 m). The Getty Research Institute,
Los Angeles

There is a path; it is lined on both sides by branches formed into fences. A woman is walking; she is walking away, down the path, toward something that cannot be seen. A cut. It is the path again, with the same fences, but in a different season, now in shade, now beneath a green canopy. The light has changed and there are children playing. A cut, and now the first path, and different children running toward the camera. A cut, the path in shade, the playing children, then the screen skips and there is another woman advancing. The voice of a body that is not seen announces: "I do not intend to speak about, just speak nearby."[1]

It is a warning or an instruction or an admonition. We cannot look long enough to know what we are looking at, and we are told that nothing will be explained. We have proceeded along a path but have not arrived.

* * * * *

Two figures face each other across an expanse, held at a distance as if by a repellent force. Neither can approach the center, in which a question hangs. The distance between the one who asked the question and the one who answered could be measured by the coordinates from which they'd traveled to this place, near and far, from a shared point of origin. This is not on-screen. I had received an answer to a question I had not asked, or rather, I had received an answer I was not seeking. Possibly, I had been misunderstood. The woman opposing me across the room had been speaking of her work and in the midst of doing so proffered a declaration: "Time is not linear in Africa." I had asked her what she meant, I had asked for clarification, I felt impatient with the generality. She countered that such things could not be explained and were not written down, and I told her I had recently been reading a collection of essays by African scholars on the concepts of time in the diaspora.[2] It seemed odd that she, who had the ability to walk the precise ground upon which generations of her ancestors had lived, was the one invoking generalities and I was the one asking for a footnote.

Another room, another question hanging in the air. This time, a group of poets, when asked to consider their relationship to what had come before them, rejected any notion of genealogy. I had received an answer to a question I had not asked; possibly, I had been misunderstood. I had not been asking about tradition, or imprimatur. There was not a straight line between then and now, one said. Another said she could not speak about it with any specificity. It's ancestral, she shrugged.

Sometimes I think of citation not as a bibliographical imperative but as a way of naming who is in the room with you. This is not just a matter of influences, or mood boards. Rather, it is an attempt to know who has already trod the ground we walk on, in whose path we travel, coming and going. The citation is also a trail we leave for those who are coming behind.

A cut.

* * * * *

A room in the New York Public Library celebrates the trustees whose largesse has supported the institution, by proceeds of the gilded ages that have unfolded since its founding. The walls of this room are adorned with expansive tapestries depicting the "Allegory of the Four Continents," a popular motif from a yet earlier gilded age, when European religious fundamentalism and the resource hunger of small countries combined to create the so-called Age of Exploration. The allegories of the continents show Europe, Asia, America, and Africa (fig. 1) embodied as women, bearing attributes of their respective territories, usually emphasizing the riches of the places that would be vanquished under conquest. In 2012 I sat with Simone Leigh beneath the tapestry titled *Africa* to have a public conversation about the work we'd begun together and the places where our work met. It was or was not a fitting backdrop, to be framed by this artifact of the Baroque style—an aesthetics that exalted the encounter of Europe with the rest of the world, with color and exuberance standing in for the shock and awe of colonization. Proliferating as tapestries, frescoes, porcelain, engravings, perhaps these images were the first souvenirs, never mind that they were usually the result of trips that had been made only in the mind of a guildsman working in a dark atelier somewhere in the low countries, attempting to fix the relation between the known world and all it was destroying.

At some point in the conversation, Leigh mentioned the tapestry and its "fraudulent ideas of 'Africa.'" A certain tone in her voice placed quote marks around the word "Africa"; her hand fluttered up to indicate the wall behind us: the lion, the dark brown body of a continent. It was only a moment, but by her hand, by her tone, she called into question the very project of the allegory, a problem of what someone knows and thinks they can speak about. Symbols do not suggest a meaning so much as fix it, by inscribing the order of the world through hidden meanings—the lion, sometimes the crocodile, and Africa herself, on her bridled wild mount. The Age of

1 *Reassemblage: From the Firelight to the Screen,* directed by Trinh T. Minh-Ha (Women Make Movies, 1983).

2 Joseph K. Adjaye, ed., *Time in the Black Experience* (Westport, CT: Greenwood Press, 1994).

Exploration had been launched upon the declaration that there were no people in all the places Europeans wanted to claim. She didn't go into these details. Her hand, her tone, enacted a work of condensed knowledge that is related to what happens in her sculpture. It was as if the tapestry had been pulled down from its place on the wall, exposing frayed edges, the lies woven into its reverse side.

* * * * *

The problem of the reference is a problem of knowability. Having cited the reference, we have shortened a distance in our field of vision, between what we can see and what we can know about it, between past and present. The citation seems to offer precision in the face of pronouncements such as "it's ancestral." I wanted to exit the feeling in search of a field. But Audre Lorde reminds us to seek "the possibility for fusion of these two approaches as keystones for survival."[3]

* * * * *

In November 1927, certain galleries in the Art Institute of Chicago were dedicated to the citywide event "The Negro in Art Week" (fig. 2). Some of the objects in those rooms had most recently traveled from New York, reprising an exhibition from earlier that year: *The Blondiau-Theatre Arts Collection of Primitive African Art.* In Chicago, African art was displayed alongside recent works by the artists who were just beginning to be understood, and understand themselves, as New Negroes. When the *New York Times* reviewed the first iteration of the show under the banner "Darkest Africa Sends Us Art," it did not mention that the grouping of works from the private collections of Belgian and American patrons had been organized under the advice of Alain Locke, a father of the nascent New Negro movement (he preferred to be known as its "philosophical midwife").[4]

Locke argued that the importance of African art to the black American revolved around the question of how it could be known, and not just known, but used. The *New York Times* was also interested in the question of use: "Almost without

exception there is a ritual or a utilitarian reason for everything. . . . [E]ach work of art was linked with its owner's life: with his racial customs, with his background of work, pleasure, superstition, culture."[5] Locke had something else to say about utility, urging that "what the Negro artist of to-day has most to gain from the arts of the forefathers is perhaps not cultural inspiration or technical innovations, but the lesson of a classic background, the lesson of discipline, of style, of technical control pushed to the limits of technical mastery."[6]

"The Negro in Art Week" at the Institute might have been visited by two men, both new to Chicago in the fall of 1927; they were acquaintances who may have glimpsed each other in the crowd, two figures held apart, at a distance. Nearly two decades would pass before the anthropologist Melville Herskovits and the sociologist E. Franklin Frazier faced each other across an incommensurable field in which they attempted to determine what was knowable about the people to whom those objects had once belonged, or who had belonged to the objects, entwined before both people and objects were sent across an ocean, into History and out of time. Herskovits and Frazier disagreed about the possibilities and impossibilities that unfolded from this movement, how near to or distant from Africa, or its idea, a dispersed people could remain. Herskovits argued that certain ways of being, language, food, and belief had been maintained among Africans in the Americas as "retentions" of an original culture.[7] Frazier countered that the violence of enslavement and forced suppression of language and custom on the plantation required the self-invention of a new people, with altogether new forms.[8]

Herskovits would have agreed with Locke's assertion that African art proved "the Negro is not a cultural foundling without his own inheritance."[9] And Frazier was among those declaring themselves, under Locke's guidance, as something new—marked, shaped, formed by the crucial break with what could not be known. The claims of Herskovits are known as "survival theory," but both men had something to say about the nature of survival: what is kept, what is lost, what is made new, what part of an original form is visible in its trace, and what is destroyed beyond recognition.

3 Audre Lorde, "Poetry Is Not a Luxury," in *Sister Outsider: Essays and Speeches* (Trumansburg, NY: Crossing Press, 1984), 37.

4 Sheldon Cheney, "Darkest Africa Sends Us Art: Stimulating Work of the Negro Craftsmen Has Been Hitherto Neglected," *New York Times*, February 13, 1927; Alain Locke quoted in Eugene C. Holmes, "Alain Leroy Locke: A Sketch," *Phylon Quarterly* 20, no. 1 (1959): 82–89.

5 Cheney, "Darkest Africa Sends Us Art."

6 Alain Locke, "The Legacy of the Ancestral Arts," in *The New Negro: An Interpretation*, ed. Alain Locke (New York: Albert and Charles Boni, 1925), 256.

7 Melville J. Herskovits, *The New World Negro: Selected Papers in Afroamerican Studies*, ed. Frances S. Herskovits (Bloomington: Indiana University Press, 1966).

8 E. Franklin Frazier, "Ethnic Family Patterns: The Negro Family in the United States," *American Journal of Sociology* 53, no. 6 (1948): 435–38.

Fig. 2 Poster for "The Negro in Art Week, November 16–23," 1927.
Ink on paper. 9 1/16 inches (23 cm) (height). The Brooklyn Museum,
New York, from the Library of Camille and Luther Clark

Fig. 3 Installation view, *African Negro Art*, The Museum of Modern
Art, New York, 1935

* * * * *

The perception of such things depends on an operation of vision that brings the near and the far into the same plane. Édouard Glissant speaks of "aesthetics of rupture and connection."[10] Whereas Locke was issuing pronouncements about an African classicism and its uses for the black American artist, and survival theory can be the pretext for a comforting narrative of continuity, an aesthetic of rupture may point us toward different possibilities.

The presence of African forms (fig. 3) in Leigh's sculpture is not automatically an interest in origins. The two can coexist without overlapping, but this alignment is often mistaken for Heritage. Perhaps we can locate in her sculpture an interest in the origin of forms. In the form, and in its making, is a body of knowledge. The body of the sculptor must be used to approach this knowledge. It is not about, but nearby. Leigh is conversant in, but not beholden to, genealogies, citations, and the trouble with archives. But she is able to name who is in the room.

A language of references and sources, of survivals and legacies, the given and the made, the authentic and the appropriated does not account for certain mobilities: of people, of objects, of meaning. Keeping this in view, it is necessary to reject what remains of the still persistent demand: that what is called a black figure must be a vehicle of allegory and fixed meaning.

With Glissant, we can orient ourselves not according to nearness or distance from a point of origin, but always in the middle of a point of entanglement.[11]

* * * * *

It is at monumental scale that Leigh's sculptures provoke the power of this mobility. The viewer must use their body to attempt an approach—coming to knowledge by being nearby. Leigh's first public sculpture, 2016's *A particularly elaborate imba yokubikira, or kitchen house, stands locked up while its owners live in diaspora,* was a site-specific installation in Marcus Garvey Park (pages 212–13), commissioned by the Studio Museum in Harlem. The physical location of the park was itself a point of

entanglement, a place where problems of origin and heritage are continually working themselves out, from the history of the park's namesake, to the ritual of displacement and belonging enacted there as a morality play when a weekly drum circle of decades-long tradition was too noisy for the inhabitants of new million-dollar apartments flanking the park.[12]

But the three structures of Leigh's installation articulated a different relationship between exterior and interior, exile and belonging. The kitchen houses upon which the sculpture is based are round. Round houses are usually made by fixing a point with a length of string attached to one's body; the movement of the body around the central point, in consistent orientation to this location, inscribes the circle on the ground upon which the structure is then built. In Leigh's structures, this was a center that could not be approached. No matter how many times one traced the perimeter, reenacting the path of the house's maker, no door could be found. The title is a narrative that rests somewhere between documentary and symbolic: the houses literally cannot be entered. The "huts," as they were often misnamed, forced the seeker into the position of one permanently out of doors—into History, out of time.

More recently, with *Sentinel (Mami Wata)*—the 2020–21 public sculpture mounted in New Orleans as part of Prospect 5—an emanation of the West African and Afro-Atlantic water spirit presided over a reordering of history and time. Sited at Egalité Circle (formerly named to honor the Confederate general Robert E. Lee), the sculpture occupied the space left behind, but not resolved, by the removal of the monument during an early enactment of the spatial revisions that, by removing monuments, participate in the logic that concentrates their power. (The Lee sculpture was taken down by workers wearing black masks to conceal their identity; later removals of similar monuments around the South unfolded under cover of darkness.)

Whereas the Confederate monument had sat atop a seventy-foot Doric column, Leigh chose to stand *Sentinel (Mami Wata)* on the steps leading to the base; you could walk up to it, stand next to it. But the larger-than-life avatar of a life-giving entity remained beyond human. Leigh's *Sentinel* features a parabolic reflector in place of a head, its geometry working to

9 Locke, "The Legacy of the Ancestral Arts," 256.

10 Édouard Glissant, *Poetics of Relation,* trans. Betsy Wing (Ann Arbor: University of Michigan Press, 1997), 151.

11 Édouard Glissant, "The Known, the Uncertain," in *Caribbean Discourse: Selected Essays,* trans. J. Michael Dash (Charlottesville: University Press of Virginia, 1999), 26.

12 Timothy Williams, "An Old Sound in Harlem Draws New Neighbors' Ire," *New York Times,* July 6, 2008, https://www.nytimes.com/2008/07/06/nyregion /06drummers.html.

focus and amplify all that is directed toward it. She may, indeed, refuse the labor of the monument, which is to project a fixed meaning. The removal was not a resolution. A renaming is not an undoing. *Sentinel* does not absolve you.

Having lived in New Orleans during the last years of the Confederate effigy, I experienced the disorientation of driving the roundabout, caught in the unending current it was designed to enshrine and maintain, a traffic pattern as historical reenactment. Not far from there, the waters of the Mississippi travel toward the sea. Michel de Certeau offers us a reading of the river: "Among the Fô of Dahomey, history is *remuho*, 'the speech of these past times'—speech (*ho*) or presence, which comes from upriver and carries downstream."[13] With the water at her back, *Sentinel (Mami Wata)* amplifies this speech, and guards against its forgetting.

Monuments are called forth, in part, by their land-scapes. So, not just the Benin bronzes but the walls around the courtyards and atriums and the pillars where they once hung, beyond History, ordering time. Not just the carved wooden doors to the palaces of Abomey, but the sacred forests into which Béhanzin and his court retreated, setting fire as they fled. It is on this ground that history and form are brought into relationship by what and how the artist sees. The past is there, whether or not it is useful. We encounter it—a field scattered with objects—and proceed in their path as if gathering the substance of time itself, making note of what has survived, and moving toward something that cannot yet be seen.

13 Michel de Certeau, *The Writing of History*, trans. Tom Conley (New York: Columbia University Press, 2005), 4.

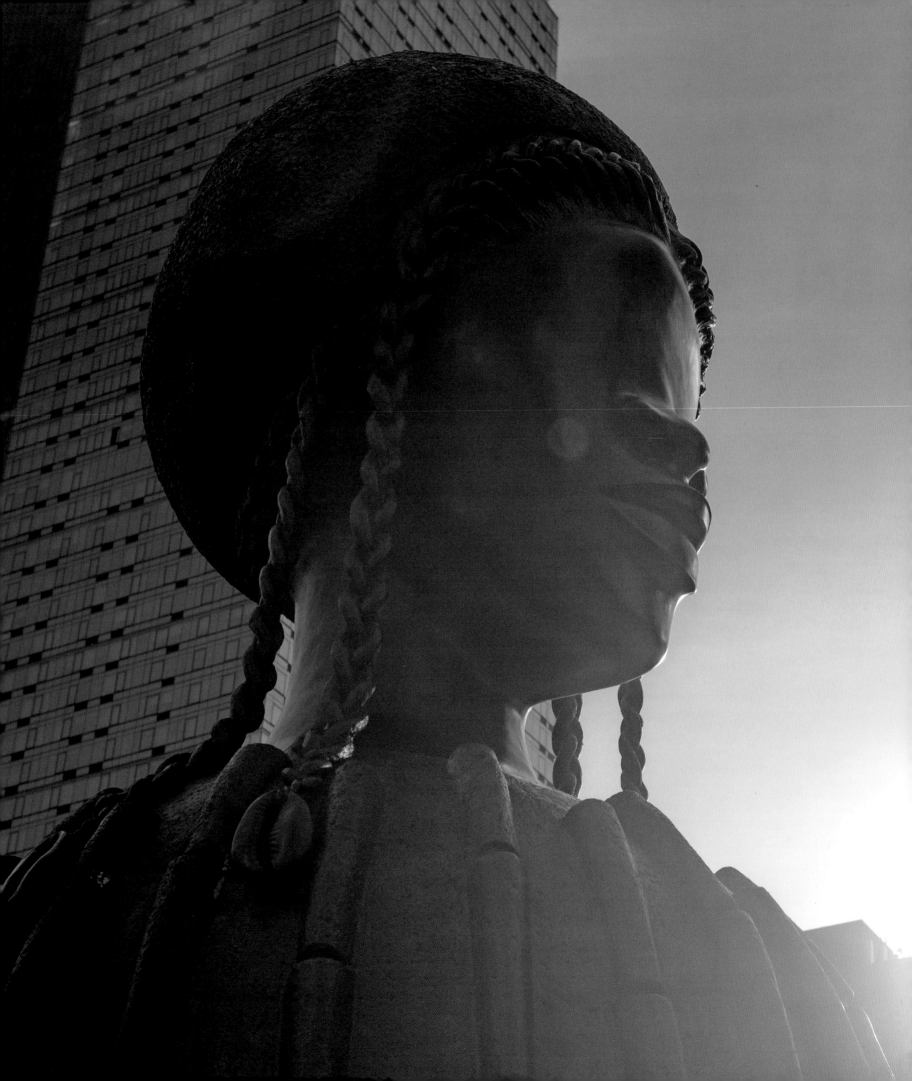

pages 214–15 and facing (detail)
Brick House, 2019
Bronze
16 × 9 feet (4.9 × 2.7 m) (height × diameter)

pages 212–13
A particularly elaborate imba yokubikira, or kitchen house, stands locked up while its owners live in diaspora, 2016. Installation view, *inHarlem*, Studio Museum in Harlem at Marcus Garvey Park, New York, 2016

Jug (2019) in process at Stratton Sculpture Studios, Philadelphia, 2018

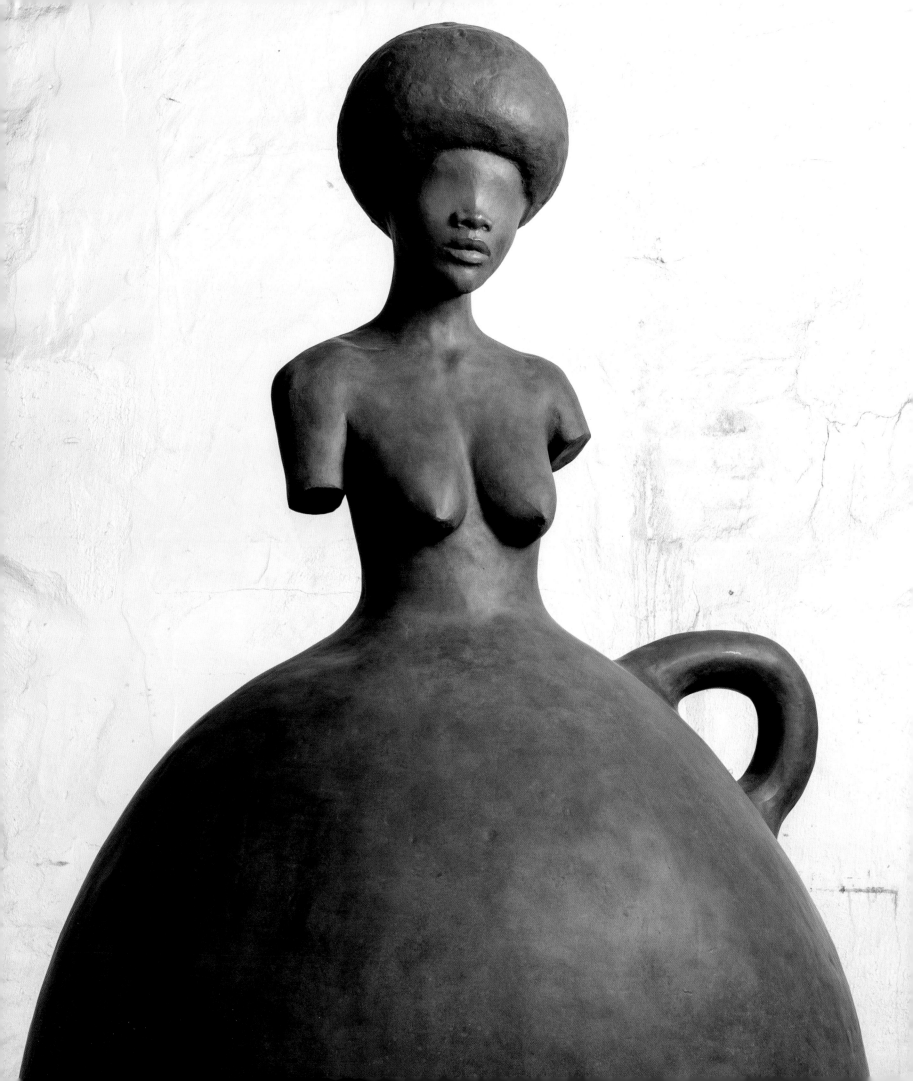

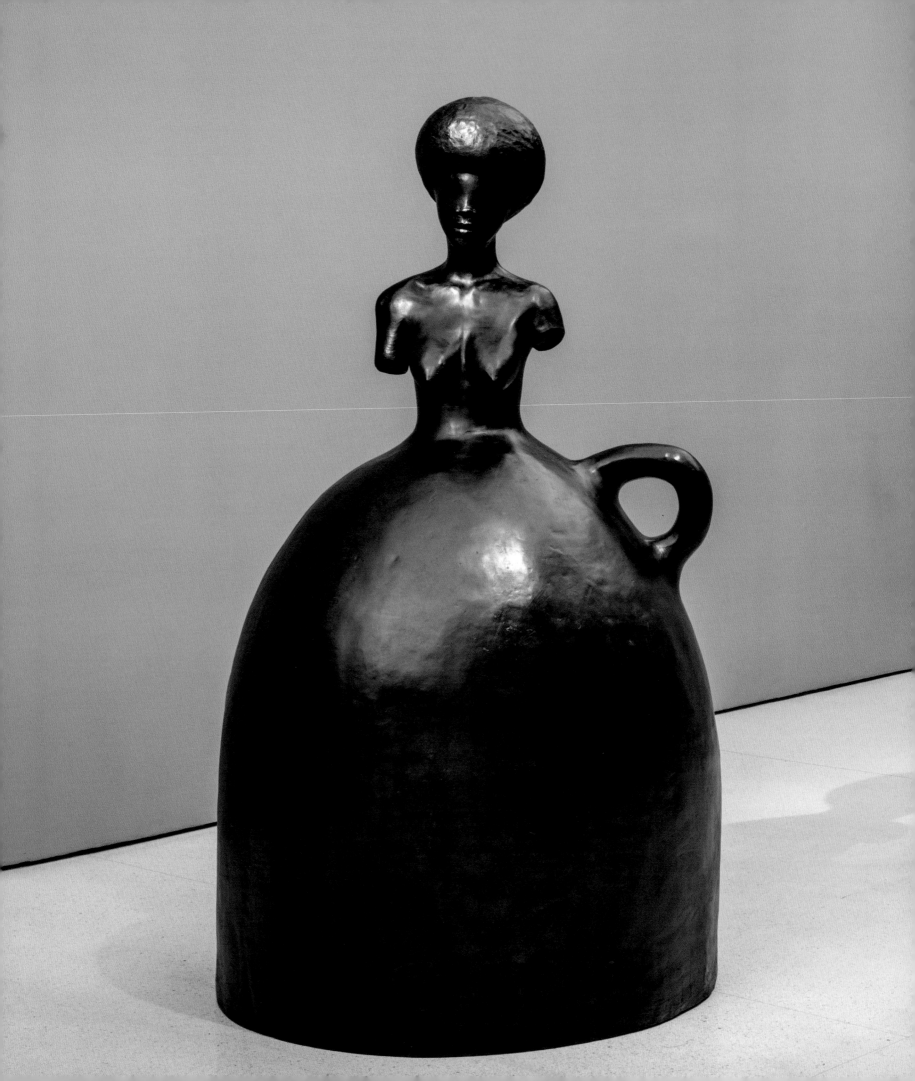

pages 220–21
Jug, 2019
Bronze
83 1/4 × 51 1/2 × 51 1/2 inches (211.5 × 130.8 × 130.8 cm)

facing
Sentinel, 2019
Bronze and raffia
71 1/2 × 72 × 42 inches (181.6 × 182.9 × 106.7 cm)

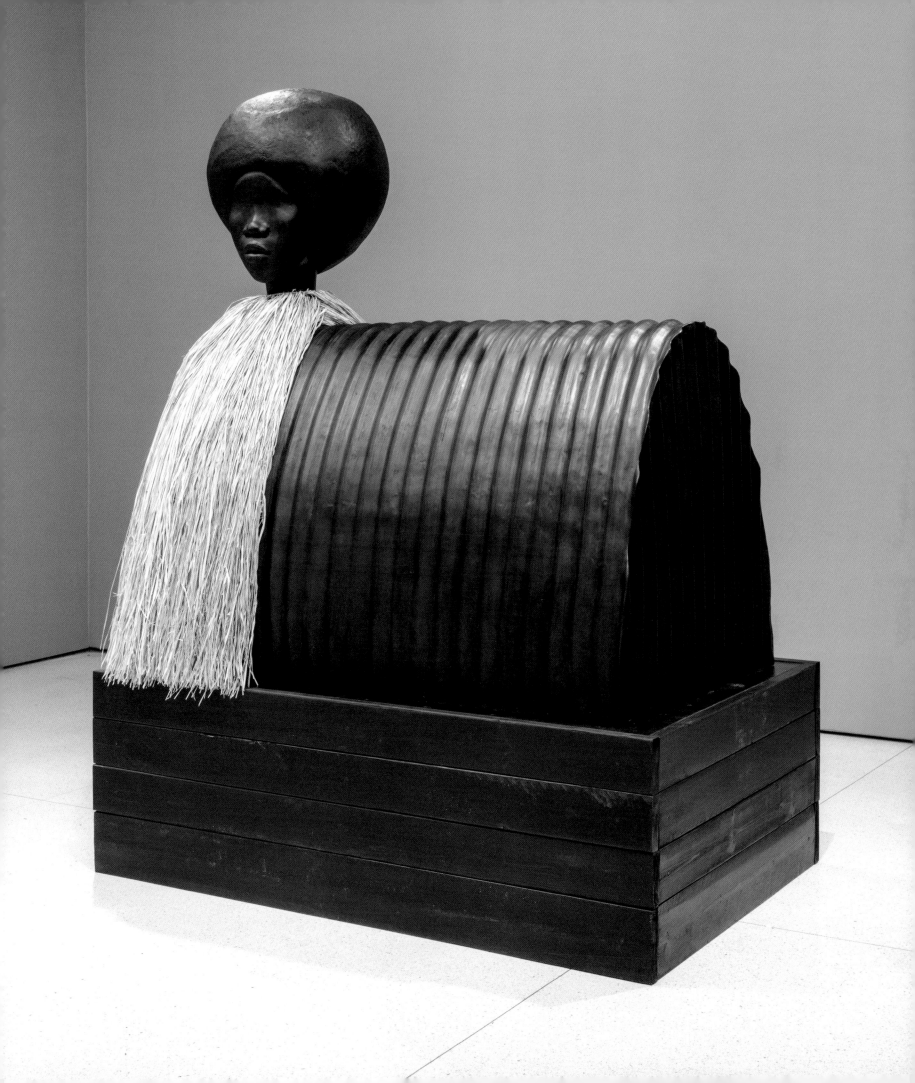

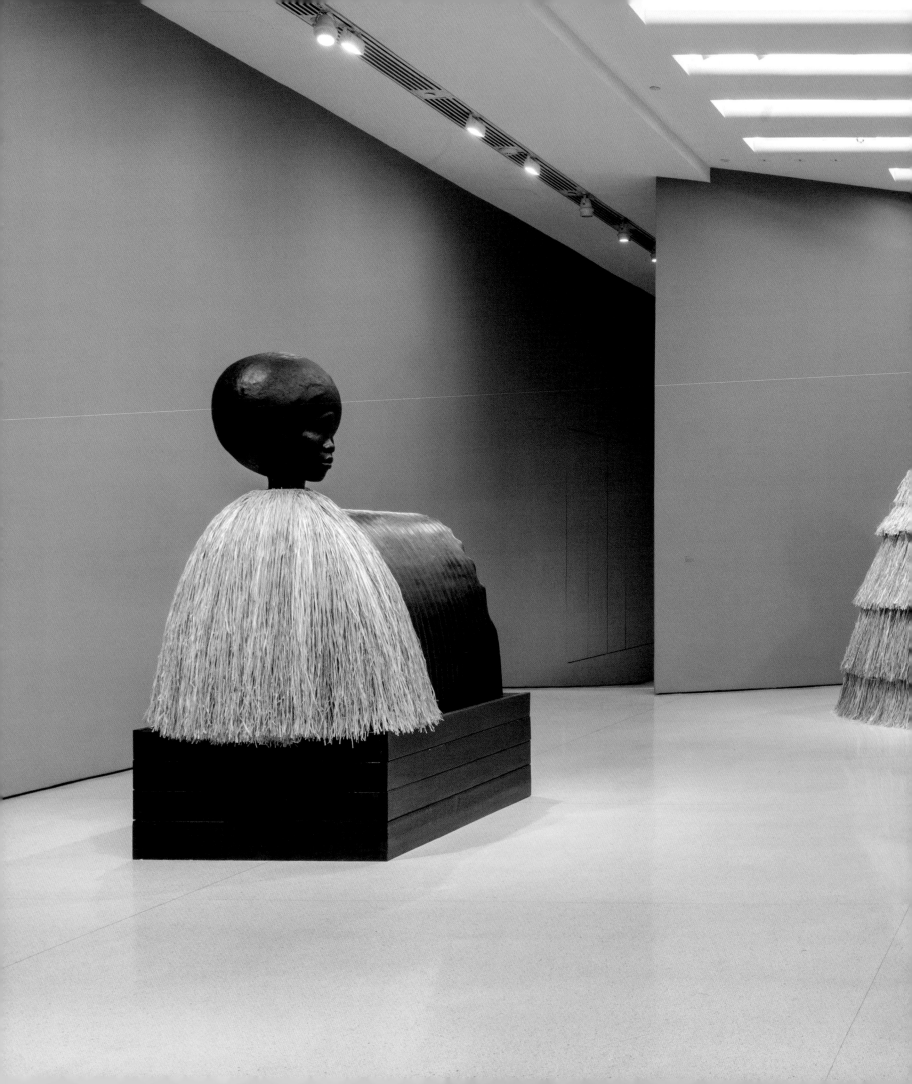

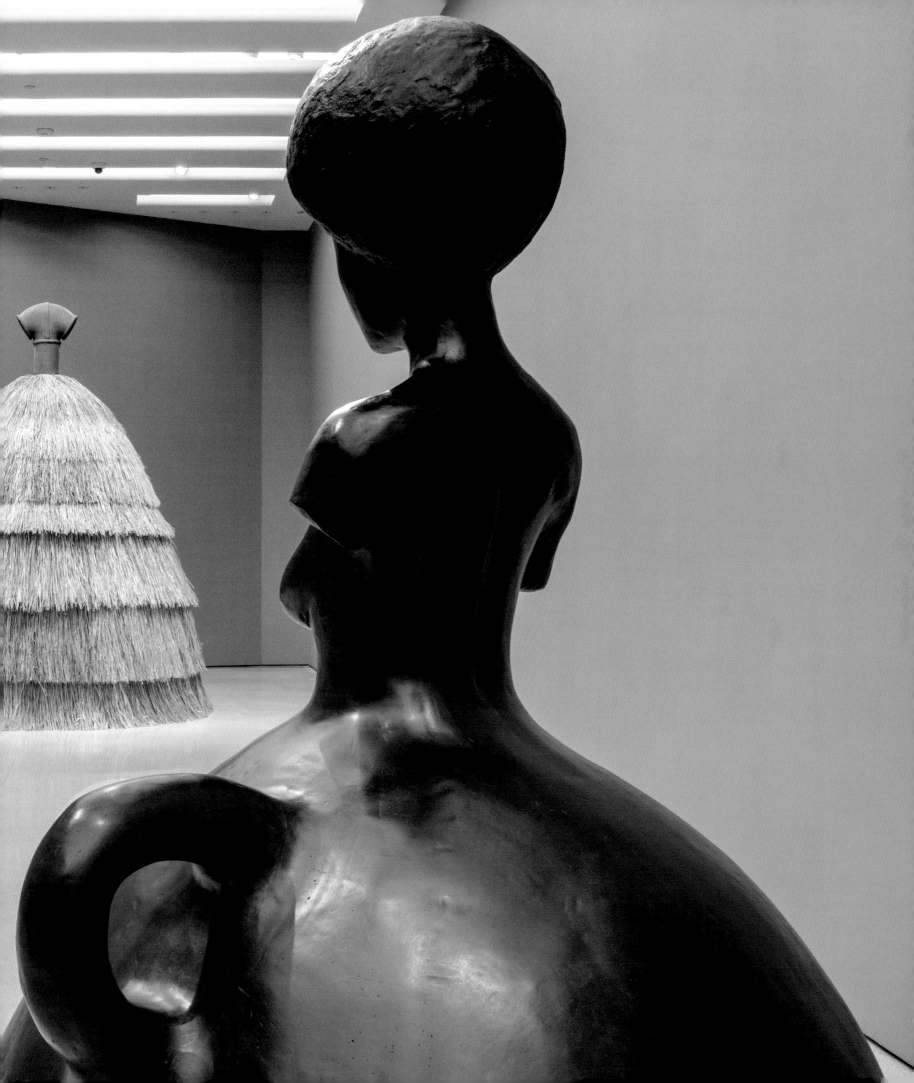

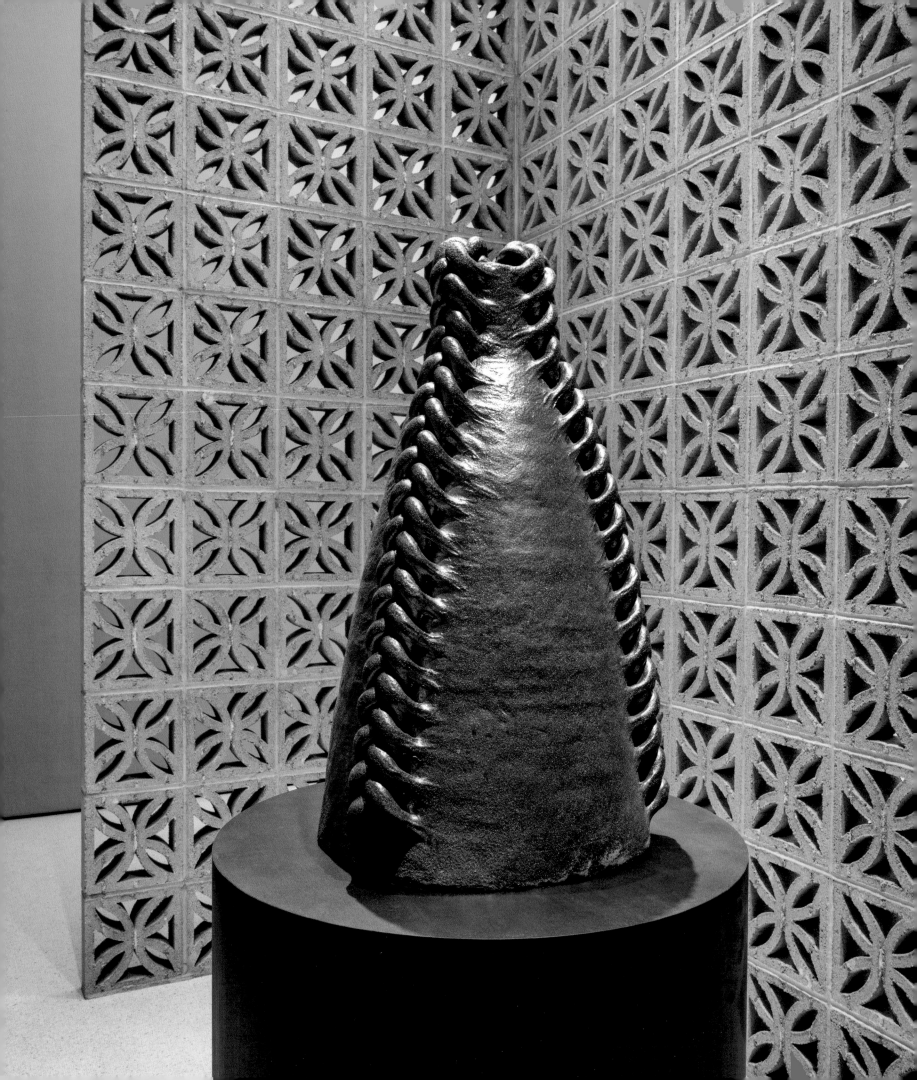

facing
Loophole of Retreat, 2018
Stoneware, concrete blocks, and sound (6:44 minutes)
Dimensions variable

pages 224–25
Installation view, *The Hugo Boss Prize 2018: Simone Leigh, Loophole of Retreat*,
Solomon R. Guggenheim Museum, New York, 2019

227

Christina Sharpe

Simone Leigh:
"a journey to scale"[1]

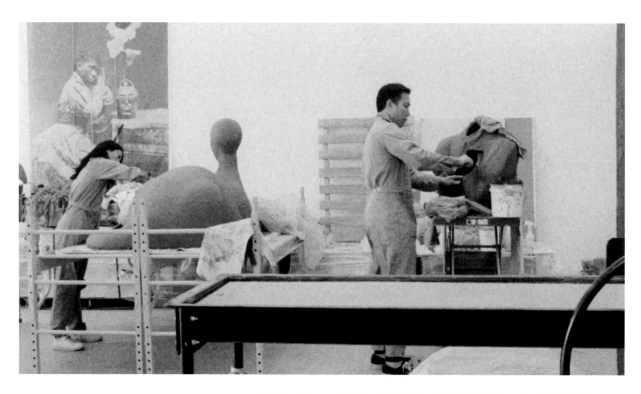

Fig. 1 Simone Leigh and Madeleine Hunt-Ehrlich, *Conspiracy* (still), 2022.
16mm and 8mm film (black-and-white, sound; 24:00 minutes)

Because I was largely ignored, I had a long time to mature without any kind of glare.[2]

Simone Leigh

Simone Leigh makes sculptures and environments, collaborative installations, and films that are both large-scale and intimate. Leigh is a gatherer, an artist, and a maker who brings together people, forms, histories, and materials as she attends aesthetically and materially to the largeness of diasporic blackness in its specificities, differences, and commonalities, and to the fact that Black women constitute a (and her) major audience. In her hands and her imagination, we (Black women) are present as capacious subjects and as broad audience. Her work, as Helen Molesworth notes—"in both its sculptural and social-practice formations—is bound up with new ways of thinking about things, new ways of claiming or holding space."[3]

Referring to her work with kilns, Leigh has often described in talks how the kiln creates an environment in which objects are changed by what they're adjacent to and what residue might be lingering there. In what follows I extend this kind of environmental, creative, and juxtapositional work in order to think through Leigh's entire ethics and practice. Drawing on and from her own deep commitments, from research, dreams, imaginings, practices of living, and from those of Black women, everywhere in the world, Leigh's work, to me, aims to "feed us in all of our hungers."[4] Her art has its own ways of attending to Black life.

i. Conspiracy

conspiracy, *n.*
1. a. The action of conspiring; combination of persons for an evil or unlawful purpose.
b. *Law.*

2. a. (with *a* and *plural*) A combination of persons for an evil or unlawful purpose; an agreement between two or more persons to do something criminal, illegal, or reprehensible (especially in relation to treason, sedition, or murder); a plot. Also in *conspiracy of silence.*
b. A body or band of conspirators. *Obsolete.*

3. *figurative.* Union or combination (of persons or things) for one end or purpose; harmonious action or effort; = CONSPIRATION *n.* 3 (In a good or neutral sense.) *Obsolete* or *archaic.*[5]

The twenty-four-minute, black-and-white film *Conspiracy* (2022; fig. 1), featuring Lorraine O'Grady and Sharifa Rhodes-Pitts, is a collaboration between Leigh and Madeleine Hunt-Ehrlich, and marks a continuation of the work between the sculptor and the filmmaker. The opening shot is from above: a close-up, bird's-eye view of a turning potter's wheel and of hands shaping and molding clay on it. We hear a woman's voice—and she is sounding something that I try to piece together and cannot until after many listenings.[6] I learn later that the singer is Jeanne Lee and that the film borrows its title from Lee's 1975 album of the same name. I wasn't familiar with Lee's work before watching and listening to Leigh and Hunt-Ehrlich's *Conspiracy*. Of Lee's track titled "Angel Chile," Leena Mahan writes that she "makes a sound poem of her daughter's name, Naima, rendering the word in soft laughter and contemplative sighs. Lee is committed to inhabiting over describing, her voice mimetic of her subject—in this case motherhood and the stillness of a quiet domestic scene—her lyric only one of the many sonic elements she uses to convey meaning."[7] Lee

1 In an interview and write-up on the Leigh and the Venice Biennale, Siddhartha Mitter notes that this is "a journey to scale." Siddhartha Mitter, "Simone Leigh, in the World," *New York Times*, April 14, 2022, https://www.nytimes.com/2022/04/14/arts/design/simone-leigh-venice-biennale-us-pavilion.html. In another profile, Leigh said, "I'm still very much someone who works with clay. . . . Some works being made today are objects that were scanned electronically and then blown up and rendered in marble or whatever, and they often look kind of machined, like something from Disney. . . . Shane and Julia [Stratton] suggested that I make mine to scale, in clay. Until I met them, I didn't know I had that alternative, and it's made a big difference. What I'm learning, getting better at, is how things look in bronze—things like drapery and clothes and shoes, how they translate." Calvin Tomkins, "The Monumental Success of Simone Leigh," *New Yorker*, March 28, 2022, https://www.newyorker.com/magazine/2022/03/28/the-monumental-success-of-simone-leigh.

2 Robin Pogrebin and Hilarie M. Sheets, "An Artist Ascendant: Simone Leigh Moves Into the Mainstream," *New York Times*, August 29, 2018, https://www.nytimes.com/2018/08/29/arts/design/simone-leigh-sculpture-high-line.html.

3 Helen Molesworth, "Art Is Medicine," *Artforum* 56, no. 7 (March 2018), https://www.artforum.com/print/201803/helen-molesworth-on-the-work-of-simone-leigh-74304.

4 I borrow from Cherríe Moraga, who writes, "Third World feminism is about feeding people in all their hungers." Moraga, *Loving in the War Years: lo que nunca pasó por sus labios* (Cambridge, MA: South End Press, 2000), 123.

5 Oxford English Dictionary, s.v. "conspiracy, *n.*," accessed September 10, 2022, https://www.oed.com.

6 As it was installed in the U.S. Pavilion at the Venice Biennale, one could hear the film long before one entered the room where it lived. That sound of the film penetrated the experience of the entire interior installation.

7 Leena Mahan, "The Sound of Jeanne Lee's Voice," *Critical Read*, accessed September 10, 2022, https://criticalread.org/the-sound-of-jeanne-lees-voice/.

elongates her daughter's name—there is a whole geography in the name as Lee stretches it to its individual vowels, to consonants, to short and long bursts of sound, plosive and assonant. Before I understand that what is being spoken and sung is a word, a name, *the* name Naima, what is utterly clear to me is that the sounds I am hearing are suffused with love. These fluttering, buoyant sounds are wrapped in, infused with, and subtended by what I can only call light and wonder, sweetness, and tenderness. The sounds land softly, like water into a bowl, like sounds moving across water in those bowls that are, or stand in for, faces in so many of Leigh's figures.

Before the word (Naima, or sovereignty, or conspiracy, or sentinel, or satellite) was the sound and, as Toni Morrison wrote, "the voices of women searched for the right combination, the key, the code, the sound that broke the back of words."[8] The sound broke the back of words, shattered the names summoned to call us out of the names we recognize as our own.

As Lee spells her daughter's name with deliberation and care, it brings to mind: Ntozake Shange's book for young readers *I Live in Music*, with text by Shange and illustrations by Romare Bearden. And then Stevie Wonder's "Isn't She Lovely (Made from Love)," a joyful song that celebrates the birth of his daughter Aisha Morris and begins with her newborn cry.

Jeanne Lee's singing and Simone Leigh's hands move together, toward the necessary scale appropriate to the histories, acts, desires, lives, and bodies of the Black women who are at the center of Leigh's work. The film's soundtrack includes the reading of ethnographic texts from Robert Farris Thompson and Zora Neale Hurston. (The sonic collaboration in *Conspiracy* reflects an ongoing practice. Leigh and Moor Mother, for instance, collaborated on an audio installation [page 226] for *Loophole of Retreat*, Leigh's 2019 solo show at the Guggenheim Museum in New York.)

An artist's tools, a writer's tools, a worker's tools, hand as a unit of measurement (How many hands tall are these figures? How many hands tall is the statue *Sharifa*, whose hands so hold our attention?). There are hands holding tools that might and have also doubled as weapons. What is the difference between a weapon and a tool? Maybe it's a matter of hands.

Again and again, our attention is turned to hands. Leigh's hands are ever articulate. And I am fascinated by the tools. The hand, Leigh's hand, is apparent throughout her creation of imaginative and material architectures, in the thatching, in the shaping of rosettes, in the smoothing of the plane of a cheek, in two hands raising a scythe over a head.

So in *Conspiracy*, *manual* is hand, handbook, work, and instruction. A manual for freedom, for liberation, for beauty. A scythe can cut materials for drying and later weaving, and it is a weapon for insurrection and revolution. Here is a conspiracy—a collaboration—a group unlawful in their/our gathering in order to plot a different world—when our well-being, our survival, is at stake.

The former colonial powers of France, Belgium, Germany, and England (in particular) argue that those stolen materials (artifacts, statuary, wearables, bronzes, reliquaries, Nkisi, etc.) they continue to hoard, but are gradually loosening their grips on, are in their care. They argue that they are preserving them; that in *their* museums and *their* storage rooms they, and only they, have the capacity to control the climate and ensure the optimum conditions—temperature and humidity and light control—to preserve these items. These are, of course, the self-same colonial powers that confiscated items and people and destroyed works and communities, often by burning so many of these materials during their rampages and reigns of terror and their ongoing violent expropriations. These European former powers continue to assign to themselves a custodial role in relation to these stolen objects, claiming that this is to ensure that they last into some future. But no, that's not why they stole these objects; they stole them to steal them, they stole them as trophy. They assign to themselves the role of caretaker with no consideration of the possibility that some or even many of these objects may not have been meant to last, or outlast their makers. What if the objects' (s. and pl.) presence in our present is counter to their use, counter to the intentions of those who made and used them? What if their disintegration was/is part of the cycle of *their* being in the world?

The concluding long shot in *Conspiracy* shows Leigh burning a papier-mâché and raffia version of *Anonymous*, a

8 Toni Morrison, *Beloved* (New York: Plume, 1987), 261.

9 Julia Halperin, "Not in Venice? Catch Works from Simone Leigh's Crowd-Favorite Pavilion When It Travels to Museums across the U.S. Starting in 202," *Artnet*, April 21, 2022, https://news.artnet.com/art-world/simone-leigh-us-pavilion-venice-2101999. Leigh's burning of the sculpture on the Red Hook waterfront (page 83, fig. 2) was inspired by the burning of the Vaval, the King of Carnival effigy, in Martinique.

10 Toni Cade Bambara says that Julie Dash's 1991 film *Daughters of the Dust* "intends to heal our imperialized eyes." Bambara, introduction to Julie Dash, *Daughters of the Dust: The Making of an African American Woman's Film* (New York: New Press, 1992), xii.

11 Leigh has described the burning as "therapeutic": "It gave me so much relief. . . . I never get to destroy my work in that way." Mitter, "Simone Leigh, in the World."

ceramic work that "depicts the unidentified Black female subject of a racist 1882 souvenir photograph by a white photographer."[9] Here is an aesthetic to "heal our imperialized eyes."[10]

Leigh's destruction of that which has been made by her hand is a kind of exorcism, done with intention and witnessed by Leigh, her studio assistants, and the artist Lorraine O'Grady.[11]

ii. Satellite/Façade/Sentinel

"the body at architectural scale"[12]

Satellite (2022) is an immense statue of a figure installed at the entrance to the transformed U.S. Pavilion in the Giardini. As the exhibition brochure describes, "The work recalls a traditional D'mba (also called *nimba*), a headdress shaped like a female bust, created by the Baga peoples of the Guinea coast and used during ritual performances to communicate with ancestors."[13] Leigh's bronze figure is large, twenty-four feet high and ten feet wide, so large and wide that you can stand under her for protection. Where the face would be Leigh has made a large satellite dish "to be a vessel for receiving and a tool for communicating."[14]

If you listen, you will hear the reports coming in and going out on the condition of Africans and all Black people in Venice in particular, in all of Italy, in Europe in general.[15] In past years, in addition to seeing Black people from all over the world who arrived for the Biennale, one would also encounter many African people who were living, trying to make a life, in Venice. In past years, I encountered dozens of African men, some of whom, unable to legally sell goods, gave us bracelets or rings in return for some small donation to help them and their families. Sometimes we had conversations with them and always we wished them well. In June 2022 I saw only five or six African men—three of whom were together and two others who were completely on their own. Those two men on their own were alone in ways that looked utterly bereft—they were rail thin and clearly living on the street, they appeared as if they were in the process of disappearing. It was shocking to encounter Black peoples' almost complete removal from the streets of Venice. I was not prepared for their absence, or rather their absent-presence, not prepared for our being all but completely pushed out.

Within this context, Leigh's *Satellite* seems to presence those absences, to turn our attention to those bodies and people here and there and also nowhere, present, at all. In Leigh's work there is a persistent valuing of what and who is hegemonically, systematically, and systemically disvalued and devalued. The disprized. (And in other directions—the directions that she follows and charts—that which is loved, valued, cherished, and reproduced.) As Malik Gaines writes, "Simone Leigh makes historical loops that are felt through material, her ceramic forms sometimes alluding to, for instance, cowrie shells—that worthless currency with which many Africans traded other Africans into transatlantic slavery. Leigh's poetic sensibility at once unveils the beauty of that natural form, its relationship to oceanic trauma, and the radical negativity of its exchange."[16]

Writing for Leigh's 2018 show at Luhring Augustine, Sharifa Rhodes-Pitts describes the statue *No Face (Pannier)* (2018; page 161): "She has no face. Maybe this is a form of anonymity, of unmarkedness. Maybe it is the refusal of identity: she is not decorative, she cannot be used. There is a wreath of roses where her face should be . . . what has happened to her face?"[17]

Rhodes-Pitts is turning our attention to the work of attending to, the work of not thinking that "we" (perhaps any we) automatically know what it is that we are seeing. Rhodes-Pitts means for us to look and attend to what is present: "For suddenly when I looked, I saw not only the absence of a face, but the presence of a violently gaping maw."[18] Not a maw in *Satellite*, but a dish.

12 *Simone Leigh: Sovereignty*, brochure for the U.S. Pavilion at the 59th International Art Exhibition of La Biennale di Venezia, 6.

13 *Simone Leigh: Sovereignty*, 6.

14 Jameson Johnson, "The Prowess of Simone Leigh in Venice," *Boston Art Review*, May 17, 2022, https://bostonartreview.com/reviews/simone-leigh-venice-biennale/.

15 While I was writing this essay, Alika Ogorchukwu, a thirty-nine-year-old Nigerian man who had lived in Civitanova Marche for eight years with his wife and son, was beaten to death in the street in broad daylight while onlookers recorded it but did not intervene to stop it. Angela Giuffrida, "Italy: Man Arrested on Suspicion of Murdering Nigerian Street Seller," *Guardian*, July 30, 2022, https://www.theguardian.com/world/2022/jul/30/italy-man-arrested-on-suspicion-of-murdering-nigerian-street-seller.

16 "Simone Leigh by Malik Gaines," *BOMB Magazine*, April 1, 2014, https://bombmagazine.org/articles/simone-leigh/.

17 Sharifa Rhodes-Pitts, "Artist Unknown, Vessel Possibly for Water," in *Simone Leigh* (New York: Luhring Augustine, 2018), 34.

18 Rhodes-Pitts, "Artist Unknown, Vessel Possibly for Water," 35.

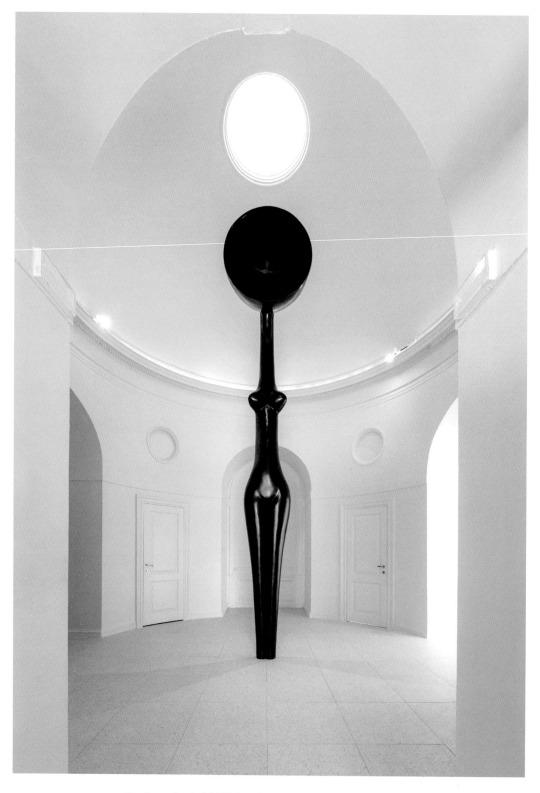

Fig. 2 *Sentinel*, 2022. Installation view, *Simone Leigh: Sovereignty*, U.S. Pavilion, 59th International Art Exhibition of La Biennale di Venezia, 2022

Perhaps, then, this figure is transmitting the signal that will guide you to shelter—from a space nominally marked as national property but with that external marking obscured. Does the satellite send a signal to those boats that are every single day attempting to cross the Atlantic, the Mediterranean, the Strait of Gibraltar to reach the shores of Fortress Europe—these contemporary boats that echo the paths of the trans-shipped during the transatlantic slave trade?

Does the statue declare: No safety here but under my sheltering frame?

The thatching is behind and to the left and right of *Satellite. Façade* (2022; pages 24–25) obscures the name of the U.S. Pavilion, and "in a dramatic makeover of the neoclassical, Jeffersonian building," as Liam Hess describes, "Leigh covered the structure with a thatched roof inspired by a traditional African rondavel, in keeping with her subversive meditations on the legacy of Western colonialism."[19]

The last time I was at the Biennale, the artist at the U.S. Pavilion was Martin Puryear. Indeed, the last three artists to represent the United States at the Biennale have been Black artists—Mark Bradford (2017), Martin Puryear (2019), and Simone Leigh (2022), and each one has approached the pavilion by obscuring or reframing some aspect of it.

Bradford, for instance, "peeled the plaster from the walls, obscured the skylight, and affixed ropes of painted-and-bleached black-and-gold paper up on the ceiling, transforming the space into an eerie ruin, reminiscent of both Angkor Wat and a foreclosed home, with a distinctly submerged feel."[20] His work also looked like a cross-section of a hive—like a structure built by the swarm. Puryear's installation in the Rotunda forced us to contend with Thomas Jefferson's rape of Sally Hemings.

But to return to the exterior and Leigh's thatching work, Jill Medvedow writes, "She is juxtaposing these two histories. Histories that precluded so many people, so many Black women, from sovereignty—the title of the exhibition."[21] Thatching work is manual and skilled and was and is often done by women working side by side. This is not a question of romanticization, but of fact and of necessity. To consider those

labors is to be attuned to what is made in and through necessity. When we so often hear about Black women's oppression, what is often omitted is what is made from within its midst, against it, despite it. And what is made just might be a thing of practicality and beauty. A vessel. A covering. A garment. A jug. What is made in that making just might be sustenance, just might be survivance.

Installed in the Rotunda, directly behind *Satellite* and forming a kind of visual and sonic echo, is *Sentinel* (2022; fig. 2), a smooth, cast-bronze, long-legged, long-torsoed figure with breasts. It too has a satellite dish or bowl as a face or where a face would be. This figure is mirrored architecturally by the oval window and by *Satellite* in the courtyard—establishing a kind of relay system or echo. And if it is an echo, it is one that is more than visual; it is also sonic and vibrational. I imagine that the architecture of that face/dish is channeling and transmitting all the sounds of the pavilion within and beyond the building. If you listen you can hear the sound of a wet finger run along the rim of a bowl or secrets whispered over a bowl of water.

Sentinel reaches backward, stretches forward toward the future, and stands firmly in the present. Leigh interrupts that Jeffersonian architecture in a way that refuses other architectures of Monticello, namely, the tunnels that Jefferson had built under Monticello so that the bodies of the people he claimed ownership over were made to disappear even as they served him, his (white) family, and his guests food. He did not want to see them, did not want to be served by their black/ened hands, did not want in colloquial terms to be "put off of his food."[22] Yet Jefferson was invested otherwise in *always seeing* the enslaved, and this was the reason he installed the six oculi in the dome of Monticello. That way he might be seen to be always watching and the enslaved would internalize that perpetual gaze.

Satellite, Sentinel, Sovereignty, Conspiracy, the titles of these works root us in the present, the past, and then they reach out to other worlds—they make material and name other modes of being and connecting. These works are figural and abstract, familiar and unfamiliar objects. At the U.S. Pavilion, as I stood in front of *Sentinel*, I half observed people move through

19 Liam Hess, "Simone Leigh and Sonia Boyce Make History at the Venice Biennale," *Vogue*, April 23, 2022, https://www.vogue.com/article/simone-leigh-sonia-boyce-venice-biennale-golden-lions/.

20 Andrew Goldstein, "Mark Bradford Is Our Jackson Pollock: Thoughts on His Stellar US Pavilion at the Venice Biennale," *Artnet*, May 11, 2017, https://news.artnet.com/art-world/mark-bradford-is-our-jackson-pollock-thoughts-on-his-stellar-u-s-pavilion-at-the-venice-biennale-957935.

21 Medvedow quoted in Lauren Williams, "At the Venice Biennale, Artist Simone Leigh Centers Experience of Black Women, WBUR, May 13, 2022, https://www.wbur.org/news/2022/05/13/simone-leigh-venice-biennale. As Williams notes in the same article, "Leigh's reinterpretation of the Jeffersonian building is intentionally contradictory. Inspired by the Cameroon Togo Pavilion from the Paris Colonial Exhibition in 1931, Leigh's facade draws on an event in which France displayed the buildings, the cultures, and the people under its colonial rule."

22 *Scientific American Frontiers*, season 13, episode 1, "Unearthing Secret America," aired October 8, 2002, on PBS.

235

the room, some of them barely looking, as if everything to be known about this figure, about these figures, was already known.

Leigh has said in several interviews that at first she wanted all of the faces in her work to be featureless but then gradually she began to give them features. It seems to me, though, that with or without those features (faces, eyes), these figures have "I's," as in they embody presence that is singular and collective, intimate, and monumental.

iii. Last Garment

"Furthermore, black domestic life and labor gave rise to a significant number of inventions borne of arduous tasks and limited resources."[23]

Mario Gooden

"Manual: as of a weapon, tool, implement, etc.; that is used or worked with the hand or hands. Actually in one's hands, not merely prospective. (Manual: short for manual exercises, i.e., physical labor, and not the exercise of reason or imagination.) A tool or an object, within one's grasp, not speculative, not a proposal for black female genius."[24]

Saidiya Hartman

Working from old photographs and a live model, Leigh made *Last Garment* (2022; fig. 3), a bronze sculpture of a woman at work washing clothes set in a black marble reflecting pool. As Jameson Johnson writes, the figure "references an 1879 photograph taken in Jamaica by C. H. Graves titled *Mammy's Last Garment*, which captured a laundress hard at work. It's the type of image that was sent on postcards to promote white tourism in the British-occupied Caribbean colonies."[25]

Last Garment is formally beautiful. There is such loving detail here. We find it in the cling that marks the texture and precision of the woman's wet clothing as it adheres to her body. There are the rosettes—more than eight hundred of them[26]—each one made by hand and placed by hand to form a thick cap of glistening curls. There are her beautiful hands, placed on the rock, shoulder width apart, and stilled for the moment.

When visitors enter the pavilion, they must walk around the edges of the sculpture, they must navigate and inhabit the perimeter of the room.[27] Julie Baumgardner describes how "the work's magnitude of scale pushes the walkway to the edges of the room, like a literal push to the edges of society."[28] Another critic wonders if the space and stature afforded the woman washing clothes on a rock in the water are necessary (he feels they are not, that this treatment lifts the banal to the status of the monumental): "'Last Garment,' a frank depiction of a Jamaican washerwoman staged in an actual pool of water, gains nothing from its weighty medium or imposing scale."[29] But those women *are* monumental, they *are* immense, and hardworking, and they have, often by choice and often not by choice, put their bodies on the line. Françoise Vergès's insistent and clarifying question "Who cleans the world?" is important here. As Vergès tells us, it is *these* women who make everything else happen, and it is they who are supposed to remain invisible to power even as power is enacted on them:

> The working body that is made visible is the concern of an ever growing industry dedicated to the cleanliness and healthiness of body and mind, the better to serve racial capitalism. The other working body is made invisible even though it performs a necessary function for the first: to clean spaces in which the "clean" ones circulate, work, eat, sleep, have sex, and perform parenting. But the cleaners' invisibility is required and naturalized. This has been happening for at least five hundred years.[30]

23 Mario Gooden, *Dark Space: Architecture, Representation, Black Identity* (New York: Columbia Books on Architecture and the City, 2016), 18.

24 Saidiya Hartman, *Wayward Lives, Beautiful Experiments: Intimate Histories of Riotous Black Girls, Troublesome Women, and Queer Radicals* (New York: W. W. Norton, 2019), 77.

25 Johnson, "The Prowess of Simone Leigh in Venice."

26 ICA/Boston (@icaboston), Instagram, May 25, 2022, https://www.instagram.com/p/Cd_EXfZOHNA/.

27 Visitors had a similar experience in Mark Bradford's Venice installation *Tomorrow Is Another Day*: "Inside the first room, a giant red-and-black papier-mâché tumor-like sculpture hangs from the ceiling and literally marginalizes the visitor, forcing him to navigate around it by clinging to the walls." Goldstein, "Mark Bradford Is Our Jackson Pollock."

28 Julie Baumgardner, "At the Venice Biennale, Simone Leigh Embraces Sovereignty," *Hyperallergic*, May 1, 2022, https://hyperallergic.com/728992/at-the-venice-biennale-simone-leigh-embraces-sovereignty.

29 Jason Farago, "At Venice Biennale, Contemporary Art Sinks or Swims," *New York Times*, April 21, 2022, https://www.nytimes.com/2022/04/21/arts/design/venice-biennale.html.

30 Françoise Vergès, "Capitalocene, Waste, Race, and Gender," *e-flux Journal*, no. 100 (May 2019), https://www.e-flux.com/journal/100/269165/capitalocene-waste-race-and-gender/.

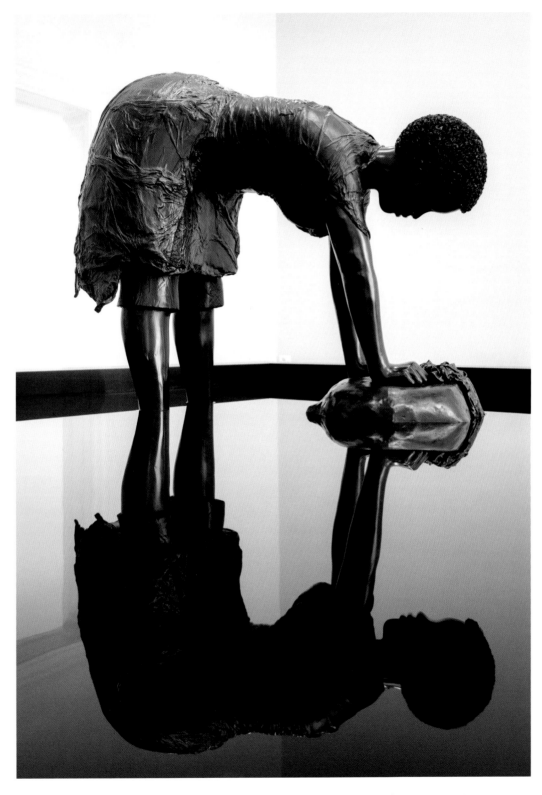

Fig. 3 *Last Garment*, 2022. Installation view, *Simone Leigh: Sovereignty*, U.S. Pavilion, 59th International Art Exhibition of La Biennale di Venezia, 2022

The figure of the enslaved washerwoman in the Caribbean is central to Omise'eke Tinsley's *Thiefing Sugar: Eroticism between Women in Caribbean Literature*. Tinsley writes about those washerwomen who worked so hard in water and so long and over so many seasons that their legs began to be eaten away by the water and they developed other lasting physical ailments like rheumatism and arthritis as a result of this work.[31] Tinsley quotes from the slave narrative *The History of Mary Prince*: "'Our feet and legs,' [Prince] recounts, 'from standing in the salt water for so many hours, soon became full of dreadful boils, which eat down in some cases to the very bone, afflicting the sufferers with great torment.'"[32]

A lot has been said about Leigh's imagining of Black women as her primary audience. This is important, especially given the worlds that we inhabit that are, everywhere, inimical not only to our well-being but to our very survival. In Leigh's work we are visible, and as an audience Black women are invited to see ourselves here. The reflective surface of the installation means that as one gets closer to the work—and especially if one tries to take a close-up photograph of the work—one almost certainly encounters oneself in the frame, even if one had not imagined oneself in it prior to that moment. How can we look at *Last Garment* and not also see an invitation—an invitation to seeing (transformed and refined), to seeing the subject of the statue, the person, and the labor, and then to see the world and ourselves within a set of power relations at work and to perhaps see them differently.

When do we become our labor? Washerwoman, woman washing. Is there a difference, some distinction? Does it matter? Is its mattering one of class? I'm not certain, but what I see when I look at Leigh's *Last Garment* is detail.

The woman working in the water might well be able to see her own refection as she labors. She might pause from this backbreaking work, stand up slowly, not so fast that her head spins from the blood draining too quickly. She might put her hand on her hip or hold her palm to her back. Stretch, raise a bent arm, put her wrist or the back of a hand to her forehead and wipe away the sweat. She might squint and look up at the sky and marvel at its clarity and color or curse its cloudless, unrelenting light and wish for something other than blueness. She might be still for one moment, or two or three. She might

take a deep breath, hope that her back will not be too stiff after all this bent-over work. She might then turn back to it, the last garment of the day.

In *To 'Joy My Freedom: Southern Black Women's Lives and Labors after the Civil War*, the historian Tera W. Hunter writes about the 1881 Atlanta washerwomen's strike in which around twenty Black women and a few men formed the Washing Society, which then called a successful strike in order to set a uniform rate for washing laundry. Hunter tells us that "the protest was the largest and most impressive among black Atlantans during the late nineteenth century."[33] (I think too that this strike is another echo, intentional or not, in Leigh's body of work, as the washerwomen in Atlanta constitute yet another example of a Black women's secret society, those histories that Leigh has so richly drawn on.)

While this washerwoman references a particular Jamaican woman, the washerwoman is a figure of the Global South more broadly. That which exceeds the work of the ethnographic photograph that was produced to reassure the white spectator appears in Leigh's full-scale sculptural imagining of the subject of the photograph, the washerwoman. In *Last Garment* we observe her hands—their smoothness and beauty are present in the photograph but in service to understanding something(s) about hygiene and labor. In other words, it is not the beauty of her hands that we are meant to attend to. But again and again in Leigh's sculptures, what we meet exceeds the human scale; the hands are beautiful, whether bent or spread out, at work or at rest, holding an implement or building a clay vessel or form.

This figure is there for those who desire to meet her in her own milieu. To meet the woman washing clothing in the hard and soft water of her life.

iv. Brick House/Vessel

"You change the object by changing the atmosphere."[34]

Simone Leigh

Where I live, in Toronto, there are more than 130 bronzes by Henry Moore. Some are in public places, such as *Large Two Forms* at the Grange, near the Art Gallery of Ontario. In the

31 Omise'eke Natasha Tinsley, *Thiefing Sugar: Eroticism between Women in Caribbean Literature* (Durham, NC: Duke University Press, 2010).

32 Tinsley, *Thiefing Sugar*, 148.

33 Tera W. Hunter, *To 'Joy My Freedom: Southern Black Women's Lives and* *Labors after the Civil War* (Cambridge, MA: Harvard University Press, 1991), 88.

34 Tomkins, "The Monumental Success of Simone Leigh."

35 "The Making of *Brick House*," *High Line Art* (blog), January 14, 2019, https://www.thehighline.org/blog/2019/01/14/the-making-of-brick-house/.

AGO itself there is the newly renovated Henry Moore Sculpture Centre, dedicated to the artist's bronzes and etchings. People in Toronto had to learn how to see this work. (There was much consternation when the sculptures first appeared in the city.) But in much of North America, the United Kingdom, and Europe, Moores are ubiquitous to cityscapes—so much a part of them as to be both instantly recognizable *and* almost unseeable.

That conjunction between the recognizable and the unseeable occurs in Deann Borshay Liem's film *First Person Plural* (2000), when she describes her first weeks in the United States as a Korean child adopted by white parents who already have two white children. As Liem speaks we see a succession of images—as I recall they are of some of the places that she visits (national parks, amusement parks, museums), landscapes that are meant both to demonstrate and then to usher her into (white) "American-ness." One of these places is Mammy's Cupboard, where her adoptive parents take her for a meal, a place "as American as apple pie and hot dogs." Liem is ushered into belonging through ingesting antiblackness, ushered into a white family through blackness. As with the Moores, the eye is trained to see aesthetic value, and the "I" is made (and unmade) in relation to that seeing.

Leigh's work, at least one insistent part of it, is the refiguration of these "architectures of anatomy"—her recombinant practice in which she draws from national myths, architectures, systems, and the like, and refuses their borders.[35] That attentive primacy defines Leigh's practice of care—even if, even as, the spaces of care that she holds open and ushers us into are fleeting.

As Rianna Jade Parker has written, Leigh has "been thinking about the labour of black women, the forms of knowledge they carry, and what kinds of labour they are involved in that's not valued."[36] Her sixteen-foot-tall *Brick House* (2019; fig. 4) is a bronze sculpture of a woman who wears an Afro and four cornrows, each of which is decorated with a single cowrie shell at the end. Leigh imagines the cornrows on *Brick House* as buttresses; they are defense, fortification, supports. The

woman's torso is a combination of forms, both skirt and house. Leigh braids the corporeal, the useable, the inhabitable, and the ethereal. As Rhodes-Pitts wrote of another of Leigh's works, Leigh was "creating a structure, provoking a void. The shape was transformed by what it could bear."[37]

Here, there is the body as a vessel that the world works to break, but in Leigh's hands and imagination is prized, cared for, rendered as monumentally beautiful. Is a vessel "a person into whom some quality (like grace) is infused"?[38]

Leaving New York City in late 2019, I caught a final glimpse of *Brick House* as she rose above the High Line, and I was transported. Installed in the Arsenale, as part of *The Milk of Dreams* international exhibition, *Brick House* appeared as holder, as keeper in the center of the room, watching over the haunting paintings of the Cuban artist Belkis Ayón (fig. 5). Is a vessel also a watcher?[39]

When Leigh talks about the process of casting *Brick House*, she turns to the kiln:

> This is the big deal. . . . It's an atmospheric kiln—the closest that ceramics come to true alchemy. At the height of the firing, around two thousand and three hundred degrees, you introduce salt, which is dispersed throughout the atmosphere of the kiln and combines with the silica in the clay to create a unique kind of glaze. You change the object by changing the atmosphere. The results are often not what you'd expect. After thirty years, I still don't know exactly what's coming out of the kiln, and I love that. I lose between twenty-five and fifty per cent of what I build—things that don't make it through the firing.[40]

This alchemical work, and I repeat myself here, is true not only of the shifting environments of the atmospheric kiln but of all of Simone Leigh's work. She works with and transforms familiar and unfamiliar materials, those that disturb as well as those that produce surprise and wonder.

36 Rianna Jade Parker, "'What We Carry in the Flesh': The Majestic Bodies of Simone Leigh." *Frieze*, June 4, 2019, https://www.frieze.com/article/what-we-carry-flesh-majestic-bodies-simone-leigh.

37 Sharifa Rhode-Pitts, "Simone Leigh: For Her Own Pleasure and Edification," in *The Hugo Boss Prize 2018* (New York: Guggenheim Museum, 2019), https://www.guggenheim.org/wp-content/uploads/2019/03/guggenheim-sharifa-rhodes-pitt-essay-simone-leigh-hugo-boss-prize-2018.pdf.

38 Merriam-Webster, s.v. "vessel," updated September 2, 2022, https://

www.merriam-webster.com/dictionary/vessel. See also Christina Sharpe, "Beauty Is a Method," *e-flux Journal*, no. 105 (December 2019), https://www.e-flux.com/journal/105/303916/beauty-is-a-method/.

39 Christina Sharpe, "What Could a Vessel Be?," in *The Milk of Dreams/Il latte dei sogni: Biennale Arte 2022* (Venice: La Biennale di Venezia/Silvana Editoriale, 2022), 366–77.

40 Tomkins, "The Monumental Success of Simone Leigh."

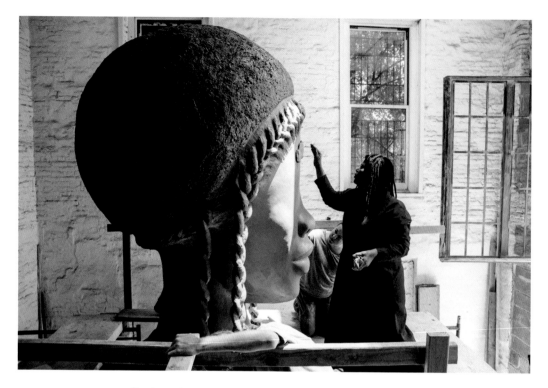

Fig. 4 Simone Leigh and her sculpture *Brick House* while in progress, 2018

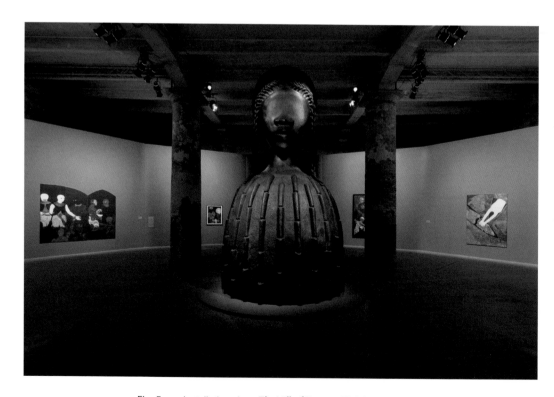

Fig. 5 Installation view, *The Milk of Dreams*, 59th International Art Exhibition of La Biennale di Venezia, 2022

Leigh says that she wanted the Black beauty of *Brick House* to be placed in the public space of the High Line plinth, where it was displayed for sixteen months, not as a lesson but because it is already there—all around.[41] Just as Leigh's reimagining of the U.S. Pavilion in Venice does a kind of shifting perspectival work, so does *Brick House*'s beauty and its proximity to that cruel, fascist architecture, that monument to capital, the 150-foot-tall *Vessel* structure at Hudson Yards. There is something at work here about the adjacency of these different kinds of vessels. There is something here about Leigh's hand versus the spiraling staircase at Hudson Yards that makes clear that the latter vessel is a monument to death and the other vessel, *Brick House*, is a monument to life.

These are the scales that Leigh works in. This is the journey to which we have had the good fortune to be both witness and participant.

41 "The Making of *Brick House*."

Hortense J. Spillers

Simone Leigh and the Monumental

Fig. 1 Girl (Chitra Ganesh + Simone Leigh), *my dreams, my works, must wait till after hell . . .* , 2011. Installation view, *Radical Presence: Black Performance in Contemporary Art*, Contemporary Arts Museum Houston, 2012

242

"Get thee to Venice" popped into my head with such eruptive force that the thought sat me down! It made perfect sense, though: the 59th Venice Biennale opened on April 23, 2022, and my birthday—this April commenced the eighth decade of my life—is celebrated on the 24th, which conjunction of events means I could have been in the city in time to drink a birthday bottoms up of something, perhaps at Harry's Bar (if it's still there), while paying inaugural tribute to Simone Leigh, whose work is featured in the United States Pavilion. According to Calvin Tomkins, Leigh is "the first Black woman to be so designated for this honor."[1] When I first visited this fabulous city in the mid-1980s (because it was time for me to see Italy), a version of the Biennale was on offer that year, too, and I vaguely remember dropping in on it at a venue near Saint Mark's. But memory is deceptive, the Freudians tell us, a screen for something other than what it appears to be, and every Venice location, perhaps, is near Saint Mark's. But I definitely visited Venice once upon a time, circa 1985, and wanted to go again to see Leigh's *Brick House*. Would I get to view it there?

Taking on this writing assignment, I am poignantly aware that I am not an art critic. The last course I had in art was conducted by one of my beloved eighth-grade teachers, who taught us what the primary colors are and how to make things of increasingly complicated shapes, skills at which I was utterly hopeless. But something stuck well beyond those years of basic learning and experimentation. What was left over was what I started with—a love of color, of design (a word that came much later for me), the smell of brick and mortar and tar, of concrete being poured, the gorgeous sheen of mahogany, a lacquered tabletop, the quiddity of old shotgun houses, of single-story ranch houses with bay windows, then the dwellings of the Black bourgeoisie, which the Spillers family was not. In short, Mr. Lewis's art class officially opened up my imagination to a world that was neither music (of school bands, big jazz bands, church choirs, college glee clubs, siblings practicing the piano, trumpet, and clarinet, Black radio and Lucie Campbell's gospel songs), nor discourse (of sermons, oratory, prayers, imprecations, invocations, benedictions, the rites of the living and the dead), but, rather, proffered a different language altogether. My astonishment at Leigh's art and my admiration of it reside there—among those primary loci of awe and wonder that we cannot name.

Enormity appears to be the hallmark of sculpture, especially as it distinguishes Leigh's preeminent signature of the *monumental*. But the contrariety effected in her work between elements of portraiture and architecture (or, more precisely, built space) in the very same spatiotemporal breath—of the human form and its hints and intimations mutually inter-animated by and intermingled with aspects of engineering and construction—is riveting. I would even call it a genuine seduction. Colloquially speaking, I would go so far as to say that the combination knocks my socks off. A striking instance of this oxymoronic resolution is captured in a still from Leigh and Chitra Ganesh's video work *my dreams, my works, must wait till after hell . . .* (2011; fig. 1), which shows a bare upper back and a palpable imitation of its anatomical features, up to the stem of the neck. The posture of the reclining figure mimics a sleeping body, as the eye follows what might naturally (or expectedly) have been a head with its hair loose and flowing around it, but the latter in this case spills out instead as a conical stack of small rocks and pebbles in what might be thought of as the interruption of pathos. The implication of supreme vulnerability in a sleeping back, turned away from an observer, is checked by the unanticipated eruption of difference. In other words, the attention must now account for the *materiality* and *substance* of what it is encountering rather than surrender to the narrative that is gathering from the felt tension in the figure's spine and vertebrae. The focus is, therefore, shared between, if not contending with, two contiguous and discrete gestures—one geared toward the feeling end of the spectrum, one toward the more distant, observational contrast that holds the former at bay.

We might also think of this problematic as a figurative conversation unfolding here and in other of Leigh's works between the *material*—what the thing is made of—and what the observer attributes (adding something) to it and gains (taking something away). If we said that Leigh's sculptures are *only ever material* and its adroit manipulations, that would not be wrong, I think, but it would be incomplete in its excision of the subjective, of the idiomatic, or what the observer sees. As I understand it, it is the play and interplay, the "choreography," between *something given* and *something conjured* that yields the magic.

In other instances, the mix of substantive motivation, if we could call it that, juxtaposes organic and inorganic elements in order to make their statement. In *Crop Rotation* (2012; pages 56–57), for example, where Leigh places a version of a catenary angle in suspension, tobacco is deployed in combination with terracotta, paint, and steel to suggest movement, or one might say that it is the tease or threat of movement that captures the attention in a kind of query: is it movement as in a clothesline that stretches round and round, or movement as in an assembly

1 Calvin Tomkins, "The Monumental Success of Simone Leigh," *New Yorker*, March 28, 2022, 46.

line whereby one thing succeeds another in an unrelenting, even dizzying, forward motion? In Leigh's *Cowrie (Sage)* (2015; page 131), sage cohabitates with terracotta, porcelain, string, wire, and steel to conjure up a hint of the human form as the mimicry of the cowrie shell itself occupies the place of a head (and by implication, a face) on a body. To my mind, this configuration embodies paradigmatic Leigh, insofar as it evinces an example of the inverted Y that hauntingly repeats in thematic variation across the canon: it is there, for example, in *Cupboard VIII* (2018) and *Figure With Skirt* (2018; page 153). Both works feature a raffia-fashioned bottom half, a common form in Leigh's sculpture that culminates, transformed into bronze, in *Brick House*. Sharifa Rhodes-Pitts points out that *Cupboard VIII* is inspired by Leigh's "ongoing investigation of the real-life Mammy's Cupboard, a restaurant in Mississippi whose entrance passes through the skirt of a monumental mammy figure."[2] Leigh's *Sentinel*, a bronze and raffia figure from 2019 (fig. 2), also figures in this broad category of sculptures. Intimately poised with what looks like a steel, or an oil, drum turned on its side and nestled in a rectangle, *Sentinel* brings together a conviviality of shapes and textures—roundness in the Afro head of the sentinel, which shape is echoed in the drum; if an observer wanted to entertain a whimsical thought for a moment and dare a fillip of mischievous humor, then she might think of the drum's roundness analogously with a gigantic loaf of grooved, uncut cranberry sauce, served up on an appropriately sized Thanksgiving platter. In any case, the formality and smoothness of bronze against the informality and coarseness of raffia, the roundness of the head and that of the oil/steel drum over and against the rectangular edges and straight angle of the skirt all draw an observer into this intriguing celebration of contrast.

The face of *Sentinel*, which was created the same year as *Brick House*, invites pause that quickly translates into puzzle—how to explain the eyelessness of the figure and that of the striking series of busts that belong to 2016? Tina M. Campt contends that the "absence of eyes that should serve as the sources, origins, or conduits of these looks intensifies our search for contact and connection."[3] Campt perceives a paradox in this conclusion, which means, in effect, that absence here "amplifies a look that is there but not there."[4] In any case, the physiognomy of the facial features is both unique to Leigh and reminiscent of the Benin bronzes. The very notion of the

statuesque seems captured in its essence by these eyeless gazers, prominently figured in busts distinguished by ceramic rosettes. I have in mind particularly the figures that take their names from female nomenclature—*Althea*, *Daphne*, and *Hortense*—joined by *Winsome* and *Swakopmund*, the latter, from 2018, named for a Namibian coastal city. I suspect that Lauren Hudgins Shuman had at least some of these works (or works like them) in mind when she observed that "there was something about them that stopped people in their tracks."[5] Shuman is referring here to the small busts that Leigh exhibited in 2016 at Manhattan's Park Avenue Armory, which highlighted the artist's use of ceramic rosettes for hair and head pieces. The multicolored rosettes on *Hortense* (page 203, fig 2) for instance, as well as the gold luster that constitutes the face of the bust, offer the sudden and astonishing explosion of color against terracotta and India ink; similar contrast is achieved in *Winsome* (2016), conferring on the figure a formidable horned hairdo of rosettes with gold tints, and in the trellis formation that the rosettes in shades of buff and gray assume on *Daphne* (fig. 3). These seductive hair postures, in their monarchial assertiveness and whimsical ingenuity, celebrate, by implication, the nappiness of tightly coiled black hair that, given its super-curly texture, really can, with a bit of assistance from pomades and hair stiffeners, take on hair configurations like *Althea*'s (fig. 4), for instance, whose glorious blue and blue-black glossy rosettes prodigiously jut out at brazen straight angles from either side of the figure's head; in this case, the hair stiffener, as it were, is epoxy. The cobalt and India ink, against porcelain and terracotta, burst on the tongue of the sight, if we might so describe it, with an appetitive poignance and tactility that are nearly edible!

Not having seen *Brick House* yet, except by photographic image, I can only try to imagine how much a sixteen-foot bronze bust of a Black/African female, installed on a plinth, no less, as it was in New York, must absolutely startle (pages 214–15). Having lunch a few months ago across the street from the High Line, I had a couple of hours to toggle in my mind, in the midst of the chatter of friends, between memory of the image and the actual empty space on the horizon in front of me where the sculpture might have stood once, near the West Thirtieth Street entrance to the Lincoln Tunnel. I imagined its imposing serenity, its utter stillness, in the dead epicenter, it seemed, of massive constructions, the noise of the subway,

2 Sharifa Rhodes-Pitts, "Artist Unknown, Vessel Possibly for Water," in *Simone Leigh* (New York: Luhring Augustine, 2019), 24.

3 Tina M. Campt, "Sounding a Black Feminist Chorus," in *A Black Gaze: Artists Changing How We See* (Cambridge, MA: MIT Press, 2021), 152.

4 Campt, "Sounding a Black Feminist Chorus," 152.

5 Shuman quoted in Tomkins, "The Monumental Success of Simone Leigh," 53.

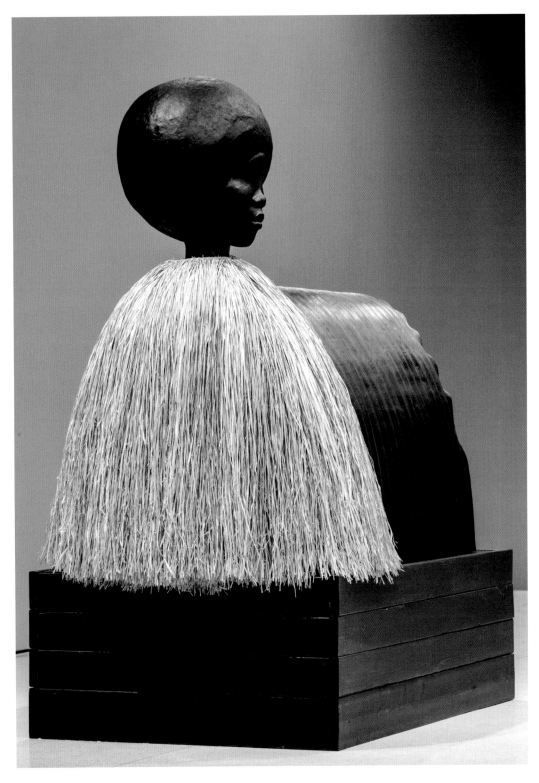

Fig. 2 *Sentinel*, 2019. Installation view, *The Hugo Boss Prize 2018: Simone Leigh, Loophole of Retreat*, Solomon R. Guggenheim Museum, New York, 2019

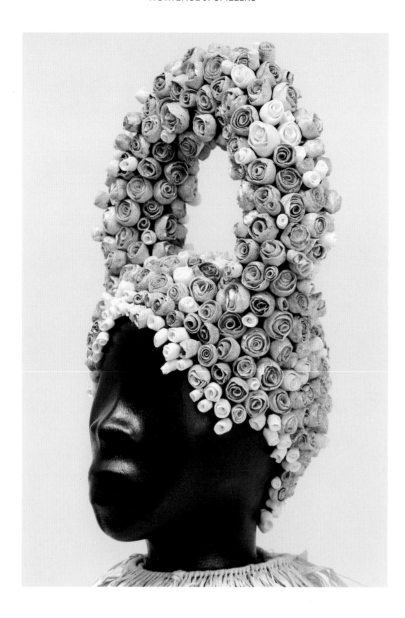

Fig. 3 *Daphne* (detail), 2016. Terracotta, porcelain, India ink, raffia, and epoxy. 32 1/2 × 28 × 28 inches (82.5 × 71.1 × 71.1 cm). Private collection, San Francisco

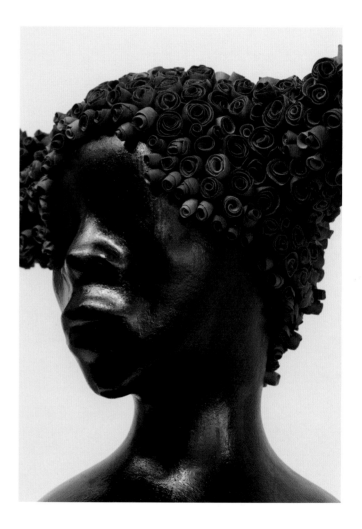

Fig. 4 *Althea* (detail), 2016. Terracotta, India ink, porcelain, cobalt, and epoxy. 26 × 24 × 15 inches (66 × 61 × 38.1 cm). Hammer Museum, Los Angeles. Purchased through the Board of Advisors Acquisition Fund

the endless traffic, and the unceasing flow of pedestrians all around it, all seasons and times. As noted in Tomkins's profile on Leigh, Cecilia Alemani, the curator of the High Line's art projects and the director of this year's Venice Biennale, commissioned *Brick House* in 2016; the piece was completed three years later in Philadelphia at the Stratton Sculpture Studios, and from the sound of it, its making evoked a powerful building project that took seven months to cast from its clay model.[6] In 2022 *Brick House* sailed to Europe (apparently too heavy for a jet liner) and required the services of a project manager and an architect to oversee its installation in Venice. Like *Sentinel* and the busts that feature the ceramic rosettes, the face of *Brick House*—the Olmec nasal broadness, the fulsome mouth, the prominence of cheekbones, and, by suggestion, the exquisite sheen and flawlessness of jet-black skin that is perfectly signified in bronze—is decisively African in its architectonic aspects; its tints and colorations, or how these differentiations appear according to the way light plays and shimmers across its surface; and its perdurability, or feel of timelessness. But there "it" is again, too, that disturbing eyelessness, or more precisely, the spatial markings for eye sockets are quite decidedly described in the face but are left as indentations instead of incisions. If so, then what's up with that?

Campt is right, I believe, to suggest that the eyes convey the "look" of a face, even though it is quite remarkable that this would be so. In fact, the concealed lower faces of one's fellow Americans over the long, wearisome travail of the nation's COVID-19 crisis showed the opposite: that the eyes alone do not capture an identity. A person's identity would come into focus—let's call it the "shock of recognition"—only when the mask was removed, and then to one's stunned surprise, the emergent face did not look at all like what one had guessed! This could only mean that the face holds its "look" as an entire ensemble of discrete yet related elements that, if altered in the slightest degree in any particular feature, however small or minor, creates another identity altogether. Perhaps this means that the face is wholly elusive in its tenor, that in its motility it is beyond capture, so that whenever we encounter our own, or another's, image, we are beholding only a fiction that turns into something else the next moment. Shape-shifting, then, is not only a mythical property or resource, but writes itself into the very DNA, as it were, of the face, making it at once the most knowable and the least calculable feature of the human facade.

What art does, it seems to me, is *canalize* this motility, more precisely, to *channel* it by promoting *one* of those evasive

moments as the single, capital moment that decides a "look." The face of *Brick House*, in its refusal of the eyeball, stops time by staging it. In other words, in its immensity of construction and intricacy of architectonic detail, the work accedes to trans-historical ambitions that render its subject every Black woman, but also something more. In a very real sense, the something more points to a program that exceeds the human and gropes toward an idea, in this case, Leigh's version of the eternal feminine. Leigh has dared not only to render the latter an instance of Africanity but also perhaps to reassert notions of feminine/woman-empowerment. If that is so, then the eyelessness of the face of *Brick House* offers itself in the service of awe and wonder that bring us once again into the realm of the terrible, although we cannot dwell there, and its imaginative possibilities. There, in that place of temporary dwelling, we are given license to be childlike once more, which is to say, a little scared.

6 Tomkins, "The Monumental Success of Simone Leigh," 54–55.

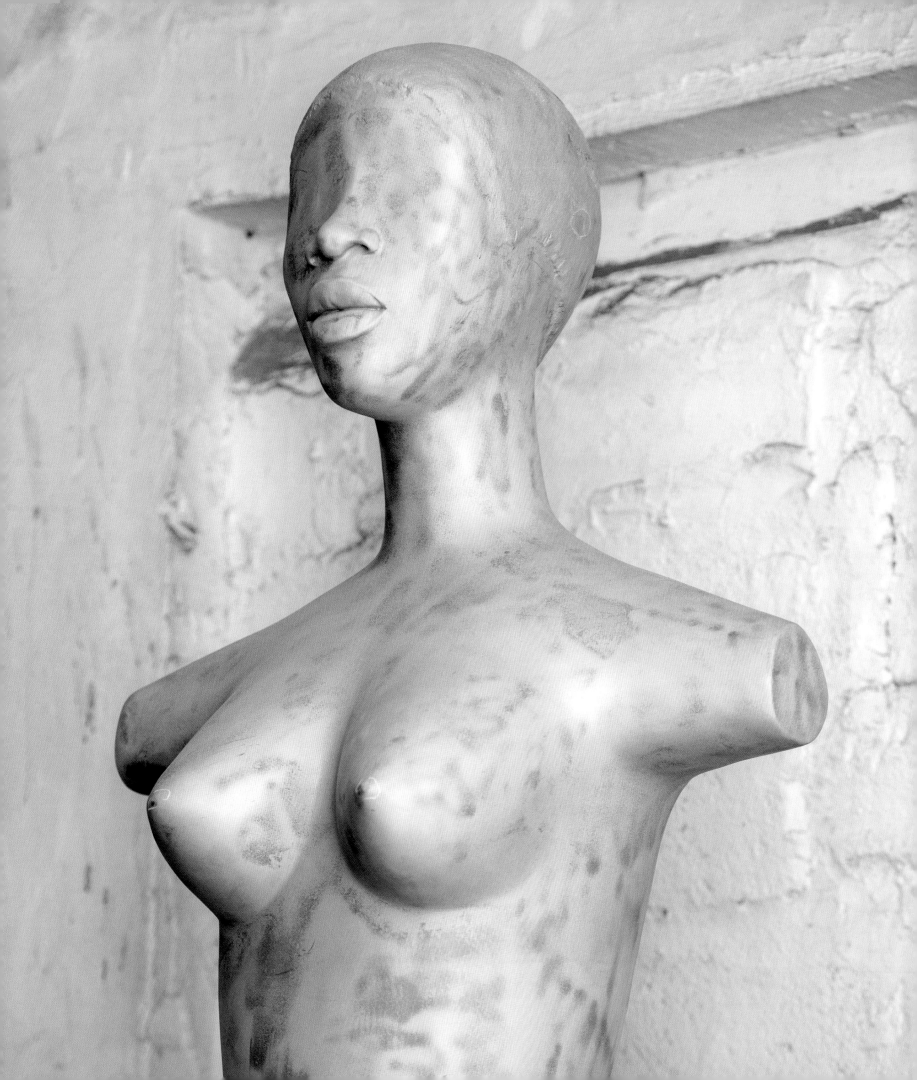

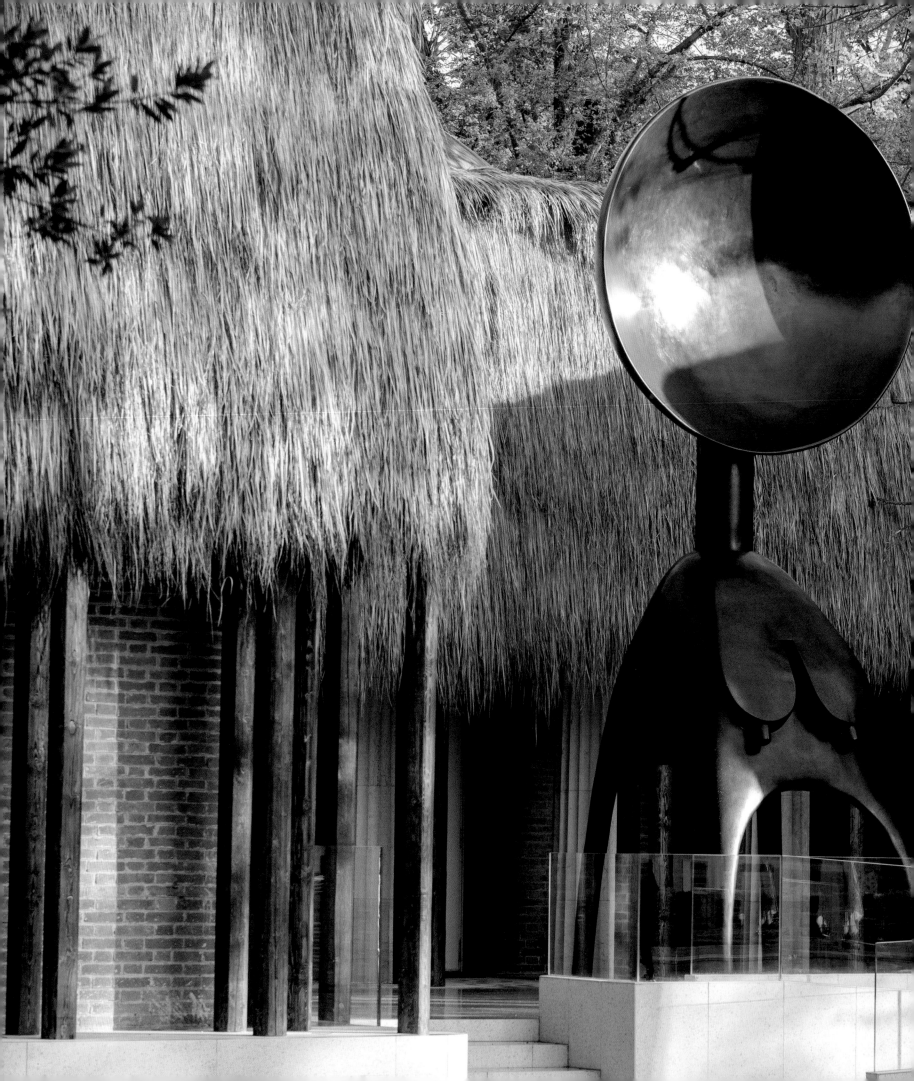

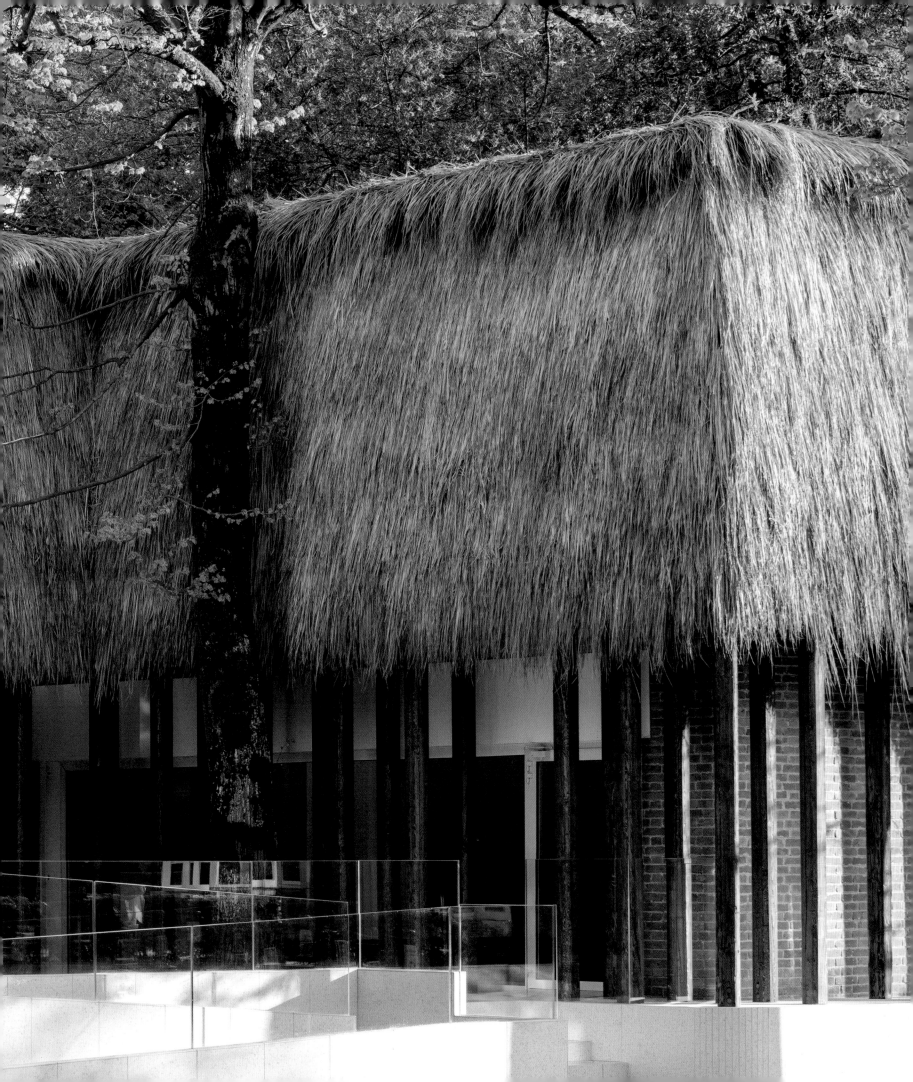

pages 250–51
Installation view, *Simone Leigh: Sovereignty*, U.S. Pavilion,
59th International Art Exhibition of La Biennale di Venezia, 2022

facing
Satellite (detail), 2022
Bronze
24 feet × 10 feet × 7 feet 7 inches (7.3 × 3 × 2.3 m)

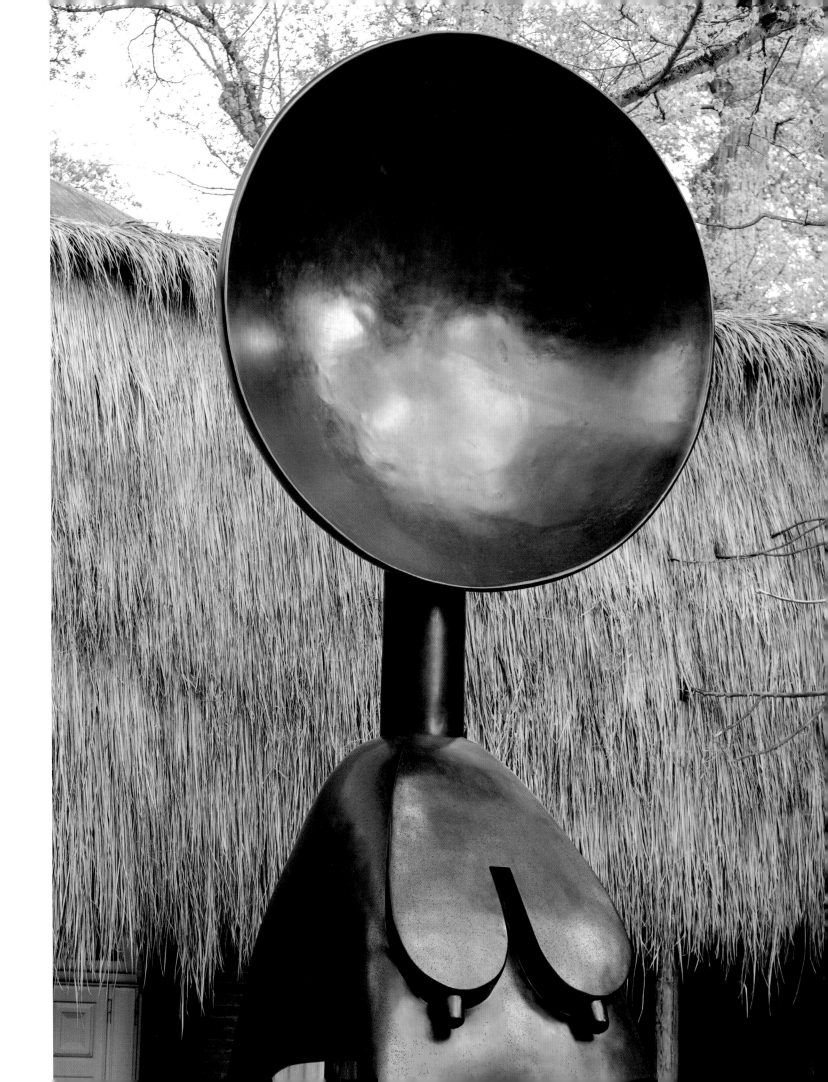

facing and pages 256–57 (detail)
Last Garment, 2022
Bronze, steel, metal, filtration pump, and water
54 × 58 × 27 inches (137.2 × 147.3 × 68.6 cm) (sculpture);
dimensions variable (pool)

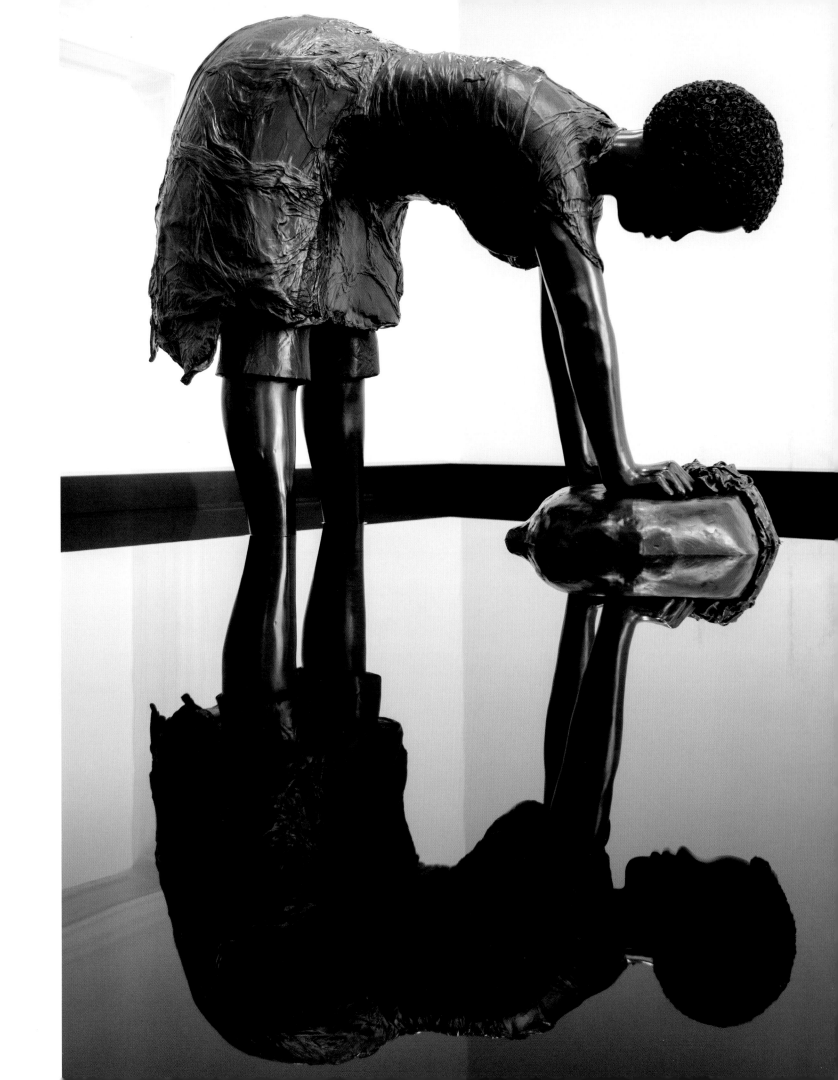

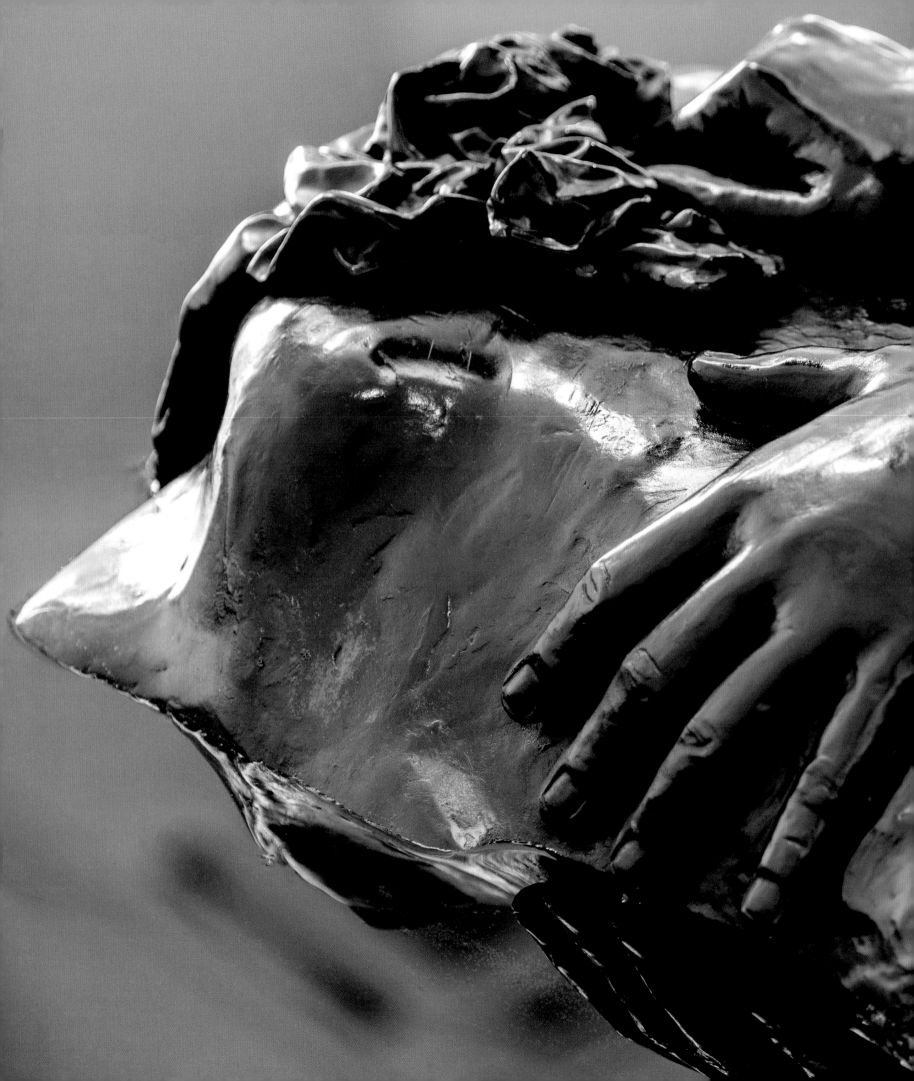

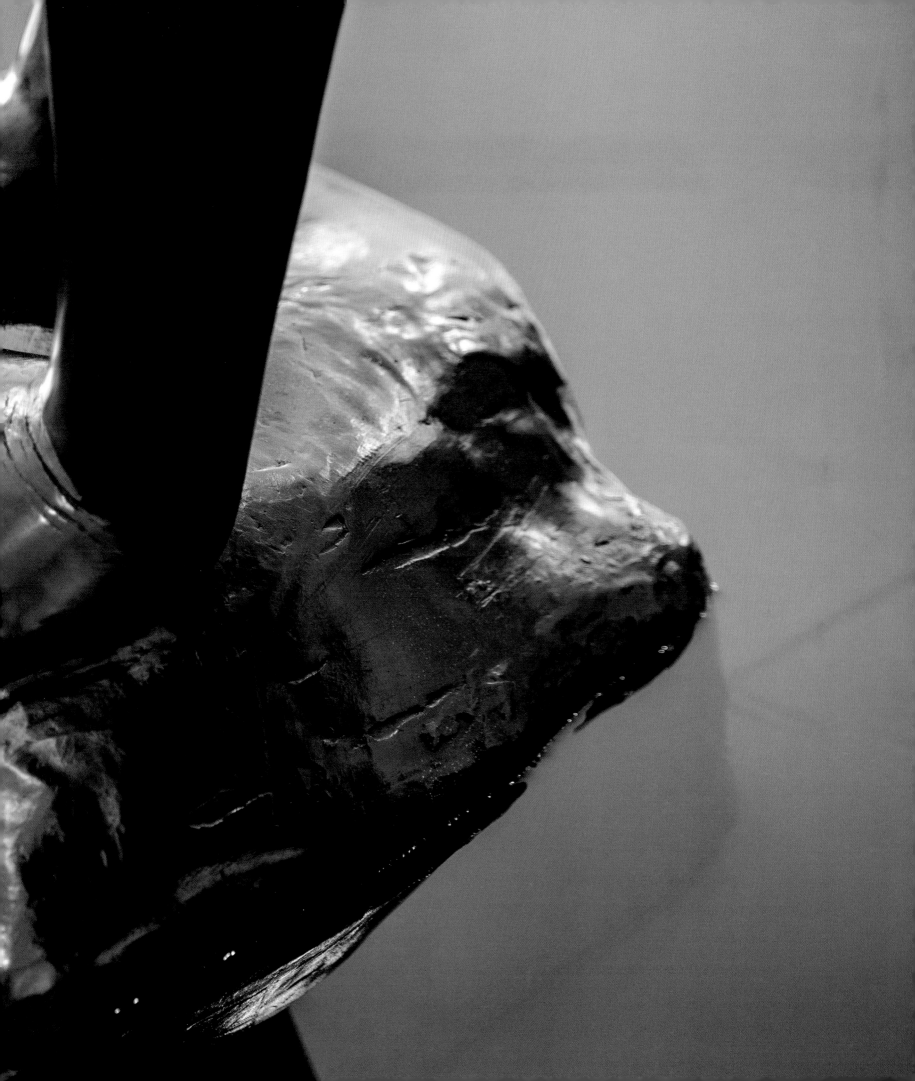

pages 260–61
Installation view, *Simone Leigh: Sovereignty*, U.S. Pavilion,
59th International Art Exhibition of La Biennale di Venezia, 2022

facing
Anonymous (detail), 2022
Stoneware
72 1/2 × 53 1/2 × 43 1/4 inches (184.2 × 135.9 × 109.9 cm)

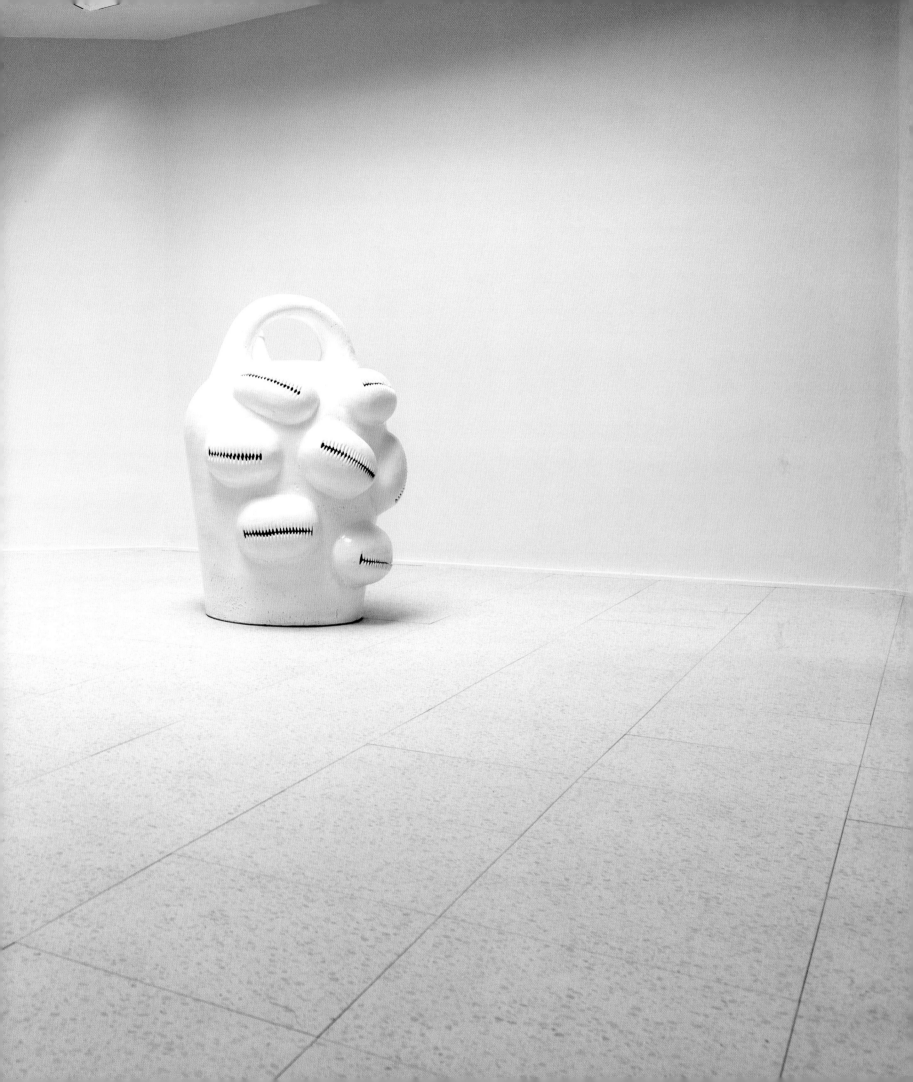

facing and pages 264–65 (detail)
Jug, 2022
Stoneware
62 1/2 × 40 3/4 × 45 3/4 inches (158 × 103.5 × 116.2 cm)

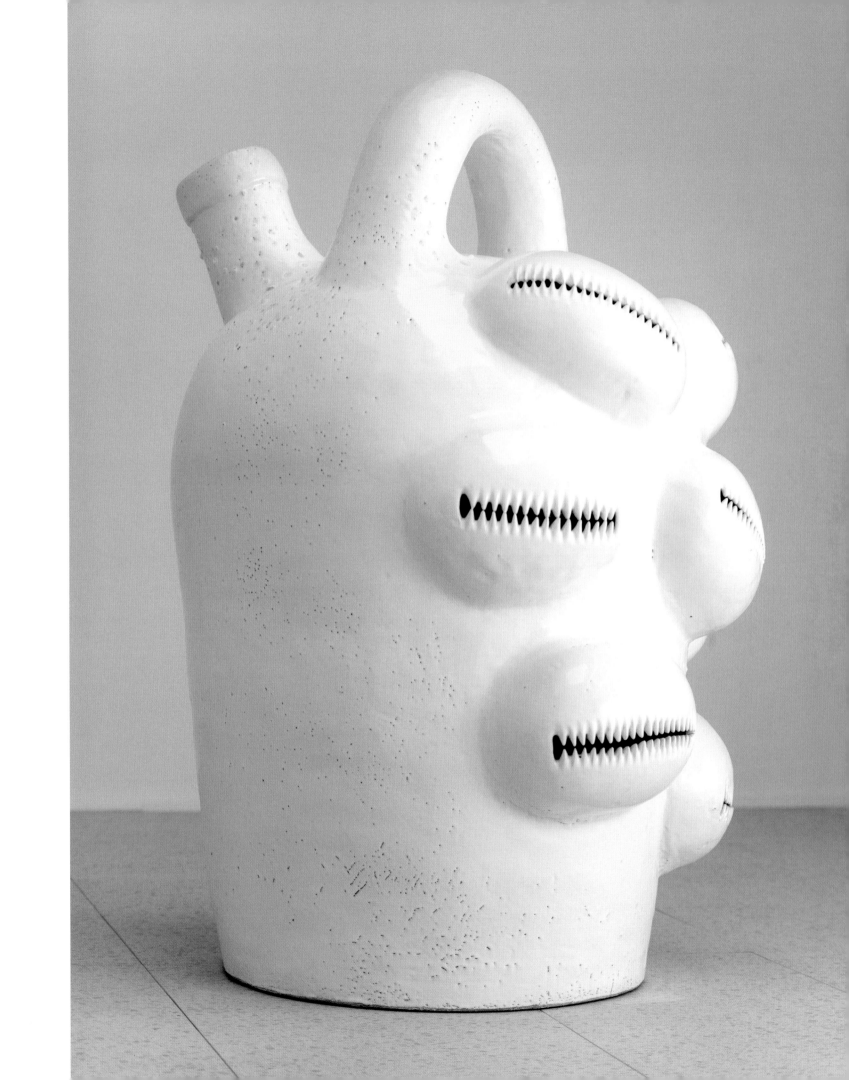

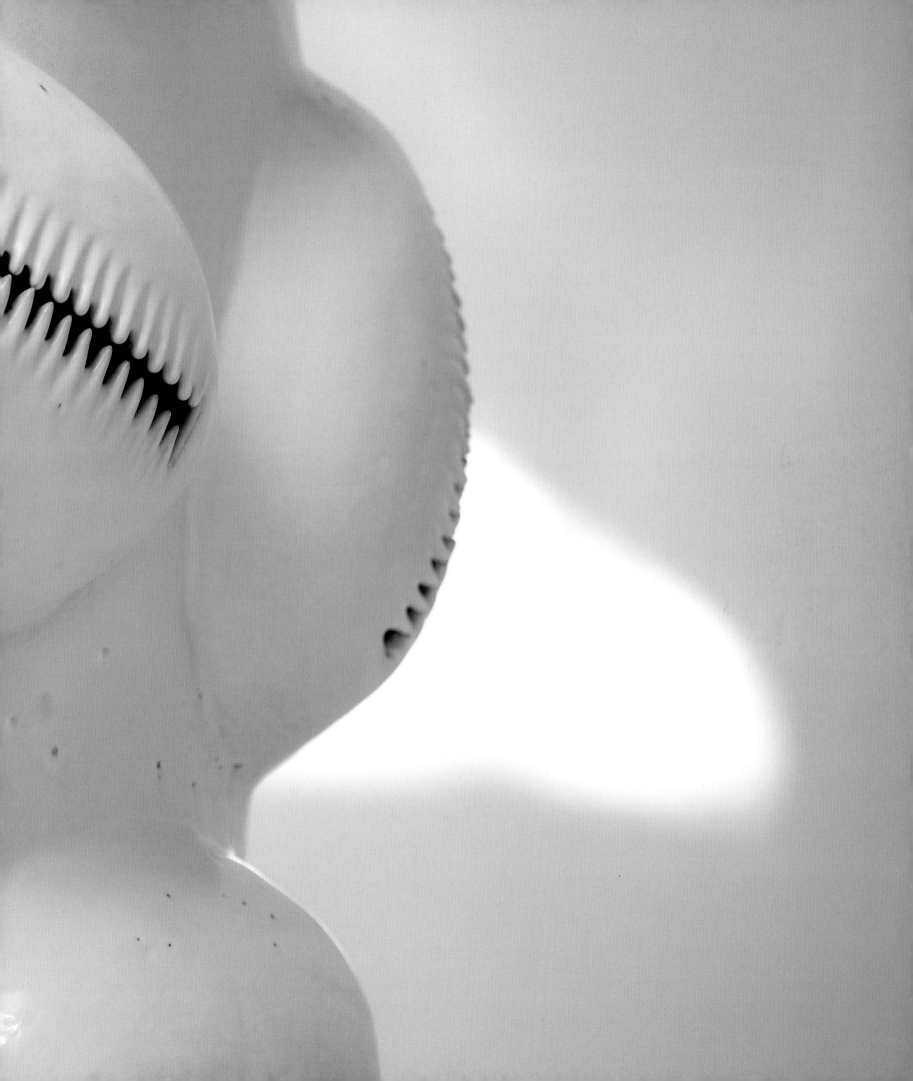

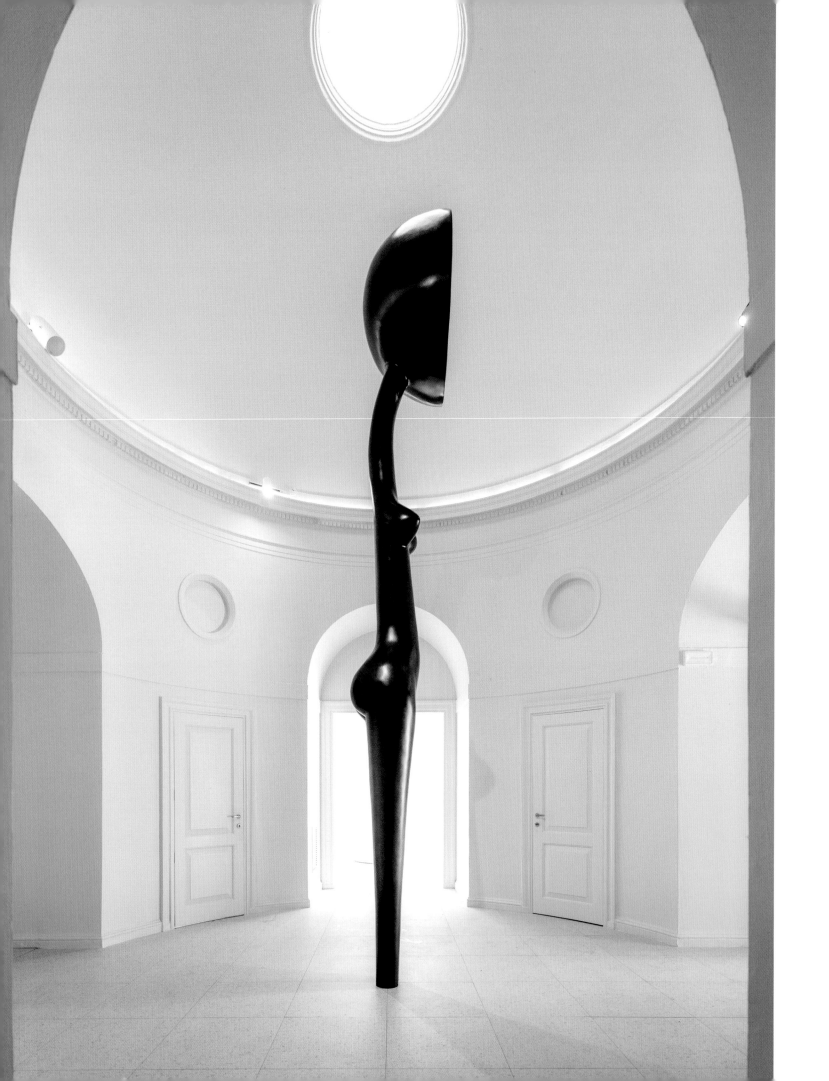

facing
Sentinel, 2022
Bronze
194 × 39 × 23 1/4 inches (492.8 × 99.1 × 59.1 cm)

pages 268–69
Installation view, *Simone Leigh: Sovereignty*, U.S. Pavilion,
59th International Art Exhibition of La Biennale di Venezia, 2022

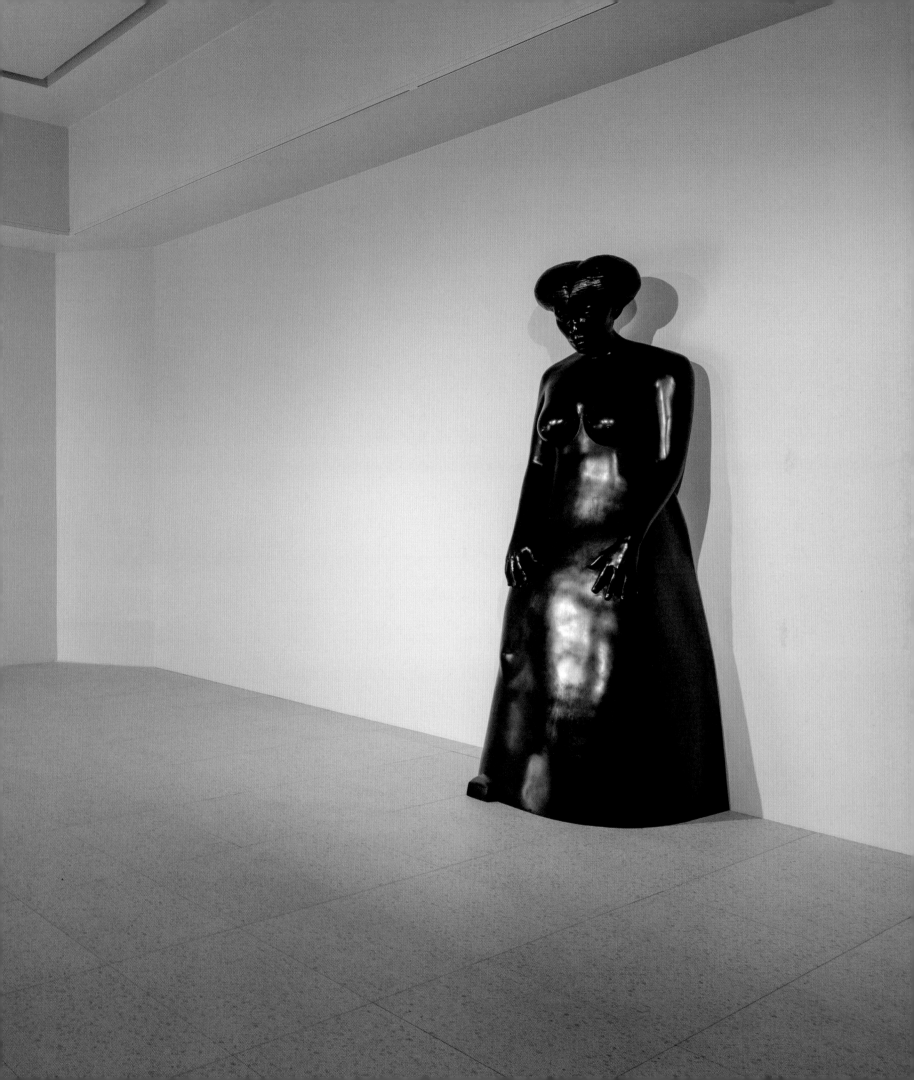

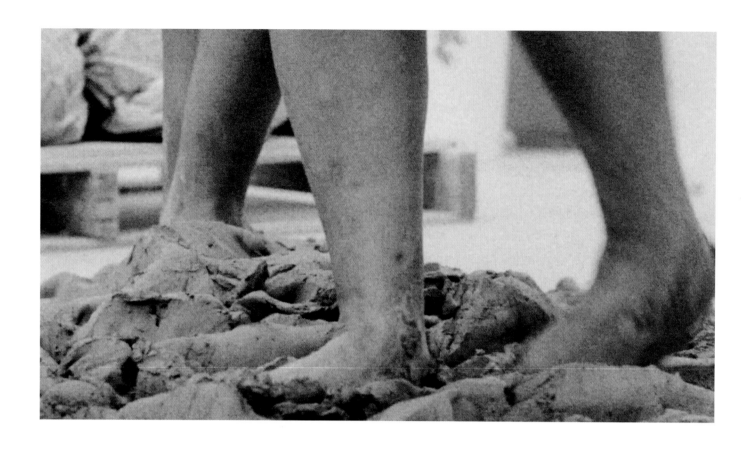

pages 272 and 273–75 (details)
Sharifa, 2022
Bronze
111 1/2 × 40 3/4 × 40 1/2 inches (283.2 × 103.5 × 102.9 cm)

above and facing
Simone Leigh and Madeleine Hunt-Ehrlich,
Conspiracy (stills), 2022
16mm and 8mm film (black-and-white, sound; 24:00 minutes)

270

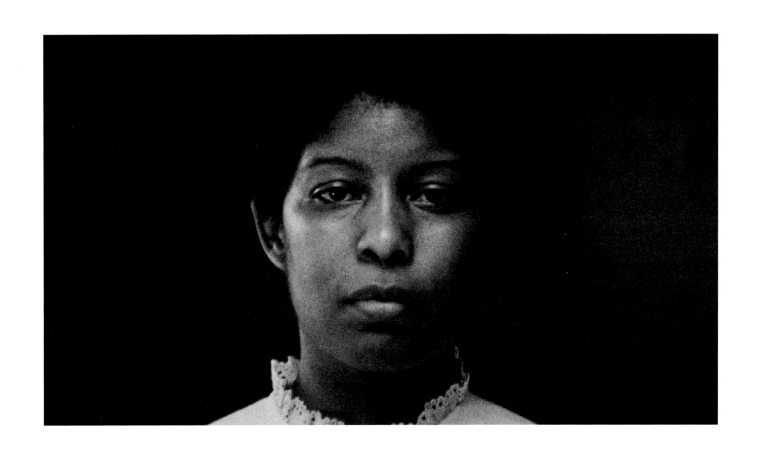

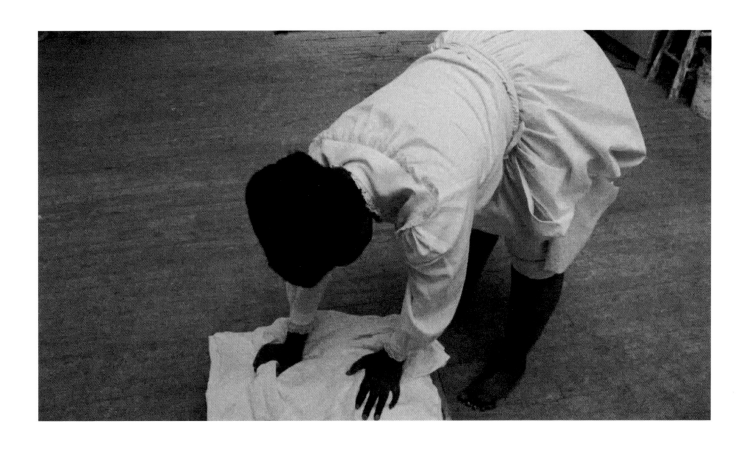

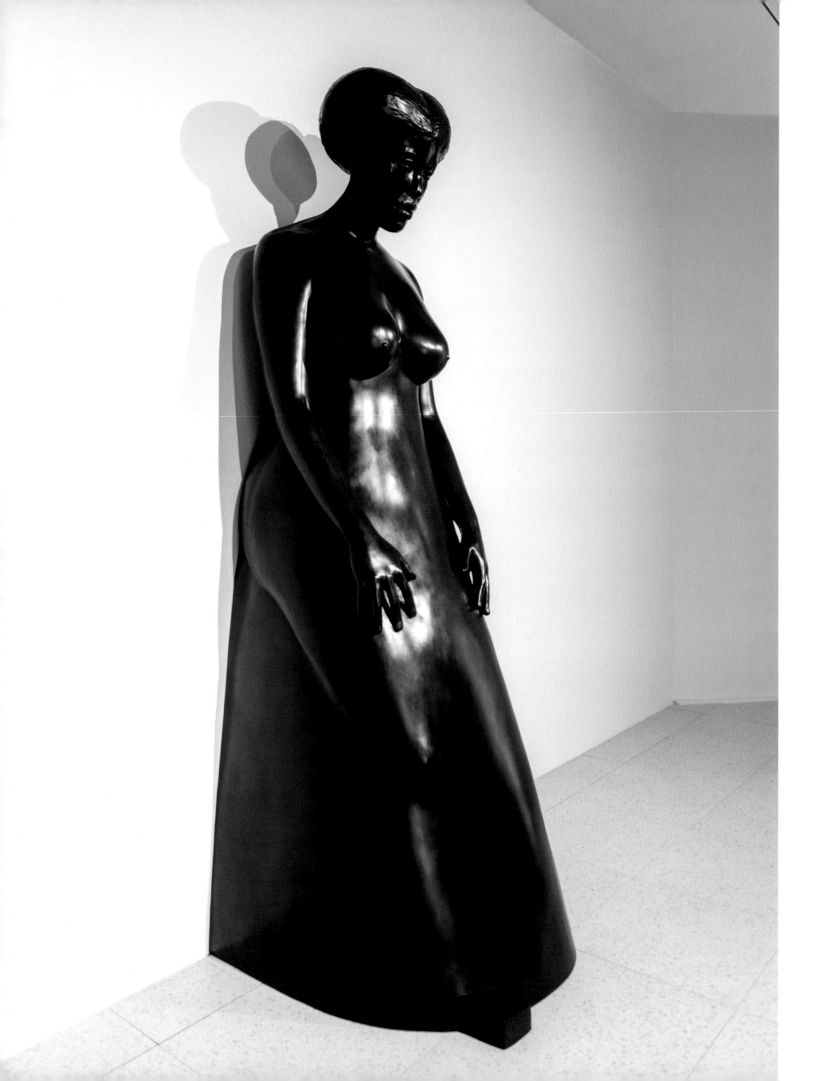

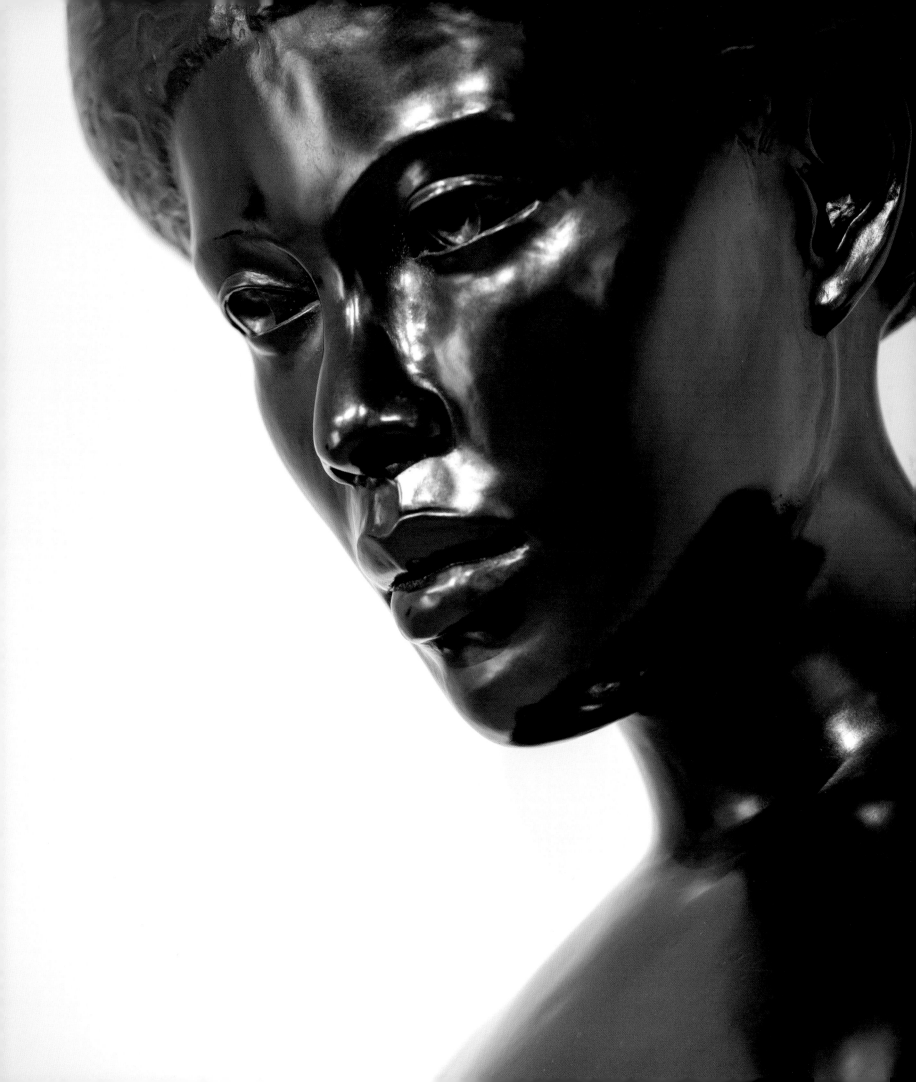

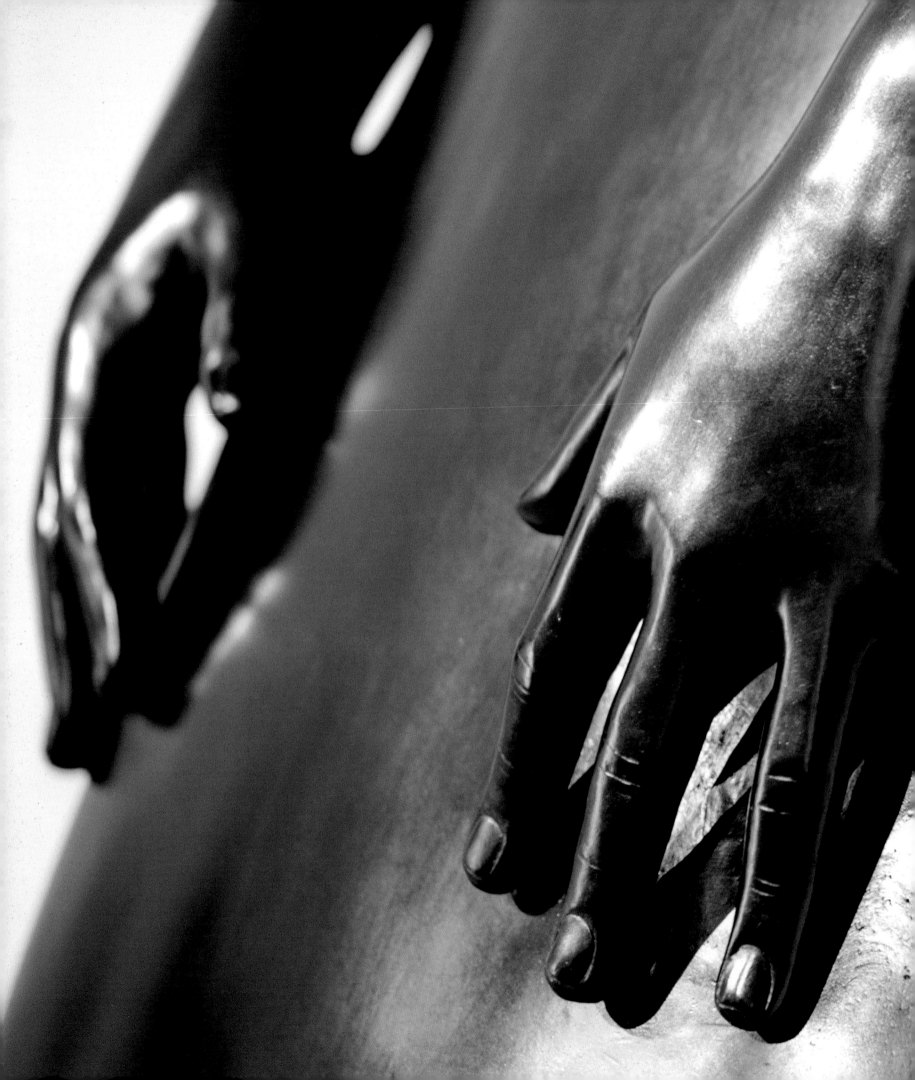

pages 276–77 (detail) and facing
Sphinx, 2022
Stoneware
29 3/4 × 56 3/4 × 35 inches (75.6 × 144.1 × 88.9 cm)

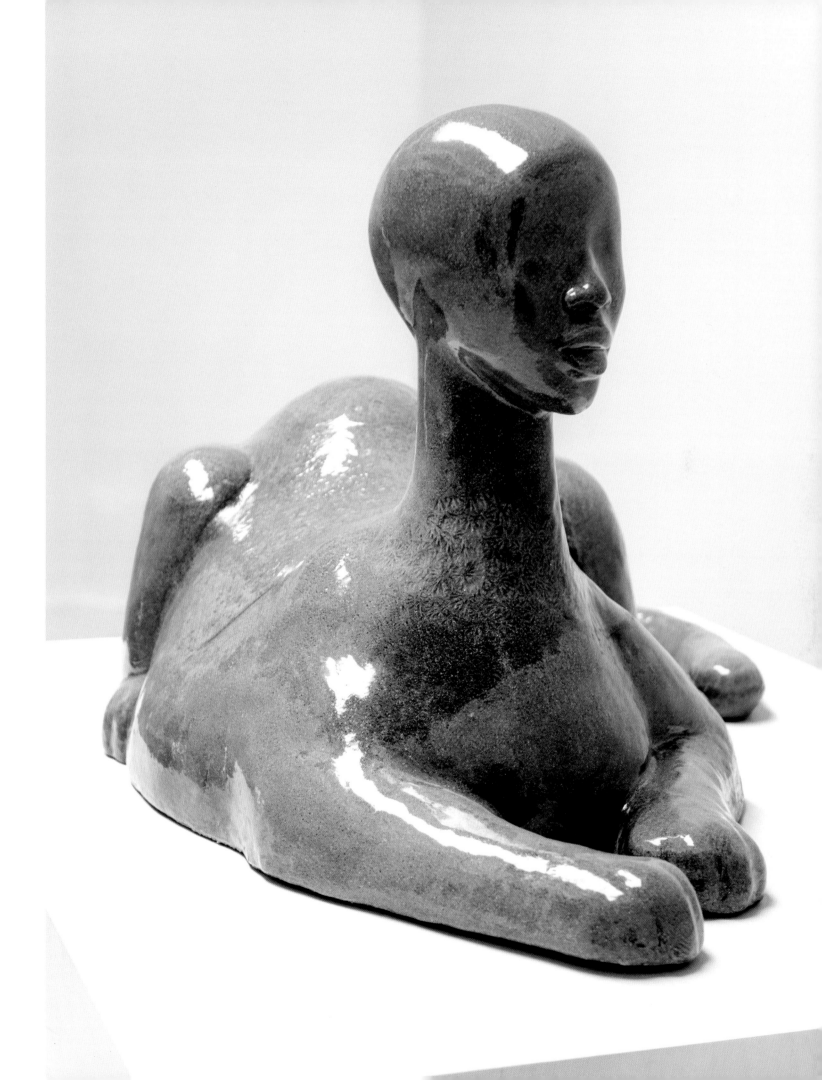

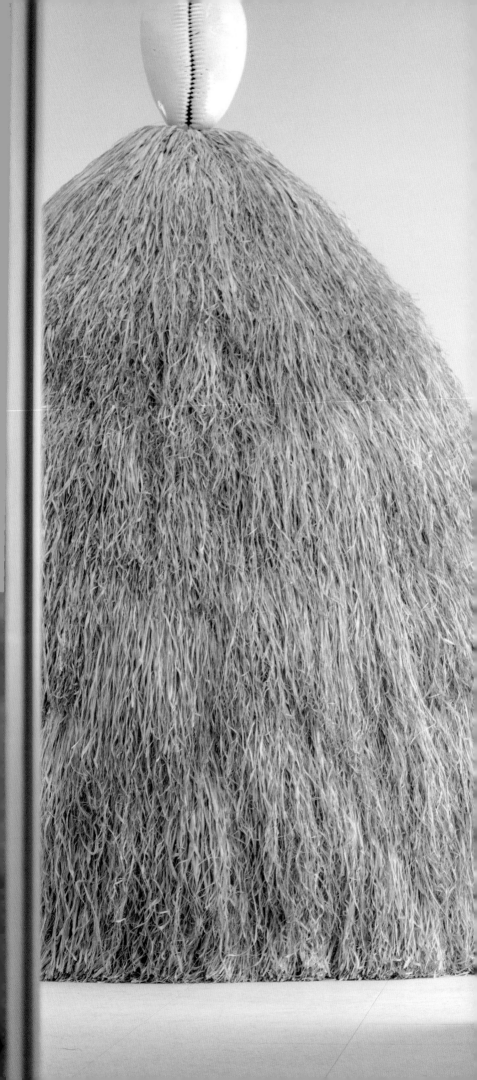

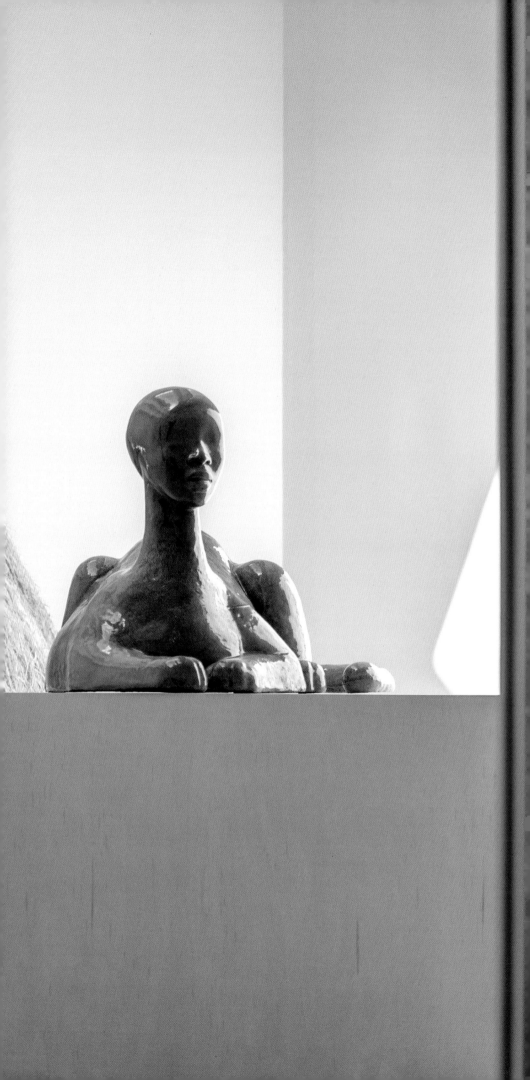

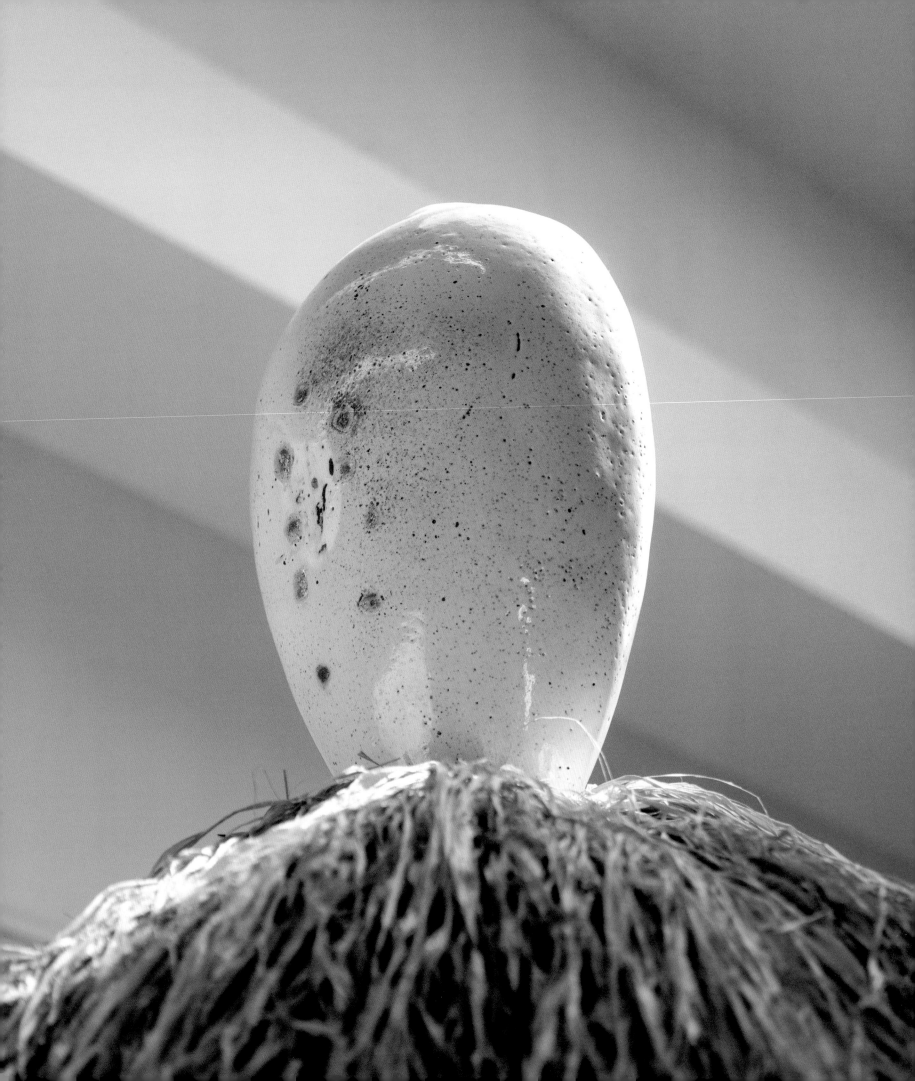

facing
Cupboard (detail), 2022
Stoneware, raffia, and steel armature
135 1/2 × 124 × 124 inches (344.1 × 315 × 315 cm)

pages 280–81
Installation view, *Simone Leigh: Sovereignty*, U.S. Pavilion,
59th International Art Exhibition of La Biennale di Venezia, 2022

Cupboard, 2022
Stoneware, raffia, and steel armature
135 1/2 × 124 × 124 inches (344.1 × 315 × 315 cm)

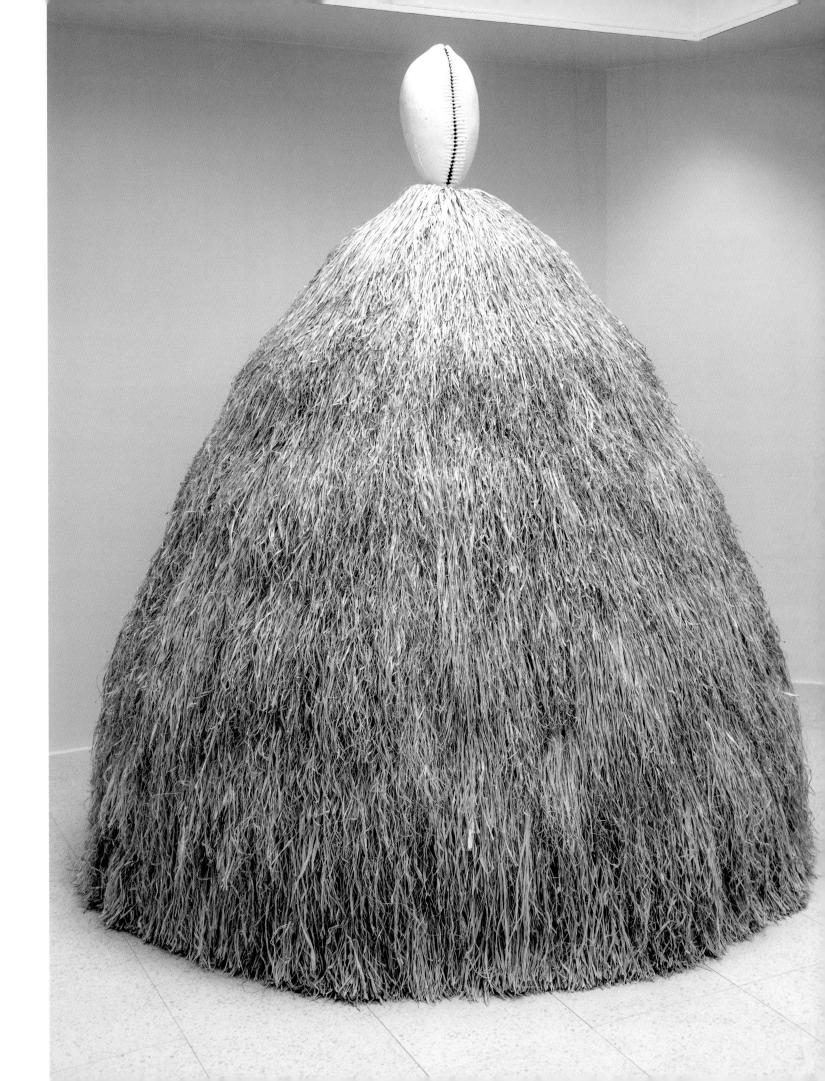

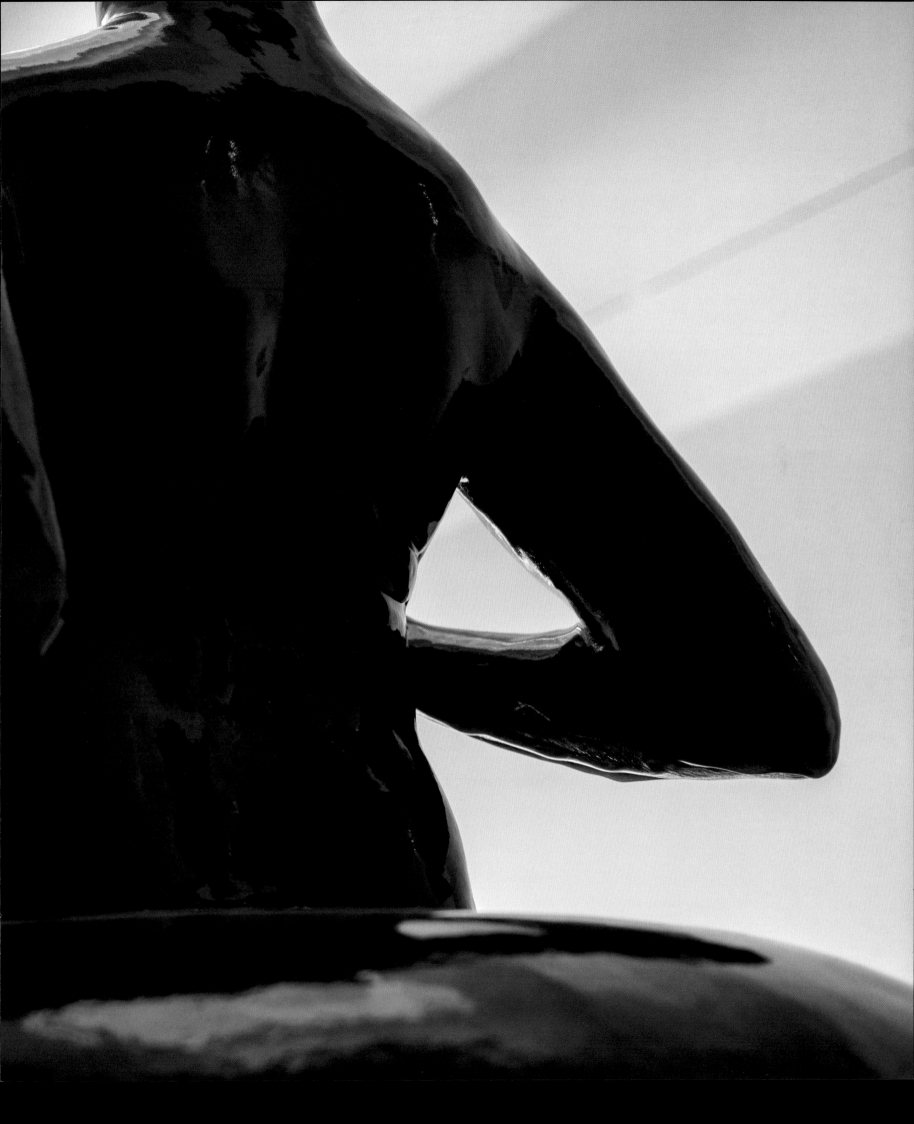

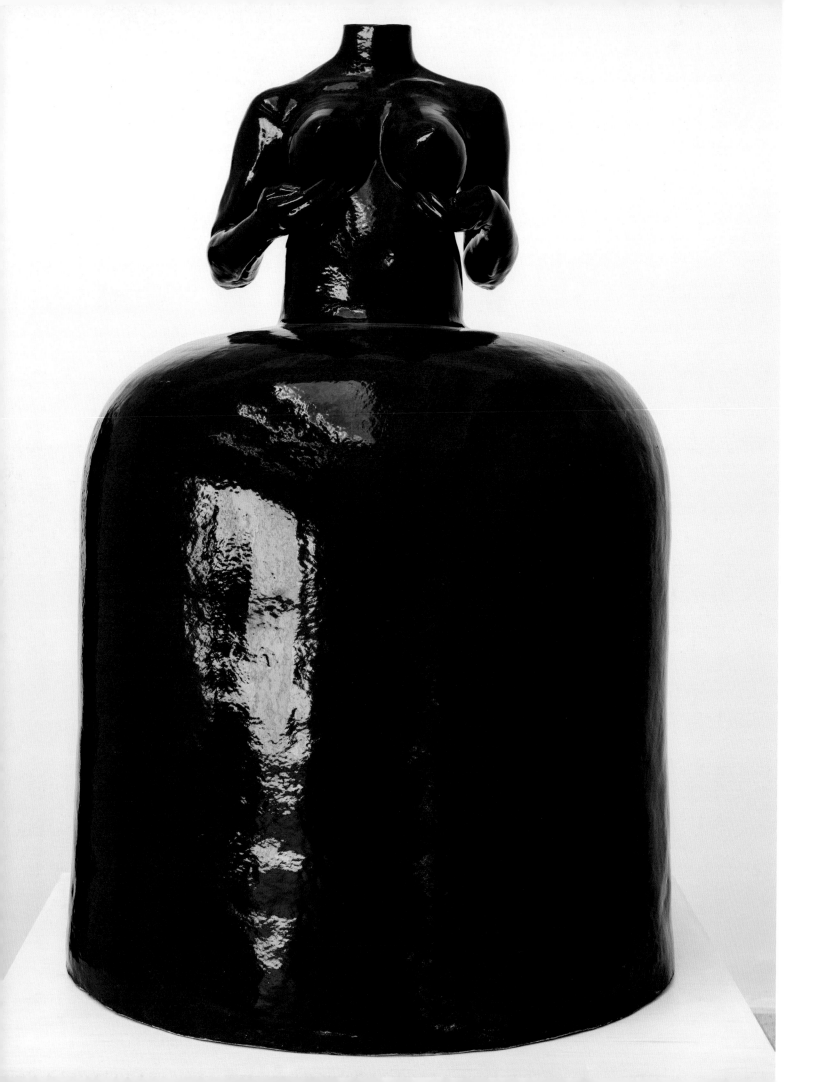

facing
Martinique, 2022
Stoneware
60 3/4 × 41 1/4 × 39 3/4 inches (154.3 × 104.8 × 101 cm)

pages 286–87
Installation view, *Simone Leigh: Sovereignty*, U.S. Pavilion,
59th International Art Exhibition of La Biennale di Venezia, 2022

pages 294–95
Installation view, *Milk of Dreams*, 59th International Art Exhibition
of La Biennale di Venezia, 2022

facing and pages 292–93
Cupboard (details), 2022
Bronze and gold
88 1/2 × 85 × 44 7/8 inches (225 × 216 × 114 cm)

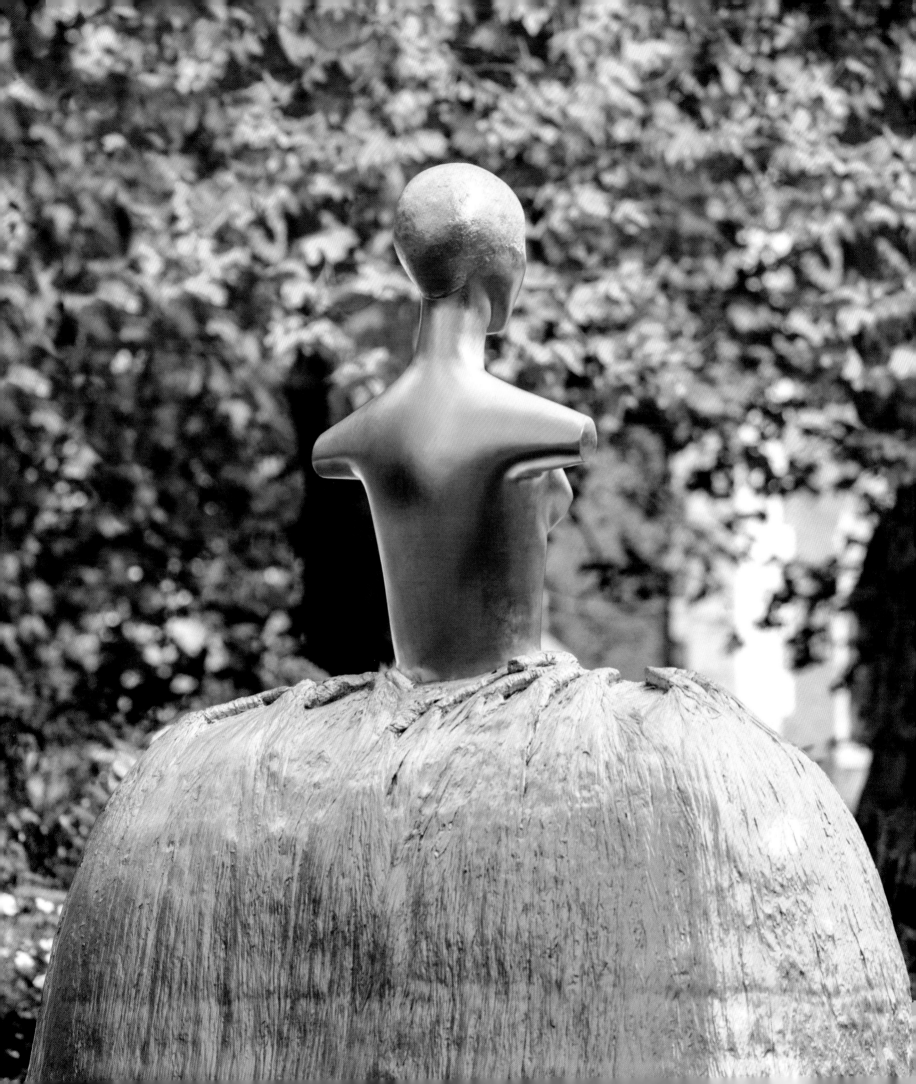

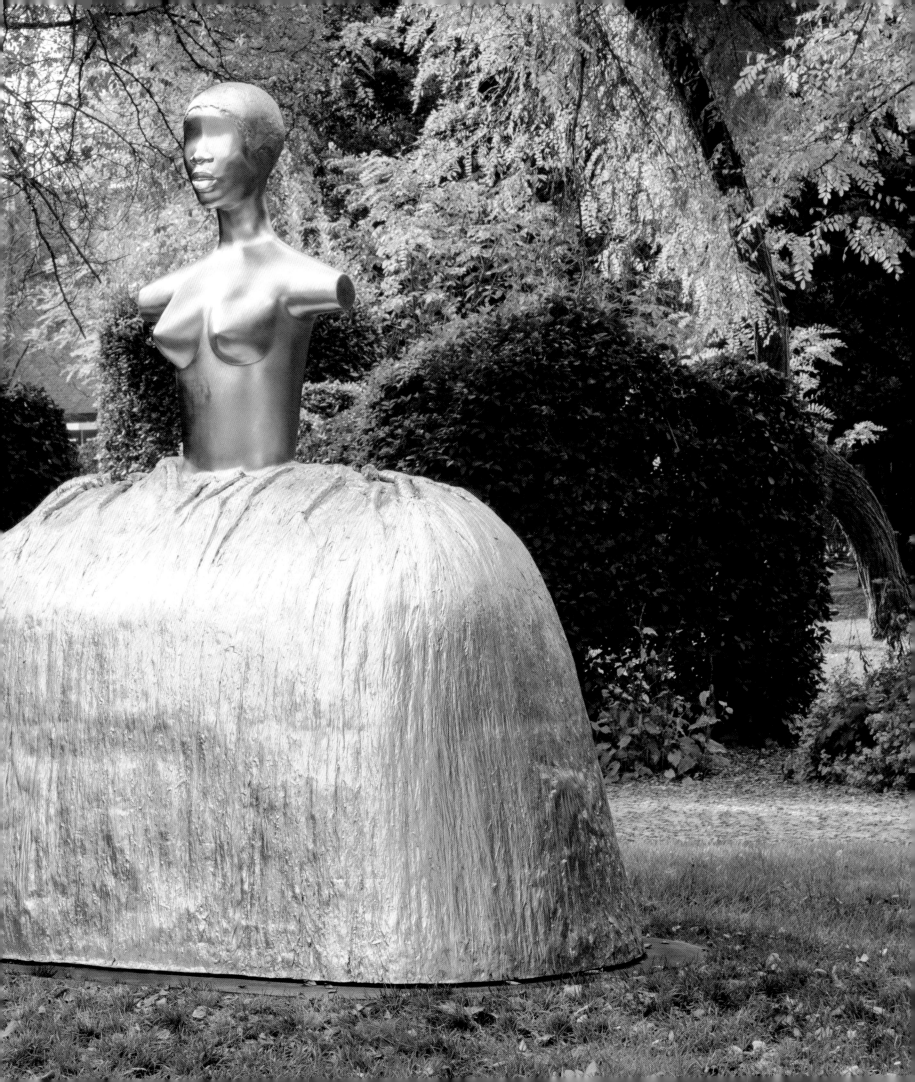

Anni A. Pullagura

Chronology of Social Sculpture Works

2010

BE BLACK BABY: A HOUSE PARTY was a four-part series of performance events centered on ideas of refusal, abolition, and revolution. Organized by Leigh in collaboration with artists, scholars, curators, and others, the series was hosted at Recess Activities, Inc., an art exhibition and studio space in New York, between 2010 and 2011. Each event responded to a specific prompt, question, or cultural reference.[1]

LOCATION Recess
 41 Grand Street
 New York, NY 10013

BE BLACK BABY: A HOUSE PARTY took as its prompt Brian De Palma's satirical black comedy film *Hi, Mom!* (1970), which includes a scene of a theater troupe's production titled *Be Black Baby!*

DATE Saturday, March 13, 2010

CURATORS Simone Leigh with Sarina Basta and
 Karin Schneider as a part of CoBraClass
 at the Bruce High Quality Foundation
 University

PARTICIPANTS Dean Daderko, David Edelstein, LaToya
 Ruby Frazier, Tyehimba Jess, Liz
 Magic Laser with Max Woertendyke,
 Nomaduma Masilela with Charl
 Landvreugd and Diane Wah, Elvira
 Dyangani Ose, Khary Orande Polk, and
 Kenya (Robinson)

BE BLACK BABY:
A HOUSE PARTY PRESENTS MICHAEL JACKSON 2004

For this evening of performance and live tableaux, participants were invited to reassess the complex cultural footprint of Michael Jackson in a reinterpretation of the inaugural Michael Jackson academic conference organized by Uri McMillan for Yale University in 2004.

DATE Friday, September 10, 2010

CURATORS Uri McMillan with Simone Leigh and
 Recess Activities, Inc.

PARTICIPANTS Michael Paul Britto, Deville Cohen,
 Abigail DeVille, LaTasha N. Nevada Diggs,
 Liz Magic Laser, Tavia Nyong'o, Lorraine
 O'Grady, Kenya (Robinson), Edge School
 of the Arts, and special thanks to Rashida
 Bumbray

1 For an in-depth discussion of the series as a whole and the individual events, see Uri McMillan's essay in this volume, page 314.

2011

BE BLACK BABY:
A HOUSE PARTY PRESENTS IF THERE'S NO DANCING
AT THE REVOLUTION I'M NOT COMING

This evening of site-specific performances, video, and dancing in the street responded to anarchist Emma Goldman's apocryphal declaration that if she couldn't dance, she didn't want to be a part of the revolution.

DATE Friday, April 1, 2011

CURATORS Simone Leigh and Naomi Beckwith

PARTICIPANTS Michael Paul Britto, Tova Carlin, Chuleta
 (Wanda Raimundi-Ortiz), Maren
 Hassinger, Jennie Livingston, and Jacolby
 Satterwhite, with MC Elia Alba

BE BLACK BABY:
A HOUSE PARTY PRESENTS ÉDOUARD GLISSANT,
INHABIT HIS NAME

Taking the poetic politics of philosopher Édouard Glissant as a point of departure, artists and thinkers ventured into the many mutations of multilingualism that are creolization and vernacular Caribbean aesthetics through a series of performances and conversations.

DATE Friday, June 17, 2011

CURATORS Simone Leigh and Madeleine
 Hunt-Ehrlich

PARTICIPANTS Vanessa Agard-Jones, Becca Albee,
 Firelei Báez, Kaiama L. Glover, Blackgold
 Dance Crew (Hanna Herbertson, Korie
 "Genius" & Kendell "History" Hinds), Kelly
 Baker Josephs, Jayson Keeling, Devin
 KKenny, Legacy Russell, and Yasmin
 Spiro

298

2014

FREE PEOPLE'S MEDICAL CLINIC

As part of Creative Time's exhibition *Funk, God, Jazz, and Medicine: Black Radical Brooklyn* and sponsored by the Weeksville Heritage Center, curator and choreographer Rashida Bumbray collaborated with Leigh to stage *Free People's Medical Clinic*, a social sculpture event that examined the intersection of race, gendered labor, and public health, with a specific focus on Black nurses, doctors, and midwives. The work took place in the converted home of the late Dr. Josephine English, the first African American woman to have an OB-GYN practice in the state of New York, and was inspired by both known and underknown histories of community-led care practices, including the Black Panther Party's health-care initiatives (for which the installation was named), the work of Dr. Susan Smith McKinney Steward, and the United Order of Tents, a secret society of Black nurses founded during the Civil War. For a period of three days at the close of Leigh's durational work, trained health-care professionals as well as community leaders offered free public classes in herbal medicine, dance and active movement, queer and transgender care, massage therapy, acupuncture, and navigating access to health care and preventive care. A publication—*Waiting Room* magazine—was designed by Nontsikelelo Mutiti and included contributions by Leigh, Vanessa Agard-Jones, Charmaine Bee, Aimee Meredith Cox, A. Naomi Jackson, Robin Coste Lewis, Alondra Nelson, and Sharifa Rhodes-Pitts.

DATES	Saturday, September 20–Sunday, October 12, 2014
LOCATION	Stuyvesant Mansion 375 Stuyvesant Avenue Brooklyn, NY 11233
CURATOR	Rashida Bumbray
PARTICIPANTS	Niv Acosta, Ancient Song Doula Services–Chanel Porchia, Stephanie Battle, Malik K. Bellamy, Julia Bennett, Majora Carter, Mona Chopra, Aimee Meredith Cox, Kendra Fox, Housing Works, Kami Jones, Joy Mitchell, and Karen M. Rose, with Neith Sa Ra, Erica Sewell, Stephen Shames, and Aron Süveg

2016

THE WAITING ROOM

Organized as part of Leigh's residency and exhibition at the New Museum, New York, *The Waiting Room* continued ideas the artist had explored in *Free People's Medical Clinic* (2014) through an intentionally curated series of durational events engaged with ideas of knowledge production for community-led health and healing. The work was dedicated to Esmin Elizabeth Green, who died in the receiving room of a New York hospital in 2008 while waiting more than twenty-four hours for medical care. The installation focused on "care sessions" in community-led and -served spaces comprising wellness, healing, and equity workshops in which rest, restoration, and justice were foregrounded. In addition to workshops in meditation, massage, and herbal medicine, these care sessions included performances and lectures by Vanessa Agard-Jones, Rashida Bumbray, Chitra Ganesh, and Lorraine O'Grady, as well as "underground" sessions on home economics in herbal medicine for Black women and femmes, taiko drumming sponsored by the Hetrick-Martin Institute, and paid teen apprenticeships over the course of the exhibition.

DATES	Wednesday, June 22–Sunday, September 18, 2016
LOCATION	New Museum, New York 235 Bowery New York, NY 10002 Fifth Floor
CURATORS	Johanna Burton, Keith Haring Director and Curator of Education and Public Engagement; Shaun Leonardo, manager of school, youth, and community programs; and Emily Mello, associate director of education
PARTICIPANTS	Vanessa Agard-Jones, Malik K. Bellamy, Julia Bennett, Rashida Bumbray, Maria Magdalena Campos-Pons, Aimee Meredith Cox, Chitra Ganesh, Lorraine O'Grady, Karen M. Rose, and Kaoru Watanabe

2016–17

BLACK WOMEN ARTISTS FOR BLACK LIVES MATTER (BWA FOR BLM)

In solidarity with the Black Lives Matter movement, more than one hundred Black women and femme artists formed the underground collective Black Women Artists for Black Lives Matter (BWA for BLM). In their manifesto, they declared: "We are a collective of Black women, queer, and gender nonconforming artists. We believe in the interdependence of care and action, invisibility and visibility, self-defense and self-determination, and desire and possibility in order to highlight and disavow pervasive conditions of racism. We prioritize the sanctity and knowledge of our own bodies and experiences. Our work emanates from that powerful center." Leigh convened BWA for BLM for the first time on July 10, 2016; the group met weekly over the course of her residency and exhibition *The Waiting Room* at the New Museum, and gathered again for a public event on September 1. The latter began and ended with a "Processional for Black Lives," with participants dressed in red, and featured music, poetry, screenings, and performances centered on ideas of healing, care, and self-determination. Following the New York convening, BWA for BLM participated in a subsequent exhibition with Project Row Houses in Houston, located in seven art houses and organized by the New York, Los Angeles, Houston, and UK chapters of BWA for BLM. In connection with the group exhibition *We Wanted a Revolution: Black Radical Women, 1965–1985* at the Brooklyn Museum, BWA for BLM occasioned a closing celebration on September 16, 2017, with performances and "talk-back" conversations in the galleries.

DATE Sunday, July 10, 2016

LOCATION New Museum
235 Bowery
New York, NY 10002

PARTICIPANTS Elia Alba, ọmọlọlú refilwe babátúndé, Firelei Báez, Laylah Amatullah Barrayn, Chloë Bass, Suhaly Bautista-Carolina, Aisha Tandiwe Bell, Joeonna Bellorado-Samuels, Michelle Bishop, Janice Bond, Alicia Boone-Jean-Noel, Charlotte Brathwaite, Sheila Pree Bright, LaKela Brown, Tracy Brown, Rashida Bumbray, Crystal Z. Campbell, Alexis Caputo, Tanisha Christie, Andrea Chung,

Elvira Clayton, Pamela Council, Aimee Meredith Cox, Vivian Crockett, Una-Kariim A. Cross, Tamara Davidson, Joy Davis, Sonia Louise Davis, Danielle Dean, Lisa Dent, Abigail DeVille, LaTasha N. Nevada Diggs, DJ Tara, Abby Dobson, Kimberly Drew, Dominique Duroseau, Tara Duvivier, Minkie English, Nona Faustine, Catherine Feliz, Yance Ford, Tia-Simone Gardner, Ja'Tovia Gary, Ebony Noelle Golden, Kearra Amaya Gopee, Stephanie Graham, Adjua Gargi Nzinga Greaves, Kaitlyn Greenidge, Deana Haggag, Carrie Hawks, Robyn Hillman-Harrigan, Kenyatta A. C. Hinkle, Lehna Huie, Rujeko Hockley, Kemi Ilesanmi, Ariel Jackson, Tomashi Jackson, Ashley James, Shani Jamila, E. Jane, Fabiola Jean-Louis, Steffani Jemison, Jacqueline Johnson, Natasha Johnson, Stephanie A. Johnson-Cunningham, Ladi'Sasha Jones, Jay Katelansky, Daniella Rose King, Nsenga Knight, Ya La'Ford, Geraldine Leibot, Simone Leigh, Toya A. Lillard, Jodie Lyn-Kee-Chow, Helen Marie, Brittany Martow, Nomaduma Rosa Masilela, Tiona Nekkia McClodden, Paloma McGregor, Nina Angela Mercer, Joiri Minaya, Jasmine Mitchell, Elissa Blount Moorhead, Nontsikelelo Mutiti, Shervone Neckles, Jennifer Harrison Newman, Mendi Obadike, Lorraine O'Grady, Adenike Olanrewaju, Sherley C. Olopherne, Jennifer Harrison Packer, Sondra Perry, Shani Peters, Julia Phillips, Sharbreon Plummer, Mary Pryor, Kameelah Janan Rasheed, Amber Robles-Gordon, Shellyne Rodriguez, Karen Rose, Clarivel Ruiz, Annie Seaton, Karen Seneferu, Derica Shields, Alexandria Smith, Tiffany Smith, Mikhaile Solomon, Kara Springer, Mary A. Valverde, Sam Vernon, Shannon

Wallace, Camille Wanliss, Patrice Renee Washington, Fatimah White, Nafis M. White, Ayesha Williams, Saya Woolfalk, Lachell Workman, Akeema-Zane

Public Event

DATE Thursday, September 1, 2016
 4:30–8:30pm

LOCATION New Museum
 235 Bowery
 New York, NY 10002

Exhibition: *Round 46: Black Women Artists for Black Lives Matter at Project Row Houses*

DATES Saturday, March 25–
 Sunday, June 4, 2017

LOCATION Project Row Houses
 Art Houses
 2505–2517 Holman Street
 Houston, TX 77004

CURATORS Ryan N. Dennis and Simone Leigh

ART HOUSES • *Well Read Women*, New York Chapter Digital Group, with Alexandria Smith, an audiovisual installation celebrating authors who are women of color
 • *What a Living World Demands*, New York Chapter Object Group, with a focus on herbal medicine and strategies of self-care, and featuring wall text describing the story of collective member Carolyn Lazard
 • *Self-Love Toolkit*, New York Chapter Ephemera Group, a primer of resource and knowledge sharing on self-care practices, made for the installation *What a Living World Demands*

• *A Litany II: (dis)place)*, New York Chapter Performance Group, honoring Black women's lives through images and artifacts from the opening gathering processional
• *The House of Witnessing*, LA Group, an augmented-reality interactive installation of found and collected ephemera
• *Thick/er Black Lines*, UK Group initiated by Rianna Jade Parker (curator), Aurella Yussuf, Hudda Khaireh, and Kariima Ali, providing a look into the history and contemporary work of Black British artists
• *Nine Night*, New York Chapter Object Group, presenting flags inspired by ancestral traditions found in Caribbean, African American, and West African communities and serving as a crossroads for the contemplation of loss, grief, and the joy of a loved communal past
• Finally, a room was dedicated as a meeting space for participants to discuss the founding of a Houston Chapter Group.

Closing Celebration for *We Wanted a Revolution: Black Radical Women 1965–1985*

DATE Saturday, September 16, 2017

LOCATION Brooklyn Museum
 200 Eastern Parkway
 Brooklyn, New York 11238

2016

PSYCHIC FRIENDS NETWORK

Organized on the occasion of Leigh's artist residency at Tate
Exchange, London, *Psychic Friends Network* convened a series
of workshops, collective listening sessions, and performances
on themes of feminism, healing, and intergenerational care.
As a companion to *Free People's Medical Clinic* (2014) and *The
Waiting Room* (2016), this work continued Leigh's explorations
of healing, community, and disobedience. The events included
sessions on Caribbean craft with Janet Kay, Leigh in conver-
sation with Rizvana Bradley, and a performance on aging by
Lorraine O'Grady. Leigh's time-based media work *Aluminum*
(2016), made in collaboration with and featuring the work of
Rashida Bumbray, was screened as part of the residency and
this installation. On the concluding day, Bumbray and Leigh
performed a call-and-response processional through the Tanks
at Tate Modern.

DATES Tuesday, November 22–
 Saturday, November 26, 2016

LOCATION Tate Exchange
 Blavatnik Building, Level 5
 Tate Modern
 Bankside
 London SE1 9TG

CURATORS Sonya Dyer, curator, public programmes,
 and Emily Stone, assistant curator, public
 programmes

PARTICIPANTS Rizvana Bradley, Rashida Bumbray, Janet
 Kay, Simone Leigh, and Lorraine O'Grady

303

2019

LOOPHOLE OF RETREAT

In 2018 Leigh was awarded the Hugo Boss Prize from the Solomon R. Guggenheim Museum, New York, which staged the exhibition *The Hugo Boss Prize 2018: Simone Leigh, Loophole of Retreat*, organized by Katherine Brinson, Daskalopoulos Curator, Contemporary Art, and Susan Thompson, associate curator, with Amara Antilla, assistant curator. The exhibition's title derives from the abolitionist Harriet Jacobs's 1861 autobiography, which recalls Jacobs's seven years of sheltered self-confinement during her escape from enslavement. As part of the exhibition, Leigh convened a daylong symposium of the same title that honored Black women writers, activists, and creatives on themes of self-determination, agency, and freedom. Participants were invited to respond to a series of prompts—"vessel," "surface," "touch," "formation," and "insurgency"—in spoken word and performance. The gathering was organized by Leigh in collaboration with scholars Tina M. Campt and Saidiya Hartman.

DATE Saturday, April 27, 2019

LOCATION Solomon R. Guggenheim Museum
 1071 Fifth Avenue
 New York, NY 10128

CURATORS Tina M. Campt, Owen F. Walker Professor
 of Humanities and Modern Culture and
 Media, Brown University, and Saidiya
 Hartman, University Professor, Columbia
 University, with Simone Leigh

PARTICIPANTS Vanessa Agard-Jones, Rizvana Bradley,
 Dionne Brand, Aimee Meredith Cox,
 Denise Ferreira da Silva, Zakiyyah Iman
 Jackson, Grada Kilomba, Lorraine
 O'Grady, Okwui Okpokwasili, Sharifa
 Rhodes-Pitts, Christina Sharpe,
 Françoise Verges, and Simone White

2022

LOOPHOLE OF RETREAT: VENICE

In 2022 the Institute of Contemporary Art/Boston commissioned Leigh for the U.S. Pavilion at the 59th International Art Exhibition of La Biennale di Venezia. As part of this exhibition, Leigh convened a second gathering of Black women writers, activists, and creatives, named for the first symposium held as part of Leigh's exhibition for the 2018 Hugo Boss Prize at the Solomon R. Guggenheim Museum, New York. In Venice, the three-day symposium was organized by Rashida Bumbray, with curatorial advisers Tina M. Campt and Saidiya Hartman. The convening brought together more than two hundred participants and attendees in intimate dialogue, performances, and presentations centered on Black women's intellectual and creative labor.

DATES Friday, October 7–
Sunday, October 9, 2022

LOCATION Fondazione Giorgio Cini, Venice
Isola di San Giorgio Maggiore
Venice, Italy 30133

CURATORS Rashida Bumbray, director of culture and art at the Open Society Foundations, with curatorial advisers Saidiya Hartman, University Professor, Columbia University, and Tina M. Campt, Roger S. Berlind '52 Professor of Humanities, Princeton University, with Susan Thompson

PARTICIPANTS Vanessa Agard-Jones, Mistura Allison, Deborah Anzinger, Firelei Báez, Holly Bass, Black Quantum Futurism Collective (Camae Ayewa and Rasheedah Phillips), Phoebe Boswell, Rizvana Bradley, Dionne Brand, Cecily Bumbray, Tarana Burke, Tina M. Campt, Nora Chipaumire, Aimee Meredith Cox, Javiela Evangelista, Ayana Evans, Denise Ferreira da Silva, Ja'Tovia Gary, Aracelis Girmay, Kaiama Glover, dream hampton, Saidiya Hartman, Leslie Hewitt, Madeleine Hunt-Ehrlich, Zakiyyah Iman Jackson, Sandra Jackson-Dumont, Zara Julius, Lauren Kelley, Bouchra Khalili, Grada Kilomba,

Daniella Rose King, Autumn Knight, Negarra A. Kudumu, Las Nietas de Nonó (Mulowayi and Mapenzi Nonó), Gail Lewis, Robin Coste Lewis, Raquel Lima, Diane Sousa da Silva Lima, Canísia Lubrin, Jessica Lynne, Tsedaye Makonnen, Nomaduma Masilela, Paloma McGregor, Maaza Mengiste, Nontsikelelo Mutiti, Kettly Noël, Stella Nyanzi, Lorraine O'Grady, Okwui Okpokwasili, Senam Okudzeto, Janaína Oliveira, Oluremi Onabanjo, Olumide Popoola, Sharifa Rhodes-Pitts, Annette Lane Harrison Richter, Legacy Russell, Christina Sharpe, Lisa Marie Simmons, Maboula Soumahoro, Tourmaline, Françoise Vergès, Alberta Whittle, Mabel O. Wilson, and Nelisiwe Xaba

Tavia Nyong'o

Simone Leigh's Social Sculpture

The critical academic questions the university, questions the state, questions art, politics, culture. But in the undercommons it is "no questions asked." It is uncondi-tional — the door swings open for refuge even though it may let in police agents and destruction. The questions are superfluous in the undercommons. If you don't know, why ask? [1]

Stefano Harney and Fred Moten

How does one give an account of a practice whose efficacy may lie in remaining opaque to outsiders? When does the explanation enact a kind of violence against the thing explained, and why is the "innocent question" never quite innocent? These concerns haunt any inquiry into the social practice of Simone Leigh, whose projects in this domain have often been conducted under the auspices of a fugitivity that repels straightforward exposition in the form of a catalogue essay. Her interventions into the field of social practice, interventions that might better be given the name *social sculpture*, draw upon and contribute to a legacy of fugitive planning and Black feminist study that is both radically accessible and highly resistant to interrogation. The paradox of this legacy, as Stefano Harney and Fred Moten argue in their now classic book-length essay *The Undercommons: Fugitive Planning and Black Study*, is that the preservation and transmission of creative struggle in the undercommons subverts any and all defensive impulses we may have about it. Instead of being a precious object that should be surrounded with protective battlements, fugitive planning itself surrounds and undermines the given social-political enclosures. "We" are surrounded by the fugitive, and her plan is "our" dissolution. Or, at least, her plan is for the dissolution of a world that relies on her subordination. In encountering Leigh's aesthetic disruptions and celebrations, we are enclosed and enveloped by a social sculpture whose plan wreaks havoc on the privatization of the individual, which is a weapon of patriarchy. By specifying Black women as the agency wherein and for whom the plan is to be mobilized, Leigh's social practice demands an art history unmanned of its masterful assumptions. Put another way, the lines of activity under consideration here repel the attention they demand and demand the attention they elude, not out of any perverse will toward obscurity, but out of the formal constraints and requisite considerations for the flourishing of Black life.

Social sculpture is a term of art attributed to the Fluxus artist Joseph Beuys; it arose in the 1960s as one name for the emergence of live art and performance alongside the plastic arts and sought to account for the intervention of the artist within a wider social sphere.[2] The "social" denotes an expanded set of practices around "sculpture" as traditionally construed:

it indicates a field of potentiality. But the avant-garde and experimental definition of a social sculpture that Beuys and others engaged in during the 1960s and 1970s was already anticipated in the lines of activity whose deep history Leigh has traced to the traditional West African water pot and the social relations organized around its manufacture, sale, and use. In many contexts, such as in Igboland in southeastern Nigeria, the commerce in water pots is the province of women. "Pottery is said to be the oldest traditional craft in Igbo land," one recent scholar notes. "The origin of this industry is not exactly known, but archaeological evidence revealed that by the Late Stone Age, pottery products had been in use in Afikpo. . . . In some non-Igbo communities such as Kano and some other Hausa communities in northern Nigeria, pottery was undertaken mostly by men. But in Igbo land the craft was an exclusive reserve for women . . . in response to an oracular voice and wish."[3] This quote highlights three relevant aspects of pottery-making in Igboland: its ancient provenance, its unascertainable "origin" in the terms of Western historiography, and the myth-making ("oracular voice and wish") around its gender exclusivity. All three aspects point to the way in which a contemporary art practice that responds to this African plastic art tradition as its inheritance must also, in and through that gesture, destabilize conventional historiographies that attribute innovation to named, usually white male, artists. Rather than an art history of the water pot, what is called for is a "critical fabulation," following Saidiya Hartman's call "to jeopardize the status of the event, to displace the received or authorized account, and to imagine what might have happened or might have been said or might have been done."[4]

The social tradition of earthen sculptural containers from which Leigh pours thus expresses a Black womanist answer to the riddle that Western philosophy presents itself with whenever it takes up the question of technology.[5] That question is usually figured in terms of how technology estranges us from the natural world, a schematic that in turn tends to place Africa, Blackness, and the feminine in the position of the natural, primitive, and nontechnological.[6] The social sculpture of the earthenware pot refutes this tired binarism. The earthenware

1 Stefano Harney and Fred Moten, *The Undercommons: Fugitive Planning and Black Study* (Wivenhoe: Minor Compositions, 2013), 38.

2 Cara Jordan, "The Evolution of Social Sculpture in the United States: Joseph Beuys and the Work of Suzanne Lacy and Rick Lowe," *Public Art Dialogue* 3, no. 2 (2013): 144–67, https://doi.org/10.1080/21502552.2013.818430.

3 Joseph C. Chukwu, "Role of Women in the Growth of the Traditional Igbo Economy," *Journal of Culture, Society and Development* 10 (2015): 40.

4 Saidiya Hartman, "Venus in Two Acts," *Small Axe* 12, no. 2 (2008): 11.

5 Martin Heidegger, *The Question Concerning Technology, and Other Essays*, trans. William Lovitt (New York: Harper & Row, 1977).

6 See also Alexander G. Weheliye, *Phonographies: Grooves in Sonic Afro-Modernity* (Durham, NC: Duke University Press, 2005).

pot holds within itself, along with water, a unity of practical use and artistic expression. Half of the human body is composed of water; there is a real sense in which the potter is in complex unity with her pot in that both are vessels for water. The typically anonymous potters create objects of individual beauty whose surfaces are formed at the utopian margin of African social life.[7] Their pattern and texture constitute the signature of an artist who discloses, in her anonymity, a presence that militates against every effort to privatize her into an individual. The earthenware pot is already a social sculpture, one that dispossesses its bearer insofar as it opens her out onto a commerce of objects that circulate in and as a common wealth. The carrying of water is a burden of "transindividual being," as Kara Keeling defines it: "stubbornly insisting on a capacity for self-creation within the languages they constantly push to their outsides even as they remain tethered to the collective projects through which they emerge."[8] An Afrofuturism is enacted through this transindividual being that sidesteps the primitivist dichotomy between tradition and modernity. It mutes the lament so often heard from the critical academic socialized into the misery of "advanced" civilization, a lament for a tradition of craft that has been lost and can only be recovered in the vanishing objects of our nostalgia. "Not every puddle I step in makes me gray," the philosopher Ernst Bloch notes in the key of this lament, just as "not every railroad track bends me around a corner."[9] Between the puddle and the railroad, however, there sits a row of pots whose design cannot be consigned either to a primal nature or to an estranging technology, but which represents the fugitive transmission of skill as the feminist refusal of antiblackness.

But why understand social sculpture as the refusal of antiblackness? And is antiblackness something that can, strictly speaking, be refused? Antiblackness, considered both as a structure of feeling and as irrational rationality, can be thought of as that which blocks any straightforward recovery of African art or culture on the part of Black people in the diaspora.[10] It blocks our efforts to assume a full and equal humanity, even as it draws upon Black flesh—Black life, vitality, aesthetic form—to replenish and renew the humanity we are to be excluded from.[11] This condition renders the scene of fugitive planning and Black feminist study that is Leigh's social sculpture a scene whose every proper name is a catachresis. As Hortense Spillers notes, the derisive epithets "by which African-American women have been called, or regarded, or imagined on the New World scene . . . demonstrate the powers of distortion that the dominant community seizes as its unlawful prerogative."[12] Spillers is careful to term "unlawful" this distorting prerogative to name Blackness as otherness, nothingness, absence, abjection, and criminality. Misogynoir is unlawful in terms of being both gratuitous and senseless: unsupported by the law that regulates and restrains "the human."[13] Refusing the distorting power of this dominant community, at least in Spillers's estimation, entails "gaining the *insurgent* ground as female social subject . . . with the potential to 'name.'"[14] It is this insurgent ground that holds the potential to refuse antiblackness, which is to say, to refuse that which has been refused us.[15]

Leigh's early attention to the generative grounds of Black sociality as a site of refusal can be seen in her 2010–11 *Be Black Baby: A House Party* series.[16] These events were a "party in both senses of the term," as Michael Hanchard puts it in his study of the historic affinities between Black political and popular culture.[17] Hanchard showed how Black popular culture—music, dance, carrying on—assumed a critical political function during the post-slavery era of segregation

7 On the concept of the "utopian margins," see Avery F. Gordon, *The Hawthorn Archive: Letters from the Utopian Margins* (New York: Fordham University Press, 2018).

8 Kara Keeling, *Queer Times, Black Futures* (New York: New York University Press, 2019), 69.

9 Ernst Bloch, *The Spirit of Utopia*, trans. Anthony Nassar (Stanford, CA: Stanford University Press, 2000), 9.

10 Frank B. Wilderson III, "Grammar & Ghosts: The Performative Limits of African Freedom," *Theatre Survey* 50, no. 1 (May 2009): 119–25, https://doi.org/10.1017/S004055740900009X.

11 Zakiyyah Iman Jackson, *Becoming Human: Matter and Meaning in an Antiblack World* (New York: New York University Press, 2020).

12 Hortense J. Spillers, "Mama's Baby, Papa's Maybe: An American Grammar Book," *Diacritics* 17, no. 2 (1987): 69.

13 See also Denise Ferreira da Silva, *Toward a Global Idea of Race* (Minneapolis: University of Minnesota Press, 2007).

14 Spillers, "Mama's Baby, Papa's Maybe," 80.

15 See also Alexander G. Weheliye, *Habeas Viscus: Racializing Assemblages, Biopolitics, and Black Feminist Theories of the Human* (Durham, NC: Duke University Press, 2014).

16 See Uri McMillan's discussion of the series in this volume, page 314.

17 Michael Hanchard, *Party/Politics: Horizons in Black Political Thought* (Oxford: Oxford University Press, 2006), 3.

and antiblack terrorism in the United States. Popular culture was a counterpublic sphere in which we could say it loud! I'm Black and proud! With the *Be Black Baby* house parties, celebration and festivity became a forum for engaging the poetics of these Black ideas "in relation," to draw on the poet Édouard Glissant, whose writings inspired one of Leigh's gatherings.[18] Gatherings become sites of transindividuation insofar as they revolve around the Afrochoreographic practice of the "open shine": the ontological antiphonal conviction that I am because we are. Literally defined as the set of improvisational steps taken when one has stepped away from one's salsa dance partner, the open shine may serve as a metaphor for the angular sociality — the apart togetherness — of Black social dance formations.[19]

An Africanist derivation of social sculpture, I would therefore submit, is one in which the tired dualism of tradition and modernity finds itself obviated in the face of the pressing matters of Black life. In the same way a pot gives shape to the liquid it holds and spills, Black sociality gives form to a formless and fabulous vitality.[20] The invitation or injunction to "Be Black Baby" was an early example of Leigh's attention to the spirit of collaboration and improvisation at the heart of the jazz tradition, which resurfaced in *Bleed* — a 2012 collaboration with the mezzo-soprano Alicia Hall Moran and the pianist and composer Jason Moran that developed social sculpture in heterodox and unexpected directions. Drawing on Zora Neale Hurston's famous commentary on "Negro Expression," in which she argued that "everything that he touches becomes angular,"[21] *Bleed* elaborated the premise that there is a meta-art of Blackness that cuts across conventional divisions of visual art, music, and beyond. This angularity — an insistence on the availability of any number of new directions and dimensions to

go off into — develops scenes of Black sociality into something both singular and complex, obviating ex post facto explanation or justification.

It is the angularity of Black womanhood in flight from the confines of gendered regulation that makes a rhizomatic link between performance and healing.[22] Leigh's interest in jazz as a matrix of Black collective self-fashioning evolved into a series of investigations into the untold history of Black women in medicine. As Harriet A. Washington has documented, Black folk have been subject to medical experimentation, malpractice, and structural neglect since before the founding of the republic.[23] This legacy has resulted in grievous racial disparities in health outcomes that continue into our present, and has contributed to widespread community distrust with public health interventions in the era of HIV/AIDS, COVID-19, and other epidemics disproportionately impacting Black and brown people. As Zakiyyah Iman Jackson has argued, the racist image of the Black body as infinitely "plastic" and thus capable of withstanding torture and abuse has underpinned much of this sordid medical history.[24] Out of this repressive context, Black health resistance has emerged to take control of medical destiny, with the Black Panther Party providing a trailblazing example in their racial health and food justice initiatives, as Alondra Nelson has explored.[25] The Panthers supplied the titular inspiration for Leigh's *Free People's Medical Clinic* (2014), which was staged at the former home of pioneering Black ob-gyn Dr. Josephine English. Resonating with Tania Bruguera's "useful art," the *Clinic* combined yoga, massage, acupuncture, Black folk dance, and other performances with visiting hours and workshops to navigate health care and medical screening.[26]

A major goal of the *Clinic* was to emphasize the long tradition of Black mutual aid organizations, highlighting in

18 Édouard Glissant, *Poetics of Relation*, trans. Betsy Wing (Ann Arbor: University of Michigan Press, 1997).

19 Danielle Goldman, *I Want to Be Ready: Improvised Dance as a Practice of Freedom* (Ann Arbor: University of Michigan Press, 2010).

20 On the fabulous and the formless, see Sandra Ruiz and Hypatia Vourloumis, *Formless Formation: Vignettes for the End of This World* (New York: Minor Compositions, 2021); and Tavia Nyong'o, *Afro-Fabulations: The Queer Drama of Black Life* (New York: New York University Press, 2018), chap. 6.

21 Zora Neale Hurston, "Characteristics of Negro Expression," in *Negro: An Anthology*, ed. Nancy Cunard (New York: F. Unger, 1970), 26.

22 Daphne A. Brooks, "'Sister, Can You Line It Out?': Zora Neale Hurston and the Sound of Angular Black Womanhood," *Amerikastudien / American Studies* 55, no. 4 (2010): 617–27.

23 Harriet A. Washington, *Medical Apartheid: The Dark History of Medical Experimentation on Black Americans from Colonial Times to the Present* (New York: Doubleday, 2006).

24 Jackson, *Becoming Human*. See also Alexander Butchart, *The Anatomy of Power: European Constructions of the African Body* (London: Zed Books, 1998).

25 Alondra Nelson, *Body and Soul: The Black Panther Party and the Fight against Medical Discrimination* (Minneapolis: University of Minnesota Press, 2011).

26 Larne Abse Gogarty, "'Usefulness' in Contemporary Art and Politics," *Third Text* 31, no. 1 (2017): 117–32, https://doi.org/10.1080/09528822.2017.1364920.

particular the United Order of Tents, a secret organization of Black nurses that formed during the U.S. Civil War and is still flourishing today. Sessions directed toward the specific needs of Black women, girls, trans*, and femme communities were hosted in the space, which made use of the domestic interior location to demarcate what was public and visible from what was private and protected. In light of the subsequent rise of neofascist and white supremacist violence in the United States, the *Clinic* was prescient in demonstrating the need for Black self-organization under the umbrella of a "right to opacity," as Glissant famously termed it.[27] In rendering these interventions in the context of an art practice, rather than social service in the expected sense of the term, Leigh was testing the limits of what could be perceived as either art or medicine. Her social sculpture ultimately exposed the need for the categories of both art and medicine to be fundamentally transformed from their present function within what bell hooks has termed a "white supremacist capitalist patriarchy."[28]

Leigh's social sculptures took place within the context of increased social and political unrest caused by ongoing police and vigilante violence against unarmed Black civilians. In 2013 the Black Lives Matter movement was founded by activists Alicia Garza, Patrisse Cullors, and Opal Tometi in response to the vigilante murder of Trayvon Martin.[29] Initiated by Black femme organizers in the tradition of Harriet Tubman, Ida B. Wells, and Fannie Lou Hamer, Black Lives Matter propelled a new model of grassroots Black politics that was "leaderful" rather than dependent on the traditional model of charismatic male authority.[30] By avoiding iconic male figureheads, this model of Black feminist organizing also sought to avoid the pitfalls of counterinsurgency that the state developed in the 1960s and 1970s, which witnessed infiltration and assassination as methods of suppressing the Black freedom struggle. It also emphasized a new ethic of radical self-care as a recipe for sustainable resistance and to forestall activist burnout.[31]

Ultimately, mutual aid and radical self-care became means for imagining and enacting "the future in the present," as theorized by C. L. R. James and José Esteban Muñoz.[32] The sequence of interventions from *Free People's Medical Clinic* through 2016's *The Waiting Room* at the New Museum to Black Women Artists for Black Lives Matter (2016–17) took place in a period that also witnessed the election of an openly racist demagogue to the U.S. presidency. The need to enact a defense of Black life that was not tethered to the "deliberate speed" of the mainstream liberal "resistance," in which freedom was always to be deferred to sometime after the next election, became especially crucial. Among Leigh's key collaborators were the anthropologist and yogi Aimee Meredith Cox, the curator and choreographer Rashida Bumbray, the artists Chitra Ganesh, Lorraine O'Grady, and María Magdalena Campos-Pons, and the anthropologist and theorist Vanessa Agard-Jones. Their multiform practices blended art, healing, Black feminist study, and art-as-healing: the tapping into of the creative potential of Black girls and women as in itself a radical act of resistance and social transformation in a society in which "we were never meant to survive."[33]

Black Women Artists for Black Lives Matter placed hundreds of Black femme, queer, and gender nonconforming artists in public solidarity with Black Lives Matter, surfacing an undercommons of rhizomatic connectivity in a sudden and unexpected display of visibility and solidarity. Resonating with the tactics of hashtag activism, buttons, posters, and T-shirts with the Black Women Artists for Black Lives Matter logo (BWA for BLM) were produced (fig. 1), and Instagram, Twitter, and Tumblr pages on social media were created. This form of visual activism activated what Gerald Raunig calls "transversal" connections between art and revolution.[34] Rather than lead the revolution in the top-down manner of the historical avant-garde, transversal art corroborates the revolutionary desires of the multitude. Such transversal corroboration is expressed

27 Glissant, *Poetics of Relation*, 111–20.

28 bell hooks, *Outlaw Culture: Resisting Representations* (New York: Routledge, 1994), 67.

29 Keeanga-Yamahtta Taylor, *From #Blacklivesmatter to Black Liberation* (Chicago: Haymarket Books, 2016).

30 Joseph A. Raelin, "The Ethical Essence of Leaderful Practice," *Journal of Leadership, Accountability and Ethics* 11, no. 1 (2014): 64–72, https://papers.ssrn.com/abstract=2447330; Erica R. Edwards, *Charisma and the Fictions of Black Leadership* (Minneapolis: University of Minnesota Press, 2012).

31 Hiʻilei Julia Kawehipuaakahaopulani Hobart and Tamara Kneese, "Radical Care: Survival Strategies for Uncertain Times," *Social Text* 38, no. 1 (142) (March 1, 2020): 1–16, https://doi.org/10.1215/01642472-7971067.

32 José Esteban Muñoz, *Cruising Utopia: The Then and There of Queer Futurity*, ed. Ann Pellegrini, Joshua Chambers-Letson, and Tavia Nyong'o, 10th Anniversary ed. (New York: New York University Press, 2019).

33 Audre Lorde, "A Litany for Survival," Poetry Foundation, https://www.poetryfoundation.org/poems/147275/a-litany-for-survival.

34 Gerald Raunig, *Art and Revolution: Transversal Activism in the Long Twentieth Century*, trans. Aileen Derieg (Los Angeles: Semiotext[e], 2007).

Fig. 1 Black Women Artists for Black Lives Matter logo printed on various ephemera, 2016

Fig. 2 Lorraine O'Grady, "Ask Me Anything About Aging," event presented as part of *Psychic Friends Network*, Tate Exchange, Tate Modern, London, November 24, 2016

311

in the title of the Brooklyn Museum's 2017 exhibition *We Wanted a Revolution: Black Radical Women, 1965–85*, curated by Catherine Morris and BWA for BLM member Rujeko Hockley. A gathering in which all were invited to wear red in solidarity with BWA for BLM put this desiring-production into action. Wearing red brought participants into angular proximity, embracing and stylizing a color often stigmatized (the "scarlet letter") and deploying it as a jubilant emblem of Black femme power.

A recurrent theme in Leigh's social sculpture is the enigmatic status of medicine as both cultural and material form. Undoubtedly this connects to her principal vocation as a sculptor, one who is forever investigating the properties and possibilities of clay, glazes, and other substrates. The performance studies scholar Barbara Kirshenblatt-Gimblett is fond of remarking that an object is just a slow-moving event. In light of Leigh's interest in constructing social environments for the contemplation and administration of medicine, we can observe that the reverse is also the case: an event is an object moving at a different speed. What we think of as an individual human body is in reality a complicated assemblage of living organisms interacting in a web of "vibrant matter."[35] And increasingly, the dismissed and denigrated knowledges of indigenous medicine in Africa, Oceania, Native America, and beyond is stepping in to supplant Western technologies of extraction. The path-breaking research of the historian Carolyn Elizabeth Roberts, for example, is revealing how West African herbal, surgical, and medical knowledge was integral to the unfolding of Black survival during the transatlantic slave trade.[36] In highlighting the place of medicinals in the "political ecology of things," as Jane Bennett puts it,[37] Leigh's social sculpture proposes a Black feminist version of new materialism. Much as deconstruction teaches us that the same substance that cures can kill, and vice versa, the apothecaries and *muthi* markets of the Black diaspora are enigmatic zones for indigenous Africanist knowledges held for too long on the periphery of Western allopathic medicine.[38]

This interest in rethinking materialism extends to the inner realm and its psychic objects. Leigh's 2016 *Psychic Friends Network* (fig. 2), held at the Tate Modern in London, furthered this exploration of the enigmatic and performative valences of Black healing practices in the idiom of popular culture. The title alluded playfully to the popular 1990s television infomercial hosted by the chanteuse Dionne Warwick, promising a network of intimacy just outside the domain of the properly authoritative. The psychic is a well-known raced, gendered, and othered figure in the West. Although extrasensory perception has been the object of serious scientific and philosophical interest by many highly credible icons of Western Enlightenment (Alan Turing, William James, Henri Bergson), it is also stigmatized as an "old wives' tale" perpetuated by superstitious people. Here it is useful to recall Spillers's opening recitation of the names by which Black women are (mis)known, including: "Earth Mother," "Aunty," "Granny," God's "Holy Fool."[39] All these notions associate age, spiritual belief, and proximity to the earth with credulity, unreliability, and exclusion from objective or positive knowledge. And yet, as Jayna Brown argues in her powerful history of Black women as ecstatic truth-seekers, many of our most enduring icons of Black liberation (Sojourner Truth being a prime example) devoted sustained time and attention to listening to the "music of other worlds."[40] One person's method is another person's madness, and Leigh's *Psychic Friends Network* playfully and defiantly occupied the space of unvalorized knowledges to perpetuate scenes of Black feminist study and aesthetics.

When we arrive at the intangible network of friendship and affinity that the *Psychic Friends Network* stages, we are also on the threshold of Leigh's *Loophole of Retreat* convenings (pages 304 and 305). All I can offer here by way of conclusion and transition to that intellectual summit is to suggest that, as with the mystic links of sorority that carried the United Order of Tents across decades of struggle and survival, these intangible and affective bonds form a possible ground whereon the seeming paradox of fugitive practice can find a landing. Recall the way I stated that paradox at the beginning of the essay: to document or define fugitivity is to risk endangering it. But much is accomplished in culture in and through the paradox, as all storytelling peoples know. Much as the Africanist water pot is the outward expression of the inner cultivation of skill on the part of the potter—herself both the recipient of a tradition

35 Jane Bennett, *Vibrant Matter: A Political Ecology of Things* (Durham, NC: Duke University Press, 2010).

36 Carolyn Elizabeth Roberts, "To Heal and to Harm: Medicine, Knowledge, and Power in the Atlantic Slave Trade" (Ph.D. diss., Harvard University, 2017), https://dash.harvard.edu/handle/1/42061516.

37 Bennett, *Vibrant Matter: A Political Ecology of Things.*

38 Jacques Derrida, "Plato's Pharmacy," in *Dissemination,* trans. Barbara Johnson (Chicago: University of Chicago Press, 1981).

39 Spillers, "Mama's Baby, Papa's Maybe," 65.

40 Jayna Brown, *Black Utopias: Speculative Life and the Music of Other Worlds* (Durham, NC: Duke University Press, 2021).

of skill and the bearer of that tradition into many possible futures—so too the art of social sculpture is the public, interactive, and ephemeral expression of a series of Africanist forms, forms that might even be thought of as incorruptible, insofar as they offer a model of Black plasticity that is counter to the effort to subjugate the Black body that has been documented so extensively in the literature. Approaching these forms of social relation as incorruptible rather than as subject to the vagaries of history and culture may establish a basis for recalling those oracular voices and communal wishes that establish the femme artist within African and African diasporic society as the sustainer and (water) bearer of a bearable life.

Uri McMillan

Be Black Baby!
Simone Leigh's Performance Commons

Jamaican American sculptor Simone Leigh's adept and generous role as a curator, specifically as the founder of *Be Black Baby: A House Party*, is an important if overlooked facet of her often collaborative artistic practice. And yet Leigh's aesthetic signatures, whether the invocation of key, albeit obscured, historical references as a primary text for her works or her privileging of Black women as her coconspirators and primary audience, also inform these idiosyncratic and performative one-offs. Staged in 2010–11, *Be Black Baby: A House Party* was a series of events organized by Leigh in collaboration with the arts nonprofit Recess Activities, Inc. and staged in the latter's 43 Grand Street space in SoHo. Each presentation was designed as a playful yet rigorous exploration of a particular question or theme that culminated in a dance party, DJ'd by the scholar Khary Polk, then a New York University graduate student. Leigh usually chose a co-curator for each iteration, working together to solidify a lineup of visual artists, poets, scholars, and performers to "respond" to the given night's concept in the most imaginative of terms. And lacking grand ambitions or an extensive budget, these quasi-happenings were determinedly lo-fi: participants often used flip drives to load their presentations onto a shared computer, a wall of the space was purposely left blank to act as a screen for projected images, chairs and electronic equipment were borrowed or rented, and press releases were disseminated over Facebook. Deeply conceptual yet loosely organized, *Be Black Baby: A House Party* suggestively revealed the artistic "path from idea to fruition,"[1] where creative inquiry, humor, and dialogue were prized more than definitive answers, straitlaced rhetoric, or marketable works of art. Moreover, it trafficked in SoHo's storied history as a locus of contemporary art and experimental performance in the 1960s and early 1970s, while its centering of racial histories, particularly Blackness, served as a needed corrective to that same oft-cited lineage.

The genesis of *Be Black Baby: A House Party*, in name and concept, is an approximately nineteen-minute black-and-white sequence in the filmmaker Brian De Palma's 1970 black comedy *Hi, Mom!* In the opening of this particular scene, a sign emblazoned with the curious phrase "BE BLACK BABY" fills the screen before shifting to two white women standing below it as the heading "Part III: The Theater of Revolt" appears on the screen as a possible clue to the proceedings. The camera then pans to a line of eager, nicely dressed white denizens waiting patiently on the street for their turn to experience this presumably unique theatrical event. Just then, the camera quickly cuts to a hallway and zooms in on a Black male with a short Afro,

glasses, and a black mock-neck sweater accompanied by other Black compatriots in similar monochromatic gear. Resembling a Black Panther, he announces to the small group of onlookers that being Black means "being loose," and his role, therefore, is to loosen them up to prepare them for the experience they are about to receive. The inquisitive white audience members are instructed to feel their Black counterparts' hands, arms, necks, and hair while commenting on any notable tactile differences. They are then cajoled to slowly roll their hips in circles and proceed to dance. One stiff audience member questions her participation in this ritualistic behavior; she insists that there is a distinct demarcation between audience and actor, and she is clearly the former. "You're also an actor in this case," a Black woman who is a member of the experimental theater troupe pointedly responds, explaining that this is part of the play. Next, the participants are given soul food to sample, specifically pigs' feet, collard greens, and black-eyed peas. The actors strongly urge the skeptical patrons to eat it since this is ostensibly the Black experience. Subsequently, the small audience is led up a staircase to the second floor, where Black actors in whiteface are waiting. The spectators are informed that now that they have eaten, danced, and felt Black, it is imperative they *be* Black.

In what follows, the perplexed and increasingly agitated white audience members are subjected to guerilla performance art that tests their resolve as much as it strains the patience of cinematic viewers. The actors haphazardly apply black shoe polish to the audience members' faces, exhorting that they are now "Black" since they supposedly look the part. Consequently, they announce that the Black actors are now "white." The humor of this striking role reversal begins to fade, though, as select audience members quickly start to question if what appears to be brazen theft by the actors of cash from a wallet and personal possessions (a purse) is, in fact, just part of the play. When one of the male bystanders goes downstairs to investigate and seems to be apprehended and assaulted by the group, the mood swiftly shifts to fear. The increasingly hostile actors now roughly handle the shocked white-turned-Black audience members, whom they repeatedly subject to racial epithets and other harsh terms, as they prepare for a "screwing scene" and the threat of rape. The participants band together and attempt to escape through an elevator but are recaptured by members of the troupe. The scene continues to escalate to an uncomfortably feverish pitch until a white police officer (played by an uncredited Robert De Niro) shows up. And yet, unbeknownst to them, the supposed ally is in on the

1 "Be Black Baby: A House Party Presents," Recess (web page), accessed July 14, 2022, https://www.recessart.org/be-black-baby.

Fig. 1 *Be Black Baby: A House Party Presents Édouard Glissant, Inhabit His Name,*
Recess Inc., New York, June 17, 2011

Fig. 2 *Be Black Baby: A House Party Presents Michael Jackson 2004*, Recess Inc.,
New York, September 10, 2010

haphazard theatrics, as he too is a member of the acting group. Surprisingly, the officer sides with the Black actors rather than the white spectators. He insists, furthermore, to the latter's shock as they seek to verify their identities via their ID cards, that they are in fact "Black" and hence are making fraudulent claims. As a result, they are escorted outside by the officer, presumably to be arrested. But just then, the mood abruptly lightens, and the "play" ends. The participants freely walk away as the jubilant actors bid them farewell with the satirical salutation "Be Black, baby!" The scene ends with the once-terrified audience members being interviewed on network TV as they excitedly proclaim their assessment of the play as a must-see theatrical event to the broadcaster.

Contextually, Leigh's use of this little-known cinematic sequence as a jumping-off point for her series of gatherings was tied to dual imperatives: its strange timeliness and its explicit artistic usage of race, specifically Blackness. As Leigh noted in a recent interview, when she first saw the striking sequence at a film screening, it felt like "a performance that could have happened the week before in New York. It was so contemporary."[2] Yet at the same time, it wildly diverged from the imperative in those years for Black visual artists to avoid the overt use of racial signifiers in their work. The term "post-black," coined in the early 2000s, had begun to be freely used as shorthand in art circles for such a direction. As Leigh explained, "We were kind of in the wake of post-blackness" in which "the mark of a real artist, if you were of color," was to scrub "all the ethnic markings off of your work. I wanted to respond to that as well."[3] Shocked by the clip and unsure what to make of it, Leigh distributed it to artists she had previously worked with or knew by association. The first Be Black Baby: A House Party (March 13, 2010, co-curated with Sarina Basta and Karin Schneider) was dedicated to these selected artists' responses.[4] The understated press release prominently featured an indelible and confrontational

image of the film's whitefaced Black actors staring boldly at the camera. Three iterations soon followed that facilitated further invitations to loosely riff on a selected thematic, emulate the film's exacting dissection of racial tropes, and explore the limits between actor and audience. These included Be Black Baby: A House Party Presents Michael Jackson 2004 (September 10, 2010, curated by Uri McMillan); Be Black Baby: A House Party Presents If There's No Dancing at the Revolution I'm Not Coming (April 1, 2011, co-curated by Leigh and curator Naomi Beckwith[5]), and Be Black Baby: A House Party Presents Édouard Glissant, Inhabit His Name (June 17, 2011, co-curated by Leigh and filmmaker Madeleine Hunt-Ehrlich).

Combining thoughtful theorizing with deliberately provocative hot takes, the Be Black Baby: A House Party series evinced Leigh's skill, Hunt-Ehrlich suggested, in developing "community building around art-making."[6] Hunt-Ehrlich met Leigh for the first time at a Be Black Baby party; she felt an immediate kinship with Leigh, she notes, because the dominance of Western art history at the time made it difficult to find conversations about art that centered Blackness, especially vernacular Caribbean imagery. Together, they began regularly attending a citywide reading group called Caribbean Epistemologies, a precursor to their collaboration on Be Black Baby: A House Party Presents Édouard Glissant, Inhabit His Name (fig. 1). Using the Martinique-born scholar Édouard Glissant's seminal text Poetics of Relation (1990) as a reference point, they explored the subjects of multilingualism, hybridity, and creolization in the Caribbean. Several other members of the reading group also participated in the one-time event.

Similarly, an academic conference on Michael Jackson that I had co-organized six years earlier became the surprising fulcrum behind my curation of Be Black Baby: A House Party Presents Michael Jackson 2004 (fig. 2).[7] Leigh invited me to curate a "fake conference" as a rejoinder to the original one,

2 Simone Leigh and Madeleine Hunt-Ehrlich, in Fuse: A BOMB Podcast, season 1, episode 1, May 29, 2020, transcript, 6, https://s3.us-east-1.amazonaws.com/bomb-images/Simone_Madeleine-Fuse-5-28.pdf.

3 Leigh and Hunt-Ehrlich podcast, 6–7. Post-Black, as a term, is often attributed to Thelma Golden, then deputy director for exhibitions and programs at the Studio Museum in Harlem. She first used the term in her introduction to the exhibition catalogue for Freestyle (Studio Museum in Harlem, 2001) to describe a cohort of artists who were simultaneously rejecting and embracing the moniker of "Black art" in often ironic ways.

4 For a full list of participants in all staged versions of the Be Black Baby: A House Party series, see "Chronology of Social Sculpture Works" in this volume, page 296.

5 Beckwith was then associate curator at the Studio Museum in Harlem. Currently, she is deputy director and Jennifer and David Stockman Chief Curator at the Solomon R. Guggenheim Museum.

6 Leigh and Hunt-Ehrlich podcast, 9.

7 Regarding Michael Jackson: Performing Racial, Gender and Sexual Difference Center Stage was held at Yale University on September 23–24, 2004. Sponsored jointly by the Department of African American Studies and the Larry Kramer Initiative for Lesbian and Gay Studies, it was the first academic conference devoted to Jackson.

a proverbial B side that traded buttoned-up seriousness for something less didactic and more spontaneous. As a result, we featured live tableaux and installation art (Deville Cohen's *Lace* and Abigail DeVille's *Dark Star*, respectively) in lieu of keynote speakers and gave participants carte blanche to interpret the legacy of Jackson's artistry. These chosen forms included critical karaoke, short videos, YouTube collages, performative meditations on child labor, and poetry. Furthermore, Leigh invited young performers from the Edge School of the Arts, a dance school based in Queens, to "activate" the space of DeVille's enormous installation. In doing so, Leigh expanded the base of participants in these experiential endeavors to encompass overlooked communities of color while foregrounding the importance of local arts institutions.[8]

This multigenerational impulse and genre boundary-breaking, moreover, were prominent in *Be Black Baby: A House Party Presents If There's No Dancing at the Revolution I'm Not Coming.* This durational event utilized the famous, if apocryphal, aphorism generally attributed to Emma Goldman as a source text. Notably, mother and daughter artists Maren and Ava Hassinger went literal with the theme: they invited the audience to dance with them on the street while Martha and the Vandellas' 1964 hit "Dancing in the Street" was played on a portable boom box. Akin to its cinematic inspiration, *Be Black Baby: A House Party* forged collectivities that encouraged social actors—be they participants or audience members—to loosen up, throw out the so-called script, and gleefully break the fourth wall.

While *Be Black Baby: A House Party* may seem a radical anomaly within Leigh's oeuvre, its collaborative approach and its challenge to traditional boundaries around artistic practice mirror more recent projects that Leigh has helmed in community centers as well as museums. These include her *Free People's Medical Clinic*, a community-based art commission sponsored by the Weeksville Heritage Center and staged at Stuyvesant Mansion in Brooklyn in 2014, and the *Loophole of Retreat* symposium at the Solomon R. Guggenheim Museum in 2019, organized in collaboration with the scholars Saidiya Hartman and Tina M. Campt.[9] While less formalized and canonized than these more contemporary projects, *Be Black Baby: A House Party* may ultimately be Leigh's prescient vision of an impromptu arts commons that dared to center racial consciousness as foundational to its experimental ethos. In the dynamic catalytic spaces Leigh and her collaborators created in the 2010s, groups of like-minded individuals traveled to a nondescript space in SoHo in pursuit of what *Be Black Baby: A House Party* quickly became known for: quirky formats, big ideas, spontaneous conversations, and the get-down.

8 Undoubtedly, this was influenced by her friendship and working relationship with frequent collaborator (and esteemed dancer) Rashida Bumbray. At the time, Bumbray was an associate curator at The Kitchen, a nonprofit, multidisciplinary avant-garde performance and experimental art institution based in Chelsea. Bumbray, whom I first met at the 2004 conference, also acted as a primary adviser for the *Be Black Baby: A House Party* focused on Jackson. Meanwhile, Legacy Russell—the first-ever Black executive director and chief curator at The Kitchen—was a participant in the *Be Black Baby: A House Party* centered on Glissant.

9 The former used the United Order of Tents, a secret organization of Black women nurses founded during the Civil War, as a linchpin for considering the intersections between public health and women's work; attendees were offered community-provided acupuncture, vinyasa yoga, HIV screenings, and instruction in Black folk dance. The latter explicitly featured an electrifying roster of Black women performers, academics, and poets responding to Leigh's body of work, including the visual and performance artist Lorraine O'Grady and the anthropologist Vanessa Agard-Jones, both participants in different editions of *Be Black Baby: A House Party.*

Nomaduma Masilela

Roving notes through an embodied archive that presents something "more true than fact"

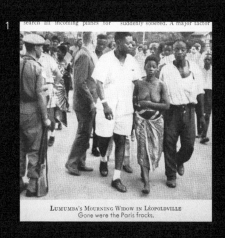

1

LUMUMBA'S MOURNING WIDOW IN LÉOPOLDVILLE
Gone were the Paris frocks.

Simone Leigh's artistic process includes a rigorous research methodology of collecting and studying archival images, many of which focus on the representation and mediation of Black women, their labor, and their creative output throughout history. The following constellation of images provides readers a window into her capacious eye. At Leigh's invitation, curator and writer Nomaduma Masilela selected images from the artist's incisive Instagram account. This small selection of images is by no means exhaustive of the many research images that inform Leigh's process, but reveals the artist's refraction of collective image-making and serves as a kind of primer for her art.

Eva Respini

In 1961, after weeks of inquiries and waiting, when she heard the news on the radio of her husband's assassination, Pauline Lumumba walked out into the streets of Leopoldville in grief. Wearing only a pagne wrapped around her waist, she walked barefoot and bare-breasted through the city, leading a growing procession of comrades, friends, and fellow citizens who joined her to collectively mourn the death of the first prime minister of their newly independent nation (fig. 1). Lumumba's fellow mourners understood her disrobed procession to be both an expression of grief over the death of a husband and a generous offering of protest, signifying their shared outrage at the brutal truncation of a national agenda and their surrogate demand for his disappeared body.

Throughout her procession, Lumumba's solitary, disrobed body remained thoroughly her own: protected by the support of the collective of mourners around her and by a lineage of past political protest and revolt led by disrobed women (specifically mothers) who had had enough.[1] Nearly sixty years later, when Simone Leigh used this iconic image of Lumumba's grieving protest to lodge an incisive public criticism of North American critics' continued desire to introduce their opinions and positions into discourses of whose important sociocultural and historical referents they are completely ignorant, she invoked the multivalent spirit of refusal and revolt embodied in Lumumba's walk, a spirit akin to that of "sitting on a man's head."[2] Leigh's Instagram page serves as an archive that activates, rather than simply records, the countless "feats, deeds, burdens, artifacts" that are definitive of Black women's creative work.[3] While it is also a repos-

Fig. 1 Newspaper photo of Pauline Lumumba leading a funeral procession and protest through Leopoldville (now Kinshasa), after the 1961 assassination of her husband and first prime minister of the Democratic Republic of Congo, Patrice Lumumba. United Press International/Time magazine, February 24, 1961. Subsequent figures begin on page 325.

1 Other examples of the political power of the disrobed mother's body include the anticolonial Aba Women's rebellion of 1929 in Nigeria, followed decades later by a women's opposition movement led by Wangari Maathai against the government of Daniel Arap Moi in Kenya.

2 Simone Leigh (@simoneyevetteleigh), Instagram, May 16, 2019.

3 Denise Ferreira da Silva, "How," *e-flux Journal*, no. 105 (December 2019), https://www.e-flux.com/journal/105/305515/how/.

itory of images of her own artwork and its various states of conceptualization, production, and exhibition, it records and activates the many tactics and technologies that Black women the world over have utilized as tools of refusal, and for enunciating complex cosmologies, masteries of opacity and creative labor, conspiracies of camaraderie, and the interpersonal and embodied transmissions of knowledge enabled through the generative mentorship of motherhood.

What Christina Sharpe describes as "antiblackness as total climate" is predicated upon the pervasive and perverse practice of extraction that is definitive of colonial capitalist logic[4]: the extraction and annihilation of Black bodies (fig. 2), of Black cultural artifacts and narratives (figs. 3, 4), and even, in the case of Patrice Lumumba, of teeth.[5] In the face of the grasping and annihilating desire that is a definitive hallmark of Western capitalism and colonialism, tactics of refusal and resistance, or of "opacity," as defined by Édouard Glissant, were and continue to be implemented; as Glissant writes, "Opacities can coexist and converge, weaving fabrics. To understand these truly one must focus on the texture of the weave and not on the nature of its components."[6] Practices of opacity and refusal produce their own archive of sensibilities and existential understandings. Objects produced clandestinely, such as under the duress of slavery in the American South (fig. 5), to this day maintain a level of impenetrability related to their purpose and use value, despite being recorded and investigated by anthropologists who wish to understand the nature of their components, and have introduced praxes of acknowledging the otherworldly within society (fig. 6) and the power of the motherworldly (fig. 7).

4 Christina Sharpe, *In the Wake: On Blackness and Being* (Durham, NC: Duke University Press, 2016), 21.

5 Clyde Hughes, "Belgium to Return Gold Tooth of Congo's Patrice Lumumba to Family," United Press International, June 20, 2022, https://www .upi.com/Top_News/World-News/2022/06/20/Belgium-Congo-Patrice-Lumumba -tooth-return/7421655742846/.

6 Édouard Glissant, "For Opacity," in *Poetics of Relation*, trans. Betsy Wing (Ann Arbor: University of Michigan Press, 1990), 190.

7 Annette Lane Harrison Richter, "Reflections on Black Sisterhood and the United Order of Tents" as told to Madeleine Hunt-Ehrlich, *e-flux Journal*, no. 105 (December 2019), https://www.e-flux.com/journal/105/305114/reflections -on-black-sisterhood-and-the-united-order-of-tents/.

Other social and protective clandestine tactics of survival require or result in direct intervention, such as braiding (fig. 8), which changed the scope of vegetation and nutrition in the New World, or the design of a new style of dress (fig. 9) that attempts to defend against the actual existential and sexual violence endlessly visited upon Black women's bodies, which continues to the present day and has only in recent years been acknowledged through the endless efforts of Black women's actions and protest (fig. 10). When Annetta M. Lane had "a vision from God to band black women together to look after one another" in Virginia in 1867, she formed the United Order of Tents, a health and benefit society for Black women.[7] Predicated on secrecy, and active to this day (fig. 11), the Order of Tents works to care for the sick and elderly, provides loans and burials, and offers other social benefits that are too often withheld; without the collective support of the community, one falls into danger of perishing from waiting for care.[8] This danger of medically prescribed waiting, or of general negligence, was nearly experienced by a world-famous tennis champion.[9] Black women know the importance of community-induced care during moments of bodily precarity (such as after childbirth) (fig. 12). These practices demonstrate the veracity of "heritage as technology,"[10] which can be seen in the conceptual and movement innovations that Katherine Dunham introduced into modern dance through her years of research in Haiti (fig. 13), and the subversions of the patriarchal visual lexicon of a male secret society by the artist Belkis Ayón through her own handiwork (fig. 14).

The importance of the endless valences of women's work is further exemplified in manual labor, not only in the use of the hands but also in

8 A. Naomi Jackson, "Waiting Room," in *Waiting Room Magazine*, ed. Simone Leigh (New York: Creative Time, 2014).

9 Simone Leigh (@simoneyevetteleigh), Instagram, January 11, 2018.

10 Sharifa Rhodes-Pitts, "Artist Unknown, Vessel Possibly for Water," in *Simone Leigh* (New York: Luhring Augustine Gallery, 2018).

providing guidelines for future practices.[11] With the collective women's work of preparing for the hunt (fig. 15) or of building an architectural compound (fig. 16), which can be similar to the work of laying on of hands or the layered process of building up a clay vessel (fig. 17), all information is carried in the body, and is transmitted from body to body and through a shared sensibility. This same process of knowledge sharing—of the work of the hands, such as those of Inge Hardison (fig. 18), or the relationship between teacher and student (figs. 19, 20)—produces a lineage and enables the mastery of a process (fig. 21) or a material technique (figs. 22, 23).

Collective labor, mentorship, and care have deep roots within the radical work of mothering (fig. 24) and of gathering together (fig. 25). The work of providing social and intimate space for the collective exchange of knowledge is a type of intellectual labor that is often excised from the written male-centered histories, and it is labor most often performed by women (figs. 26, 27). However, it is the work that binds artists and scholars together intergenerationally—the meetings, the protests, the processions, the museum inversions (fig. 28), the support that comes from older generations supporting those who come after (fig. 29), and of the sisterhood of chosen family (fig. 30).

These are the ways of being and sensibilities that Simone Leigh espouses in her art, and through her work as a teacher and mentor, which serves as an extension of radical mothering, within both her life (fig. 31) and her practice.[12] This enables not only herself but also those who see and understand her work and the sensibilities she references to feel a capacity and liberation of renaming (fig. 32) and endless possibilities of being (fig. 33).

11 Saidiya Hartman, "Manual for General Housework," in *Wayward Lives, Beautiful Experiments: Intimate Histories of Social Upheaval* (New York: W. W. Norton & Company, 2019).

12 Alexis Pauline Gumbs, China Martens, and Mai'a Williams, eds., *Revolutionary Mothering: Love on the Front Lines* (Richmond, BC: PM Press, 2016).

2

3

Fig. 2 Commemorative T-shirt marking the return of three Herero skulls to
Namibia by the German government in 2011. Gift given to Simone Leigh from
Esther Utjiua Muinjangue, president of the National Unity Democratic Organisation
(NUDO) party of Namibia, 2015

Fig. 3 Head of a King (Oba), ca. 1700s. Bronze. 10 1/2 × 7 3/4 × 8 1/2 inches
(26.7 × 19.7 × 21.6 cm). Currently, Benin Kingdom. Previously, RISD Museum,
deaccessioned by the Fine Arts Committee and Board of Governors, Fall 2020,
Ex Gift of Miss Lucy T. Aldrich

Fig. 4 *Exposition coloniale 1931, Paris* catalogue (Paris: Arts et Metiers Graphiques, 1931)

Fig. 5 James A. Palmer, *The Wilde Woman of Aiken*, from the series Aiken and Vicinity, 1882. Albumen silver print from glass negative, 6 1/2 × 4 1/8 inches (16.5 × 10.5 cm), Metropolitan Museum of Art, New York. Purchase, Nancy Dunn Revocable Trust Gift, 2018

Fig. 6 Video documentation of Senegalese Kumbo masquerade (still), date unknown

Fig. 7 Photo documentation of the Gèlèdé spectacle of the Yoruba, date unknown

8

9

10

Fig. 8 Video documentation of Edith Adjako, of Maroon descent, showing how her female ancestors hid rice grains in their hair when they escaped from slavery and fled into the Suriname forests (still), July 2017

Fig. 9 "Negro Women, Dutch Guiana," from Sir Harry Hamilton Johnston, *The Negro in the World* (London: Methuen, 1910). Schomburg Center for Research in Black Culture, Jean Blackwell Hutson Research and Reference Division, The New York Public Library

Fig. 10 Removal of J. Marion Sims statue in Central Park, New York, 2018. Dr. Lynn Roberts (right), Harriet A. Washington (center), and Dr. Aletha Maybank (left)

Fig. 11 Image taken during the Grand Encampment of the United Order of Tents 150th Anniversary in Chesapeake, Virginia, 2017

11

Fig. 12 Video documentation of the Hali/Kingika dance by the Pokomo women of Kenya (still), date unknown

Fig. 13 Katherine Dunham at home in Martissant, Port-au-Prince, Haiti (1962) (still). Video

Fig. 14 Belkis Ayón, *La consagración III* (detail), 1991. Collography on paper. 81 1/2 × 119 3/8 inches (207 × 303 cm)

Fig. 15 Water-drumming ritual performed before a hunt by women of the Baka Forest People, Cameroon, video accompanying *Liquindi I* (still), from *Voice of the Rainforest*, by Orchéstre Baka Gbiné, released December 25, 2013

Fig. 16 *Traces, Women's Imprints* (still), 2003, directed by Katy Lena Ndiaye. Film (color, sound; 52:00 minutes)

17

18

19

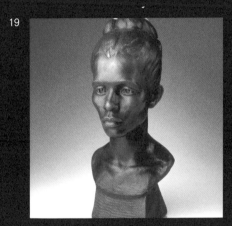

20

21

Fig. 17 Marilyn Nance, *Iya Alamo, Professor Agbo Folarin, and Winnie Owens-Hart at FESTAC '77, Nigeria*, 1977

Fig. 18 John W. Fletcher, *Hands of Inge* (still), 1962. Video (color, sound; 10:00 minutes). Smithsonian National Museum of African American History and Culture, Gift of Pearl Bowser

Fig. 19 Augusta Savage, *Gwendolyn Knight*, ca. 1937 (cast 2001), Bronze. 17 5/16 × 8 1/2 × 8 inches (44 × 21.6 × 20.3 cm). Telfair Museums of Art, Savannah, Georgia, Gift of The Walter O. Evans Collection of African American Art, 2003.18

Fig. 20 Herman Andrew, *Augusta Savage with her sculpture "Realization"* (detail), ca. 1938. Silver gelatin print. Approximately 10 1/4 × 8 1/4 inches (26 × 21 cm). Federal Art Project, Photographic Division collection, circa 1920–1965. Archives of American Art, Smithsonian Institution

Fig. 21 *Five Artists* (still), 1971, directed by Vicki Kodama. Film (color, sound; 30 minutes). Featuring Barbara Chase-Riboud, Charles White, Romare Bearden, Richard Hunt, and Betty Blayton

Fig. 22 Magdalene Odundo, *Untitled #10*, 1995. Earthenware. 21 1/4 × 12 × 12 inches (54 × 30.5 × 30.5 cm). Newark Museum, Purchase 1996 Louis Bamberger, Bequest Fund 96.29

Fig. 23 Glaze produced from salt kiln firing during Leigh's artist's retreat at Watershed Center for the Ceramic Arts, Newcastle, Maine, 2016

Fig. 24 Elizabeth Catlett, *Madonna*, 1982. Ink on paper. 21 × 16 inches (53 × 41 cm). Ruth Chandler Williamson Gallery, Scripps College, Claremont, California. Gift of Samella Lewis

Fig. 25 *Mary McLeod Bethune, Ida B. Wells, Nannie Burroughs, and other women at Baptist Women's gathering, Chicago*, 1930. Silver gelatin print. 8 1/4 × 10 1/4 inches (21 × 26 cm). Photo by Woodard's Studio, Chicago. Schomburg Center for Research in Black Culture, Photographs and Prints Division, The New York Public Library

Fig. 26 André Breton, Esteban Francés, Suzanne Césaire, Jacqueline Matisse-Monnier, Denis de Rougemont, Elisa Breton, Sonja Sekula, Madame Nicolas Calas, Yves Tanguy, Nicolas Calas, Marcel Duchamp, Patricia Kane Matta, Alexina "Teeny" Matisse, and Aimé Césaire, photograph taken in New York on November 20, 1945

28

29

30

31

32

33

Fig. 27 Left: Photograph of Suzanne Césaire (née Roussi), date unknown. Right: Photograph of Paulette Nardal, ca. 1920s

Fig. 28 Fatima White and her grandmother, Charlesetta Wicks, with Black Women Artists for Black Lives Matter, New Museum, New York, September 1, 2016

Fig. 29 Lorraine O'Grady (left) and Peggy Cooper Cafritz (right) at the Tate Modern for a gathering of Black Women Artists for Black Lives Matter UK, 2016

Fig. 30 Rashida Bumbray performs *Motherless Child Set* at the opening of *Simone Leigh: The Waiting Room*, New Museum, New York, on June 23, 2016

Fig. 31 Simone Leigh with Zenobia Marder, ca. 1999

Fig. 32 Signed and dedicated front page of Audre Lorde's *Zami: A New Spelling of My Name* (New York: Crossing Press, 1982)

Fig. 33 Elizabeth Catlett, *Which Way?*, 1973–2003. Lithograph. 11 × 14 1/2 inches (27.5 × 37 cm)

Malik Gaines, Simone Leigh, and Lorraine O'Grady

Conversation

Fig. 1 My Barbarian (Malik Gaines, Jade Gordon, Alexandro Segade),
Transparency 2021, 2021. Performance view, Whitney Museum of American Art,
New York, 2021

Multidisciplinary artists Lorraine O'Grady and Malik Gaines have been longtime interlocutors with Simone Leigh. O'Grady has appeared in several of Leigh's works, the two women have been in public conversation, and Gaines has written insightfully on both Leigh and O'Grady. The three artists have a mutual admiration for one another's works, and shared concerns are evident in their art practices. Scattered across the country, Leigh, O'Grady, and Gaines gathered on September 13, 2022, over Zoom for an insightful, far-reaching, and warm conversation among colleagues and friends.

334

MALIK GAINES The last few years have been intense. So much has happened for you, Simone.

SIMONE LEIGH Which is why I ended up in the sanatorium [in Fall 2022]. I've always had a fantasy of going to such a place after every exhibition. You know, like in the movies in the '30s, where after you contracted tuberculosis you would go to a sanatorium and get pushed out on the veranda in a wicker wheelchair for air in the Alps. This was always my ideal for how to recover from an exhibition. And this spa in the mountains was pretty close to that.

LORRAINE O'GRADY Hearing that you were in a medical spa was interesting when thinking about the kinds of things that you were talking about in the context of *The Waiting Room* (page 300). You were pretty clear that Black women needed Black health care.

SL I'm still clear about that. One of the things that was the most shocking when I listened to lectures about Black pain and health care at the time is that people investigating this problem were finding that most people don't think that Black people experience pain. And that even Black people think that Black people don't experience pain as much as other people. We've absorbed some of this. It's a classic version of the colonized mind.

MG And this is across all systems. There are studies like this that you could look at—at every step of criminal justice, or every step of law. You can look at every step of education outcomes, every step of housing, every step of infrastructure, and you'll see these kinds of disparities. Some are quite subtle, like this observation about perceptions of pain. And there are so many of them that it's really overwhelming.
 But I guess I think about *The Waiting Room* and the project you did where you created a provisional medical space [*Free People's Medical Clinic*]. You've done a couple of projects creating social space that could allow for care of Black people. And you've talked about the medical waiting room where someone waits and waits and waits with no care, and that's an image of an empty space with a voided body in it. This seems so different to me from these giant, full figures you're making now, like those in the Venice Biennale—these bodies have such integrity, such wholeness, such stability.

SL Solid. That's something I have in common with Lorraine, where I've had to participate in the art world in different ways, just for survival. And for many years, no one wanted to support me making sculpture. Actually, the way I met you, Malik, is I had to figure out a way to describe my research to make sculpture as being something that sounded a little bit more social practice-y.

LOG Strategic.

SL It was completely strategic. And Rashida [Bumbray] had offered me an opportunity to work with Creative Time, which was a really big deal. I hadn't had that kind of visibility previously in my career. I was doing okay, but it was huge for me to get that project. And I thought, well, if I were going to make social sculpture, what would it be? It would definitely have to revolve around Black women's labor, and I started

from there. But I don't think I would've done the project at all had someone been happy to support my own work in sculpture. In retrospect, though, I'm glad that I had to make these excursions, and I have never regretted doing these projects. They always made my work better.

LOG It's funny, the relationship between one's more personal, individual art and social practice. There's always such a difference of the mind-heart relationship to these things. The involvement in social sculpture with social practice, I think it's unavoidably intellectual and there's the feeling that people are looking over your shoulder, that sort of thing. And I'm finding that in order to stay sane, I have to develop, and I haven't done it yet, but I have to develop some kind of theorizing around the importance of individuality—not individualism, but individuality, and the relationship of that to the community.

Because you're plumbing your individual. . .

SL Self-thought.

LOG Self, exactly, thoughts, whatever. That doesn't mean that you're not connected to the community. It just means that this is the way you feel you're going to get the best you have to give to the community.

There's such a "groupthink" among certain sectors of the population, and the idea has set in that somehow this is a higher form of art-making at the moment. We have to not be afraid to stand up for our individual concerns and how that's going to enrich the community in ways it doesn't know yet.

MG Perhaps we're using the term "social practice" to talk about a lot of different things. Because there was a moment we all passed through—Simone, you're talking about a certain funding stream where that term was in use. But, for example, Lorraine, you and I have both worked in performance in a lot of different ways. And even when that's from a committed individual vision, that's social, from beginning to end.

We obviously have three very different practices and ways of living in a world of art. But one thing the three of us have in common is a really careful attention to how to create an audience for our work, or awareness of who the audience is for our work. Or even, as you've talked about a lot, Simone, making work that is for the audience that you want, not for a presumed art audience. And that too is social. And of course I, the performer and performance studies scholar, tend to lose sight of a distinction between the individual and the social. But the idea of social practice as a discipline so often falls short.

SL I've always admired you and My Barbarian [Malik Gaines, Jade Gordon, and Alexandro Segade] for your fearlessness (fig. 1). I thought that there were no artists more exciting at the time than My Barbarian. Your centrality in art discourse was crystal clear. When I met you, Malik, I remember the shock of realizing that performance isn't well supported in the art world. And I feel like this is still such a big thing in the art world, where there's just adoration of performance and whatever we want to call it, social practice works, but no real material support for that work.

Fig. 2 *London/LA LAB: We'll think of a title after we meet,* curated by Suzanne Lacy and Susan Hiller. Franklin Furnace, New York, 1981

Fig. 3 A.R.M., *Out of Line: Blood Fountain*, performance at The High Line,
New York, August 14–15, 2019

Fig. 4 A.R.M., *Out of Line: Blood Fountain*, performance at The High Line,
New York, August 14–15, 2019

LOG Listen, in the early '80s, Martha Wilson and Franklin Furnace did the first ever gathering of performance artists. Maybe thirty or forty artists from Los Angeles and thirty or forty from London. It was called "London/Los Angeles" (fig. 2). I think there was more talking about performance than there was any doing of performance in this thing. It had more of a symposium feel, but with everybody sitting around on the floor. Somebody asked, "Well, how come we don't hear of any other Black performance artists?"

I was the only Black performance artist in the room. I wasn't even from Los Angeles or London, but I was there. And I found myself just telling the truth: What Black artist would spend money to make their work? There's no chance of making back any of the money. First of all, who even had the money to spend? I wouldn't be able to be a performance artist if I hadn't had some crazy money that came at that moment—somebody must have died recently and left something and so now I could make a performance. The economics of it were so forbidding that I couldn't imagine Black people doing what I did, which was to identify solely as a performance artist.

There were other Black people making performance, but only once in a while and mostly it wasn't something that they focused on. It was part of a painting career or a sculpture career or something else. I was the only one who was saying, this is what I am, a performance artist. And because of the whole money thing, it seemed awfully elitist.

It wasn't that the work itself was elitist. . .

SL Ironically, yes.

LOG But I was more constrained by the fact that there weren't many ways of being an artist that were open to me, given my skill set, so I had to do this. And I knew I could do it well, and I knew I could find stuff in it that would be worth bringing to the art world as a whole, even though the art world didn't think too much of it.

SL Lorraine, I'm concerned about asking you this because I feel that recently, with a lot of interviews I've been in, the point of the interview is, "How did you get to be like yourself?" And I don't know how to answer the question. I don't want to ask you that question. What I do want to ask is: Where do you think the confidence or the conviction came from? Besides the fact that we're Jamaican.

LOG I know. Being Jamaican is a big one. When I'm being honest in answering that question, I have to say, from the time I was a little child, I could look around whatever situation I was in, like my almost all-white third-grade classroom, and even though you're always getting these messages about how you're inferior, these messages made absolutely no sense to me. Because I would look around and I would say, there isn't anybody here who's smarter than me. There isn't anybody here who's cuter than me. And then I would go out into the bigger world, like my seventh-grade classroom at Girls Latin, and I would still find the same thing. Even when I found somebody who was smarter, they weren't as cute. Or if they were cuter, they weren't as smart.

I felt pretty special from the get-go. And I did not understand how anybody could look down on me. I really couldn't. And I never have learned how they felt that they could look down on me, except for some sort of group insanity. What I'm

trying to say, in the humblest possible way, but there's no way to be humble about it, is that when I looked at the reality of what I felt I was in comparison to the way everything around me was sort of trying to stuff me into some little pigeonhole, it made no sense. And so I always felt superior to the culture I was living in. I guess that's a sad way of saying that's how I got my agency.

SL Well, it's also a sad way of saying that you were born in the '30s in Boston. That's quite a culture to emerge in.

LOG My parents immigrated to the States one year apart—my mother in 1917 and my father in 1918. My mother was the only person in the entire family who came legally through Ellis Island. Everybody else came in through Canada. That's what they did. Get on a boat from the Islands, go up to Canada, and just walk over. Sometime after they were both there in Boston, my father went to see my uncle bowl in a cricket match. In the late teens, there was a very large immigration from all of the British Empire—Australia, New Zealand, Canada, wherever. And also from the Islands. So there was actually a cricket league with eighteen teams in New England, and my uncle was part of something called the British West Indies Cricket Club. He was really good. And my father had come to see him and then met my mother at the tea table.

 I recently did this article that was basically a comparison between my father as a Black immigrant in Boston and Thomas McKeller, who was John Singer Sargent's model, who had immigrated to Boston from South Carolina. When I started to write out what they had in common, you had to ask yourself, "How did they function in a place like Boston?" They had come from a majority Black situation—one from segregation in the American South and one from Jamaica, which was 96 percent Black or brown. That's a big percentage, and palm trees everywhere.

SL My father came to the United States from Jamaica when he was already thirty-three. And he was just too old to accept American racism. He thought it was a joke. He thought he was on Mars. The idea that someone would consider him inferior was so preposterous to him. I feel like it really did affect us as children because he just couldn't take American racism seriously. And it was incredibly useful for me, I have to say; it protected me my whole life.

 Malik, as a Black American artist in performance, did you feel protected and supported?

MG My Barbarian recently had a well-supported survey exhibition [at the Whitney Museum of American Art], with access to curatorial funds that we wouldn't have had much earlier in our career. And it was really interesting to see what happens when you're in the more powerful channel of the museum, what can get done. And then you realize that performance can be the most expensive thing to show. You're not just putting something on a wall. You have to coordinate a lot of different departments and materials and time and space, and that takes a lot of care.

 But of course the work itself was created with an expectation of "this is in the moment, this is ideologically inexpensive." It wouldn't necessarily have to be preserved in the way that fancy commodities are. But it was still very gratifying

to get that exhibition done. And, of course, to commit to performance art in that way, and as a collective, we relied on doing multiple things, including being professors, which wasn't a desperate calculation, but just a normal part of the kind of discursive work we do. This inventiveness and flexibility have followed us into all of our own mature work and allow us each to keep developing. For example, I'm now bringing this more provisional energy into working on operas.

Also, my parents are artists. So I wasn't raised with an idea that it was bad planning to be precarious and creative; I was raised in a place where that was really valued. I also was aware that you have to invent your own way to do that.

I've interviewed Lorraine a couple of times, trying to understand some of this kind of inventiveness. Simone, you said something about how in interviews you get questions about how you became who you are. And I also heard Lorraine saying something about pigeonholing expectations. So I'm thinking of you, Simone, in your current prominence, doing interviews and profiles with major reach, beyond our familiar communities of artists and thinkers, and wondering what expectations they come at you with and how you're negotiating those.

SL Doing magazine articles has been very traumatic for me. I don't enjoy them at all. I don't like to be in front of the work. I like all the visibility to be about the work. Often I've encountered journalists who haven't been willing to give me final edit. They're interested in what I said, not in what I meant to say. Over time, it's become clear that these articles don't add value.

Until recently, the question of what to say no to, what not to say no to, was always fraught and difficult. I have been raising a girl for most of the time I've been an artist in New York. And also, until 2010, working almost full time. Right now, I feel comfortable saying no to everything and just focusing on my health. But that certainty started in just the last two years.

Malik, to answer your question about expectations that come with press interviews, they haven't been an effective way to reach new audiences.

MG Before I saw your incredible pavilion in Venice, I had asked a leading figure in our field, someone I had run into in Harlem, how it was, and they told me it's incredible, it's beautiful, it's wonderful. And I was like, "Do people get it?" And they were like, "I don't know if they *get* it." You've talked a lot about making work for Black people, for Black women. And now there's this other audience.

SL I love that you said in the beginning that one of the things the three of us have in common is a lot of intentionality around the audience, cultivating one. I think it was in 2004 and a friend of mine was telling me the different things I needed to do to get my work more visibility. I hadn't gone to grad school. And she said, "You need, at a certain point, to just accept that you have a white audience and then move forward."

LOG Oh yeah.

SL She was trying to encourage me to just grow up and understand this is what it is. "And then," she said, "you'll be able to be a lot more comfortable and move more forward in your work because you're clear." And I felt myself digging in my heels in

that moment. I thought, "I'm not doing this to have a white audience. It cannot be that way."

I don't know why it was so outrageous for me to just want to make work about myself for myself, for my own community. And I made the decision to talk about it. I don't know why it was considered such a bold thing to do, but I'm glad I made that decision to talk about it because I feel like it did get me here. It went out like a call, and many of my current interlocutors responded to that statement—that my primary audience is Black women—because they had like-minded feelings. In the end, they helped create the audience I wanted.

LOG About thirty years ago the culture was seriously dominated by discussions around Black artists choosing to make work for Black people. When Toni Morrison and a few other Black women writers began to become well known and well published, and there was nothing but a cadre of established white reviewers, they almost went to war with each other. So many white men were saying to Toni Morrison that she must have white characters in her novels. She must address this point of view, blah, blah, blah. But she chose to fight. Everywhere she went, whatever print interview or television interview or radio interview she did, she made no bones about fighting and she was not going to give an inch. And the worst of it is that the biggest fight came after she had already won the biggest prizes. This big thing about why she must make art for white people as well as Black people really began after she won the Nobel Prize [in 1993]. So thirty years later for you to be having the same discussion . . .

SL Oh, I think it'll go on forever.

I always knew that I could tie my work to a white philosopher and use different materials and be a much more successful artist. What was insulting to me is I felt that people thought I was making the work I was making because I didn't get the memo. They didn't believe that I was doing it with intention.

LOG I had a strange experience, which is almost the opposite. I always thought that my audience was going to be white. I mean, on the simplest level, it's kind of weird to me, but I have a vocabulary that is almost impossible to acquire in today's age. And so I always thought that I was rarefied despite my Bohemian lifestyle or whatever. So I always pitched my audience at the Black girls I knew socially, the ones I had been in teenage clubs with or went to Wellesley with or whatever, that group of Black people. I had no idea that the Black audience was going to expand to such a degree that there would be so many types of Black women and men; they might not have things to say to each other socially, but they would all need me.

I was sitting in one of those outdoor café places on Tenth Avenue the other day. And some Black people came up. I was the only Black person at a table of maybe twenty white people. It was a Hauser & Wirth event for a friend of mine. And these Black people came up and they asked, "Are you Lorraine O'Grady?" That's unnerving. And then they just said, "Thank you. Thank you for your work."

SL So lovely.

LOG This is one of the most wonderful things that's happened to me, but it's also the most unexpected.

MG When I was writing about Nina Simone, I was asked to consider the idea of the prophetic—is this work prophetic because it speaks to a future generation? And because I'm not really attached to a religious tradition, that's not exactly my favorite word. But I think it describes some artists like you, Lorraine, who might have had a certain audience at the time of making each piece, and as time passes there's a clarity and intention that really reaches someone else, that predicts something else and becomes important in another way. And that story reminds me of that.

And I'm thinking of a time when I was working with A.R.M. [collaborative group composed of Alexandro Segade, Robbie Acklen, and Malik Gaines]. We were doing a project on the High Line [*Blood Fountain*, 2019] where we constructed this elaborate fountain that was a group costume—we were enacting an AIDS anti-memorial as a performance, wrapped in tubes that shot red liquid everywhere to represent blood (figs. 3, 4). It was complicated to install.

And it was at the same time that *Brick House* was installed on the same platform. We had to close that platform for our rehearsals. The whole time I was so worried that a busload of aunties was going to show up to see your work and the platform would be closed because I'm doing my outrageous queer performance piece. At one point a woman came up with her grandmother and they were told that the platform was closed, and I was like, "No, no, no!" I ran over there and escorted them around like a docent so they could spend some time with *Brick House*. Later that night, that Trump-y real-estate guy who developed the hideous Hudson Yards and all of that, he showed up with his henchman because they wanted to survey their real-estate empire from that same platform. They were very angry that we would not let them enter. But sorry, *Brick House* said "no."

So there is some difference between this whiter audience and this other audience. But Lorraine, you've made work about miscegenation. You've made work about interraciality. You've made a lot of work on this edge that feels difficult today. The work of My Barbarian—in which I'm Black and the others aren't, nobody is the same thing and everyone is more than one thing—is about differences, about queerness, about multiplicity. And it came out of a time [early 2000s] when we maybe had a utopian idea that you could create that as an audience too. Which is harder than it sounds.

LOG I don't know how you determine which audience is going to come and which audience is going to stay. That's the thing. For instance, I would say that my audience does now tend Black, if not in numbers, the intensity of the audience is Black. I did this performance film, a one-night premiere at the Brooklyn Museum. And I'm not quite sure how people found out that it was there because I was so busy editing, I didn't have time to promote it. The audience was at least 50 percent Black, but the energy was 100 percent Black. They were the ones who got up at the end and asked all the questions. And there was something about what they were doing and feeling that was communicating itself without language, without sound, without anything, throughout. So that two different people, one Asian and one Black, but super sophisticated, accused me of having a cult audience.

SL Oh my God.

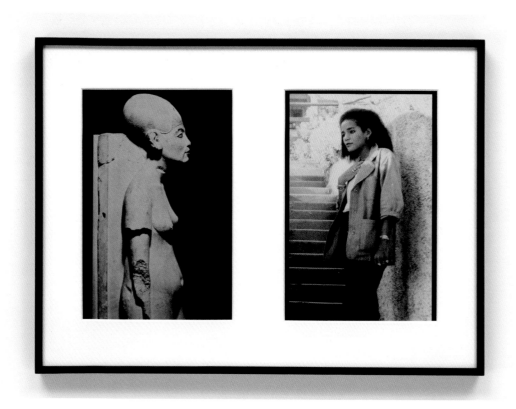

Fig. 5 Lorraine O'Grady, *A Miscegenated Family Album (A Mother's Kiss), 15. Cross-Generational (L: Nefertiti, the last image, R: Devonia's daughter Kimberley)*, 1980/1994. Cibachrome prints. 20 × 16 inches (50.8 × 40.6 cm) each

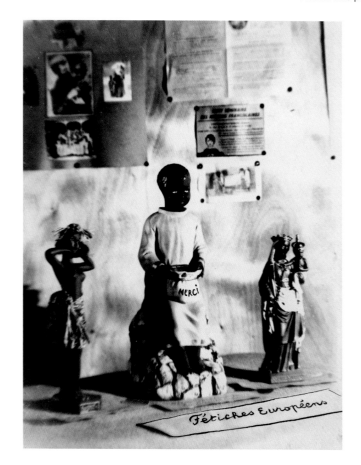

Fig. 6 Unknown photographer, *Fétiches européens*, from *Views of the exhibition La vérité sur les colonies*, 1931. Gelatin silver print. 9 1/4 × 7 inches (23.5 × 17.9 cm). Getty Research Institute, Los Angeles (2003.R.20)

LOG How could I have prepared for that? There you go. So now I am worried what people do think—that if you have too many Black people enamored of you, you must be limited or you must be something they don't need to be interested in. So we'll see how it all plays out. But it's very unexpected what's happening to me. Whereas the courage that you expressed when you said that you were making art for Black women, that still registered as courage of a very extreme and noble sort. It did. It still does. And I thought I was registering a different kind of courage, but I'm not sure that it's registering.

SL Well, I used to describe you as my mentor-after-the-fact. I feel like this about a few people, like Nancy Elizabeth Prophet. And I think it's true that many Black women feel this way about you, Lorraine, which is that even though we may not have known you were there, we are so happy you were there. We needed you to be there. And we're happy to know now that you were there. It's a relief.

LOG That's a very good word, relief. Relief to know that I was there. I don't know how solid thick this is. Whatever it is. It's just not what I was imagining.

MG So it turns out an awareness of audience is extremely complicated. Imagine these artists who just say, "I don't even know who's seeing me, I'm just doing this elemental thing."

LOG All I know is that I've always been me. There hasn't been one second when I've not been myself. So stupidly, in many ways, I've been myself, to put it mildly. At least even if they don't understand me at the level of the stuff that I think I may be putting into the work, they are getting something that's really true. At least I think so.

SL Do either of you feel that you're like a Hilma af Klint, that your audience will be one hundred years from now?

MG If those media formats hold up! Not in the way your bronzes will still be around one hundred years from now, but perhaps. But in terms of creating an audience, I've noticed Black artists in this last period really carefully try to make Black spaces, Black performances. And that's super interesting and different from the kind of *Miscegenated Family Album* work that Lorraine has brought to us (fig. 5), or My Barbarian's dispersals. And I feel like this is a flow that we all continuously go through, how to deal with this space of representation, because nothing ever quite solves it.

LOG It's so funny because there's something going on at this moment, this whole business of Queen Elizabeth's funeral. And the way in which these people who had an empire that owned literally a third of the earth, that they are so unselfconscious and so totally unaware that they're putting this stupidity on a thousand screens going out to the rest of the world.

MG My family had the TV on this morning, with nonstop coverage of the Queen's corpse being schlepped around the English countryside. This is literally sovereignty, which is the title you used for your Venice pavilion, Simone. And if you dig

into that concept, if you're reading through the European literature where that term comes up, there's already a monarch at the head of that philosophical idea. The power to administer violence and the power over life and death, including to kill with impunity, that's what a king does, that's what sovereignty is. Sorting out who is enslavable and who isn't is also bound up in what developed as an idea of sovereignty. Sovereignty takes on other meanings when it comes to Indigenous nations under settler colonialism in the Americas. But then we sometimes talk about sovereignty as just being able to control our own bodies. And Lorraine, when you say, "I was always me," that's the most glorious form of sovereignty. So how did you come to place this term in a relationship to your figures, Simone?

SL Well, I originally had titled the exhibition *Grittin*, which is a kind of posture in African American culture. I started seeing a lot of African American performance showing up in fashion shows; I think maybe Beyoncé started this. And I saw these women performing who were in a sorority and really grimacing at each other, but it was a kind of protective stance, and they called it grittin. And then within three weeks, I realized I was going to have to be talking about this all. It was going to take me fifteen minutes to explain what the title was. So I gave up on *Grittin*.

I also noticed that people immediately seized on an idea that I was representing Black women who were angry, which people will never let go of. So it just felt like it was an idea that was going nowhere. But I did want to talk about self-determination. I like that Toni Morrison uses the expression "self-regard." It is a technology that has been developed over many centuries by people in the Black diaspora to fight oppression. And it's come up several times in this conversation about how we feel about our ourselves and how we imagine ourselves.

And while I was really happy when Hortense Spillers wrote her piece ["Mama's Baby, Papa's Maybe: An American Grammar Book"] refuting the 1965 Moynihan Report, I feel like this pride and self-regard that Black women have are often used against us and read as masculine or emasculating, as not feminine, as ugly. And I just want to celebrate these wonderful qualities that Black women have developed, qualities of self-protection. And everywhere I go, I see these same qualities. I just wanted to speak to that.

MG It's an incredible exhibition of course. But the only reason I even think of the European philosophical question is because of the architectural move that you made in costuming this Enlightenment, Jeffersonian building in African material that just covers it up. It's gone.

SL I knew that I didn't want to respond to the extremely problematic architecture or be in discourse with it in any way. I feel very proud to have just sidestepped it entirely and changed the subject. *Façade* is one of the more important pieces in the show for me. Also, I returned to the 1931 Paris Exposition, which was a crucible in the 1930s and brought the idea of the hut into the metropole. Not only was it a human zoo, it was a re-creation of the colonies while the colonial project was still happening. But the resistance these exhibitions spurred affected everything. The surrealists were protesting these kinds of events. They created a show in response called *The Truth about the Colonies* (fig. 6). Suzanne and Aimé Césaire were a part of that. Négritude was being formed. Josephine Baker and these huts were creating the fuel that

346

Fig. 7 Lorraine O'Grady, *Greetings and Theses* (still), 2022. Video (color, sound; duration variable)

modernism would use for it seems like an eternity. I felt great to be able to point back to the specific context of the building of the pavilion but also to obfuscate that history. To change the subject. In the show, an image that has similar layers of significance is re-created and later in the show it is destroyed. This feels right.

This is the first exhibition that left me feeling accomplished. Normally I wake up and go on to the next. But this time I feel strangely finished. I am taking a year off to focus on my health. Do you feel that way now, Malik, having done the survey at the Whitney, which felt like the necessary canonization of My Barbarian?

MG I was giving a talk yesterday and I was like, "I have three incredibly busy years planned, and then I'm going to take a nap." And I look at artists like Lorraine and others, and they don't seem to operate that way. They just work and work. I saw Grace Jones perform recently, and what a blessing to be able to hula-hoop to "Slave to the Rhythm" forty years later. And so I wonder if there will be a generational shift around that, a need to slow down, or if we're just going to keep working anyway.

LOG Well, I just came off of showing a video called *Greetings and Theses* at the Brooklyn Museum. It's still a work-in-progress, but it's also the first time I've made art in real time (fig. 7). All the art that I've been living with and talking about was made years and years and years ago. This work was being made now with an audience that was present and expecting and expectant. It was in the present tense, and I was in the present tense. And I don't know very much. I can't say very much about what the new work has accomplished or what it is or how good it is or not. All I know is that it felt like, oh, so this is who I am. Okay. That's who I am.

It wasn't like I was constructing myself, it was that I was being myself. So I'm feeling very interested and I guess you could say eager to see how it turns out. But I also have to do so much other work that I can't be fully eager, because I have to think about how I have to get ready to die at the same time I'm getting ready to make new work. But I feel as curious about it as anybody else would feel. "What's she going to do next?" I have no clue. Maybe that's what many artists do. They don't have a clue, they just move. I like that feeling. It's freeing. It's freeing.

SL I just need another few months in the wicker chair.

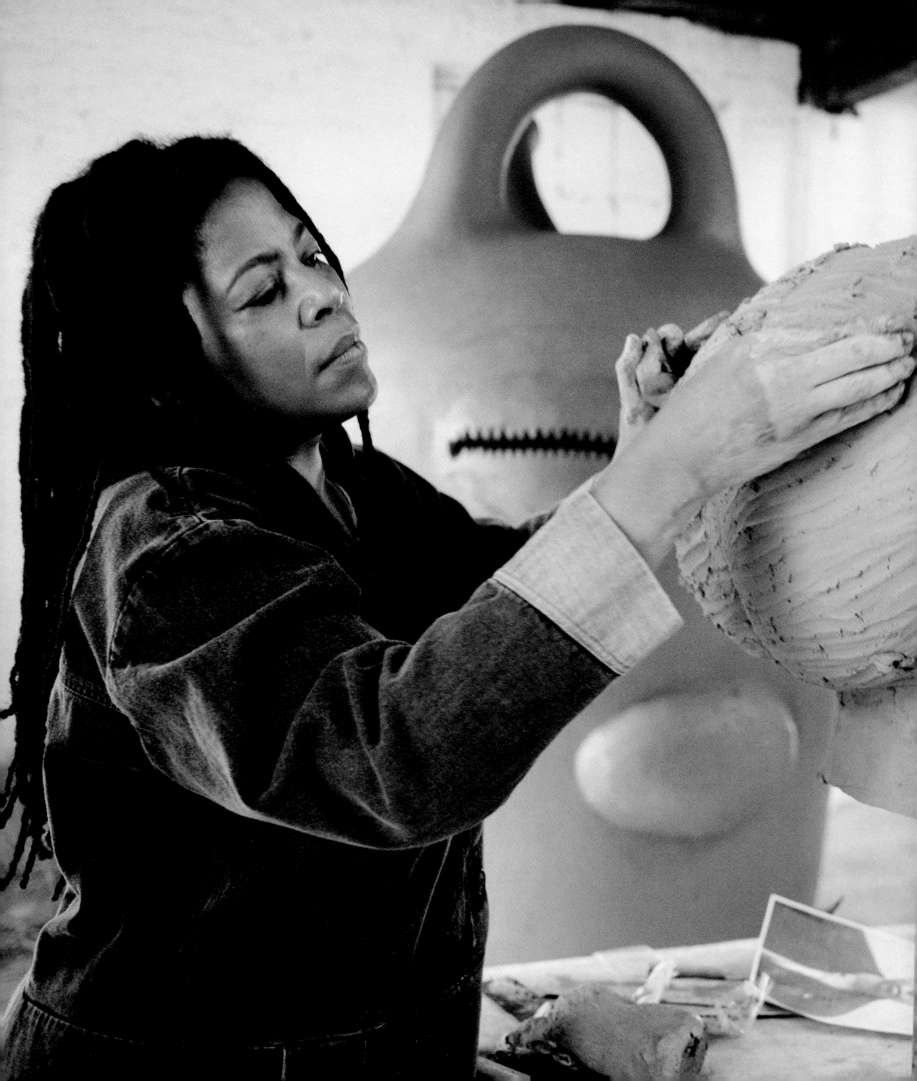

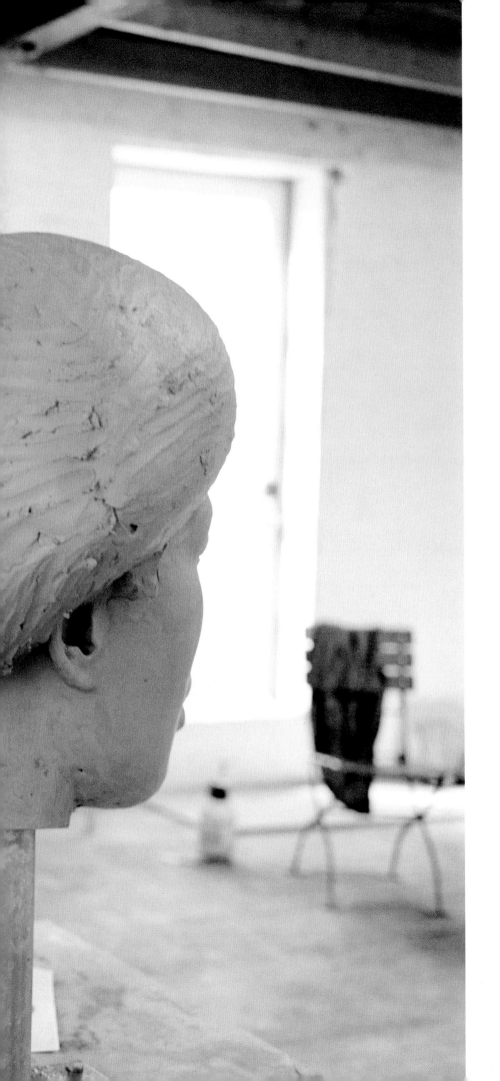

Simone Leigh sculpting *Sharifa* (2022), 2021

All artworks are by Simone Leigh (b. 1967 in Chicago), and courtesy the artist and Matthew Marks Gallery, unless otherwise noted. This checklist reflects the exhibition at the Institute of Contemporary Art/Boston.

White Teeth (For Ota Benga)
2001–4
porcelain, steel, glass, and wire
approximately 84 × 120 × 12 inches
(213.4 × 304.8 × 30.5 cm)
Collection of Sherry Brewer Bronfman,
New York
pp. 60–61

Liz Magic Laser and Simone Leigh, in
collaboration with Alicia Hall Moran
Breakdown
2011
single-channel video (color, sound; 9:00
minutes)
pp. 88–89

Girl (Chitra Ganesh + Simone Leigh)
my dreams, my works, must wait till after hell . . .
2011
single-channel video (color, sound; 7:14
minutes)
pp. 92–93

Overburdened with Significance
2011
porcelain, terracotta, and graphite
22 × 8 × 14 inches (55.9 × 20.3 × 25.6 cm)
Bridgitt and Bruce Evans
p. 120

Cowrie (Pannier)
2015
terracotta, porcelain, and steel
58 × 54 × 32 inches (147.3 × 137.2 ×
81.3 cm)
Collection of Jonathan and Margot Davis
p. 129

Head with Cobalt
2018
porcelain
15 × 7 × 11 3/4 inches (38.1 × 17.8 ×
29.8 cm)
Warren and Maxine Eisenberg
p. 169

102 (Face Jug Series)
2018
stoneware
12 1/2 × 7 × 9 inches (31.8 × 17.8 ×
22.9 cm)
Private collection, Boston
p. 155

Cupboard IX
2019
stoneware, raffia, and steel armature
78 × 60 × 80 inches (198.1 × 152.4 ×
203.2 cm)
Institute of Contemporary Art/Boston.
Acquired through the generosity of Bridgitt
and Bruce Evans and Fotene Demoulas and
Tom Coté
p. 158

Jug
2019
bronze
83 1/4 × 51 1/2 × 51 1/2 inches (211.5 ×
130.8 × 130.8 cm)
Collection of Charlotte and Herbert S.
Wagner III
p. 220

Sentinel
2019
bronze and raffia
71 1/2 × 72 × 42 inches (181.6 × 182.9 ×
106.7 cm)
Private collection, Boston
p. 223

Martinique
2020
stoneware
59 1/2 × 50 1/4 × 41 1/2 inches (151.1 ×
127.6 × 105.4 cm)
p. 12

No Face (House)
2020
terracotta, porcelain, cobalt, India ink,
epoxy, and raffia
29 × 24 × 24 inches (73.7 × 61 × 61 cm)
Bridgitt and Bruce Evans
p. 157

Sentinel IV
2020
bronze
128 × 25 × 15 inches (325.1 × 63.5 ×
38.1 cm)

Anonymous
2022
stoneware
72 1/2 × 53 1/2 × 43 1/4 inches (184.2 ×
135.9 × 109.9 cm)
Private collection, Boston
p. 259

Breeze Box
2022
stoneware
37 1/2 × 26 × 23 3/4 inches (95.3 × 66 ×
60.3 cm)

Simone Leigh and Madeleine Hunt-Ehrlich
Conspiracy
2022
16mm and 8mm film (black-and-white,
sound; 24:00 minutes)
pp. 270–71

Cupboard
2022
stoneware, raffia, and steel armature
135 1/2 × 124 × 124 inches (344.1 × 315 ×
315 cm)
Glenstone Museum, Potomac, Maryland
p. 285

Cupboard
2022
bronze and gold
88 1/2 × 85 × 45 inches (225 × 216 × 114.3 cm)
pp. 294–95

Jug
2022
stoneware
62 1/2 × 40 3/4 × 45 3/4 inches (158 × 103.5 × 116.2 cm)
Institute of Contemporary Art/Boston. Acquired through the generosity of Susana and Clark Bernard, Adelle Chang and Eddie Yoon, the Miller-Coblentz Family, Grace Colby, Fotene Demoulas and Tom Coté, Mathieu O. Gaulin, Jessica Knez and Nicolas Dulac, Christine and John Maraganore, and the Acquisitions Circle
p. 263

Last Garment
2022
bronze, steel, metal, filtration pump, and water
54 × 58 × 27 inches (137.2 × 147.3 × 68.6 cm) (sculpture); dimensions variable (pool)
p. 255

Martinique
2022
stoneware
60 3/4 × 41 1/4 × 39 3/4 inches (154.3 × 104.8 × 101 cm)
p. 288

Satellite
2022
bronze
24 feet × 10 feet × 7 feet 7 inches (7.3 × 3 × 2.3 m)
pp. 250–51

Sharifa
2022
bronze
111 1/2 × 40 3/4 × 40 1/2 inches (283.2 × 103.5 × 102.9 cm)
p. 272

Sphinx
2022
stoneware
31 1/2 × 56 1/2 × 37 3/4 inches (80 × 143.5 × 95.9 cm)

Sphinx
2022
stoneware
29 3/4 × 56 3/4 × 35 inches (75.6 × 144.1 × 88.9 cm)
Glenstone Museum, Potomac, Maryland
p. 279

Dunham
2023
bronze
64 × 47 × 41 inches (162.6 × 119.4 × 104.1 cm)

Slipcover
2006/2023
porcelain, steel, and plastic slipcover
33 1/2 × 24 1/2 × 7 inches (85.1 × 62.2 × 17.8 cm)

Untitled
2023
stoneware
24 × 11 × 13 inches (61 × 27.9 × 33 cm)

Village Series
2023
stoneware
approximately 55 × 47 1/2 × 47 1/2 inches (139.7 × 120.7 × 120.7 cm)

My first and foremost thanks go to Simone Leigh, for the gift of her work. The richness and complexity of ideas, beauty, and artistry in Simone's art are unparalleled and have provided me, and everyone on this project, with never-ending inspiration. It has been a great honor to bring this important exhibition and publication to fruition.

This exhibition and book are the result of the hard work and assistance of many dedicated and talented people, both within and outside of the ICA. I extend my heartfelt appreciation to Jill Medvedow, Ellen Matilda Poss Director, for championing this project from the beginning, and to the ICA's devoted and fearless Board of Trustees for their continuous support of our activities. Also deserving of my deep gratitude are the numerous supporters of this project, from the presentation of *Simone Leigh: Sovereignty* at the U.S. Pavilion for the 59th International Art Exhibition of La Biennale di Venezia, presented in partnership with the Bureau of Educational and Cultural Affairs of the U.S. Department of State and with the collaboration of the Peggy Guggenheim Collection, Venice, and the Solomon R. Guggenheim Foundation, New York, to the realization of this exhibition at the ICA and its U.S. tour. I join Jill Medvedow in gratefully acknowledging the many philanthropic partners (listed on pages 357) for their magnificent support of this presentation, as well as the lenders to the exhibition (listed on page 357), who are willing to share their works with a larger audience.

I am grateful to my colleagues at the Hirshhorn Museum and Sculpture Garden, Smithsonian Institution, Washington, DC; the California African American Museum, Los Angeles; and the Los Angeles County Museum of Art for recognizing the importance of this project in early support of the exhibition tour. My thanks go to our partners at all three institutions: at the Hirshhorn, Melissa Chiu, director; Evelyn C. Hankins, head curator; and Anne Reeve, associate curator. At CAAM, Cameron Shaw, executive director; Isabelle Lutterodt, deputy director; and Taylor Renee Aldridge, visual arts curator and program manager. At LACMA, Michael Govan, CEO and Wallis Annenberg Director; Rita Gonzalez, Terri and Michael Smooke Curator and Department Head, Contemporary Art; and Naima J. Keith, vice president of education and public programs.

A stellar group of writers and thinkers contributed to this book, and I am sincerely grateful for their insightful essays as well as the enormous influence of their work and collaboration with the artist: Vanessa Agard-Jones, Rizvana Bradley, Dionne Brand, Denise Ferreira da Silva, Malik Gaines, Saidiya Hartman, Daniella Rose King, Jessica Lynne, Nomaduma Masilela, Katherine McKittrick, Uri McMillan, Sequoia Miller, Steven Nelson, Tavia Nyong'o, Lorraine O'Grady, Rianna Jade Parker, Yasmina Price, Sharifa Rhodes-Pitts, Christina Sharpe, and Hortense J. Spillers.

Enormous thanks are due to Anni A. Pullagura, assistant curator, for her superb coordination of the book's many details and her assistance in every aspect of the organization of this exhibition. I warmly acknowledge Jeffrey De Blois, associate curator and publications manager, for his managing supervision of this volume, which I hope will be a resource for many years to come. Tessa Bachi Haas, curatorial fellow, and Chenoa Baker, former museum fellow, provided much-appreciated research, support, and

contributions to the project. Several individuals offered feedback on my essay, and I thank them for their time and care: Rashida Bumbray, Jacob Dyrenforth, Ruth Erickson, Jill Medvedow, Jenelle Porter, Anni A. Pullagura, and Gloria Sutton. I am deeply appreciative of our text editor Michelle Piranio, who worked tirelessly to make a coherent and fluid book. My praise and thanks go to Nontsikelelo Mutiti for her elegant graphic design and artistic vision, with the support of Ryan Diaz and NMutiti Studio. The ICA is very fortunate to have a copublisher in DelMonico Books, and I extend my thanks to Mary DelMonico and Karen Farquhar for their partnership.

My heartfelt gratitude goes to the supremely capable and outstanding team at the artist's studio, who worked industriously with the ICA to help realize the many aspects of the exhibition, especially Rebecca Adib, studio director, and Katherine Driscoll, archivist. The Venice project would not have been possible without the contributions of Sinfonia Group and Susan Thompson, formerly with the Leigh studio. I am also grateful for the valuable work of those who represent and work closely with the artist at Matthew Marks Gallery, including Matthew Marks, owner; Jacqueline Tran, senior director; Alex Fang, associate director; and Sean Ryan, head preparator.

The organization and presentation of the exhibition benefited from the commitment and expertise of all staff at the ICA. My sincere appreciation goes to: Liz Adrian, director of retail; John Andress, Bill T. Jones Director/Curator of Performing Arts; Liv Biel, exhibitions coordinator; Brianne Chapelle, curatorial department coordinator; Zelana Davis, former exhibitions coordinator; Megan Des Jardins, associate registrar; Katrina Foster, director of development; Karin France, director of institutional giving; Monica Garza, Charlotte Wagner Director of Education; Betsy Gibbons, director of teen programs; Kelly Gifford, deputy director of public engagement and planning; Alison J. Hatcher, senior registrar; Kate Herlihy, director of exhibitions; Fabienne F. Keck, former curatorial department coordinator; Whitney Leese, chief of staff and governance; Margaux Leonard, former public relations manager; Magali Maiza, financial consultant, Venice project; Toru Nakanishi, preparator; Savanna Nelson, registration assistant; Abigail Newbold, former director of exhibitions; Tim Obetz, chief preparator; Kay Moriarty O'Dwyer, director of individual giving; Colette Randall, chief communication and marketing officer; Angela Torchio, principal designer; Natasa Vucetic, chief financial and operating officer; Kris Wilton, director of creative content and digital engagement; and the ICA's installation team.

Finally, I could not carry out my work without the incredible support of my family: Jacob and Skye. I am indebted to them for their encouragement and love throughout this project.

Eva Respini
Deputy Director for Curatorial Affairs
and Barbara Lee Chief Curator

CONTRIBUTORS

VANESSA AGARD-JONES is assistant professor of anthropology at Columbia University, New York.

RIZVANA BRADLEY is assistant professor of film and media at the University of California at Berkeley.

DIONNE BRAND is a renowned poet, novelist, and essayist, and recipient of the Windham Campbell Prize; she is editorial director of Alchemy by Knopf Canada.

DENISE FERREIRA DA SILVA is professor at the Social Justice Institute-GRSJ at the University of British Columbia, Vancouver, and adjunct professor in art, design, and architecture at Monash University, Melbourne.

MALIK GAINES is an artist and associate professor of visual arts at the University of California San Diego.

SAIDIYA HARTMAN is University Professor at Columbia University, New York.

DANIELLA ROSE KING is a writer and adjunct curator, Caribbean Diasporic Art at the Hyundai Tate Research Centre: Transnational, Tate Modern, London.

JESSICA LYNNE is a writer and art critic, and a founding editor of *ARTS.BLACK*, an online journal of art criticism from Black perspectives.

NOMADUMA MASILELA is an artist, curator, and writer.

KATHERINE MCKITTRICK is Canada Research Chair and professor of Black studies and gender studies at Queen's University in Kingston, Ontario.

URI MCMILLAN is a writer, art historian, and associate professor of English and gender studies at the University of California, Los Angeles.

SEQUOIA MILLER is chief curator and deputy director at the Gardiner Museum of Ceramic Art, Toronto.

STEVEN NELSON is dean of the Center for Advanced Study in the Visual Arts at the National Gallery of Art, Washington, DC.

TAVIA NYONG'O is chair and professor of theater and performance studies and professor of American studies and African American studies at Yale University, New Haven.

LORRAINE O'GRADY is an artist as well as a cultural and institutional critic.

RIANNA JADE PARKER is a writer, historian, and curator based in South London and Kingston, and a contributing editor of *Frieze* magazine.

YASMINA PRICE is a writer, programmer, and Ph.D. candidate at Yale University, New Haven.

ANNI A. PULLAGURA is assistant curator at the Institute of Contemporary Art/ Boston.

EVA RESPINI is deputy director for curatorial affairs and Barbara Lee Chief Curator at the Institute of Contemporary Art/Boston and co-commissioner and curator of *Simone Leigh: Sovereignty* for the U.S. Pavilion at the 59th International Art Exhibition of La Biennale di Venezia.

SHARIFA RHODES-PITTS is assistant professor of writing at Pratt Institute, New York.

CHRISTINA SHARPE is a writer, professor, and Tier 1 Canada Research Chair in Black studies in the Humanities at York University, Toronto.

HORTENSE J. SPILLERS is professor of English, emerita, and Gertrude Conaway Vanderbilt Chair, emerita, at Vanderbilt University, Nashville.

LENDERS TO THE EXHIBITION

Collection of Sherry Brewer Bronfman, New York
Collection of Jonathan and Margot Davis
Warren and Maxine Eisenberg
Bridgitt and Bruce Evans
Glenstone Museum, Potomac, Maryland
Institute of Contemporary Art/Boston
Simone Leigh, courtesy Matthew Marks Gallery
Private collection, Boston
Collection of Charlotte and Herbert S. Wagner III

SUPPORTERS

With warmest thanks, the ICA/Boston gratefully acknowledges the following philanthropic partners for their magnificent support.

Major support for *Simone Leigh* is provided by the Ford Foundation and the Mellon Foundation.

Lead corporate support is provided by eu2be.

Generous support is provided by Bloomberg Philanthropies, Paul and Catherine Buttenwieser, Girlfriend Fund, and Wagner Foundation.

TERRA HENRY LUCE FOUNDATION

Leadership gifts are provided by:
Amy and David Abrams
Stephanie Formica Connaughton and
 John Connaughton
Bridgitt and Bruce Evans
James and Audrey Foster
Agnes Gund
Jodi and Hal Hess
Hostetler/Wrigley Foundation
Barbara and Amos Hostetter
Brigette Lau Collection
Henry Luce Foundation
Kristen and Kent Lucken
Tristin and Martin Mannion
Ted Pappendick and Erica Gervais
 Pappendick
Gina and Stuart Peterson
Helen and Charles Schwab
Terra Foundation for American Art

Frankenthaler

Essential support is also provided by:
Suzanne Deal Booth
Kate and Chuck Brizius
Richard Chang
Karen and Brian Conway
Steven Corkin and Dan Maddalena
Federico Martin Castro Debernardi
Jennifer Epstein and Bill Keravuori
Esta Gordon Epstein and Robert
 Epstein
Negin and Oliver Ewald
Alison and John Ferring
Helen Frankenthaler Foundation
Glenn and Amanda Fuhrman
Vivien and Alan Hassenfeld and the
 Hassenfeld Family Foundation
Peggy J. Koenig and Family
The Holly Peterson Foundation
David and Leslie Puth
Cindy and Howard Rachofsky
Leslie Riedel and Scott Friend
Mark and Marie Schwartz
Kim Sinatra
Tobias and Kristin Welo
Lise and Jeffrey Wilks
Kelly Williams and Andrew Forsyth
Jill and Nick Woodman
Nicole Zatlyn and Jason Weiner
Marilyn Lyng and Dan O'Connell
Komal Shah and Gaurav Garg
 Foundation
Kate and Ajay Agarwal
Eunhak Bae and Robert Kwak
Jeremiah Schneider Joseph
Barbara H. Lloyd
Cynthia and John Reed
Anonymous donors

Additional support for
this publication is provided by
the Fotene Demoulas Fund
for Curatorial Research and
Publications.

358

REPRODUCTION CREDITS

Pages 9, 104, 350–51: Photos by Shaniqwa Jarvis

Pages 11, 24–29, 234, 237, 250–61, 266–69, 272–75, 286–88: Installation views, *Simone Leigh: Sovereignty,* United States Pavilion, 59th International Art Exhibition of La Biennale di Venezia, 2022. Photos by Timothy Schenck 2022

Page 12: Installation view, *Simone Leigh,* David Kordansky, Los Angeles, 2020. Photo by Elon Schoenholz

Page 17: Creative Commons BY-NC 3.0

Page 18, fig. 3: Digital Image © The Museum of Modern Art / Licensed by SCALA / Art Resource, NY

Page 18, fig. 4: Courtesy National Museum of African Art, Smithsonian Institution

Page 21, fig. 5: Courtesy Hélène Leloup

Page 21, fig. 6: Photo © 2022 Museum of Fine Arts, Boston

Pages 30–31, 44–45, 70–71, 86, 102–3, 116–17, 134–35, 148–49, 194–95, 210–11, 228–29, 249: Works in progress, 2022. Photos by Timothy Schenck 2022

Page 36: Courtesy Peggy Guggenheim Collection, Venezia (Solomon R. Guggenheim Foundation, New York)

Page 47: Pérez Art Museum Miami, museum purchase with funds provided by PAMM's Collectors Council. Image courtesy Pérez Art Museum Miami (PAMM). Photo © Oriol Tarridas Photographer 2022

Pages 48–49, 51, 53, 56–57: Installation views, *You Don't Know Where Her Mouth Has Been,* The Kitchen, New York, 2012. Courtesy The Kitchen, New York. Photos by David Allison

Page 54: Installation view, *Black in the Abstract, Part 2: Hard Edges/Soft Curves,* Contemporary Arts Museum Houston, 2014. Courtesy Contemporary Arts Museum Houston. Photo by Paul Hester

Pages 59, 60–61, 63: Installation views, *Lisa DiLillo & Simone Leigh,* Momenta Art, Brooklyn, NY, 2004. Courtesy Momenta Art

Pages 64–65: Installation view, *In Practice Projects, Summer 2009,* SculptureCenter, New York, 2009. Courtesy the artist and SculptureCenter, New York. Photo by Jason Mandella

Pages 67, 189–91: Photos by Timothy Schenck 2022

Pages 72, 203: Courtesy Hammer Museum, Los Angeles. Photos by Brian Forrest

Pages 80, 83, 142, 230, 270–71: © Simone Leigh and Madeleine Hunt-Ehrlich

Pages 88–89: © Liz Magic Laser and Simone Leigh

Pages 90–91: Image © Solomon R. Guggenheim Foundation, New York. All rights reserved. Photo by David Heald

Pages 92–93: © Girl (Chitra Ganesh + Simone Leigh)

Pages 94–95: Courtesy Atlanta Contemporary

Pages 96–97: Installation view, *Energy Charge: Connecting to Ana Mendieta,* Arizona State University Art Gallery, Tempe, 2016. Courtesy Arizona State University Art Gallery. Photo by Craig Smith

Page 106: Courtesy George R. Gardiner Museum

Page 109: Courtesy Metropolitan Museum of Art, New York

Page 112: © and courtesy the National Library of Jamaica. All rights reserved

Page 115: Photo by Joe Molinaro

Pages 119, 129, 131–33: Installation views, *Moulting,* Tilton Gallery, New York, 2015. Courtesy the artist and Tilton Gallery

Pages 120–21, 154–55, 161, 164–69: Photos by Farzad Owrang

Pages 122–23: Installation view, *Simone Leigh,* David Kordansky, Los Angeles, 2020. Courtesy David Kordansky. Photo © 2020 Jeff McLane Studio, INC

Pages 124–26: Installation views, *Crop Rotation,* Kentucky Museum of Art and Craft, Louisville, KY, 2015. Courtesy Kentucky Museum of Art and Craft

Page 139: The High Line, New York. Photo by Timothy Schenck

Page 145: Courtesy The New York Public Library Digital Collections

Page 151: Installation view, *Trigger: Gender as a Tool and a Weapon,* New Museum, New York, 2017. Courtesy New Museum, New York. Photo by Farzad Owrang

Pages 152–53: The Nelson-Atkins Museum of Art, Kansas City, MO, purchase: William Rockhill Nelson Trust through the George H. and Elizabeth O. Davis Fund. Photos by Farzad Owrang

Pages 157, 181: Photos by Dan Bradica

Page 158: Institute of Contemporary Art/Boston. Acquired through the generosity of Bridgitt and Bruce Evans and Fotene Demoulas and Tom Coté

Pages 162–63: Courtesy the artist and Luhring Augustine. Photo by Farzad Owrang

Page 171: Solomon R. Guggenheim Museum, New York, purchased with funds contributed by the International Director's Council, 2017. Photo by Ariel Williams

INDEX

Figures and images are indicated by italicized page numbers.
Titles of exhibitions and works by Simone Leigh are indexed as
main headings.

Dionne Brand

Ars diagnostic

vol. 16.001

Where is the medicine for this? The sculptor's hand is on a little pouch of blue poultice hidden in the garment, close to the chest. A pencil, some oil with a wick, but, too, the toxic details of everything—these in a bag around the waist.

100cc *Indigofera anil*
150cc *Indigofera tinctoria*
250cc columbite-tantalite
26cc vervain
160cc guaco
Bagasse-lignin
Hemicelluloses at 60 convolutions per centimetre, waxed pectins, proteins

vol. 19

This sentinel whose larynx can summon whales, and small orange-legged insects, pelagic squadrons, and green-ribbed patches of air, and lines of prehnite; whose frequency may break a seabed; whose stillness is not still; who sounds like absence; who collects the radial poisons that arrive each evening before sleep, each morning after waking; this sentinel once held the grand water of the south equatorial gyre; held her medicines, dense with eddies, branched, banded in her smooth-skinned vortices and volume.

vol. 03

We were sick from water; we were sick from air; equilibrium deserted us. What streets in these places we inhabit can trace us then, what petrol does it need, and how many kilometres of highway to take us away; we've carried this world on aggregate now; we've made enough music for what

anti-venin; packed enough clothing as nomads and visited each museum
in the Western world to send them bailiff notices. Our accountants have
arrived with the total of our bodies driven to seized machines, burned
on labour; we've calculated the cost of our brains used as engines. We've
weighed the cemeteries, the 93 billion vertebrae, the girl hung in a cell, the
one who leapt over the balcony, the 40 bullets eviscerating the boy, the
one, the iron pipe in his eyeless socket: all their sweet middays passing.
We've summed up the hemispheres' malign objectives. And we've rejected
this whole system of knowing.

vol. 1.1
What is the medicine for this?
Silence

vol. 8.9
Then, the artist must prepare her hands for weight. I will say now this
weight may be immeasurable and dynamic; may vary in volume, unpredict-
ably. In light of this our hands, our hands . . . our panic, the heat in our
lungs, so much depends . . . Then, the artist must prepare our hands for
acid. Have a bowl of vinegar ready. And, also, a thick paste of baking soda
and water. Though, these may not be enough. The skin burns, and leafs.
The incessant pathologists pace. Yet we travel with the speed of light
ahead of all our trouble.

vol. 5.2
This house reminds me of a house, the elemental house, the house of hous-
es, the house that knows breezes, and sighs to what is gone and here. The
approach that hesitates footsteps, makes them forget their eagerness. The
bell, the boiling pot indolent from grief. The paper crumpled with reasons
and justifications. The house that is not the house once it is the house. The
day this house exists it is already not a house, and we must take it as the
lost house of houses. The house that loses all houses in it. Loses the mean-
ing for house. The braid of trash and palm, *Hyperthelia dissoluta* subsides
in concessions to spectacle. We leave these things to be discovered later,

to learn again as artistry—the hands folding out the rain, the heat, the weather's cupidity, the air's petulance. The day we built these houses were the lost days, as days absent of meaning and the meaning of days. As days lost themselves to routines without purpose, with only purpose. We built a shelter. And what of that? Were we not supposed to live, to walk in and out without the satellite and camera and scope, the pincer and forceps in our eyes, the protractor scoring our foreheads and face? This soft and restful house became a wharf, an exchange, noise-filled, airless, a prison. And all its breath, its hush and ease, retreated behind our eyes, our limbs. And we turned our backs on houses, burned rosettes on our skins to remember the breeze of houses, the glimpse of houses, the flecked intimacies of rooms, the you and I of houses, the drape and gasp of windows, the morning of windows, the long look of windows, the wood of sleep and sleeplessness, the russet drag of footsteps out the door, and in. Doors hung broken, we tenderly made hinges with our tongues; we knitted steel joists from our ankles. After our insurrections they made heroic paintings of themselves 'giving' us liberty.

vol. 7200

Undoable, our inconsolability, as it should be. We undertook the diacritic writings. We used two hundred and eighty litres of blood, hourly. We sent some to the heart, we made ink with the rest. We were out of breath in our desire. We were faultless.

vol. 57.007

The last garment—the stone to be chosen, the day to be chosen, the load to be borne, the breeze to be measured, the cumulous and altocumulus movement in the high blue. The time to begin is the time when the sun is still calculating whether to make us appear; we are an afterthought, if that, in its twenty-five-day orbit, somewhere on its third or fourth dust ring. But we, we have cloth to be wounded, to be soothed, to shake out in the mercy of the sun's indifference. Between us, the sound of grackle, and mourning dove. The stone then, we choose the stone, the green, grey schist come by accident, or nothing we understand as purpose, to the middle of the river. We do not know the broken bone of the shaking world. And so, the

garment dipped and rubbed to have water be its fluid path, its relief at changing shape. And the woman, the woman given the rosettes in the hair, considers the water, considers transmutation, considers, anticipated and suspended, the bonds of hydrogen and oxygen adjacent to the day's work; considers the science of the garment, the science of the hours, the science of her arms awake to water and weight.

vol. 43.011

Inconsequential, we learned to live in the intertidal, above the water at low tide and below the water at high tide, this way we survived the interstitial, the war on us; we drained seaweed, we clung to rock, this way we resisted our enemies; we ate algae and delicious animals, this way we survived our enemies; we made shells of ourselves, we hid near *Gorgonia ventalina. Monetaria moneta* — we were soft inside like anyone, like anyone we drank salt water, like anyone we lived on living; we sieved the planet ocean with our teeth, like anyone we perished beautifully. Nacreous, organic and inorganic, we lacquered infinitesimal rosettes of our beauty.

vol. 3.08

The garments to be washed — we carried these on our hips, on our heads, in our palms, in our waterlogged hands, we became amphibious. We dressed in dresses, one to tie around our waists to keep dry for the journey home, one to receive the damage of water, one to cover our legs in the river, one to weigh us down. We examined the cut of stone, the small wells and serrated edges. There was one stone we all wanted. We came early to claim it; it was in the river's way. We trusted the water; we mistrusted the water. The thing that water does to stone, to body, to legs, to feet, to thought — the water did. It never ceased to be faithful to all of us bent to stone, sculpting garment and water and stone. The photographers were superfluous. Only the river mattered. By the end of day, we were water too; and not water; returning to being the beings we were, the finite, the worried, the children, the solid parts of the planet ocean; but also water, the liquor in our throats, the liquid in our insoluble breath.

vol. 16.1.002
What is the medicine for this? This life.
Clay, the catalyst
Our resistance to weather of all kinds
And on the other hand, bad weather anywhere
Snowstorms
And hurricanes
And you are the one washed away
Any path is a good path out of here

vol. 0.2022
Though, we lived through several epochs of crises that arrived at this one;
we lived through the economics of growth and failure, stocks and bonds
and commodity and money market instruments; and the river water be-
came poison, and the fast fashion piled up in the deserts, and the broken
ships leaked their essences on our hands, and they returned the tantalum
in pieces that flooded up to our ankles; the housing crises broke us and
the food crises broke us; and the heart attacks took us and the tear gas
took us; and the parades and poems poisoned us, and the unrecorded
violences of love songs and their electromagnetic radiation burned us.
From the rims of our satellites from January to June this year, we recorded
the disappearance of 3,988 square kilometres of breathing forest in one
place, and in another year, in another place, 377,000 thousand hectares of
wind and tree cover, gone. They vaccinated us over and over to inhale the
toluene and dioxin and cadmium and breathe the fast-mutating viruses.
We managed to walk during three springs. They sold us plastic raincoats
for the microplastic rain falling.

vol. 16.1.001
What is the medicine for this? The sculptor's hand is at the cheekbone, the
perpendicular plate of the ethmoid bone, the lacrimal bone all worn.
2 streets without bullets
1 acre of skipping ropes
16cc lemon juice
1 city with anything useful like

600 kilometres singing Stevie songs
1,000 words spit into 1,000 pieces of paper and tied with twine
3 rooted hairs burnt and put in an envelope under a pillow
1 night, held, belly to back
4am to 4am of breathing

vol. 3.0790
And why do I consider this morning of any consequence after the long all souls' night on the front steps tending to the candles? Because this morning, the day felt like verditer blue and smelled like vetiver, and everyone we knew, in all our registered epochs, passed by last night, leaving a carved-out way with their mallets and knives.

vol. 23
The chemistry of roses
Beta-damascenone
The properties of rose petals
Superhydrophobic
Anti-inflammatory
Antiparasitic
Antiseptic

vol. 1
and we adjust all frequencies, all wings, all gills, to nebulae ahead.

This book is published on the occasion of the exhibition *Simone Leigh*, organized for the Institute of Contemporary Art/Boston by Eva Respini, deputy director for curatorial affairs and Barbara Lee Chief Curator, with Anni A. Pullagura, assistant curator; with the support of Tessa Bachi Haas, curatorial fellow, and Chenoa Baker, former museum fellow.

ICA/Boston
April 6–September 4, 2023

Hirshhorn Museum and Sculpture Garden
Washington, DC
November 3, 2023–March 3, 2024

California African American Museum, Los Angeles, and Los Angeles County Museum of Art
May 2024–January 2025

Published in 2023 by the Institute of Contemporary Art/Boston and DelMonico Books • D.A.P.

Institute of Contemporary Art/Boston
25 Harbor Shore Drive
Boston, MA 02210
icaboston.org

DelMonico Books
available through ARTBOOK | D.A.P.
75 Broad Street, Suite 630
New York, NY 10004
artbook.com
delmonicobooks.com

First edition © 2023 Institute of Contemporary Art/Boston and DelMonico Books • D.A.P., New York

All artworks by Simone Leigh are © Simone Leigh, courtesy the artist and Matthew Marks Gallery, New York, unless otherwise noted.

ISBN: 978-1-63681-078-2
Library of Congress Control Number: 2023900703

Editor: Eva Respini
Text Editor: Michelle Piranio
Design: Nontsikelelo Mutiti
 with Ryan Diaz and support by Jiani Liu
 for NMutiti Studio
Publication Coordinator: Anni A. Pullagura
Publication Manager: Jeffrey De Blois
Proofreader: Bruno George
Indexer: Enid L. Zafran,
 Indexing Partners LLC

Printed and bound in China

Cover: Work in progress, 2022. Photo by Timothy Schenck 2022